INFINITE GAME UNIVERSE

Level Design, Terrain, and Sound

INFINITE GAME UNIVERSE

Level Design, Terrain, and Sound

Guy W. Lecky-Thompson

CHARLES RIVER MEDIA, INC.
Hingham, Massachusetts

Publisher: David F. Pallai
Production: Paw Print Media
Cover Design: The Printed Image

CHARLES RIVER MEDIA, INC.
20 Downer Avenue, Suite 3
Hingham, Massachusetts 02043
781-740-0400
781-740-8816 (FAX)
info@charlesriver.com
www.charlesriver.com

This book is printed on acid-free paper.

Guy W. Lecky-Thompson. *Infinite Game Universe: Level Design, Terrain, and Sound.*
ISBN: 1-58450-213-4

Library of Congress Cataloging-in-Publication Data

Lecky-Thompson, Guy W.
 Infinite game universe. Level design, terrain, and sound / Guy W. Lecky-Thompson.
 p. cm.
 ISBN 1-58450-213-4
 1. Computer games—Programming. I. Title.
 QA76.76.C672 L428 2002
 794.8'151—dc21
 2002005152

Printed in the United States of America
02 7 6 5 4 3 2 First Edition

CHARLES RIVER MEDIA titles are available for site license or bulk purchase by institutions, user groups, corporations, etc. For additional information, please contact the Special Sales Department at 781-740-0400.

Requests for replacement of a defective CD-ROM must be accompanied by the original disc, your mailing address, telephone number, date of purchase, and purchase price. Please state the nature of the problem, and send the information to CHARLES RIVER MEDIA, INC., 20 Downer Avenue, Suite 3, Hingham, Massachusetts 02043. CRM's sole obligation to the purchaser is to replace the disc, based on defective materials or faulty workmanship, but not on the operation or functionality of the product.

This book is for my daughter, Emma, who arrived during
the writing of this book and who is a constant source of amusement
whenever the writing becomes stressful.

CONTENTS

ACKNOWLEDGMENTS

Once again, I owe a debt of thanks to the Charles River Media team and especially Dave Pallai for their help throughout this project. My family, as usual, has supported me with constant encouragement throughout the writing and development of this book. My wife, Nicole, deserves a special mention for her patience with a book-obsessed husband.

There are many people who have been involved with this project in a very indirect way—those whose work I have read, quoted from, and pieces of code and prose that have inspired me. They are credited individually throughout the book, but deserve a collective mention as providing much food for thought.

Finally, as always, my continuing success is largely thanks to the nurture and education that I have received over the years from the various educational institutions that I have attended. Some of the ideas that spawned this book first took shape during the course of that education—probably while I was supposed to be concentrating on something else!

PREFACE

Welcome to *Infinite Game Universe!* Whereas *Infinite Game Universe: Mathematical Techniques* detailed the mathematical concepts behind creating game universes of truly enormous scale, this book will attempt to put those techniques into context. We shall look at many different possible applications of the mathematical techniques explored in that first book, while also adding some less-mathematical algorithms that can be used in many situations.

It is worth noting that reading the first book is not a prerequisite to understanding any of the concepts presented in this book; they can be used as is without knowledge of the background that led to them. However, the reader might benefit from having read *Infinite Game Universe: Mathematical Techniques* and, if they find this volume useful, will certainly benefit from reading it at a later date.

MINIMUM RESOURCE STORAGE

In the same way that the first book sought to use mathematics to create worlds that have no bounds, here we shall be always trying to reduce the amount of storage (file size) necessary for game data, such as level information, sound samples, and graphics. The keyword is "efficiency"; we hope to become so efficient with our information storage and retrieval that some platform limitations will become reduced.

We put so much emphasis on this for many reasons. To begin with, some environments simply do not support the storage and distribution of large amounts of information. Handhelds and consoles, for example, might have very limited static storage capability available to them. Then again, there might also be problems in processing information fast enough in its raw format due to bandwidth limitations, for example.

Other reasons for keeping game data storage requirements low will also be discussed, but the previous two examples are enough to illustrate what we are trying to achieve. Of course, not all the techniques will be applicable in all situations, and the choice of which technique to use is up to the designer or developer. Extending the capabilities of the chosen platform requires a slightly delicate treatment, but the rewards are worth the effort.

GENERATION VERSUS STORAGE

One of the principal techniques behind many of the concepts introduced in *Infinite Game Universe: Level Design, Terrain, and Sound* is based on the mathematics introduced in *Infinite Game Universe: Mathematical Techniques*. This is not to say that the first book needs to be read and understood in order to use these concepts, but the thought processes that spawned their creation would be better understood by reading the first volume of *Infinite Game Universe*.

The principle is that rather than storing vast quantities of information, we can instead store a lesser amount and seek to generate vast quantities of varying and useful information from it. In other words, we can use encoding and compression to store and retrieve the game data. These are not new concepts, perhaps; but they are only the beginning.

We can extend these ideas so that only storage of a few well-chosen numbers are needed to generate enough data to create a whole planet. What is more, we can generate different planets, or the same planet at will without storing any additional information. We can introduce an infinite number of levels into a game, leaving it open-ended if we wish, and run it on a handheld platform.

BALANCING GENERATION & STORAGE

There will always be the need for balance, however. Some platforms benefit from a very fast processor, and much higher levels of compression are possible. Other platforms will have static storage capabilities that exceed our ability to fill them with level data, but they will be restricted in temporary storage.

Alongside each technique that is presented within this book is a discussion of its fitness for a given application. Much of this information is contained in Part V: "Limited-Resource Environments," which is aimed at trying to satisfy as much of the market as possible by showing the various ways in which the specific restrictions of those platforms can be overcome.

OVERVIEW BY PART

PART I: LEVEL DESIGN TECHNIQUES

Various techniques for storing game level information are discussed, and particular game types are referenced.

PART II: TERRAIN & LANDSCAPE DEFINITION

An overview of techniques specifically related to storing and creating different types of landscapes are presented along with algorithms for their creation.

PART III: SOUND & MUSIC

Ways of encoding, generating, and making new sounds for use in games will be examined. A detailed introduction to computer-generated music and speech synthesis techniques will also be included.

PART IV: WORDS & PICTURES

This part takes an in-depth look at the ways in which language and graphics are used in gaming contexts, including digital imaging and image processing, and generating/understanding natural language.

PART V: LIMITED-RESOURCE ENVIRONMENTS

Decisions on platform choice with respect to specific limitations of popular gaming environments will be discussed. Which techniques can be used for which platforms? Programming-specific information will be presented for those platforms.

LEVEL DESIGN TECHNIQUES

INTRODUCTION

This part of *Infinite Game Universe* is concerned with how level data can be created and stored with respect to the different types of levels that might be created. Of course, by and large, the types of levels that need to be created are related to the style of game. Some games lend themselves to using levels based on platforms, and others are based simply on the differing interactions between certain objects within the game universe.

Some games do not have a distinct level system that relates to actual, discretely labeled levels (such as numerically designated levels #1, #2, #3, etc.), but rely on a general progression of difficulty that relates to player input, such as in shoot-em-ups like *R-Type* or *Space Invaders*, where progressively more shots are required to destroy the attacking craft.

DEFINITION OF 'LEVEL'

In general and depending on the game, a 'level' consists of a collection of game-specific challenges for the player to overcome. Moreover, a level can also include an increase in difficulty, as noted above. The level structure is also key to the concept of success. From the player's point of view, attaining each level represents an important goal toward improving their score.

Shooter games such as *Elite* and *Wing Commander* have different classes of players who have titles that are based on the player's success. In *Elite*, combat ratings range from "Harmless" to "Mostly Harmless" to "Average" to "Competent," and to "Dangerous" and "Deadly" before finally reaching "Elite." At each level, a higher number of craft must be destroyed than in

the previous level; furthermore, the player becomes more likely to be attacked, because they acquire a reputation along the way.

Other games, such as *Tetris*, only employ the concept that speed increases with an increase in the player's score. There are, of course, many examples of games such as this, in which the progression from one level to another means either more enemies or a faster pace of play.

INCREASING DIFFICULTY

The simplest way in which levels can change is just to add more adversaries to be shot, or to make them move and fire faster. This will make it more difficult for the player to destroy enough of them, without being themselves destroyed, in order to enable moving to the next level.

There is another aspect: As the player's craft, persona, and so forth becomes damaged, they can begin to slow down, become erratic, or generally degrade in performance. Hence, the game also gets more difficult. This adds another type of level for the player to avoid.

INCREASING COMPLEXITY

For some games, like *Thrust!*, the game actually becomes more complex as the player moves from level to level. In *Thrust!,* the player descends into the bowels of a planet to retrieve an orb, which can be towed by the player's spacecraft back to the surface. As each level is completed, other objects are added to the subterranean mazes, such as limpet guns in overhangs that shoot on sight and doors with controls that must be shot before they will open.

In the end, though, a game will probably need to use a combination of increased difficulty and increased complexity in order to retain the imagination and attention of the player. Once a game has been completed, there should still be a good reason to play it, or the shelf life of the game will be short; players will simply copy it, rather than desire to purchase it.

With all of the above in mind, let us now look at how levels can be designed, generated, or created so that the challenges mentioned above can be applied to each level, enabling the general difficulty of the game to increase as the player becomes more adept.

PLATFORM-BASED GAMES

INTRODUCTION

One of the first styles of computer game to become popular was based upon a very simple design concept that involved placing the player in control of a figure capable of walking (in some cases, running), jumping, and occasionally shooting weapons. The game universe usually consisted of nothing more than a series of platforms that supported the figure's actions; hence, the moniker "platform games" was born.

Although the technology behind games machines has advanced in recent years, it is always worth taking the time to look back into history to see how these games started the revolution of games software. The basic principles still apply, no matter how advanced the machine. Even a first-person-perspective shoot-em-up like *Doom* or *Quake* has its roots in the first games to hit the arcades in the late 1970s and early 1980s.

By going back to the roots of gaming, we can see how the games were put together; and do not forget that at the time they were created, they were at the cutting edge of game technology. In addition, it is useful for the budding game designer to begin with simple, easy-to-complete game-programming exercises. Believe it or not, no matter how good a programmer is, creating the ultimate game straight off is nearly impossible and very frustrating—especially when the project lies unfinished.

So, not only is this chapter an analysis of basic design techniques, but it also lays the foundations for the coded examples that follow in the remaining chapters of Part I.

A good example of a 'pure' platform game is *Ghouls*, released in 1984/1985 by Micro Power, for the Commodore 64, Acorn Electron, and BBC Micro. The screen shot in Figure 1.1 shows the basic layout of a typical *Ghouls* level.

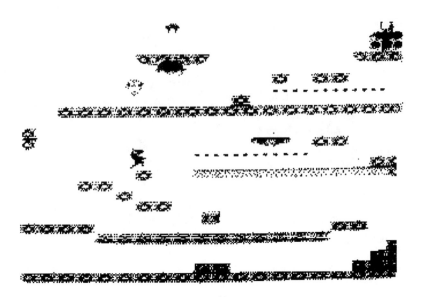

FIGURE 1.1 *Ghouls* screenshot. Copyright © 1985 by Electron User. All rights reserved.

The idea behind the game is to move from platform to platform, jumping over various obstacles, avoiding floating ghosts, and eating power pills. Each level's objective is to reach the 'goal,' which usually resides in the top-right-hand corner of the screen.

Variations exist; some platforms are moving, others disintegrate when touched, and others act as elevators, lifting the little yellow *Pac-Man*-esque character at the center of all the action. Indeed, the game is a strategic version of *Pac-Man* with many similarities. As an example of the way in which all games, no matter how advanced, share concepts, *Pac-Man 3D*, which was released much later, incorporated some of the features first seen in *Ghouls*.

History lesson aside, *Ghouls* employs some of the basic, key elements for the definition and storage of game universes, particularly when we note that with 32Kb of memory, there was barely enough RAM for the game play code, let alone the pretty graphics that made up each level. Objects were even animated, which required either some clever programming or clever storage.

There are visual clues, especially in the Acorn Electron version of the game. When it is loading (from tape, taking about three minutes or so), strange characters appear on the screen. Upon closer examination, these characters reveal themselves to be pieces of the level—the odd bit of sprite and other graphical elements.

Without going into specifics, according to the *Acorn Electron Advanced User Guide*, written by Mark Holmes and Adrian Dickens (Cambridge, U.K.: Acornsoft, Adder Publishing, 1984), some memory was set aside for user-defined fonts (p. 190). It seems that this might overlap with screen memory at some point, leading to the fonts being displayed on the screen as the game is loaded.

Indeed, in some cases, programmers have been known to use screen memory (which is usually invisible) to store graphical fonts in order to release memory for the game code itself; again, during the loading process, these graphics might be displayed on the loading screen if the mode in use is not the same as the regular game-playing mode. Different modes, especially in the Acorn Electron games, use different memory ranges.

As long as the screen is not *scrolled*, the programmer can assume that screen memory covers a well-defined portion of available RAM, which can be accessed through a series of low-level access routines.

These are all clues as to *how* the game was engineered. We can make several assumptions that will aid us in understanding *why* it was written in this way.

For example, looking at the game, we can assume that a text-based display mode was used with user-defined fonts representing the game sprites. In this way, standard, fast, and well-integrated routines can be used to display the 'text' in much the same way as if they were standard letters. As a bonus, due to the fact that a standard user-defined font is being used, each character (sprite) has a numeric ASCII value that can be stored and applied directly to display the sprite.

This brief analysis leads us to our first technique that we can use to define and store game universe information—plain text. The theory is that no matter the platform, copying textual data to the screen is handled with far more efficiency than other, more-complicated graphical operations.

Based upon this assumption, we can store our universe data as a two-dimensional array of characters and copy this information to the screen as required. Of course, it will be more efficient to retain two such arrays and display only the difference between the two, differences that are caused by things like player interaction or game rules.

In effect, we have a map of the screen held in memory, which we can then use to update the screen. This simple technique can be applied to almost any kind of game or platform with very little in the way of modification. We shall come back to this technique again and again; it always seems to play a role at some point in game development.

LADDERS & LEVELS

The concept of 'ladders and levels' adds a little more complexity to the basic platform genre. Now our character can run, jump, shoot things, *and* climb up and down ladders. At first glance, this doesn't seem much of a jump in complexity. After all, all we are doing is adding another graphical element.

In fact, adding ladders poses some interesting questions that are not inherent to the standard platform-style game. In the standard platform game, we can assume that at a given moment in time, no two graphical elements can occupy the same space. The only possible exception to this is when the character encounters an obstacle that causes death or loss of energy. This has been worked around by freezing the character in place just in front (behind, above, or below) the obstacle, occasionally leading to slightly bizarre game play (as in *Frak!*).

Add a ladder, and the complexity level rises visibly. Now we have to worry about how to represent, using one character in our array, the possibility of two sprites occupying the same space in the game universe. Not only this, but we need to be able to overlap the sprites correctly (it would be strange in the extreme to see the ladder disappear as our hero climbed it), or define a whole range of new sprites to cope with these possible new actions.

There are actually three distinct problems here. The first is knowing what to do when the sprite representing the hero passes in front of the ladder sprite; the next is related to the action (up or down) that the sprite needs to do in order to 'use' the ladder. Finally, we need to be able to cope with the state change when the character leaves the ladder.

Each of the above actions must be accompanied by a change in the on-screen representation of the particular space in the game universe that we are concerned with. This change could be either the overlapping of two sprites or the output of a single sprite designed to represent the desired state.

So, rather than storing a map of the screen with static values in each element of the array, we should allow for the possibility that the values can metamorphose to represent changes in state. There is actually one other option—store an array for each of the possible classes of game element. However, this would require storage space, and this method is inefficient when checking whether two or more elements occupy the same space in the game universe.

The more efficient approach requires (as is usually the case) slightly more design work, a little more coding finesse, but much less run-time leg work for the computer. The design work involves establishing the various

states that a space in the game universe can have and deciding whether combinations of states are permitted for a given class of object.

We shall refer to these spaces as "cells." Using *Ghouls* as an example, we can define a set of finite state diagrams to deal with the possibility of objects either moving around in the game universe or disappearing completely (e.g., when pills are eaten). Figure 1.2 shows the finite state diagram for a section of moving floor, which (as an example) is one sprite (cell) long.

The diagram format is simple enough that no further discussion is required, and can be extended to cover a three-state animation sequence, such as is required to depict the possibility of two sprites overlapping. Figure 1.3 shows all possible states and state changes.

It is a fairly simple matter to transfer these state changes to program code. We simply need to designate a set of values that also translate sprite

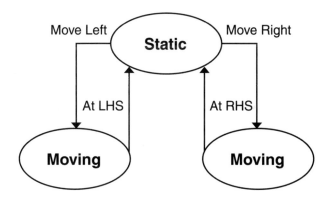

FIGURE 1.2 Moving-floor finite state diagram.

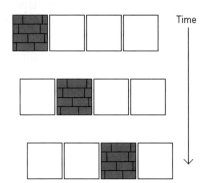

FIGURE 1.3 Moving-floor states and state changes.

representations. There are two aspects: first, to manage the values themselves using the finite state diagram; and second, to translate the resulting values into sprites. We shall see how these modeling aspects work in due course.

Resources

Until now, we have ignored one vital aspect. Games such as *Ghouls* do not consist of a single game screen. Instead, they consist of a set of levels of increasing complexity. The object is to survive each level and build up a respectable score. From a design point of view, each level should be harder to complete than the previous level.

Our representation is fine as far as it goes, but keep in mind that the machine upon which it was running had a mere 16Kb of available memory. Each screen defined as an array of cells in the textual display mode (Mode 5 on the Acorn Electron) would require 20 × 32 bytes—a total of 640 bytes. The total available memory is 16 × 1024 bytes, or 16,384. Divide 16,384 by 640, and we have a total of 25 screens that can be defined this way. Furthermore, what about the code required to manage the cells, their display, the states of each game element, and scorekeeping?

Clearly, although the technique is good for working space, it was not used by game designers to store the basic level data. There just was not enough space.

As an aside, with the mammoth amounts of memory available in today's computer systems, the game programmer would be forgiven for not caring one way or the other about using 640 bytes per level for storage. However, as game complexity increases and the levels get bigger and bigger, it is wasteful and inefficient to use this technique for anything but working space. It is also good practice to get into the habit of finding the most-efficient solution to each problem, because machines still exist that are limited in available run-time resources (e.g., Game Boy, Xbox).

Difference Encoding

One possible solution is very similar to our technique for efficiently displaying the screen as the game is played. This is referred to as "difference encoding." The trick in screen updating is to only update the changes (reminiscent of early animation techniques), which is why we have two 20 × 32 grids and compare them to get the updated information.

We can also use difference encoding to split the workload of level definitions between storage and algorithmic manipulation. In simple terms, we define the basic screen configuration, making assumptions about the positioning of certain elements, and keep it static. Any level-specific information we store is merely the difference between a template, or blueprint screen configuration, and the desired appearance of the level itself.

For example, in *Ghouls*, the exit point of each level is always in the top-right-hand corner of the screen and takes up 2×2 cells. There is never anything else in the top two lines of the screen. The bottom line of the screen is always solid, so that the character, whatever he does, cannot fall through the bottom of the screen. The left- and right-hand columns are also always the same, and contain walls.

In addition, the prize that marks the exit point is always supported by a section of floor that is three cells wide and one cell deep. All of these assumptions add up to the possibility of reducing the amount of storage space required to around 516 bytes. Good, but not good enough.

Part of the beauty in using finite state technology to manage the various interactions between the player, nonplayer characters, and screen objects is that the level set-up code need only be executed once. Thereafter, since each object follows strict rules, we do not need to regenerate the level.

However, for some elements, such as disappearing blocks, states might need to be reset in cases where the current play session is suspended due to the player's character unwittingly running into, say, a spike or ghost. Using finite state technology, we will have a 'shadow' for where such blocks exist, and they can be easily replaced. We shall see this technique in more detail at a later stage.

PLATFORM ENCODING

The difference encoding technique could be used for the level definition itself, but would probably result in software that is unnecessarily complex. Instead, we can use a similar technique called "selective positioning."

The key to selective encoding is to store a bare minimum of information and decide upon the representation when building the level array for the first time. One characteristic of platform games is that the number of objects on the screen changes from level to level, as does the general layout of the platforms.

A first level might contain simple obstacles, such as spikes for impaling the unwary player, some basic foes, and perhaps one moving platform.

The remainder of the level is usually a collection of platforms with the occasional hole across which the player must jump.

Further on in the game, the player is likely to encounter different kinds of foes, perhaps some variations on the moving-platform theme (such as disappearing blocks), and more holes in the platforms arranged to cause maximum inconvenience.

To illustrate these concepts, consider Figures 1.4 and 1.5, which depict an easy level and a more complex one, respectively.

Actually, encoding these can be have very little impact on resources if we adhere to a few simple rules. These rules might change from game to game; they merely serve to illustrate possible conventions that can be used to manage the construction of a level design.

The first step is to decide how to represent the various game objects and their states, and to associate known codes with them. Care should be taken when choosing codes so that the states can be easily mapped. Figure 1.6 shows possible encodings for a *Ghouls* clone.

Using Figure 1.6, we can see that, for example, there are blocks that disappear but do not come back, and that ghosts animate between three states. It is important to note that these encodings only relate to visual state changes and bear no relation to movement directly. That particular chore must be dealt with separately (see Chapter 5: "Introduction to Event Sequencing").

FIGURE 1.4 Easy level.

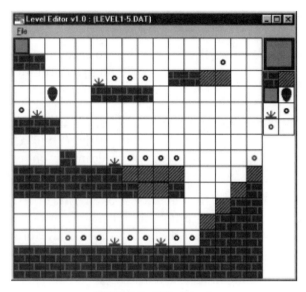

FIGURE 1.5 Difficult level.

Now that we have determined encodings for the sprites, we can turn to the task of encoding the level design (see Figure 1.4). It is clear at first glance that the level can be divided into lines of sprites. Indeed, this is by design, since we are going to encode each line as a collection of strings of sprite codes. Thus, each line consists of one or more pairs of numbers. The first is the number of sprites, and the second is the sprite starting code.

There are 21 lines, each of 16 sprites. Thus, starting from the bottom left, we can encode the first two lines (0 and 1) as:

```
16, 20 : 16, 20
```

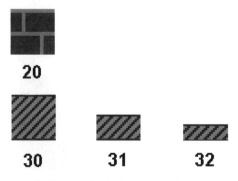

FIGURE 1.6 *Ghouls* clone game object codes.

Lines 2 and 3 would be encoded as:

```
4, 0, 8, 70, 4, 20 : 12, 0, 4, 20
```

The above convention is only used for readability. It is actually quite wasteful, and so we might choose to use an encoding scheme that states that numbers can consist of a maximum of two digits (00 through 99), and that line separators are implied. This would render the first four lines as:

```
15201520040008700420120000420
```

This string of 29 bytes represents 16 × 4, or 64 bytes of actual information. We can take this one step further and assume that each line wraps around, which alleviates us from the necessity to actually store the first two lines separately, since they are identical. Therefore, they simply become:

```
3220
```

and the entire first four lines as:

```
3220040008700420120000420
```

This results in 24 bytes for 64 bytes of information. To encode the remainder of the screen, we continue in this fashion; beginning at the bottom left, we work toward the right-hand side. When we reach the right-hand side, we then wrap around to the next line and do the same thing. Continuing to wrap our way up the screen, the following string is generated:

```
32200400087004201200042013001420030013200400012003000120020001600470210003203400042013000370010006201100052012000470040007200500022003000570250007200300032003000670020000150020001800181140001820183
```

If counted, this yields 198 bytes for a screen design of 336 (16 × 21) bytes, a savings of 59% on the memory requirements. This example in itself is not a staggering achievement; but the implication that a given game universe could be 59% larger if these techniques are *not* used *is* staggering.

This deals with the technique; now we should concentrate on how it can actually be coded. The algorithm is straightforward enough to reproduce here in full. There are, however, two assumptions. First, the actual array size of the level data that we wish to encode is held static. Second, we assume we are starting with a level designed in some kind of editor, the output of which

is an array of dimension [LEVEL_HEIGHT][LEVEL_WIDTH], where LEVEL_HEIGHT and LEVEL_WIDTH are the previously defined dimensions of the level data array.

Bearing these slight limitations in mind, let us examine Code Sample 1.1, which implements a possible encoding routine, LevelEncode.

CODE SAMPLE 1.1 LevelEncode algorithm.

```
// LevelEncode
// Copyright © 2001 by Guy W. Lecky-Thompson

// Purpose : To encode level data of LEVEL_WIDTH * LEVEL HEIGHT
   using a
//            reasonably waste-less algorithm

// Inputs : An array of [LEVEL_HEIGHT][LEVEL_WIDTH] characters
// Output : A variable length array of bytes
// Return Value : Size of malloc'ed data block

int LevelEncode(     char
   szLevelData[LEVEL_HEIGHT][LEVEL_WIDTH],
            char * szEncodedLevelData)
{
   int nEncodedLevelDataSize = 0;
   // Initially, no data is needed
   char nCurrentChar;
   int nCurrentCharCount;
   int nLevelDataX, nLevelDataY;

   // Check for null pointer
   if ( szEncodedLevelData != NULL )
     free (szEncodedLevelData);
   // Return memory to OS

   szEncodedLevelData = (char *) malloc( 1 );
   // Allocate at least 1 byte

   nCurrentChar = szLevelData[0][0];
   nCurrentCharCount = 1;

   for ( nLevelDataY = 0; nLevelDataY < LEVEL_HEIGHT;
   nLevelDataY++ )
```

```
{
  for ( nLevelDataX = 0; nLevelDataX < LEVEL_WIDTH;
nLevelDataX++ )
  {
    if ((  szLevelData[nLevelDataY][nLevelDataX] ==
nCurrentChar ) &&
        (  nCurrentCharCount <= 255 ))
    {
      nCurrentCharCount++;
    }
    else
    {
      nEncodedLevelDataSize += 2;

      // Resize the memory to be used for storage
      szEncodedLevelData = (char *) realloc(
      szEncodedLevelData,
      nEncodedLevelDataSize);

      // Set the data according to the local variables
      szEncodedLevelData[nEncodedLevelDataSize-2] =
nCurrentCharCount;
      szEncodedLevelData[nEncodedLavalDataSize-1] =
nCurrentChar;

      // Change the current character to the new one
      // (or the same, if we have simply overrun the 255
      // limit)
      nCurrentChar = szLevelData[nLevelDataY][nLevelDataX];
      nCurrentCharCount = 1;
    }
  }
}
  return nEncodedLevelDataSize;
}
```

The reader will no doubt have noticed that the LevelEncode algorithm has an additional refinement over the technique initially described. Rather than storing the level data as four bytes, since it has been established that neither value will exceed 99, we can store each number as one byte, giving us a value of up to 255.

The implementation is simple enough; the program simply scans the array, taking note of each character and checking to see if it is the same as

the previous character. If it is, and if there have been less than 255 occurrences of the character, it increments the current count of the character in question. Once the character changes, or a string of more than 255 has been found, the program resets the counter and adapts itself accordingly.

If the reader is not familiar with the `malloc`, `realloc` and `free` functions, they are simply ways of dealing with memory (in this case, a simple, variable-length character string) in a way which enables us to dynamically allocate memory as we need it. Those readers who are familiar with these functions will have noted that no error conditions (such as running out of memory) have been tested for. Actual implementations should perform these tests in order to ward against crashing the computer.

To be of any use, we should actually store the resulting string somewhere. While this is a trivial matter, there are a few traps for the unwary. The simplest way of storing a variable-length string in a file can be seen in Code Sample 1.2; it works for any block of memory up to a size limited by the representation of a `long int`, roughly 16Mb.

CODE SAMPLE 1.2 Memory block file writing.

```
// WriteMemoryBlockToFile
// Copyright © 2001 by Guy W. Lecky-Thompson

// Purpose : To write a pre-allocated, variable-length memory
// block to file.

// Inputs : File handle, block of data, of type char *
// Output : None
// Return Value : None

void WriteMemoryBlockToFile ( FILE * hFile, char *
  szMemoryBlock )
{
  long int lBlockSize = strlen(szMemoryBlock);

  if (hFile != NULL)
  {
    // Write out the memory block size
    fwrite( &lBlockSize, sizeof (long int), 1, hFile);
```

```
    // Write out the memory block itself
    fwrite( szMemoryBlock, sizeof (char), lBlockSize, hFile);
  }
}
```

We could have just used the fprintf routine, but it is not as fast for large memory blocks and not as portable. Windows programmers, for example, can directly port the fwrite call to a native Windows API call, _lwrite, with very few changes.

The fwrite call itself takes a type of void * as the first argument, which is C++'s way of saying that you can pass a memory block containing anything you like to the function, and it will be able to deal with it on a byte-by-byte basis. Hence, the pass by reference of the lBlockSize variable is used to provide the compiler with a memory block.

THE DECODING ALGORITHM

Now that we have seen how to encode and store our level data, it is time to define the functions that perform the inverse—read in and decode (expand) the level data. The basic algorithm does not need much explaining, since by and large each function has a direct inverse, as can be seen from Code Samples 1.3 and 1.4.

CODE SAMPLE 1.3 Memory block file reading.

```
// ReadMemoryBlockFromFile
// Copyright © 2001 by Guy W. Lecky-Thompson
// Purpose : To read a variable-length block from a file

// Inputs : File handle, 'empty' pointer
// Output : Pointer referencing memory block
// Return Value : None

void ReadMemoryBlockFromFile ( FILE * hFile, char *
  szMemoryBlock )
{
  long int lBlockSize;

  if ( szMemoryBlock != NULL ) free( szMemoryBlock );

  if (hFile != NULL)
```

```
{
  // Read in the proposed block size
  fread( &lBlockSize, sizeof (long int), 1, hFile);

  // Allocate the memory that will be required, plus the NULL
  // character
  szMemoryBlock = (char *) malloc ( lBlockSize+1 );

  // Read in the memory block itself
  fread( szMemoryBlock, sizeof (char), lBlockSize, hFile);

  // Terminate with NULL character
  szMemoryBlock[lBlockSize] = '\0';
}
}
```

Again, it is easy to understand what the ReadMemoryBlockFromFile function does, but there are a couple of useful points to note. First, we make sure that the memory block represented by the szMemoryBlock variable is empty before we allocate the memory that we need. However, this does not preclude the possibility that a noninitialized pointer was passed to the function, in which case an error will occur. Thus, the pointer should be declared in the main program as static char *, which will hopefully cause it to be initialized with a sensible value. Adding a statement to assign a null value to the variable is also a good idea.

The second point worth noting is that the memory block assigned is one byte larger than the value stored in the lBlockSize variable suggests. This is due to the fact that the strlen function used to get the size in the WriteMemoryBlockToFile function does not count space for the NULL character. To make manipulation easier, therefore, we add a NULL character ourselves, hence the 'extra' byte in the allocation statement.

CODE SAMPLE 1.4 LevelDecode algorithm.

```
// LevelDecode
// Copyright © 2001 by Guy W. Lecky-Thompson

// Purpose : To decode previously encoded level data of
   dimension
//           LEVEL_WIDTH * LEVEL HEIGHT
```

```
// Inputs : A variable length array of bytes
// Output : An array of [LEVEL_HEIGHT][LEVEL_WIDTH] characters
// Return Value : None

void LevelDecode(    char * szEncodedLevelData,
                char szLevelData[LEVEL_HEIGHT][LEVEL_WIDTH])
{
  // Check for null data pointer
  if ( szEncodedLevelData == null ) return;

  long int lLevelDataSize = strlen ( szEncodedLevelData );

  long int lCurrentPair;
  int nX, nY, nCharCount, nChar;

  nX = 0; nY = 0;

  for (lCurrentPair = 0; lCurrentPair < lLevelDataSize;
  lCurrentPair += 2 )
  {
    nCharCount = szEncodedLevelData[lCurrentPair];
    nChar      = szEncodedLevelData[lCurrentPair+1];

    while (nCharCount > 0)
    {
      szLevelData[nY][nX] = nChar;
      nX++;
      if ( nX >= LEVEL_WIDTH )
      {
        nY++;
        nX = 0;
      }
      nCharCount-;
    }
  }
}
```

The code in Code Sample 1.4 needs no real discussion, and might not even be the most efficient way to encode the reverse algorithm of the LevelEncode algorithm. It is, however, easy to understand.

USING LEVELENCODE AND LEVELDECODE

On the companion CD-ROM, besides the source code above, the reader will also find a complete set of tools for manipulating levels stored in this way. The TextLevelEncode program will take a sample level file, prepared with a text editor or similar tool (ensuring that lines are terminated with a carriage return, '\r\n'), and produce a file with the encoded data in it. The program accepts any level size up to 1000 × 1000 that is defined by the MAX_LEVEL_WIDTH and MAX_LEVEL_HEIGHT constants.

The sister program, TextLevelDecode, takes the output file containing the encoded level data and produces a text file that should be identical to the input provided to the encoding software.

The algorithms and techniques that these small programs represent provide the basis for all the other encoding and decoding algorithms that we shall come across in the ensuing chapters of this book, so it is important that the reader understands their strengths and weaknesses.

RUN LENGTH ENCODING

For those readers who have been programming in the Microsoft Windows arena for any length of time, the LevelEncode/Decode algorithms will seem vaguely familiar. In fact, they make use of something that we shall refer to throughout the book—a technique originally conceived for use when storing bitmap files.

Historically, the main image file storage format under Windows has been the bitmap, whether it be a device-dependent bitmap or a device-independent bitmap (containing a palette). A regular, uncompressed, 24-bit color bitmap (otherwise known as 24 bits per pixel) measuring 640 × 480 pixels and having a red, green, and blue component for each pixel would require 640 × 480 × 3 bytes: 921,600 bytes, plus the header containing the scheme, color depth, and dimensions.

However, if we can encode the image in a way similar to our level encoding/decoding algorithms above, we can reduce this storage substantially, since most images will have areas of pixels where all the colors are the same. The technique of reducing redundancy in this way (storing two bytes indicating the value and number of repetitions) is known as Run Length Encoding (RLE).

RLE works with most types of data where there is a good chance that the individual data elements (pixels, in this case) will be grouped in areas of like value.

AN INTRODUCTION TO MAZE THEORY

So far, we have dealt with platform games in a way that insists that it is the game designers that actually do all the work in producing levels that are challenging and interesting to play. While the best level designer is indeed human, there is a lot of work that can be farmed out to the computer. This is especially true when dealing with high-end hardware platforms, such as the Playstation2 (Sony), Pentium IV-class PC, or Apple Macintosh G4.

Other machines, such as the Game Boy (Nintendo) or equivalent handhelds, will not have the processing power that is required to perform the functions that we are about to discuss here.

Consider, for a moment, designing a maze. There are many ways in which this can be done, but one of the easiest is shown in Figures 1.7 and 1.8. The first step is to define a path from point A to point B with a given number of turns (depending on the complexity of maze required). In Figure 1.7, we show a simple path with four turns.

Once we have decided how the player is going to get from A to B, we can add a passageway, shown in Figure 1.8 as a corridor with thicker borders than the rest of the maze.

The completed maze is shown in Figure 1.9, and it is probably not going to confuse the player for very long! The important point here is not the difficulty of the resulting maze, but the steps that we have gone through to create it. Let us assume that we give the computer our desired path. Is it possible to instruct the machine to build a maze around the path so that we only need to supply the path itself?

If we take this approach one step further, we could even imagine giving the machine point A, point B, and the desired number of turns, and have the machine define the path, too. Of course, we would also need to tell it a

FIGURE 1.7 Simple path.

FIGURE 1.8 Corridor path.

FIGURE 1.9 Finished maze.

few other parameters, such as maximum and minimum corridor lengths for the desired path, and dimensions for the bounding walls of the maze.

Finally, we could even enable the machine to determine the position of points A and B. Then, we just tell the machine how complex a maze we want, and tell it to produce a suitable maze. While this approach is presented as a thought experiment, we will attempt to implement each of these three scenarios, because individually they are very useful for building-based game designs (see Chapter 2).

REPTON-ESQUE

A final variation on the platform theme that encompasses both platform and maze game design techniques was embodied in the hit 1985 game *Repton* (Superior Software). Incidentally, *Repton* was played over 12 levels, each with an area of $(9 \times 9) \times (4 \times 4)$ cells. The total memory requirement, assuming a straightforward array-based implementation, is 15,552 bytes, or a little over 15Kb. Add this to the memory required by the probable screen mode used, 10Kb, and we have about 25Kb. The machine that this game was designed for was, again, the Acorn Electron, which had 32Kb of *total* system memory.

In the best-case scenario, using pure arrays leaves 7Kb for game code. Not a great deal by most standards, and probably not enough to control every aspect of the *Repton* game core. Obviously, some clever techniques, such as those presented here, were at work.

The map in Figure 1.10 shows the solution to *Repton*, clearly revealing the extent of the complexity of this great game. The object is to march around the maze and gather diamonds, while being careful not to block off the various corridors by inadvertently dropping rocks behind yourself.

FIGURE 1.10 *Repton* map view.

There are a number of different game elements: rocks, diamonds, walls, and earth. Earth is removed as *Repton* digs his way around the maze, and only earth supports rocks; they tend to fall off of diamonds. On top of that, if they fall on *Repton*, he dies.

Using the game level encoding techniques presented here, many levels can be stored; whereas if the information was stored simply in arrays, then it would be impossible. Why, however, do we put so much stock in being able to store many levels in memory? Surely it would work as well to store them on diskette, or CD-ROM, or even tape?

In fact, at the time the game was written, all home game machines used cassette tape to store the information, with all the implications that such a medium entails. It is just not practical to store level data on tape; there is too much chance for mechanical error, as anyone who has used this medium will confirm.

Storing multiple levels in memory is not a bad habit to get into, either. It means that as your games increase in complexity, you will always be seeking to store them in the smallest space in the most-efficient way possible. The end result will be that the game will be more readily adapted to the limited resource platforms of the future, such as the Game Boy, Xbox, handheld devices, and Internet gaming.

CONCLUSION

This chapter presented a quick overview of the platform game genre, paying specific attention to historically important games that illustrate the way

in which some encoding techniques can be used to minimize the storage requirements placed on the host machine.

While these might not seem important right now—bearing in mind that most gaming machines currently available on the open market have powers that far outweigh the early gaming systems—as one moves toward more-limited platforms, such as handhelds or mobile systems, these techniques become increasingly more important. Besides which, it is easy to fall into bad habits and assume that gamers possess the best of the best, when the reality might be quite different.

BUILDING-BASED GAMES

INTRODUCTION

In Chapter 1, we looked at a very specific genre of game that was based on platforms. In recent years, platform games have diminished in popularity. They've been replaced by first-person exploration and battle games, such as *Wolfenstein 3D* and its successor, *Doom* (both by ID software). This is not to say that the platform genre is extinct; there have been several successful platform games in 1999–2001, such as *Fear of the Dark*.

However, these are neither pure platform games nor even pure ladders and levels. They are a mixture of first person and platform, which will be called "building based."

Any game that encourages exploration will usually revolve around a building of some sort. In the case of games such as *Doom*, the building is a cavernous affair with a high-tech bent—rocks intermixed with brushed steel, elevators, and stone stairs.

Putting aside for the moment the stunning graphics that are the hallmark of modern games, all first-person building-based exploration games have their roots in earlier games such as the wire-frame, graphics-based *3D Maze*.

The storage and construction of building-based level data can be dealt with in the same fashion as the platform games described in Chapter 1. However, the size and detail that these types of game levels contain means that in order to have a realistic game universe, large amounts of storage will be required.

At the time of this writing, storage space requirements do not pose a great problem for the advanced computers on the market. But the advent of the Game Boy and Game Boy Advanced (Nintendo) marks a new push in the handheld market that would not be sensible to ignore.

Indeed, in order to make games more portable between platforms of differing technical specifications, minimum resource requirement techniques should be used wherever possible—which leads us to the problem of defining entire buildings in such a way that their storage requirements are kept to a minimum. In this chapter, we shall examine how a building can be constructed and how the various graphical elements that make up the building's key features can be introduced.

FROM THE OUTSIDE IN

If we imagine how a building is designed and built, from the architect's plans to the final building, we see that form follows function. That is to say, the external appearance of the building is largely dictated by the internal configuration. This is an overly simplistic view, of course, and any architect would be quite correct in taking issue with that statement.

For our purposes, however, it is a good principle to adhere to. In any case, the architect creates the plans, showing the rooms that are required by the client, and configures them according to either the client's wishes or personal whim.

The external walls of the building are, therefore, set in a manner that reflects to some extent the rooms within—after all, the outside walls are also inside walls for some of the rooms.

The builders build the building according to the plans, starting with the foundation, adding the external and internal walls from the ground up, and finally putting on the roof and tidying up the inside. The end result is a building with a certain form. If we were to slice off the roof and look only at the external walls, we might have something resembling Figure 2.1, which is, in fact, based on the author's house.

Since form follows function, it is equally likely that function can follow form. That is, we can start with an external representation and add the internals along the way. A shape such as that shown in Figure 2.1 is easy to create.

We begin with a rectangle of random dimensions. We then choose a random point on two sides of the rectangle and draw lines toward the center of the rectangle from each of the points until they touch. Then we eliminate the corner that we have just cut off. Figure 2.2 shows the four steps to completion of this operation.

We now have an L-shaped configuration of the external walls for our building. The next step is to divide the shape into pieces internally; these divisions will serve as walls between the rooms. Again, we pick two points

FIGURE 2.1 The outside walls of a building. FIGURE 2.2 Four steps to building a building.

on the external walls; but this time we restrict ourselves to corners, and we connect the two points. This can be performed as many times as necessary, but be wary of making too many lines, or the rooms will be smaller than is really practicable.

The diagram in Figure 2.3 shows a possible internal configuration for the final building. This, then, is the theory. And theoretically, we need only store a few numbers, such as initial size, number of corners to cut, and number of rooms to make; and then we determine exactly where to use a repeatable algorithm.

FIGURE 2.3 Adding possible internal walls.

In Code Sample 2.1, we show the core of a program that creates random buildings in this way.

CODE SAMPLE 2.1 Random building algorithm.

```
// Assume a predefined array oObject[x][y]
// Select two points between 0,0 and x,y
// In this case, they are on set borders, but the code can be
   adapted to
```

```
// allow for any pair of points.
int nX1, nY1, nX2, nY2;

nX1 = rand() % width;
nY1 = 0;

nX2 = width - 1;
nY2 = rand() % height;

for (x = 0; x < nX1; x++)
{
  oObject[x][0] = 1;
}

for (y = 0; y < nY1; y++)
{
  oObject[x][y] = 1;
}

for (x = nX1; x < width; x++)
{
  oObject[x][y] = 1;
}

for (y = nY1; y < height; y++)
{
  oObject[x][y] = 1;
}

for (x = width - 1; x >= 0; x-)
{
  oObject[x][y] = 1;
}

for (y = height; y >= 0; y-)
{
  oObject[x][y] = 1;
}

  .
  .
  .
```

While they might not be completely realistic, if a large number of buildings are required, this is a fairly cheap way to construct cities. If a little more finesse is desired, then there are alternatives that require more processing power.

PASSAGES AND DOORWAYS

Until now, we have discussed rooms, but we haven't mentioned how they will be connected. The usual fashion is by placing doors between them, and occasionally a natural passageway will be formed with a door at each end. The placement of doors does, to a certain extent, guide the movement of the player through the building. Unless they are faced with two doors, there is only one exit, save the door they entered through.

The point is that if we wish to try and place doors between rooms, there is no easy way to do so if we simply try to connect the rooms one by one. Indeed, if we do try this method, then there might be some inaccessible rooms, which is not a desirable trait.

By using the guiding principle stated above, we can place doors according to the path that we would like the player to follow. Figure 2.4 shows a possible path overlaid onto the building discussed in Figure 2.3.

Using this as a guide, we can then place doors in walls at appropriate points. In Code Sample 2.2, the algorithm attempts to guide the player from one side of the building to the other, possibly visiting each room, but not necessarily doing so. This avoids having some inaccessible rooms, and the zigzag approach taken ensures an interesting walk-through.

FIGURE 2.4 Overlaid path connecting rooms.

CODE SAMPLE 2.2 Path-overlay algorithm.

```
// We shall overlay a path, starting between 0 and nX1.
// This can be adapted for other situations, involving more
// walls etc.

x = (rand() % nX1);
y = 0;

// Head off down, until we hit nY1

while (y > nY1)
{
  y++;
  oObject[x][y] = PATH;
}

// Continue until random(height - nY1)

while (y < height)
{
  y++;
  oObject[x][y] = PATH;
  if ( rand() % 100 > 50 ) break ;   // Ok, so this is a cheap
  method !
}

// Go right until x = width - 2...

while (x < width)
{
  x++;
  oObject[x][y] = PATH;
}
```

While the above serves in very simple cases, it is no substitute for real maze-building techniques, which can be used to create anything from a simple building to a complex three-dimensional maze.

Maze Solving & Construction Techniques

There are many theories about how mazes can be constructed and as many theories dealing with how mazes can be solved. It is the aspect of maze solving that can give rise to clues about how mazes can be built. For example, if we consider that many algorithms actually build a copy of the maze in memory as possible paths, copies that are tried and discarded, we might use this information to suggest that a maze can be built in the same way.

Coupled with this is a technique for maze solving that determines a path through a maze based on the effective cost of moving from one position to another within the maze. The technique hinges on a recursive, breadth-first, path-searching algorithm. To understand how the algorithm can be used to create mazes, we first need to establish how it works when attempting to solve a maze.

Recursion in Maze Solving

Many maze-solving techniques are recursive in nature. There is a good reason for this. Recursion offers a vital advantage in that, in programming terms, each step can be *backtracked* so that should a mistake be made, the algorithm can always return to a previous step and choose another alternative as long as one exists.

Before we look at the skeleton code for a recursive path-finding algorithm, we should define "recursion" in the sense that we shall be applying it here. In general terms, a recursive algorithm is one that calls itself, or returns. In fact, when we first attempt to design a recursive algorithm, we must always ensure that it provides a way to exit; otherwise, it will continue to call itself forever.

With this quality in mind, our first attempt—a skeleton that can be used as a basis for implementing future solving algorithms—can be written as in Code Sample 2.3.

CODE SAMPLE 2.3 Recursive maze-solving skeleton.

```
// FindPath
// Copyright © 2001 by Guy W. Lecky-Thompson

// Purpose : To find a path from where we are to an adjacent
// square
```

```
// Inputs : The maze object and current location
// Output : None
// Return Value : A status flag based on achieving the target

int FindPath(sLocation * oMoveData, cMazeObject * oMazeObject)
{
  // Test to see if the current location represents the end
  // point
  // If so, return a given value : MAZE_SOLVED for example

  // For each possible direction adjacent to this cell...
  // ...Call FindPath with the new cell and maze object and
  // test the result
  // If the result is MAZE_SOLVED return MAZE_SOLVED

  // If none of the directions attempted yield MAZE_SOLVED...
  // Return MAZE_NOT_SOLVED
}
```

The *MazeSolver* software included on the CD-ROM uses this testing approach to solve mazes of a given dimension that have a start and an end point, and which are bound by a wall. There is no test, however, for a nonsolvable maze. So, if you want to give it new mazes to solve by changing the contents of the TestMaze.TXT file you should ensure that there is a starting point and an achievable ending point.

An important element that has been left out of the skeleton code above is that we should also implement some way of ensuring that we do not re-visit a cell that we have come from. There is a danger that if this test is not performed, the algorithm will recursively move back and forth between the two cells forever.

This is one of the pitfalls of using recursion; once all the code has been written that is supposed to ensure that the program exits at some point, we can never be entirely certain that, when blended with the pseudorandom infinite universe techniques presented here, these algorithms will behave as expected. The lesson is that recursion is powerful; but it should be used with extreme caution.

A quick look at the BreadthFirstFindPath function in the Solver.cpp source code file included on the CD-ROM will reveal how we can ensure that we only visit certain cells once. Essentially, the key lies in 'painting' the last cell visited so that we know not to revisit it in the next turn. As a point of finesse, it is also 'unpainted' if it

is found not to be on the solution path. In this way, the *MazeSolver* software can also show the solution path found.

Without reproducing the entire glut of source code here, there are some snippets that are of interest not only to the discussion above, but for other applications as well. First, the `cMazeObject` class deserves some introduction, because we will be using it for generating mazes later on. The key definitions are shown in Code Sample 2.4. They are not all-encompassing; but for a simple maze object, they provide adequate functionality.

CODE SAMPLE 2.4 MazeObject definition.

```
class cMazeObject
{
 private:

  int * nMazeData;
  int nMazeWidth;
  int nMazeHeight;
  int nStartX;
  int nStartY;

  void CreateBlankMazeObject();
  void AllocateMazeObjectMemory(int nW, int nH);
  void ReadMazeObjectFromFile(char * szFileName);

 public:

  cMazeObject();                    // Basic constructor
  cMazeObject(int nW, int nH);      // Overload #1 : Blank Maze
  cMazeObject(char * szFileName);   // Overload #2 : From file
                                    // definition

  ~cMazeObject();

  int GetCellValue(int nX, int nY);
  int GetWidth() { return this->nMazeWidth; }
  int GetHeight() { return this->nMazeHeight; }
  void LeaveTrail(int nX, int nY);

  void StoreStartPosition(int nX, int nY)
    { this->nStartX = nX; this->nStartY = nY; }
  void RestoreStartPosition()
```

```
{ this->nMazeData[this->nStartX+(this->nStartY*this-
>nMazeWidth)]=2; }
```

```
};
```

Note that the maze data is stored in a simple array of integers. This makes the allocation of memory very simple:

```
this->nMazeData = (int *) malloc(sizeof(int) * (nW * nH));
```

Despite the ease of memory allocation, the code required to access an individual cell is slightly convoluted, as can be seen below.

```
Cell_value = this->nMazeData[nX + (nY * this->nMazeWidth)];
```

Aside from these minor points, the rest of the cMazeObject class implementation is straightforward enough to not require additional comments.

The Solver.cpp module implements the recursive skeleton in Code Sample 2.5 and adds some interesting pieces of code to perform the functions listed therein. First, though, we should consider how the core maze-solving function is called. Code Sample 2.5 shows the 'interface' function to the path-finding module itself.

CODE SAMPLE 2.5 Annotated BreadthFirstSolveMaze function.

```
void BreadthFirstSolveMaze(cMazeObject * oMazeObject)
{
  // Local variables for coordinate data
  sLocation oStartPos;
  sLocation oMoveData;

  // See if we have a valid start position in the maze data
  if (FindStartPosition(oMazeObject, &oStartPos) == 0)
  {
    // Ensure that the start position can be recovered.
    // This is necessary because we shall be overwriting the
    // cell data
    // with the 'trail' that means that we won't revisit the
    // start cell.
    oMazeObject->StoreStartPosition(oStartPos.x,oStartPos.y);
```

```
// Set up the start coordinates to pass to the path-finding
// recursive function.
oMoveData.x = oStartPos.x;
oMoveData.y = oStartPos.y;

// Call the actual recursive path-finding algorithm
BreadthFirstFindPath(&oMoveData,oMazeObject);

// Restore the previously stored start position
oMazeObject->RestoreStartPosition();
  }
}
```

This interface function carries out some basic housekeeping before actually attempting to solve the maze. The recursive function that actually performs the path-finding solution search is not much more complicated. It can be seen in Code Sample 2.6.

CODE SAMPLE 2.6 Annotated BreadthFirstFindPath function.

```
int BreadthFirstFindPath(sLocation * oMoveData, cMazeObject *
  oMazeObject)
{
  // Set up the storage for the next move to be attempted
  sLocation oNextMoveData;
  // The list of possible adjacent cells to try
  sLocation oMoveList[4];
  int i;

  // Set up the adjacent cell list, in breadth-first fashion
  oMoveList[0].x = 1 ; oMoveList[0].y =  0;
  oMoveList[1].x = -1; oMoveList[1].y =  0;
  oMoveList[2].x = 0 ; oMoveList[2].y =  1;
  oMoveList[3].x = 0 ; oMoveList[3].y = -1;

  // Check to see if the current cell is the end cell
  if (oMazeObject->GetCellValue(oMoveData->x, oMoveData->y) ==
  END_POSITION)
  {
    return MAZE_SOLVED;
```

```
}

    // Add this cell to the list of those recently visited by
    // painting it
    oMazeObject->LeaveTrail(oMoveData->x, oMoveData->y);

    // For each adjacent cell
    for (i = 0; i < 4; i++)
    {
      // Add the offsets from the adjacent cell list to the
      // current position
      // to get the next position to test
      oNextMoveData.x = oMoveData->x + oMoveList[i].x;
      oNextMoveData.y = oMoveData->y + oMoveList[i].y;

      // Test to see of we can move in the desired direction
      if ((oMazeObject-
>GetCellValue(oNextMoveData.x,oNextMoveData.y) !=
          MAZE_WALL)
          &&
      (oMazeObject->GetCellValue(oNextMoveData.x,oNextMoveData.y)
!=
          CELL_PAINTED))
      {
        // Call myself again to follow the path and test for
        // solution
        if (BreadthFirstFindPath(&oNextMoveData, oMazeObject) ==
MAZE_SOLVED)
            return MAZE_SOLVED;
      }
    }

    // If we reach this point it is because this cell is not on
    // the solution path and can be unpainted
    oMazeObject->LeaveTrail(oMoveData->x, oMoveData->y);
    return -1;
}
```

Scanning the code reveals that it is simple and fairly elegant. At the base is the basic trial-and-error approach to finding the next possible cell, and a check to see if the solution has been found. If not, the next possible cell is analyzed, and the resulting path followed.

If none of the paths attempted result in arriving at the end point, the initial call to the function will return a value of −1, since all possible back-tracked paths will have been exhausted. The maze is therefore unsolvable.

MAZE CONSTRUCTION

The reason we have spent so much time analyzing how a simple recursive maze-solving algorithm works is because we can use the same theory to generate random mazes. That is, the solving algorithm adheres to a set of principles that also help in maze construction techniques, such as:

- Goal-based solutions (getting from a start to an end position)
- Simple tracking mechanisms (so we never cover the same ground twice)
- Cost-based reasoning (e.g., we cannot go through walls)

In essence, if we can mimic the saving algorithm in such a way that the above principles are adhered to, a very similar algorithm can be used to create a maze. Let us look at this idea in more detail.

When we create the maze, we need to perform several steps:

1. Choose a suitable maze dimension, and construct a bounded maze.
2. Select the start and end points.
3. Trace a path from start to end at random.
4. Fill in random corridors in the remaining squares.

We shall tackle these steps, along with source code, one by one.

#1 Construct the Maze

In very simple terms, the smaller the maze dimensions, the less complex the paths will be that join two locations. Strictly speaking, this is not completely true; but only humans and very advanced algorithms have the 'creative spark' to build truly cunning mazes with many strange twists, turns, and disorienting backtracking.

Assume that the complexity of the maze is directly dependent on the dimensions of the maze and the positioning of the start and end points (more on this later). Code Sample 2.7 shows the very simple code required to construct our initial cMazeObject.

CODE SAMPLE 2.7 Constructing the maze object.

```
void ConstructMaze(cMazeObject * oMazeObject, int nComplexity)
{
  // Assume that nComplexity runs from 1 through 10
  // This is totally arbitrary; for other scales, please feel
  // free to change the coding in this function.

  // First, check to see if the oMazeObject is already
  // initialized
  if (oMazeObject != NULL) delete oMazeObject;
  // Now that it is an empty pointer, we can construct the maze
  // object
  oMazeObject = new cMazeObject(nComplexity * 10, nComplexity *
  10);

  // Check that we had enough memory available to create the
  // object
  if (oMazeObject == NULL) return; // We didn't

  // Put a border around the maze object, and blank the rest of
  // it
  oMazeObject->BorderMaze();

  // Choose the Start and End Points
  oMazeObject->SelectStartAndEndPoints();

  // Create the path from Start to End
  oMazeObject->CreateSolutionPath();

  // Fill in the rest
  oMazeObject->CreateOtherPaths();

  // We're done!
}
```

The reader will notice that four additional member functions of the cMazeObject have crept into the above function. We shall be tackling three of them in the sections below, but BorderMaze deserves an explanation now.

In essence, BorderMaze does two things. First, it sets all the cells in the cMazeObject to a defined value, EMPTY_CELL. Once it has done this, a border of cells with the value MAZE_WALL needs to be created, otherwise the CreateSolutionPath function will not know where the edges of the 'world' are. Code Sample 2.8 shows how the BorderMaze function might be implemented.

CODE SAMPLE 2.8 Bordering the maze object.

```
void cMazeObject::BorderMaze()
{
   // Check that the member variable that contains the MazeData
   // is valid
   if (this->nMazeData == NULL) return; // It's not.

   int nX, nY;  // Cell position counters

   // Set all the cells to EMPTY_CELL
   for (nX = 0; nX < this->nMazeWidth; nX++)
   {
      for (nY = 0; nY < this->nMazeHeight; nY++)
      {
         this->nMazeData[nX + (nY * this->nMazeWidth)] =
EMPTY_CELL;
      }
   }

   // Create a border of CELL_WALL cells, assuming it's not
   // square. Do the left- and right-hand sides.
   for (nY = 0; nY < this->nMazeHeight; nY++)
   {
      // LHS
      this->nMazeData[nY * this->nMazeWidth] = CELL_WALL;
      // RHS
      this->nMazeData[this->nMazeWidth + (nY * this-
>nMazeWidth)];
   }
   // Do the top and bottom
   for (nX = 0; nX < this->nMazeWidth; nX++)
   {
```

```
  // Top
  this->nMazeData[nX] = CELL_WALL;
  // Bottom
  this->nMazeData[nX + ((this->nMazeHeight-1) * this-
 >nMazeWidth)];
  }

  // We now have a blank, bordered maze object
}
```

Once we have a blank canvas onto which to paint our maze, we can begin the maze construction in earnest.

#2 Select Start and End Points

One might be tempted, when deciding how to choose the start and end points for the maze, that it is enough to just pick two cells at random. As long as the start cell is not equal to the end cell, then it would be possible to trace a path from one to the other.

There are, however, inherent problems with doing this, not least of which is that it does not take advantage of the fact that we have tied complexity to the maze dimensions. In other words, the two cells chosen could be right next to each other, even in a huge maze, which would not lead to a complex enough maze to warrant the dimensions used to construct it.

With this in mind, we need a way to select two cells that are a suitable distance from each other. The simplest way is to choose points in two opposite corners, as in Code Sample 2.9.

CODE SAMPLE 2.9 Selecting start and end points.

```
void cMazeObject::SelectStartAndEndPoints()
{
  // Check that the member variable that contains the MazeData
  // is valid
  if (this->nMazeData == NULL) return; // It's not.

  // Not very adventurous, just select the top-left and bottom-
  // right corners.

  this->nMazeData[2 + this->nMazeWidth] = START_POSITION;
  this->nMazeData[(this->nMazeWidth − 2) +
```

```
        (this->nMazeWidth * (this->nMazeHeight -
  2)))] =
        END_POSITION;

}
```

We could make this progressively more complex by choosing different corners or even cells on opposite sides, all chosen at random. For now, however, the code in Code Sample 2.9 is sufficient.

#3 Create a Path from Start to End

The CreateSolutionPath function is where the code begins to become a little more interesting. The above (Code Sample 2.9) is possible, but not terribly imaginative. However, when we start to devise ways in which it might be possible to link the start and end points, we need to be quite creative.

First, it is important to note that there is more than one way to devise an algorithm to link the start and end points. The algorithm we are about to explore is one that has its roots in traditional path-finding techniques that are based on the cost associated with a given path. We could, however, base our algorithm on making a set number of turns through a set number of degrees of angle and with specific corridor lengths. In the end, however, this would be much more complex than the approach we are about to discuss.

Before we continue, we should define what we mean by the cost of a path. Each cell in the grid created by our cMazeObject has a value associated with it. The EMPTY_CELL value is the smallest, while the values associated with CELL_WALL, START_POSITION, and END_POSITION are larger, in this case 10, 11, and 12, respectively.

The values between EMPTY_CELL and END_POSITION are entirely arbitrary, but it should be clear that values greater than or equal to CELL_WALL, but less than END_POSITION, represent cells for which the associated cost is so high as to be an impossibility.

Thus, the cost of a path is represented as the total cost of the cells that lie on that path. If we then create a random array of values and select start and end points, we shall be able to calculate a path from the start position to the end position based on choosing the highest or lowest cost associated with moving from one cell to another. This would be either the cheapest or most expensive path. It would also be random, since the initial-value array has been randomly populated.

Clearly then, the first step is to randomly populate the cMazeObject with values between EMPTY_CELL and CELL_WALL. Code Sample 2.10 shows a very simple implementation.

CODE SAMPLE 2.10 Populating the grid.

```
void cMazeObject::RandomizeCellValues (long lSeed)
{
  // Check that the member variable that contains the MazeData
  // is valid
  if (this->nMazeData == NULL) return; // It's not.

  int nX, nY;  // Cell coordinate counters

  // Seed the random number generator
  // Standard call — we could use our own pseudorandom number
  // if we chose for additional security.

  srand(lSeed);

  for (nY = 0; nY < this->nHeight; nY++)
  {
    for (nX = 0; nX < this->nWidth; nX++)
    {
      // Check that the cell is not filled with something more
      // important
      if (this->nMazeData[nX + (nY * this->nMazeWidth)] ==
  EMPTY_CELL)
      {
        this->nMazeData[nX + (nY * this->nMazeWidth)] =
            EMPTY_CELL + (rand() % (CELL_WALL — EMPTY_CELL));
      }
    }
  }
}
```

Before we continue, we have a choice to make. Do we want our maze to have a strict corridor width or not? In some cases, the answer will be "yes." This will mean that for each cell visited, we have to border it to prevent fu-

ture cell choices choosing an adjacent cell, which would effectively double the size of the corridor at that point.

We shall deal with two approaches, beginning with the most simple—no bordering of individual cells. The core of the process is in choosing the cell to move to next. We noted above that this choice is based on the cost associated with that cell; but if this were used in isolation, we could not be certain to reach the end position, ever. In fact, we should try to factor into the cost equation the distance between the possible target cell and the end position.

In Code Sample 2.11, we can see how the distance between two cells in our cMazeObject can be achieved. Note that we are again using the sLocation, user-defined type to store cell-positioning information.

CODE SAMPLE 2.11 Calculating the distance between two cells.

```
double DistanceBetween (sLocation oLocationOne,
                        sLocation oLocationTwo)
{
  double d1 =
   max(oLocationOne.x, oLocationTwo.x) − min(oLocationOne.x,
   oLocationTwo.x);
  double d2 =
   max(oLocationOne.y, oLocationTwo.y) − min(oLocationOne.y,
   oLocationTwo.y);
  return sqrt((d1*d1) + (d2*d2));
}
```

Using the above function, we can influence the choice of cell in order to choose one that is at least in the vague direction of the target, if not the closest cell of all the possible alternatives. As an aside, if we were to perform this test without taking into account the value of the cells, we would force the algorithm to take the shortest route between the two: a straight line—except that in this case it would be a zigzag stepping toward the lower-right corner because we can only move north, south, east, or west, and not diagonally.

Which brings us to our final utility function before we write the function that will tie it all together. This final utility function chooses a direction, taking into account the cell values and distances to the target. In Code Sample 2.12, we can see how this could be implemented.

Before looking at the code, it is worth mentioning that two new functions have been introduced that are members of the cMazeObject, namely

FindStartPosition and FindEndPosition. These functions are extremely simple; they just scan the array from top to bottom and left to right until they find a cell containing the appropriate value. At this point, the function stops and stores the *x* and *y* position of the current cell in the sLocation object passed to it.

CODE SAMPLE 2.12 Choosing a cell to move into.

```
int cMazeObject::GetNextCell(sLocation oSourceCell, sLocation *
  oTargetCell)
{
  sLocation oLocationList[4];
  int nMinCellCost, nCheapestCell, nCellValue;

  // Build the movement list
  oLocationList[0].x = oSourceCell.x - 1;
  oLocationList[0].y = oSourceCell.y;

  oLocationList[1].x = oSourceCell.x + 1;
  oLocationList[1].y = oSourceCell.y;

  oLocationList[2].x = oSourceCell.x;
  oLocationList[2].y = oSourceCell.y - 1;

  oLocationList[3].x = oSourceCell.x;
  oLocationList[3].y = oSourceCell.y + 1;

  // Find the cheapest of the above.
  nCheapestCell = -1;
  nMinCellCost = 100;   // Should be high enough

  for (int nCell = 0; nCell < 4; nCell++)
  {
    nCellValue =
        this->GetCellValue(oLocationList[nCell].x,
  oLocationList[nCell].y);

    // If it's the target, that is where we are going
    if (nCellValue == END_POSITION)
    {
      nCheapestCell = nCell;
      nMinCellCost  = -1;
      break;
```

```
  }
  // Otherwise, just pick a likely contender
  if (nCellValue < MAZE_WALL)
  {
     // The reader can develop their own random cell choosing
  algorithm
  }
}

// After the above has been dealt with, we can assign oTarget
oTarget->x = oLocationList[nCell].x;
oTarget->y = oLocationList[nCell].y;

return (this->GetCellValue(oTarget->x, oTarget->y);
}
```

If you have already taken a look at the source code that accompanies this book, you might have noticed that there is a subtle difference between the approach used there and the one shown here. To enhance speed, the calls to find the start and end positions should only be carried out once, outside the above function, and passed as sLocation objects. Besides this, the mechanics are identical.

To bring all of the above together into one recursive function, code similar to that in Code Sample 2.13 can be used. The important thing to note is that the function also covers its tracks so that each cell is only visited once.

CODE SAMPLE 2.13 Recursive build path.

```
int cMazeObject::BuildPath(sLocation oCurrent)
{
  sLocation oNext;

  if (this->GetNextCell(&oNext, oCurrent) == END_POSITION)
  return 1;

  // Setting it to TRACK_ON makes it impossible to choose...
  this->SetSetValue(oNext->x, oNext->y, TRACK_ON);

  this->BuildPath(oNext);
}
```

Once the above is understood, it is quite easy to see how the bordering of each cell can be carried out in order to produce a tunnel. For example, the algorithm used here produces mazes such as the one shown in Figure 2.5.

FIGURE 2.5 Open-wall maze.

We call these "open-wall" mazes because there is no forced closing of the sides of the path being blazed through the grid. Closed-wall mazes, on the other hand, have to be bound on both sides as the cell is populated so that a tunnel is created.

It only requires a simple addition to the code (see Code Sample 2.13) to create the path, and the short snippet in Code Sample 2.14 shows just the additions required.

CODE SAMPLE 2.14 Code Snippet for bordering a cell.

```
    .

    .

    .

  this->SetCellValue(oCurrent.x, oCurrent.y, CELL_VISITED);
  // Use the relationship between oCurrent and oNext to place
  // borders
  if (oNext.x != oCurrent.x)
  {
    // Horizontal movement .'. vertical border
    this->SetCellValue(oNext.x, oNext.y - 1, MAZE_WALL);
    this->SetCellValue(oNext.x, oNext.y + 1, MAZE_WALL);
  }
  if (oNext.y != oCurrent.y)
  {
    // Vertical movement .'. horizontal border
    this->SetCellValue(oNext.x - 1, oNext.y, MAZE_WALL);
    this->SetCellValue(oNext.x + 1, oNext.y, MAZE_WALL);
  }
```

.
.
.

The result of applying this code can be seen in the closed-wall maze example in Figure 2.6.

FIGURE 2.6 Closed-wall maze.

#4 Filling in the Blank Cells

We now have a path that travels around the cell grid, but this does not strictly constitute a maze: It is, after all, just a path. So, in order to create the finished product, we can create corridors at random in the empty cells that will lead nowhere.

The actual implementation is left to the reader, but using similar 'trailblazing' algorithms to the ones presented above, it is clear that the most basic approach is to create a path that leads from the main path to the nearest border (be it horizontal or vertical) and terminates there. In this way, the player is given multiple opportunities at some junctions, giving the feeling of being in a maze.

This brings us to the end of our look at mazes in detail, but we do need to make it clear that, powerful though these techniques are, the reader should be wary of using them to create entire games; they will ultimately frustrate game players who find themselves unable to actually complete a game!

CONCLUSION

In this chapter, we have seen exactly how it is possible to create entire levels (be they buildings or mazes) without actually storing very much

information at all. In fact, all the work is in the algorithms that are used to build the level data. Thus, we achieve two vital goals.

First, we can repeat the algorithms ad infinitum to generate many, many buildings without storing very much information. Games can be very large and not make any sacrifices in terms of features like graphics, sounds, or playability.

Second, using an algorithm in this way reduces the amount of level storage space required, which is useful for limited-resource environments, for example. This means that we can recuperate some of that memory for storing generated building plans, which we can access during play time to create the on-screen representation.

DISCRETE, OBJECT-BASED GAMES

INTRODUCTION

In a sense, all games are based on objects of one kind or another. There exists, however, a certain class of game made popular by the Nintendo 'Game and Watch' series of LCD handheld electronic games of the 1980s. These are entirely based around objects: There is no universe to speak of. The LCD handhelds were very limited, allowing for only a predefined series of objects in different poses.

With just one game per handheld, they were fairly sophisticated for their time and sparked off a whole range of clones. Building on this, Nintendo then released the Game Boy. Again based on an LCD and with a primitive sound system, the Game Boy is arguably the most popular of its genre. The big innovation was the ability to use the same machine for different games.

The way that these games are designed is based on sprites. A sprite is essentially an object with a graphical representation. There are known limits to how many sprites can be on the screen at the same time, whether or not they overlap each other, as well as limits to their position on the screen. All these functions are inherently supported in the Game Boy OS.

This chapter deals with several aspects of programming in an object-based game universe, including (by way of example) programming for a Game Boy-style virtual machine. In order to understand why the approach required is a little different from the others in this book, we shall examine how to make a simple sprite-based, programmable gaming system for the Windows platform.

As a more-advanced example, the game *Elite,* in all its various incarnations, is also principally object-based. *Elite* consists of planets, stars, space stations, and spacecraft of one type or another. Each planet object,

however, it is also landscaped in a pseudorandom way so that not only is each one different, but each one also has features that are repeatable. Therefore, we shall also discuss mixtures of object-based and other techniques in the course of this chapter.

THE PC-KID VIRTUAL MACHINE

In a way, the sprite-based style of games is one of the simplest to implement. The Game Boy, for example, is actually a very restrictive environment. But this makes it easier to understand the role of each specific object that the Game Boy operating system can manipulate. We shall be looking only at the sprite side of the interfaces provided by the Game Boy (GB), and we shall try to encapsulate it within our own cut-down version for the PC—the PC-Kid Virtual Machine (PCK).

Each sprite will be treated as an object, which could be an 8 × 8 grid with each cell on the grid being set to a 1 (black) or 0 (nonblack, white) pixel to be displayed on the screen. In this way, we can reuse our grid management techniques from Chapter 1. Since this is also a limited resource environment (see Part V: "Limited-Resource Environments"), it is an advantage to also be able to use the RLE compression from Chapter 1, as well.

More specifically, we can adapt the LevelEncode algorithm (see Code Sample 1.1) to use an 8 × 8 grid as the szLevelData [LEVEL_HEIGHT] [LEVEL_WIDTH] argument. Similarly, the ReadMemoryBlockFromFile and WriteMemoryBlockFromFile can also be adapted. Incidentally, we can also RGB-encode sets of long integers to represent a color pixel by bit-shifting to fill the long integer with three bytes. The Microsoft Windows API provides some macros for encoding and decoding RGB values stored in this way, as can be seen in Code Sample 3.1.

CODE SAMPLE 3.1 RGB-encoding macros.

```
typedef unsigned char BYTE;
typedef unsigned short WORD;
typedef unsigned long DWORD;

typedef DWORD COLORREF;
```

```
#define RGB(r,g,b)
  ((COLORREF)(((BYTE)(r)|((WORD)(g)<<8))|(((DWORD)(BYTE)(b))<<
  16)))

#define GetRValue(rgb) ((BYTE)(rgb))
#define GetGValue(rgb) ((BYTE)(((WORD)(rgb)) >> 8))
#define GetBValue(rgb) ((BYTE)((rgb)>>16))
```

In Code Sample 3.1, which is taken from version 6.5 of the Borland implementation of the public-domain Windows 3.1 header file, the type definitions have been left in to make the macros slightly more understandable. If the above seems like too much hard work, we can always store three grids of short integers (values 0-255) to provide a 'red grid,' 'green grid,' and 'blue grid.' For the purpose of this discussion, however, we shall stick with the simpler monochrome scheme.

Our sprite definition needs a grid containing displayable values and positioning information. In the GB (Game Boy), it is assumed that any sprite at position 0,0 is invisible—simple and effective, which also means that the visible screen locations start at 1,1, which is a little unconventional. The private data storage part of the PCK (PC-Kid Virtual Machine) sprite could be defined as in Code Sample 3.2.

CODE SAMPLE 3.2 PCKSprite.

```
class PCKSprite
{
  private:
    char nBitmap[8][8];
    int  nXPos, nYPos;

};
```

As in the GB, we shall assume that the PCK has no access to external storage, meaning that the sprites have to be stored on the cartridge (and/or in memory). For ease of programming, the GB developers often represented the key game sprites by a matrix of values rather than use complicated RLE or similar compression techniques. Code Sample 3.3 shows an example.

CODE SAMPLE 3.3 Simple sprite definition.

```
    .
    .
    .
nBitmap[0] = "00011000";
nBitmap[0] = "01100110";
nBitmap[0] = "01100110";
nBitmap[0] = "01111110";
nBitmap[0] = "01111110";
nBitmap[0] = "01100110";
nBitmap[0] = "01100110";
nBitmap[0] = "01100110";
    .
    .
    .
```

Notice in Code Samples 3.2 and 3.3 that we have slightly altered our definition of the basic grid for storing these values by using character arrays (or strings). This is done purely for convenience. There are many useful string-handling routines in C and C++. Be aware, however, that using a character array means an additional step is necessary when displaying a pixel.

If an integer grid is used, one can simply assign the value stored directly to the API call in order to color the pixel on the screen. This will likely be a function call along the lines of PSet(p,x,y), where p is the color and x and y are the coordinates of the pixel to set. This enables us to use a call such as PSet(oSprite.nBitmap[i][j],oSprite.x + i,oSprite.y + j) to set one of the pixels represented by the bitmap attached to the sprite itself.

The additional step necessary for string-handling arrays, as mentioned above, consists of converting the character reference in the string array to a pixel color. There are generally two approaches. The first is to store a character value that corresponds to the numerical value that we wish to use for the pixel color. For black and white, this does not present a problem, since it is likely that the system will only use a value of 0 or 1 for each pixel color. Problems creep in when we want to use code similar to that in Code Sample 3.3, because we lose the advantage of a tidier representation; the ASCII characters represented by 0 and 1 are nonprintable.

To get around this, we use (as in Code Sample 3.3) actual printable characters. We need to be able to convert freely between a numerical value

of 0 or 1 and the ASCII value for "0" or "1" so that we can choose to either set a pixel or not, depending on the value stored at the target grid position. Luckily, our exercise here exists in a monochrome environment; setting colored pixels based on character values is a little more involved.

The GB API, however, handles all the sprite display itself, so budding GB programmers need not overly worry about representation. On the Windows platform, we could write our own sprite-display routine (minus bounds checking), as in Code Sample 3.4.

CODE SAMPLE 3.4 Windows sprite display.

```
void PCKSprite::DisplaySprite(HDC hdc)
     // Windows device context
{
  for (int a = 0; a < this->nWidth; a++)
  {
    for (int b = 0; b < this->nHeight; b++)
    {
      COLORREF clrColor;

      if (this.nBitmap·[a] == '1')
      {
        clrColor = RGB(0,0,0);
      }
      else
      {
        clrColor = RGB(255,255,255);
      }
      SetPixel(hdc, this->nXPos + a,
                    this->nYPos + b, clrColor);
    }
  }
}
```

A couple of final points before we proceed: The preceding code can be used to write directly to the screen, but this is slow. The performance of nearly every platform is affected by writing individual pixels in this way, and it is not generally good practice. Code Sample 3.4, above, is a way to handle device context passed to the DisplaySprite function, and this device context could be the screen, or it could be an off-screen bitmap.

Many devices make the distinction between on-screen memory and off-screen memory. It is possible to write to the off-screen and use the native API functionality to 'blit' the bitmap onto the visible screen. This can be taken even further, keeping more than one off-screen memory device context and swapping between them.

Updating the entire screen is a straightforward exercise. All we need to do is ensure that all the visible sprites are drawn at their respective coordinates (sprites that haven't moved need not be redrawn) and that all now-invisible sprits be not drawn. Remember: Visible sprites are those on-screen from coordinates 1,1 up to the screen width.

Some final code snippets will also be required to lead us into the next section. First, the constructor, destructor, and some access functions for the PCKSprite object are necessary. Code Sample 3.5 gives two constructors to choose from. The simplest initializes the sprite with no data, while the overloaded version enables passing a string to be used as the sprite bitmap.

CODE SAMPLE 3.5 PCKSprite constructor.

```
PCKSprite::PCKSprite() // Simple constructor
{
  this->nXPos = 0;
  this->nYPos = 0;

  for (int x = 0; x < 8; x++)
  {
    for (int y = 0; y < 8; y++)
    {
      this->nBitmap[y][x] = ' ';
    }
  }
}

PCKSprite::PCKSprite(char * szData) // Overloaded constructor
{
  this->nXPos = 0;
  this->nYPos = 0;

  int n = 0;

  for (int x = 0; x < 8; x++)
  {
```

```
    for (int y = 0; y < 8; y++)
    {
      this->nBitmap[y][x] = szData[n];
      n++;
    }
  }
}
```

Of course, a suitable encoding function can be substituted for the raw char * szData array used here, and we have seen some RLE (for example) utility functions in Chapter 1. The destructor does not do anything spectacular and is included in Code Sample 3.6.

CODE SAMPLE 3.6 PCKSprite destructor.

```
PCKSprite::~PCKSprite() // Destructor
{
  this->nXPos = 0;
  this->nYPos = 0;
}
```

The reason for providing a constructor and destructor is so that the model used for storing the bitmap data can be changed from the static char nBitmap[8][8] to the dynamic char * nBitmap by just inserting the relevant code. This is also why a class rather than a struct was chosen for this implementation; it is already a dynamic object and makes the garbage collection associated with memory management easier.

So that we have some way of accessing the sprite data or changing it once it has been created, we can also define some access functions, such as those in Code Sample 3.7.

CODE SAMPLE 3.7 PCKSprite access function.

```
// Simple function for making sure that whatever coordinates
// are being used by the programmer, they fit into the sprite's
// object space.
```

```
void PCKSprite::AdjustCoordinates(int * x, int * y)
{
  if (x < 0) x = 8 - x;    // Admittedly, it would be better to
                           // use a
  if (y < 0) y = 8 - y;    // constant reference instead of
                           // hard-coding the sprite dimensions,
                           // and even better to use
  x = x % 8;               // member variables, but this is our
                           // way of saying
  y = y % 8;               // that we can't deal with variable
                           // sized sprites.
}

// Function for setting individual sprite pixels.

void PCKSprite::SetPixel(char n, int x, int y)
{
  int nX, nY;
  nX = x;
  nY = y;
  this->AdjustCoordinates(&nX,&nY);
  this->nBitmap[nY][nX] = n;
}

// Function for retrieving individual sprite pixels.

int PCKSprite::GetPixel(int x, int y)
{
  int nX, nY;
  nX = x;
  nY = y;
  this->AdjustCoordinates(&nX,&nY);
  return this->nBitmap[nY][nX];
}

// Function to move the sprite around.

void PCKSprite::SetPos(int x, int y)
{
  this->nXPos = x;
  this->nYPos = y;
}
```

This finishes the rough design of the sprite class needed to display meaningful graphics on the screen. It would also be helpful to create some kind of world-management class also. This would give us a pseudo off-screen or virtual screen, which contains the sprites, the refresh list, and the screen-refresh function.

OBJECT INTERACTION

In order for us to be able to move the sprites around the screen (which, after all, is what makes the game), we need to keep track of them in memory and be able to tell whether a sprite needs to be refreshed (painted) in the next cycle or not. The `PCKVirtualScreen` object, defined in Code Sample 3.8, provides the member variables required to achieve this.

CODE SAMPLE 3.8 PCKVirtualScreen class definition.

```
class PCKVirtualScreen
{
  private:
    PCKSprite * oSprites[MAX_SPRITE];
    int nRefreshList[MAX_SPRITE];
};
```

We are using an array of pointers for simplicity's sake. It would be nice to have a dynamic pool of sprite objects; but in reality, the GB has limited working space available for sprite management, and so we could pass off our array as a foretaste of Part V, which deals further with limited-resource environments.

So far, we have dealt only with the visual aspect of the sprite universe. However, there is also the logical aspect—that which is not seen, but which has an effect on the game play. Each object type will react to the universe in a given way and will also cause effects beyond those that affect it directly. We need a framework into which the sprites can be placed and interact with each other, something which the GB programming interface does offer. Chores such as these are left largely to the programmer.

However, as we shall see in Part V of this book, the GB API does provide everything needed to run the screen, and we can extend this representation if required. The fact still remains, however, that much of the information will be stored twice; we need an off-screen memory map that

we can use to manage the interaction between logical game objects, not necessarily sprites.

We have gone to a lot of trouble (in a book that is supposedly about Infinite Universes) to detail the inner workings of a system that is very finite in concept. Of course, just because the system is finite does not mean that the games made using it need also be finite. For example, one could reserve a set of sprites as being modifiers of other sprites, or possibly even sprites that can be combined together to create objects. In this way, if we assume that there are 10 such sprites, we can calculate that if each can be combined (at pseudorandom) with the others, there are a large number of possible objects that can be created, like building with *Lego*, where a finite number of blocks of differing attributes can be combined to produce an almost infinite number of end products.

Unlike *Lego*, these objects can themselves be nonstatic. They can be programmatically changed during the course of the game. Perhaps, mutated would not be too strong a word; rather than recombining sprites to produce different and varied objects, we can also combine sprites in different ways so that the resulting sprite is a chimera—that is, a combination of other sprites. Taking this further, the sprites used to generate mutated versions can themselves be mutated versions, and each sprite can even be part of a larger object.

Thus, we store abstractions of the sprites as other objects and create and manipulate them as required. It is a technique sometimes known as "organic programming" (or "genetic programming"), and we shall return to it time and time again in some form or another because it can be put to many uses. One of the simplest is in masking, where each cell of one sprite is `eXclusive ORed` (`XORed`) with the corresponding cell from another sprite. We say that one provides the mask for the other and is very useful in rendering backgrounds that can be traversed by a sprite 'in front' without leaving a trace.

THE INFINITE OBJECT SPACE

We have seen above how sprites can be used to create games, but these games still have their roots in platform-style, level-oriented games. We are now going to look at another style (genre) that was spawned by the game *Elite*, which was also the inspiration for this series of books. When David

Braben and Ian Bell wrote *Elite*, they created both a game and a game style that paved the way for many other games that follow similar lines.

The backdrop for *Elite* is a true object-based game universe. There is no playing grid per se, no memory-mapped collection of squares as such. Each object exists at a given point only because that is the point at which it is calculated to exist. Put another way, given an *x,y* point in the game universe, it can be calculated whether or not a game object should exist there and what attributes it should have.

A brief evolutive history of the game is instructive at this point because we are going to follow this implementation and devise ways in which it *could* have been implemented. Since the source code to these magnificent games was not actually available, it is quite possible (indeed likely) that they were written in an entirely different manner; the examples here are purely illustrative. They do, however, work.

We shall be looking at the two main incarnations of *Elite*, namely *Elite* and *Elite II: Frontier*. The *Elite* universe began as a very simple collection of stars, each with highly likely names, spread over a predetermined number of galaxies of set dimensions. Each star had a single planet and an orbiting space station. The player flies in hyperspace to a given 'system' (star, planet, and space station), and then proceeds in real space to the planet, and eventually tries to dock with the space station.

With the release of *Frontier*, the complexity of the game universe had been stepped up both in terms of object types and attributes; the known universe had been incorporated into the *Elite* game universe. We shall see what a difference this made to the programming of the game in due course. The *Frontier* universe was much more realistic than the previous release; stars now had multiple planets (with moons) and multiple space stations. The planets themselves had graduated from circular 'blobs' to landscaped objects that the player could explore—complete with buildings, roads, and artifacts. A quick exploration of planet Earth reveals several such artifacts, like the Golden Gate Bridge and Eiffel Tower.

Part of this enhancement can be explained by the difference in processing power between the target machine for the original game (8-bit, 6MHz, 6520 architecture, 32Kb memory, 5½-in. floppy drive, 8-color screen) and the minimum specification for *Frontier* (IBM 80386 or compatible, 33MHz, 1Mb memory, 256-color VGA or SVGA screen). The software still, however, fitted neatly onto a single 3½ inch floppy disk and worked in real DOS mode, sneaking in under the 640Kb memory limit, although expanded memory is required for temporary workspace.

Those, so to speak, are the numbers. The two machines (BBC Model B circa 1982, and IBM PC circa 1992) are worlds apart both in terms of raw power and storage space. The question is, how did Braben and Bell get so much into 32Kb of memory? Let us first consider the problem, namely that we wish to construct a game universe of almost infinite dimensions that, for convenience, we shall break down into galaxies of a given widths and heights.

The simplest theory for constructing each galaxy is as follows: For each possible location x,y, we can generate a pseudorandom number seeded on the universal location of the first location of the current galaxy. We then test the pseudorandom number to see what kind of artifact inhabits that location. With this in mind, it is time to look at some more numbers.

The ANSI C rand function yields a number of type long, which is capable of representing a number between 0 and 4,294,967,295. In addition, according to the ANSI definition, the algorithm used generates numbers with a period of 2^{32}, which means that after the 4,294,967,296th such number, the sequence will repeat itself. For our application, this simply means that we have a limit of 4,294,967,295 possible universal locations.

Our universe's dimensions, then (assuming it to be square), will be the square root of 2^{32}, or 65,536 locations to a side. Of course, we can only comfortably fit a maximum of 640 × 480 pixels on the screen, so we can break down our universe into tiled galaxies of a given set of dimensions. Since 256 is the square root of 65,536, we choose this number. So, we have a universe of 256 × 256 galaxies, and each galaxy has 256 × 256 possible universe locations.

If we were to begin at location 0,0 and generate 2^{32} pseudorandom numbers, we would have generated one for each of our possible locations. However, we want instead to generate a subset of the 2^{32} possibilities. For this reason, we use seeding, using the universal location of the location for which we wish to generate a pseudorandom number. A complete discussion of such techniques is out of the scope of this book, but can be found in *Infinite Game Universe: Mathematical Techniques* (Hingham, MA: Charles River Media, 2001).

The principle for generating the seed, however, is very simple. Essentially, each location can be expressed in terms of its container object. A galaxy is a container for 256 × 256 locations, and the universe object is a container for 256 × 256 galaxies. Hence, point 77,201 in galaxy 96,3 can be represented by reference and using the known dimensions of the container objects as:

```
( galaxy_width * location_y ) + location_x
```

This yields (256 * 201) + 77, or 51,533 as the reference in the current galaxy. To this, we must add the location of the galaxy within the universe:

```
( ( universe_width * galaxy_y ) + galaxy_x ) * (
galaxy_width * galaxy_height )
```

For the above example, we arrive at ((256 * 3) + 96) * (256 * 256), or 56,623,104 as the starting point (0,0) of the galaxy in question. Adding these two values together yields the universal location of 56,674,637, which we can then use as a seed to generate a pseudorandom number. By way of proof of these calculations, we can do the same for the last point in the universe, which lies at location 255,255 of the galaxy at 255,255 in the universe. The two calculations are:

```
( 256 * 255 ) + 255
```

and

```
( ( 256 * 255 ) + 255 ) * ( 256 * 256 )
```

Adding the result of these two together, we arrive at 4,294,967,295, which just happens to be the last possible seed before the ANSI pseudorandom number generator repeats itself at the 2^{32}nd value.

Based on the *Space Trader's Flight Training Manual* released by Acornsoft in 1984 along with the game, we can construct an object capable of storing the information for any given universal point, as shown in Code Sample 3.9.

CODE SAMPLE 3.9 Possible *Elite*-style game object.

```
struct sPlanet
{
  int nEconomy, nGovernment, nTechLevel, nPopulation, nRadius;
};
```

Before we continue, it is useful to point out that the original game had eight galaxies, each with over 250 recognized planets. This yields roughly

2,000 (probably 2,048, or 2^{11}) objects, which is plenty for any game—the chances of visiting them all is quite remote. This is not, however, the only reason for the limitation.

In Code Sample 3.9, we have defined five attributes to be used when constructing the object. The problem is that if we want to construct the object on the fly, we need to generate a pseudorandom number and use it as the seed to generate five other numbers that will be used to represent the attributes of the sPlanet object.

However, each of these five numbers that we generate has to come out of our set of 2^{32} values, as does the 'sixth,' which is the original test to see if a planet exists at the location x,y. So, we do not really have 2^{32} possible objects at all; we only have 715,827,882 objects, which yields a universe of about 26,754 locations per side. A convenient galaxy size is around 163 units per side. This may seem a little small (just over half of our original), but it offers a sizeable number of possible locations—precisely 705,911,761 locations.

Each of the possible attributes for which we need to generate a value must be treated as their own separate 'universe' of values. A simple multiplication function will suffice for this purpose. With the theory out of the way, we can construct some useful generic code. First, we construct a generic object for storing any number of data elements, as shown in Code Sample 3.10.

CODE SAMPLE 3.10 Generic object.

```
class cObject
{
  private:
    int nDataElements;
    int * oDataElements;

  public:
    cObject( int nE );
    ~cObject();
};

cObject::cObject( int nE )
{
  // Request memory
  this->oDataElements = malloc(sizeof(int) * nE);
```

```
// Test and report
if (this->oDataElements != NULL)
  this->nDataElements = nE;
else
  this->nDataElements = -1;
}

cObject::~cObject()
{
  if (this->oDataElements != NULL)
  {
    free (this->oDataElements);
    this->nDataElements = -1;
  }
}
```

With this definition in hand, we can also define how values should be assigned to each of the data elements. The cObject::Populate method in Code Sample 3.11 performs this task.

CODE SAMPLE 3.11 The Populate method.

```
cObject::Populate( int nSeed )
{
  srand(nSeed);

  for (int n = 0; n < this->nDataElements; n++)
  {
    this->oDataElements[n] = rand();
  }
}
```

It is the responsibility of the calling process to determine the correct seed and ensure a unique stream of numbers generated within the used scope. In the code sample above, we specify that each of the items in the oDataElements[n] array should be considered as being part of a range of values in its own little universe.

Thus, nSeed can be set based on the position of the object within the game universe, along with the number of elements that the data object

contains and the dimensions of the game universe. This serialization requires that we modify our seed generation algorithm slightly:

```
( ( ( universe_width * galaxy_y ) + galaxy_x ) * (
galaxy_width * galaxy_height ) ) * data_elements
```

We are essentially saying that instead of having a single point at each universe location, there is a `data_elements` number of points at each universe location. Thus, we have somewhere in the region of 2^{32}/`data_elements` possible universe locations, which we can break down as we did above to arrive at a convenient 29,000 × 29,000 universe grid, possibly comprised of 170 × 170 galaxies, each of dimensions 170 × 170. At a 1% population rate, we can therefore manage around 835,210,000 objects, which is a sizeable universe.

Finally, we do not even need to store this number of objects; we can simply populate an object with a unique location seed at run time. The sequence of events is very simple. First, we generate a pseudorandom number using the basic serialization equation. We test to see if this number modulo 1000 is greater than 998 (assuming a 1% population rate). If it is, we can then reseed based on the modified serialization equation and populate a dynamically created `cObject`.

ENTER FRONTIER

The above discussion shows how it is possible to create universes at random. One of the key changes between the original *Elite* and its subsequent *Frontier* was the migration from a basic object-based world with random star systems represented by simple wire-frame graphics to a universe incorporating both the original, random (pseudorandom) game universe and many aspects of the known universe—a universe filled with three-dimensional planets in their own solar systems that can be explored by the player.

Taking today's hardware into consideration, this might not seem like such a big leap, but one has to remember that not only was *Frontier* designed to run at an acceptable speed on a 386 SX 33 with 1Mb of system memory, but it also fit onto a single, 1.44Mb diskette and almost never accesses the hard drive.

The mixing of real and pseudo-randomly generated game universes can be put to good use in almost any game. In *Frontier,* it is likely that only certain aspects of the game universe are fixed, while others are generated; one might expect, for example, that certain attributes (e.g., name, location, and

size of star systems and planets) are stored, whereas other attributes are generated using the same principles as for the rest of the game universe.

It is impossible to give any concrete code samples to illustrate the above that are generic enough to be of any real use. The theory is all we have. The reader might like to speculate how *Frontier* works internally as a mental exercise before attempting to apply the theory to their own creations.

CONCLUSION

As in Chapter 1, some of these techniques might seem to be superfluous given the power available to the modern game programmer. However, we can extrapolate these simple examples to serve far more complex and far-reaching games in order to exercise the hardware fully. Each time that more visually-complex aspects, such as movies and textures, are added to a game, resources become limited for other aspects.

By using some of the techniques evident in older games, we can achieve two goals: an increase in the complexity of the game universe coupled with an increase in the realism with which we can represent that game universe to the player. These are two important aspects of creating games with extended shelf lives that remain aesthetically current vis-à-vis the competition.

In order to clarify this last point, look again at *Elite*, which is still being played, despite its age and even though the graphics are slightly dated; the game is fairly open-ended. Nobody realized quite how long the shelf life of the game would be, but it could be that the lack of graphical detail was the prime reason that the game stopped being bought, long after the interface began to look dated. People still played it (and still continue to play it) for the game and not for the graphics.

LANDSCAPE-BASED GAMES

INTRODUCTION

So far, all the level design techniques that we have discussed have been based upon essentially closed game universes. From levels to buildings, even the discrete object-based techniques represent a game universe in which there are limits to the representation.

Typically, landscape-based games tend to be somewhat larger and more open-ended. In addition, the landscape wraps around to provide the backdrop for the game itself. The most common form of landscape is the tile-based world (TBW).

In general terms, tile-based worlds are based on a series of interlocking sections of landscape with each section representing a particular landscape feature. Such a feature might be a piece of water, grass, road, rocks—whatever is needed.

The tiles themselves are predefined and designed as large textures that are then cut up and used at random so that two tiles of the same kind set side by side will lock together, while not being identical. This might or might not be important; it depends on the game and will usually be a compromise between realism and storage space. There are, of course, a few things that can be done to make better use of the storage space, as we shall see.

SIMULATORS

In a sense, all games simulate something to various degrees of realism. When a game rises above being solely a matter of amassing points, protecting a given number of lives, or trying to simply work one's way through

level after level of evil beasties bent on destroying the world as we know it—it becomes a simulation. Games such as *Elite* are simulations of space trading and warfare. Many racing games fall into this category, too, as do most commercial aircraft flight games.

Unlike war games, which will be covered in the first subsection on wire frames, simulators offer a real-time simulation of a single vehicle—be it a spacecraft or car— in an environment that is as close to and as complex as the real world as possible—or at least the assumed real world. In the case of *Elite*, for example, the game universe is an assumed future of the inhabited universe as we will come to know it.

Games based on driving at high speeds along a predetermined race track are covered in their own section below under Driving Games; they are subject to their own rules. This section is purely devoted to simulations in a large (possibly even infinite) game universe that hovers as close to reality as the implementation platform's technology allows. Many of the techniques that we shall explore can be lifted and used in other games, too; simulations represent the pinnacle of the machine's ability.

WIRE FRAMES

There once was a game called *Tank Commander*, which was a very early tank battle simulation. The graphics were not stunning when compared with the highly graphical games that regularly appear on store shelves today. Its graphics were based on wire frames; but at the time, it was a big success. The goal of the game was fairly simple: Get them before they get you—in this case, 'them' being tanks.

The landscape was similarly low-tech—a range of mountains that moved from side to side as the turret of the tank rotated in search of targets. What was clever was that objects and background features 'nearer' to the tank moved at a different pace than those farther away. Despite the low level of detail in the graphics, this technique added a touch of reality to the game and made it more playable—closer to a simulation than a game.

By the same token, *Elite* was also based on black-and-white wire-frame graphics, but the realism of the game lay in the handling of the spacecraft and the game universe that surrounded the core of the game—the trading and changing of the pilot's legal and combat status. Without these unique touches, in essence, *Elite* would just have been about flying around and shooting at things.

As far as level design is concerned, wire frames are about the easiest objects to store and draw, and any game based around them can afford to pump up other areas of play, such as the calculations required to maintain

a realistic game universe or scope of universe that can be inhabited by the player. Indeed, such is the nature of wire frames and their apparent low-tech look; they will generally need support of this kind, since a pure wire-frame shoot-em-up in two dimensions will probably not sustain interest for very long, except on the lowliest of handheld machines.

The easiest way to break up wire-frame objects into storable objects is to break them down into polygons and draw them based on the *x,y* coordinates of each vertex. Take, for example, the following representation (Figure 4.1) of the *Mamba* spacecraft from the original *Elite*:

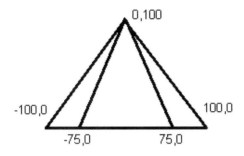

FIGURE 4.1 *Mamba* spacecraft wire-frame coordinates.

As can be seen in Figure 4.1, we have in this two-dimensional view four polygons—three triangles and one rectangle. These can be encoded using the Cartesian coordinate system as the following four sets of numbers:

1	-1, -1	4	-0.15, -0.25
	0, 1		-0.25, 0
	-0.5, -1		0.25, 0
2	-0.5, -1		0.15, -0.25
	0, 1		
	0.5, -1		
3	0.5, -1		
	0, 1		
	1, -1		

As we can see, the polygons do not necessarily have to have the same number of vertices. In the table above, we have triangles and a rectangle; but we equally could have had any mixture of polygons of varying numbers of sides. To allow a flexible implementation by which we can store any two-dimensional objects made up of polygons of different shapes and sizes, we are not going to restrict ourselves to modeling based solely on triangles.

For an accurate definition and storage of such objects, we can use a basic structure for storing coordinates, such as that shown in Code Sample 4.1.

CODE SAMPLE 4.1 Coordinate storage structure.

```
struct S2DCoord
{
  double x, y;
};
```

We are using a double precision representation to make the geometric calculations required to more easily position the shapes accurately. Such calculations suffer from a lack in precision if based on integer mathematics. When using Code Sample 4.1, we need to be able to store enough S2DCoord objects to make up each shape that forms a part of the overall figure. Code Sample 4.2 shows a possible C structure-based implementation.

CODE SAMPLE 4.2 2D-shape structure.

```
struct S2DShape
{
  S2DCoord * oVertices;
}
```

So far, so simple. We do, however need some functions to set up and manipulate the shape using the two structures defined in Code Samples 4.1 and 4.2, which are shown in Code Sample 4.3.

CODE SAMPLE 4.3 Manipulating 2D shapes.

```
#include <malloc.h>

int CreateShape(S2DShape * oShape, int nVertices)
{
  if (oShape->oVertices != NULL) free (oShape->oVertices);
  oShape->oVertices = (S2DCoords *) malloc (sizeof(S2DCoords) *
  nVertices);
  if (oShape->oVertices == NULL) return MALLOC_FAILED;
```

```
  return MALLOC_OK;
}

void DestroyShape(S2DShape * oShape)
{
  if (oShape->oVertices != NULL) free(oShape->oVertices);
}

void SetShapeVertex(S2dShape * oShape, int nVertex, S2DCoord
  oVertex)
{
  oShape->oVertices[nVertex]->x = oVertex.x;
  oShape->oVertices[nVertex]->y = oVertex.y;
}

void GetShapeVertex(S2dShape * oShape, int nVertex, S2DCoord *
  oVertex)
{
  oVertex->x = oShape->oVertices[nVertex]->x;
  oVertex->y = oShape->oVertices[nVertex]->y;
}
```

With these functions in hand, we are ready to take the final step and create the class that will store the entire two-dimensional figure, which is built from a number of shapes. To avoid memory corruption, we must set up each shape and then add it to the memory allocation set aside for the shape's space in the main class. Figure 4.4 shows the basic implementation of the C2DShape class.

CODE SAMPLE 4.4 2D-figure class.

```
struct C2DFigure
{
  private:

    S2DShape ** oShapeSpace;
    int nShapes;

  public:

    C2DFigure();
```

```
    ~C2DFigure();

    void AddShape(S2DShape * oShape);
    void GetShape(S2DShape * oShape, int nShape);
}

C2DFigure::C2DFigure()
{
  this->nShapes = 0;
  this->oShapeSpace = NULL;
}

C2DFigure()::~C2DFigure()
{
  // Do it backward to avoid memory problems...
  for (int n = this->nShapes; n > 0; n++)
  {
    DestroyShape(this->oShapeSpace[n]);
  }
}

void C2DFigure()::AddShape(S2DShape * oShape)
{
  // Allocate some (extra) memory
  if (this->oShapeSpace == NULL)
  this->oShapeSpace = (S2DShape *) malloc (sizeof(S2DShape *));
  else
    realloc(this->oShapeSpace, sizeof(S2DShape *));

  this->nShapes++;

  int nVertices = sizeof(oShape) / sizeof(S2DCoords);

  CreateShape(this->oShape[nShapes-1], nVertices);

  for (int n = 0; n < nVertices; n++)
  {
    SetShapeVertex(this->oShape[nShapes-1], n,
  oShape->oVertices[n]);
  }
}

int C2DFigure()::GetShape(S2DShape * oShape, int nShape)
```

```
{
  DestroyShape(oShape);
  int nVertices =
    sizeof(this->oShape[nShape]->oVertices) /
  sizeof(S2DCoords);

  for (int n = 0; n < nVertices; n++)
  {
    GetShapeVertex(this->oShape[nShapes-1], n, oShape-
  >oVertices[n]);
  }
}
}
```

The class in Code Sample 4.4 allows us to construct a figure comprising many shapes, each of which can have a differing number of vertices. Before we move on to other, more-complex operations, we shall look at how the image in Figure 4.1 can be created using the code samples we have just been discussing.

CODE SAMPLE 4.5 *Constructing the Mamba-class spacecraft.*

```
.
.
.

C2DFigure * oMamba = new C2DFigure();
S2DShape oShape;
S2DCoords oCoords;

CreateShape(&oShape, 3);

oCoords.x = -1.0;
oCoords.y = -1.0;
SetShapeVertex(&oShape, 0, oCoords);

oCoords.x = 0.0;
oCoords.y = 1.0;
SetShapeVertex(&oShape, 1, oCoords);

oCoords.x = -0.5;
oCoords.y = -1.0;
```

```
SetShapeVertex(&oShape, 2, oCoords);

oMamba->AddShape(&oShape);

// Other shapes are implemented in the same way as above to
// make up the whole figure.

   .
   .
   .

// When we are done with the two temporary variables, we should
// destroy them.

DestroyShape(&oShape);

   .
   .
   .

// When we no longer need the oMamba object, we can destroy it.

delete oMamba;
```

Adding a third dimension to this implementation is as simple as adding a z coordinate to the S2DCoords structure to create the S3DCoords structure. Other than that, the process of building the figure from shapes that now contain one or more vertices, each with a possible x, y, and z coordinate, is left as an exercise for the reader.

Now that we can describe a figure in three dimensions, we should look at how we can store each figure more efficiently, how to manipulate the figures, and furthermore, how such figures can be constructed mathematically to avoid any static storage of the individual coordinates.

We began this chapter by discussing landscapes; but somewhere along the way, we have been sidetracked into discussing spacecraft, which really belong in the object-based universe discussion. However, it was important to talk about something we know about before extending the techniques to landscapes—about which we know little at this point. (We will become very familiar with landscapes in Part II of this book.)

The techniques for creating two-dimensional and three-dimensional wire-frame spacecraft also apply to landscapes. A pyramid, for example, is a closed three-dimensional shape, like the *Mamba* spacecraft we looked at previously. Rocks and boulders are also examples of closed shapes that can be represented by vertices in the same way. Scrolling backgrounds, such as mountains, are examples of open shapes; that is, they have no apparent form beyond the hills that they depict. Figure 4.2 shows the inherent difference between open and closed landscape shapes.

The easiest landscape style that can be constructed using generation alone (with minimal storage) is the two-dimensional background mountain range. This is a horizontally scrolling background with one or more 'layers.' The farther each layer is away from the player, the slower it scrolls, giving the illusion of three dimensions by using two-dimensional mathematics. We shall cover techniques for creating such landscapes in Part II; for now we shall just assume that each layer is generated using a pseudo-random number generator.

If we require two mountain ranges, we can create two arrays of integers and populate them as required. Please note that in the event that the storage space required is not available, it is also quite possible to generate the array numbers as they are required using code similar to code that we are about to discuss. Scrolling the landscapes is left as an exercise for the reader (hints are given in future chapters).

The theory for building these landscapes is very simple. The front landscape will move faster and thus requires more peaks, while the back landscape will move more slowly and will have fewer peaks. So, if we want a landscape that is, say, five times the typical screen width with 12 peaks per screen, we need an array of 60 integers for the foreground and 15 integers for the background. The choice of these numbers will become clear as we go along.

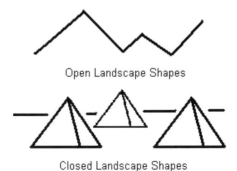

Open Landscape Shapes

Closed Landscape Shapes

FIGURE 4.2 Open and closed landscape shapes.

We can store the peak information in one of two ways: absolute or differential. Absolute means storing the actual peak height, whereas differential storage need only denote whether the next peak is higher or lower than the current peak. This is the best method for generating the peaks during the play session, but it requires that we know the multiplier and the minimum and maximum peak heights. For this discussion, we shall remain with the absolute method.

CODE SAMPLE 4.6 The foreground peak array.

```
#include <stdlib.h> // For random math functions

void CreateForegroundPeakArray(long lSeed, int * oPeakData,
                               int nPeaks, int nMaxHeight)
{
  srand(lSeed);

  if (oPeakData != NULL) free (oPeakData);

  oPeakData = (int *) malloc (sizeof(int) * nPeaks);

  for (int n = 0; n < nPeaks; n++)
  {
    oPeakData[n] = rand() % nMaxHeight;
  }
}
```

Code Sample 4.6 shows how to populate the array and allows for an array of any size. To create the background from the foreground, we simply sample the foreground array by taking the average of every four peaks and multiply it by two. In this way, we can build up a background that mirrors the spirit of the foreground. The code to do this is shown below in Code Sample 4.7.

CODE SAMPLE 4.7 The background peak array.

```
void CreateBackgroundPeakArray(int * oForeground, int nMaxPeak,
                               int * oBackground)
{
  // Set up a new array, 1/4 the size of oForeground
```

```
if (oBackground != NULL) free (oBackground);

oBackground = malloc (sizeof(oForeground) / 4);

int m = 0;
int nTotal = 0;

for (int n = 0; n < sizeof(oForeground) / sizeof(int); n++)
{
  nTotal = nTotal + oForeground[n];
  if ((n % 4) == 0)
  {
    m++;
    oBackground[m] = (nTotal / 4) * 2;
    nTotal = 0;
  }
}
}
```

In addition to simple landscapes such as these, we can construct two- and three-dimensional wire-frame models of other features, such as boulders, using similar techniques. Boulders, for example (like those in the Atari game *Asteroids*), can be constructed from deformed hexagons, where each calculated vertex is altered by some random x,y offset.

TEXTURED POLYGONS

From wire-frame graphics, the next stage is to be able to work with planes as well as vertices. The first way in which planes are useful is in hidden line removal. If we consider that the rotation of a three-dimensional wire-frame object will alter the z coordinates of a vertex such that some parts of the object will become hidden behind others, then clearly we would like those edges to be hidden in some way.

One way of doing this is to calculate the z-order of each of the planes, which in this case means each of the shapes that make up the object. In order to do this, we calculate the distance from a nominal point in the center of each shape. Then, we draw the shapes in reverse order; those furthest away (with the lowest calculated z-order) are drawn first and then overdrawn with filled planes so that the lines that should be hidden are superimposed by the filled shapes.

Filling with black is well and good, but we can take it one step further and fill in the planes with solid color or a texture (see Part IV: "Words & Pictures"). In any event, textures wrapped around the wire-frame grid require slightly different definition and storage, such as needing to define an RGB color as the fill color, specifying a palette index, or specifying a texture map index.

DRIVING GAMES

Driving simulations, which are often based on a track layout with some kind of background, are the classic example of how landscapes and terrains can be mixed. Add in some difficult driving conditions, perhaps with some simulated weather, and this forms the basis for the game. Of course, the physics of driving also needs to be added, and the actual backdrop could be modeled on either the real world or, for example, a futuristic *WipeOut*-style landscape; but at the base of it all is the track and surrounding terrain.

There are many different ways to look at the problem of storing the track itself. In this section, we shall examine how the track definition can be stored, retrieved, and manipulated. One of the manipulations involves bridging the gap between storage and generation—using both in conjunction to reduce the storage space required and also provide flexibility for creating new tracks.

When reflecting on games such as *SimCity*, it is obvious that the easiest way, conceptually speaking, is to store the track and terrain in a tile-based fashion. We can store the terrain-based world (TBW) in memory, based on integer figures (one for each tile), and render the screen based on what the driver 'sees' from the current position.

Keeping these two positions (visible and invisible) synchronized is an important part of the work needed to maintain the correct level of reality in the game. The first step is to determine what is visible from a given point on the track in terms of distance and then to determine what is hidden, either behind landscaped features or too far away to be seen.

We can, of course, cheat and border the entire track with large mountains, which serves two purposes; first, it ensures that the player cannot stray too far from the track, and it also makes much of the surrounding landscape effectively invisible so that it does not need to be rendered.

Once again, we shall begin with the simplest possible example of such a game and work toward more complicated games as we refine the techniques used to build and render tracks. The very first racing game was

based on a very simple block display that scrolled down the screen toward the player's vehicle, which was drawn at the bottom of the screen. We can model this kind of simple game based on ASCII graphics, and play it in a DOS window.

TOP-DOWN RACER

The representation for the game universe in this case could be modeled using a simple, two-dimensional array of characters with each cell representing a piece of straight track, a corner, or even an intersection. Figure 4.3 shows a simple, ASCII text-based track.

The characters used for the track have been chosen for ease of editing. The "S" character shows where the start position of the track is; and with a little trickery, the race can be run in either direction. Some tricks are required because when traveling around the track, there is sometimes no correlation between the tile at the current position and the target tile once the current tile has been successfully traversed.

So, the first task is entirely nonvisual; we need to know how to move correctly from one tile to the next. For example, one would expect that having negotiated a tile of type "/," the next tile would lie at $x+1,y+1$ (with x and y being the current tile's coordinates). But a quick look at Figure 4.3 shows that this is not always the case, especially when turning corners (e.g., from "-" to "\").

The array needed to store the oval track in Figure 4.3 can be defined as nTrack[29][13], allowing us to locate the start point as nTrack[0][6]. Assuming that we want to implement this in a reusable, portable way, we

FIGURE 4.3 Simple ASCII track.

should provide some functions along with the storage array to automatically locate the start point from the array as well as the direction in which we need to move.

In Code Sample 4.8, a structure is defined that can be used to model the universe in this abstract way. We are sticking with ANSI C for the time being, because defining a C++-based class would be incompatible with some handheld development suites, such as the Game Boy (GB) SDK (or GBDK). When we move away from limited environments, functionality will be migrated to an object-oriented representation that will scale better with the additional game complexity possible with higher-capability environments.

CODE SAMPLE 4.8 The STrack game universe structure and start-up code.

```
#define CLOCKWISE      1
#define ANTICLOCKWISE  2
#define FOUND          3
#define NOT_FOUND      4

struct STrack
{
  int nTrack[TRACK_X_DIMENSION][TRACK_Y_DIMENSION];
  int nStartPositionX, nStartPositionY;
  int nStartDirectionX, nStartDirectionY;
  int nCurrentDirectionX, nCurrentDirectionY;
  int nTrackDirection;
};

int FindStartPosition(struct STrack * oTrack)
{
  int x,y;

  for (x = 0; x < TRACK_X_DIMENSION; x++)
  {
    for (y = 0; y < TRACK_Y_DIMENSION; y++)
    {
      if (oTrack->nTrack[x][y] == 'S')
      {
        oTrack->nStartPositionX = x;
        oTrack->nStartPositionY = y;
        return FOUND;
      }
    }
```

```
  }
  return NOT_FOUND;
}

// Utility function to test a cell, can be reused anywhere
char TestPosition(int x, int y, struct STrack * oTrack)
{
  if ((x < 0) || (y < 0)) return ' ';
  if ((x >= TRACK_X_DIMENSION) || (y >= TRACK_Y_DIMENSION))
  return ' ';
  return oTrack->nTrack[x][y];
}

// Utility function to find offsets from a tile, can be reused
// anywhere, taking into consideration the direction
// (anti-clockwise or clockwise)
void GetDirection(char nTile, int * nX, int * nY, int
  nDirection)
{

  nX = 0; nY = 0; // The default error condition

  switch (nTile)
  {
    case '|' :
      if (nDirection == CLOCKWISE) { nX = 0; nY = -1; }
      else { nX = 0; nY = 1; }
      break;

    case '/' :
      if (nDirection == CLOCKWISE) { nX = 1; nY = -1; }
      else { nX = -1; nY = 1; }
      break;

    case '\\' :
      if (nDirection == CLOCKWISE) { nX = -1; nY = -1; }
      else { nX = 1; nY = 1; }
      break;

    case '-' :
    case '_' :
      if (nDirection == CLOCKWISE) { nX = 1; nY = 0; }
      else { nX = -1; nY = 0; }
```

```
        break;
    }
}

// Utility function to find the next tile offset, if the above
// function fails i.e., x and y both 0
// nDirection can be either CLOCKWISE or ANTI_CLOCKWISE
void FindNextTileOffset(int nStartX, int nStartY,
                        int * nX, int * nY, int nDirection,
                        struct STrack * oTrack)
{
  // Set up an eight-position offset array for the x and y
  // coordinates
  int nXOffset[] = { -1,  0,  1,  1,  1,  0, -1, -1 };
  int nYOffset[] = { -1, -1, -1,  0,  1,  1,  1,  0 };
  int n;

  if (nDirection == CLOCKWISE)
  {
    for (n = 0; n < 8; n++)
    {
      if (TestPosition(
          nStartX + nXOffset[n], nStartY + nYOffset[n],
  oTrack) != ' ')
      {  nX = nStartX + nXOffset[n]; nY = nStartY +
  nYOffset[n]; return; }
    }
  }
  else
  {
    for (n = 7; n >= 0; n--)
    {
      if (TestPosition(
          nStartX + nXOffset[n], nStartY + nYOffset[n],
  oTrack) != ' ')
      {  nX = nStartX + nXOffset[n]; nY = nStartY +
  nYOffset[n]; return; }
    }
  }
}

void SetStartDirection(struct STrack * oTrack,
                       int nDirection)  // Anti-Clockwise or
                                        // Clockwise
```

```
{

  FindNextTileOffset(oTrack->nStartPositionX,
                     oTrack->nStartPositionY,
                     &oTrack->nStartDirectionX,
                     &oTrack->nStartDirectionY,
                     nDirection, oTrack);
}
```

There is rather a lot of code in this sample, and the reader would be well advised to read it several times in order to become familiar with exactly what the code is trying to achieve. In particular, there are several reusable utility functions, which we shall be coming back to in future implementations, such as:

```
char TestPosition(int x, int y, struct STrack * oTrack)
```

used to find out whether there is a tile present at x,y, and:

```
void GetDirection(char nTile, int * nX, int * nY, int
nDirection)
```

used to return the probable x,y offset of the next tile based on the current one, and:

```
void FindNextTileOffset(int nStartX, int nStartY,
int * nX, int * nY, int nDirection,
struct STrack * oTrack)
```

used to find the offset for the next tile to be moved to in cases where Get-Direction fails.

At first sight, it can seem overly complicated to define all of the above code just to try and determine which piece of track will be visited next, especially since we do not seem to do anything with the different tile representations "/," "|," "\," "-," and "_." However, it serves two purposes. The first purpose is simply that the visual representation advantage is gained, as in Figure 4.3. Second, it enables us to render the track in a slightly more-realistic way. Of course, this could be done by comparing the last (or current) position with the next; but by using tile types, the process is slightly more efficient.

Now that we know where to begin and in what direction we should move to get to the next tile, we can concentrate on the function required to move along the track, section by section (or tile by tile). For now, let us assume that the player can only keep to the track without taking any shortcuts, and they can only move in a forward direction.

Once we have loaded (by whatever means) the array representation of the track into the nTrack member of the STrack structure, we can perform the initialization steps (see Code Sample 4.9) and set up some global variables to store the current state of play.

CODE SAMPLE 4.9 Initializing the STrack game universe structure.

```
struct STrack * oTrack;
int nCurrentX, nCurrentY;

 .
 .
 .

FindStartPosition(oTrack);
SetStartDirection(oTrack,CLOCKWISE);

 .
 .
 .

nCurrentX = oTrack->nStartPositionX;
nCurrentY = oTrack->nStartPositionY;

 .
 .
 .
```

Movement from tile to tile can be effected using the code in Code Sample 4.10, below, which looks for the next cell to move into and updates the nCurrentX and nCurrentY global-positioning variables.

CODE SAMPLE 4.10 Updating tile location information.

```
GetDirection(oTrack->nTrack[nCurrentX][nCurrentY],
            &nCurrentX, &nCurrentY, CLOCKWISE);

if (TestPosition(nCurrentX, nCurrentY, oTrack) == ' ')
{
  FindNextTileOffset(nCurrentX,   nCurrentY,
                     &nCurrentX, &nCurrentY,
                     CLOCKWISE,
                     oTrack);
}
```

To complete the implementation, we need some way to render the ASCII map on the screen—in this case, the first-person perspective. Assuming a 25 × 80 standard DOS screen, we can make a few arbitrary decisions about visible track width and decide to use 20 characters. We also need a 'car' sprite, which will also be rendered in ASCII. Figure 4.4, below, is a possible rendering:

FIGURE 4.4 Rendering of visible track and car.

This shows the 'car' at the 'start' position of the track. Reconciling this view with the track 'overhead' view, we note that some conversion is required. For example, we could say that for each tile of the overhead view, the top-down view that represents it will cover an entire screen. In other

words, once the top of the screen scrolls down to the bottom, it is time to introduce the layout for the next tile at the top of the screen.

However, we are getting slightly ahead of ourselves. First, we need to describe the way that the track is to be rendered using ASCII characters. What follows is a description of a possible game called *ASCII Racer* that uses ASCII characters to represent the movement of a Formula 1 car around a track. The reader might like to try implementing it (on a Game Boy, for example).

ASCII Racer

The formula is that (in memory) the car races around the track, passing from one tile to another at a given speed. Corners, straightaways, and other visual elements are rendered on the screen one tile at a time. There are two counters that could be held in memory that describe where the car is on the track at any given time.

Let us assume that the nTile counter specifies the exact tile that the car inhabits based on the *x* and *y* locations of that tile in memory. Also, assume that there is a second counter, nTileLine, which determines how far along the current tile the car is. When nTileLine reaches a preset value, the next tile must begin to be displayed. Of course, nTileLine will relate to the number of lines that can be displayed on the platform's screen in text mode, and the lines simply scroll off the bottom.

Corners are rendered with the "/" or "\" characters, interlaced with "|" characters if the corner is not too steep. The speed at which the lines move down the screen is directly proportional to the speed of the car, which in turn means the speed at which the 'virtual' car moves around the track in memory. This, in essence, is how the *ASCII Racer* software works.

Although it is possible to compress the grid that stores the track by using the RLE techniques previously described, the main advantage of the representation depicted in Figure 4.4 is in the design phase. It is not, however, a very efficient way of storing the information; nor is it a very efficient way to recreate the track during the play session. For a start, it contains very little information and an awful lot of white space.

RLE REVISITED

During the design phase, it is quite acceptable to use techniques that are less efficient than those destined for the final game. The game itself needs to use the most efficient techniques because it is unacceptable to force the player to wait while the computer recalculates, decompresses, or processes some vital piece of information. This is excusable only in pre-game and

post-game session phases where information (text) can be put on the screen to hopefully distract the player while the machine does its heavy processing. Otherwise, heavy calculations within the course of the game will cause very undesirable effects, such as frame-dropping or slowdown.

This is less noticeable in a low-frame-rate game like *SimCity* or other top-down simulations. But in driving games that require a high frame rate in order to be realistic, it becomes marked. This is not to say that the grid approach will cause such effects on a high-end PC platform, but it might very well do so on lower capacity machines, such as the Game Boy.

Rather than using the grid, we can store the various twists and turns of the track much more simply by using a stream of numbers that we can build up from the grid representation. Using this technique and a rule-based system, we can implement a much more efficient, but less easy to visualize, solution to the track problem if we assume that the following encoding will be used:

```
L   –      Left-hand turn
R   –      Right-hand turn
S   –      Straight
```

And that, when turning, each L or R indicates a turn of 30°, we can encode Figure 4.4 as a series of letter values, as shown below:

```
SSSRRRSSSSSSSSSSSSSSSSSSSSSSSRRRSSSSSRRRSSSSSSSSSSSSSSSSSSSS
SRRRSS
```

This gives us a string of 66 bytes for a simple oval track. From this string, we note that there are many substrings that are identical; and so we can encode it in much the same way as with the RLE grid compression we used previously, to yield the following:

```
3S 3R 22S 3R 5S 3R 22S 3R 2S
```

The above is arranged as pairs of bytes, which can contain values from 0-255 (`unsigned char`) and gives a string of values 18-bytes long, a reduction of almost 73%. While this reduction size cannot always be guaranteed, we can take it a step further and use a building-blocks approach to track construction, which would encode specific track features (such as hairpin bends) with a specific set of numbers that indicate the feature type and orientation in degrees. Take, for example, the hairpin bend depicted in Figure 4.5.

FIGURE 4.5 ASCII hairpin bend.

This can be represented by a string of characters:

SSSSSSSRLSSSSSSS

Of course, if we follow our theory from above, in this case, we have a strange, 30° zigzag right and then left. Clearly, we should add a rule that states that if ever a right-hand turn (/) is followed immediately by a left-hand turn (\), then it is effectively a hard right-hand turn, or hairpin. Likewise, if a "\" is followed by a "/," then a hard left must be implemented. Employing such a rule would expand our string defining the hairpin bend above to:

SSSSSSSRRRRRRSSSSSSS

We can then RLE this string to produce a compressed:

6S 6R 6S

Or we can encode by adding the right-hairpin code (1) and the orientation (90°) to the right of north as two simple bytes:

01 90

Our last example before we move from tracks to landscapes proper is a real-life rendering (or as close as possible, given that we are encoding using ASCII) of the world-famous U.K. Formula 1 racetrack, Silverstone. Figure 4.6 shows a possible rendition. The figure can be translated into a series of values, as follows:

```
012S 001R 007S 001R 001S 001R 004S 001L 001S 001L 001S 001L
001S 001L 001R 004S 001R 001S 001L 001S 001L 001S 001R 001S
001R 002S 001R
```

These adhere to a few rules, namely that if two or more turn tiles of the same type follow each other, then the result is a turn followed by a straight-

FIGURE 4.6 ASCII Silverstone

away. Also, if a right turn is immediately followed by a left turn, then this is to be interpreted as a hairpin turn.

FILLING IN THE BLANKS

Previously, we stated that there was a lot of white space on the grid where no track was present. If we are to create a more-realistic driving simulation, we need to fill in this white space with landscape features. Clearly in these cases, it is not possible to use the previous single-stream approach because it is not possible to introduce this information under a similar scheme. In cases where the stream approach is to be used, the landscape must be simulated on the fly.

If realism is required, then we have no choice except to encode the various landscape features, such as hills and lakes, using the techniques from Chapters 1–3 to encode these features, store, and reproduce them accordingly. On the other hand, if we just want to fill in the gaps in a random way, then there are a number of things we can do to add landscape features to the track.

Part II of this book ("Terrain & Landscape Definition") concentrates on techniques for actually creating landscapes, but the basic theory is to assume, as we did in Chapter 2, that form follows function. In our case, this means that the track is shaped the way it is because there are landscape features that dictate its overall form. There could be a hill that the track needs to bend around, or a river that it runs beside or even over. Before we look at these variables in detail, we shall take a short break to look at event sequencing.

CONCLUSION

In this chapter, we have seen a variety of techniques for encoding different kinds of shapes associated with landscape-based games. From wire-frame to textured polygons and 'free-space' style games, through to top-down racing games, there will always be a landscape to be stored, especially if we need a track of some description.

Generally speaking, encoding will always be based on either numerical values (e.g., coordinates for a shape) along with many mathematical formulae designed to transform (rotate and scale) these shapes, or reduce the complexity of data types (such as ASCII characters) that represent some kind of feature, such as a track. If we consider a track by way of example, we can encode it as either a stream of numbers or on a grid as an ASCII layout, as we did in this chapter.

Since many of the techniques can be applied in a variety of situations, it will be a matter of choosing the one that is most appropriate. For example, wire-frame graphics, while conceptually possible, do not work well with a sprite-based game engine, such as that provided by the Nintendo Game Boy. So, if the game is to be written for the Game Boy, then a different representation needs to be used, which will change both the on-screen representation and also the way in which the game universe is stored, and thus the techniques needed to manipulate it.

INTRODUCTION TO EVENT SEQUENCING

INTRODUCTION

In any game, the order of events is possibly the most important facet. However, it is important to try and decide what exactly we mean by the term "event." Events can fall into many categories, the two broadest being:

1. sporadic events that are presented to the player in order to confuse, destroy, or maim them; and
2. events that occur as a direct result of player input.

Generally speaking, the game engine is driven by these two kinds of events—either player-induced or engine-triggered by the passing of time. There are also events that might be triggered in response to a preceding chain of events, a sequence of actions, or reactions that lead to a cumulative event taking place to satisfy multiple conditions brought about by the same sequence of events.

It is less cumbersome to look at a specific example that is loosely based on the Acornsoft adventure game of the early 1980s, *Sphinx Adventure*. The solution to the game hinges on the player's ability to procure a wand, kneel before the *Sphinx*, collect a large amount of treasure, and wave the wand.

In this case, as in most adventure games, the player's winning the game is a culmination of many events and event chains, all of which lead to the successful completion. Testing for this target condition and managing the sequences of events that lead the player through the adventure fall into the category of 'event sequencing.'

To a certain extent, we can say that either the player drives the game or the game drives the player. Sometimes, however, the player's driving the game is an illusion because the game (system) is really always in control.

In this chapter, we shall look at several aspects of event sequencing from the point of view of game objects, the game universe, and even as related to random event sequencing in the true infinite universe. When working with game objects and the game universe, all of the techniques should be portable across many different platforms and scalable enough to cover the most complex and intricate game universes.

WHAT HAPPENS NEXT?

There are two ways of looking at events and event sequences in game programming—from each interacting object's point of view, and from an interaction point of view with the game universe itself. In the real world, of course, the events that shape what happens in the universe are the sum of the interactions between all of the objects involved plus a chance 'God' style of intervention.

When we construct a game universe inside the mind of a machine, however, some of these interactions have to be rolled together and elicited by the game engine itself. This is because even the most high-powered and sophisticated machines will not be able to efficiently deal with the sum interaction of all the different game objects. This leads to a certain necessity: In order to increase the general playability and efficiency of the game universe, we will only concern ourselves with those objects that fall within the player's scope of play and the interactions of those objects with the player object and the rest of the game universe.

Steve Rabin (*Game Programming Gems*. Charles River Media, 2000) notes that:

> There are basically two ways for game objects to react in the world: by actively watching the world (polling) or by sitting back and waiting for news (event driven). (p. 221)

Many operating systems work on a basis of messages, usually grouped into system and user messages. Examples include the Microsoft Windows platform and certain handheld operating systems. This message-based architecture is a classic example of an object-based system with interobject

communication—and the user is given the illusion of control; but the operating system controls all the messages and is thus really always in control.

Messages are mainly used in the realm of event-driven game universes. We shall restrict polling to the game universe itself, thereby allowing it to watch over objects in the immediate scope of the player and send the occasional message when the controlling process sees something it has been programmed (or has learned) to react to.

This 'intelligent' game engine is especially useful in infinite universe domains because it is nearly impossible to predict every possible sequence or chain of events that might occur during the play session. Indeed, it would also be restrictive to attempt to control the environment in such a way that it becomes possible to predict every single outcome. Ben Elton notes in his novel, *Eden,* that while it may be easy to determine the cause of certain effects, it is nearly impossible to predict the outcome from a series of possible causes.

So, in essence, we need an event-driven, message-based architecture that follows the interaction between all of the game objects within the immediate scope of the player's sphere of influence. We also need a slightly benign polling object that represents the rest of the game universe—an object that can react to the presence or absence of messages in an appropriate way. As a bonus, we would also like to introduce a little piece of magic in the way of random events.

Considering that we wish to implement this to accommodate the lowliest of game machines, such as the Game Boy (with apologies to Nintendo), it seems like a tall order. As usual, we shall take our example of the game *Elite,* which has had a big impact in the game industry, and look at how it deals with this kind of problem.

First, the objects themselves fall into three categories: immediate, local, and remote. Immediate objects are those objects that the player can see and interact with at any given point during game play. Local objects are those objects that are in the immediate vicinity, but which cannot be interacted with directly. Finally, remote objects are those objects which *might* exist, and their existence can be tested for; but they do not have any effect on the player *right now.*

Of course, objects are free to move between categories as the game progresses, depending on whether or not they have an effect on the player. And some objects might not even exist at a given moment, but they might spring up in the next moment and become a member of one of the three object categories just defined. Taking *Elite* as an example, Table 5.1 shows the categories and the objects that could be placed in them at a given moment during game play.

TABLE 5.1 Object Categories in Elite

Immediate	*Local*	*Remote*
Enemy Spacecraft	Current Planetary System	Other Planetary Systems
Space Station	Neighboring Systems	Other Galaxies

If, for example, the player is flying along quite happily minding their own business, and is attacked by some pirates (Enemy Spacecraft), they might find themselves overpowered and make for the Space Station. If they cannot prevail, even with help from the Police Ships that have flown out of the Space Station, a hyperspace jump might be required to a Neighboring System.

This would move the Enemy Spacecraft and Space Station from the immediate category to the remote (or possibly local) category, but would not affect the status of the Current System or Neighboring Systems unless the player's hyperjump was an intergalactic one, which would move the Current System or Neighboring Systems into the remote category and pull one of the systems from the (previously) remote category into the local or (possibly) immediate category.

This may all sound unnecessarily complex and detailed, but it is important that the game universe to be implemented be broken down in this way if it is to be effectively managed during the play session.

MESSAGES AND EVENTS

"Messages" can be defined as the results of events taking place. Each message needs to be routed from one object to another, watched over by the event generator. It seems natural to roll this routing facility into the event generator, to combine the event-driven part of the architecture with the message-based component. In this way, the event generator (or sequencer) can also examine what messages are being transmitted through the system and schedule new messages and events as required.

In the same way that we can organize objects into categories depending on their relevance, we can also group message types according to their purpose. Some messages will have a low-level function, such as altering the direction or speed of a game object; others might be used for higher-level functions, including altering specific behaviors or values of certain objects.

Messages can be defined in any way that the game designer seems fit—from a very simple style of message that takes its form from assembly programming:

```
action [[parameter] [parameter]]
```

to a more-complex variety, suggested by Steve Rabin (*Game Programming Gems,* Charles River Media, Inc., 2000):

```
name <from> <to> <deliver_at_time> <data>
```

Perhaps a combination will be better suited to an individual application, as in Code Sample 5.1.

CODE SAMPLE 5.1 Hybrid message format.

```
typedef struct
{
  int action_code;
  int * parameter_list;
} message_data;

typedef struct
{
  int from_object_class;
  long from_object_id;

  int to_object_class;
  long to_object_id;

  double delivery_time;

} message_envelope;

typedef struct
{
  message_envelope Routing_Info;
  message_data     Payload;
} message;
```

The hybrid message format includes elements from each style, the simple message forming the payload of the message plus its delivery details, which are used as a kind of envelope. The message payload comprises the action and a variable-length parameter list, while the routing information

includes source and destination object classes and identifications, as well as time-sensitive information.

The class information might not strictly be necessary, except that some messages might have the same action code, but be handled differently for different object types. Also, it enables us to define a 'broadcast' message that can be delivered to all objects of a specific class at (more or less) the same time.

Messages can perform a variety of functions, such as carry causal information (i.e., targeted at having an effect on something) or effect information (i.e., the result of a message carrying causal information). Such a message is more accurately called an *event*. The message is merely the way to convey the information that is required to register the result of an event. Events can be spontaneous (with no real cause) or a result of a complex sequence of messages—some of which being the results of events in themselves.

MOVING BACKGROUNDS

The simplest of all event-sequencing techniques is used mainly for action games—the moving background. We have already covered certain forms of moving backgrounds in previous chapters. Now we are going to look at the continuously moving background—that is, a background in which we can only move forward, and once it has moved off the screen, it can be forgotten about as far as the play session is concerned.

Furthermore, moving backgrounds can be used in conjunction with other game universe objects and even predicate their movement or appearance. Generating a moving background on a pseudorandom basis is very simple and effective, and can be put to good use, especially on handhelds. It is also simple enough to be portable between platforms; only the graphics become more complex as the platform power increases.

Our first code example is the line-based, horizontally scrolling background, which can be generated using a calculated differential. There are many different calculations that can be applied, ranging from a simple random up or down:

```
if ( rand( ) % 100 > 50 ) height = height + 10; else height
= height - 10;
```

to more complex procedures involving taking a random percentage of the current height and either subtracting or adding it to the current height, depending on another pseudorandom number. This is the basis of the algorithm in Code Sample 5.2.

CODE SAMPLE 5.2 Height percentage calculation.

```
#define PERCENTAGE_BAND 25

int GetNextHeight ( int nMax, int nMin, int nCurrentHeight )
{
  int nPercentage = (rand() % PERCENTAGE_BAND);
  nPercentage = (int)
    ((double)nCurrentHeight * ((double)nPercentage / 100.0));

  if (rand() % 100 > 50) nPercentage = nPercentage * -1;

  if (nPercentage > nMax) return nMax;
  if (nPercentage < nMin) return nMin;

  return nPercentage;
}
```

Of course, since we are working with percentages in Code Sample 5.2, you will probably want to keep nMin to a suitably large (5–10) value, and nMax to a percentage of the height of the play area. Apart from these small caveats, the code comes with no special side effects. Using it is fairly simple, providing we remember that the drawing always has to be done one step ahead (off-screen) so that scrolling from one value to another is smooth. Figure 5.1 shows how a simple, line-based background scrolling technique works.

FIGURE 5.1 Simple line-based background scrolling in action.

Scrolling backgrounds are not limited to guiding the player toward their target, either. They can be used to provide choices, too; and they can scroll in any direction that is required. They are a simple, but effective way to provide a semblance of motion to the game, as if it is moving in a given direction, and can also be used to preempt certain events. If a certain event happens at a certain point along the way, as denoted by the scrolling background, then the player will learn from this and improve their game.

THE ELEMENT OF SURPRISE

Finally, we would like to introduce some method whereby events can take place in an unplanned, unpredictable fashion. Throughout this book, we will be discussing techniques that are based on pseudorandom number sequences, largely because the majority of the time, when we need to generate a sequence of numbers, we would like it to be repeatable. This is especially important for level generation, since Level 1 should be the same every time it is played.

When it comes to events and event sequencing, we also need to be able to generate events that happen at random intervals. This might range from lightening forks in the sky to the cry of a beast in the night, or other, slightly less-benign and more-aggressive effects, such as the appearance of an enemy spacecraft at some unplanned point in time.

The point is, events such as these rely on a true random number generator. Of course, this is not possible because computers are deterministic machines and are not capable of producing purely random numbers—they must always be 'seeded' by something. However, there are some ways in which we can try to generate unique seeds.

The simplest is a technique used in textbooks all over the world:

```
srand ( time ( NULL ) )
```

The above code simply seeds the random number generator based on the current system time; `time` returns as the number of time increments since midnight 1970, as per the ANSI specifications. This is handy, and will be pretty much unique each time it is required. The only slight drawback is that at some point we are bound to generate the same sequence of numbers with two different seeds for reasons that are mathematically provable (see *Infinite Game Universe: Mathematical Techniques*, pp. 29–39. Charles River Media, 2001).

After seeding, we can then call the generator as many times as needed in order to generate our random events. Whether or not we reseed the generator during the play session depends largely on the length of the play session and number of random events required. In any case, it is up to the game designer; but one last note before we continue—it should never be forgotten that in any one game written using ANSI C (and probably most other languages), there is only a single number generator, and it must be shared by all components.

If we want to retain several generators, we need to reseed the generator with the last value generated before we make a call to it. All that is required is that we maintain a list of as many double precision values as we need random number generators. A simple mechanism for this is provided in Code Sample 5.3.

CODE SAMPLE 5.3 Multiple random number generators.

```
#define GENERATOR_LIST 10

static double pseudo_gen_list[GENERATOR_LIST];

void Seed_Generator( int nGen, double dSeed )
{
  pseudo_gen_list[nGen % GENERATOR_LIST] = dSeed;
  // Ok, so we would probably rather do some better bounds
  // checking...
}

double Generate_Value ( int nGen )
{
  srand(pseudo_gen_list[nGen % GENERATOR_LIST]);
  pseudo_gen_list[nGen % GENERATOR_LIST] = rand();
  return pseudo_gen_list[nGen % GENERATOR_LIST];
}
```

While this will work with ANSI C implementations, it relies on using a particular type of pseudorandom number generator that uses the current value for the seed. In cases where this is not the way that the generator works, the above code will not be sufficient.

THE EVENT ARCHITECTURE

To put this together, we shall now discuss possible implementation strategies that will fit into most kinds of event-driven, object-oriented gaming systems. The basis is a finite state machine (FSM), like that proposed by André LaMothe in *Windows Game Programming for Dummies* (Hungry Minds, 1998):

> *The FSM works by looking at its current state, its inputs, and the rules about when it can change states; after the analysis, the FSM then performs the right action. (p. 30)*

With a slight twist, the event-scheduling system itself is a FSM, but the actual universe objects are either FSM-based (polling objects) or event-based, in which case a special kind of FSM needs to be designed.

POLLING OBJECTS

These are pure FSMs; at a given moment in time, they check their own state and the state of the universe around them, and move into a new state if required. We call them "polling objects" because they do not receive messages, except a generic time-based wake-up. Instead, they look out for other messages and events in the game system.

A motion-activated limpet gun, as seen in the artist's impression of the game *Thrust* in Figure 5.2, is a good example of a polling object.

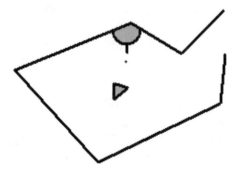

FIGURE 5.2 Motion-activated limpet gun in action.

There are three states that the limpet gun has: waiting, firing, and loading (only one shot in the air at a time). The gun moves from waiting to firing upon spotting the player, at which point it changes to loading and remains so until the gun's shot either goes wide or the shot hits the player. Depending on whether the player is still in the area, the gun will either fire again or return to the waiting state.

The limpet gun might look for a message that tells the system that the player's craft is moving or register to receive such a message upon its creation, and then the gun would continuously poll the system for the 'moving' message. How often the object polls the system is arbitrary, but it should not miss any events in which it is interested.

Event-Driven Objects

The player's craft, persona, or other game universe element are good examples of event-driven objects. The events will come from either the keyboard or joystick, from the universe around the object, or from the underlying game system.

Of course, we can also implement the limpet gun example above as an event-driven object by continuously sending it a message that tells it where the player is. The trouble with this is that if there are several such limpet guns on the screen at once, then the messaging system needs to send each one a message, probably several times per second, leaving the system little time to manage its own affairs. The polling object gets around this small problem.

Random Events

Our third and final entity category is for benign objects that we can call every now and again to create random events in the system. Although a simple procedure, there is still an implementation choice to be made for dealing with how we recognize the event (or nonevent) generated by the object, not to mention what we will do with it.

Conclusion

There is always a tendency to avoid the issue of event sequencing when designing a game in the interest of allowing the relationships between objects to evolve in such a way that the sequence of events follows the model dictated by the game universe. For example, many games are entirely

player-driven, and the reaction of the game objects to the player's movements within the game universe actually provide a semblance of event sequencing without explicitly defining the sequence of events as such in the design phase.

However, by taking a short, but fresh look at the subject, it becomes evident that a new kind of game can emerge in which the player plays both a central role and that of a bystander. Whether this is explicit or whether it is an immersive side-effect of the game itself depends largely on the choice of model made by the game designers, but it is hoped that this chapter has sparked off some trains of thought that might aid designers in the process of determining the game style.

TERRAIN & LANDSCAPE DEFINITION

INTRODUCTION

While Part I of this book dealt with the ways in which different game styles require different techniques for establishing, storing, and manipulating the game universe, Part II is specifically dedicated to defining ways in which games based to some extent on a discrete, mappable play area can populate that play area.

This may sound a little convoluted; but in essence, we are talking about making maps and placing objects on them. Clearly, this approach does not strictly apply to every game. But most (except pure platform or ladders-and-levels type games) require some degree of terrain or landscape generation.

THE DIFFERENCE BETWEEN LANDSCAPE & TERRAIN

A landscape is simply a collection of formations, such as peaks and troughs. Imagine a Styrofoam model of a planet that just shows the relative heights of each point on the globe—then that would resemble a landscape. We are allowed to color it, of course; but it might not contain anything that cannot be derived from measurements handled by the algorithm (see Chapter 6 and discussion on *heightfield*).

A landscape becomes terrain when features such as water, rivers, trees, buildings, or roads are added to it. Their placement will depend on the landscape; the evolution of lakes is molded exactly by the landscape, but it is only by their addition that the landscape will become an interesting terrain upon which the game can take place.

TERRAIN MAPPING

While much of this part of the book will talk about the terrain in terms of a top-down 'map,' it is important to realize that in the end, what is contained within these chapters has very little to do with the resulting display. Each and every technique is as valid for a top-down map as it is for a three-dimensional elevation, since it is only the internal representation that we are concerned with here. With this in mind, let us begin our journey through the various techniques that can be used to create an infinite variety of terrains.

SMOOTHED, RANDOM LANDSCAPING

INTRODUCTION

As discussed in preceding chapters, there are many types of games in which the game universe is entirely created by an artist or level designer. However, we also saw cases (e.g., maze design) where a combination of level design and real-time level generation can be mixed. Landscaping is one area where techniques for real-time, pseudorandom level-generation techniques can be implemented alongside traditional techniques.

This chapter presents ways to create algorithms that are efficient and repeatable, which can be used when a landscape is required to be generated during the play session. Future chapters will build on the techniques examined here. But in order to present them in an easy-to-understand manner, we shall first consider landscapes generated with the standard ANSI C/C++ functions for generating sequences of pseudorandom numbers.

THE PURE RANDOM HEIGHTFIELD

Within games software, landscapes can be stored in a variety of ways, but the most common way is the 'heightfield.' A heightfield is simply a defined area containing a series of points. Each point has a specific value associated with it, which corresponds to the height above or below a nominal 'sea level.'

The heightfield is usually treated as a torus, in which opposite sides are connected together, thereby making a cylinder in which the ends are connected to make a three-dimensional ring. Populating the heightfield could

not be a simpler proposition; all that is required is a nested loop, as shown in Code Sample 6.1.

CODE SAMPLE 6.1 Populating a random heightfield.

```
#include <stdlib.h>  // Standard library for pseudorandom
   functions

#define WIDTH   100
#define HEIGHT 100

#define MAX_HEIGHT 100

   .
   .
   .

void PopulateRandomHeightField ( int
   nHeightField[WIDTH][HEIGHT] )
{
  int x,y;

  for ( y = 0; y < HEIGHT; y++ )
  {
    for ( x = 0; x < WIDTH; x++)
    {
      nHeightField[x][y] = rand() % MAX_HEIGHT;
    }
  }
}
```

The function above, PopulateRandomHeightField, will produce an array of integers, each between 0 and MAX_HEIGHT − 1. Of course, for mathematical reasons, it is often useful to have a series of numbers that fluctuate around zero, for example, between +MAX_HEIGHT and -MAX_HEIGHT. If this is the case, the nominal 'sea level' is at zero, and Code Sample 6.2 shows the replacement assignment to be used in the PopulateRandomHeightField function.

CODE SAMPLE 6.2 Zero-based sea level assignment code.

```
.
.
.

  for ( y = 0; y < HEIGHT; y++ )
  {
    for (x = 0; x < WIDTH; x++ )
    {
      nHeightField[x][y] = rand() % MAX_HEIGHT;
      if (rand() % 100 > 49) nHeightField[x][y] = 0 -
                          nHeightField[x][y];
    }
  }
.
.
.
```

By subtracting nHeightField[x][y] from zero, the entry in the array is made negative in one simple step. It is short work to adapt this so that a value can be assigned to be the 'sea level' at the programmer's or designer's discretion. Code Sample 6.3 shows the necessary changes.

CODE SAMPLE 6.3 Arbitrary sea level assignment code.

```
.
.
.

  for ( y = 0; y < HEIGHT; y++ )
  {
    for (x = 0; x < WIDTH; x++ )
    {
      nHeightField[x][y] = rand() % MAX_HEIGHT;
      if (rand() % 100 > 49)
        nHeightField[x][y] = SEA_LEVEL - nHeightField[x][y];
    }
  }
.
.
.
```

There are a couple of small caveats that the programmer should be aware of in Code Samples 6.2 and 6.3. In the interest of keeping the algorithm as simple as possible, each array element requires two calls to the pseudorandom number generator in order to determine the final value.

Since most pseudorandom number generators eventually repeat themselves, using this approach means that there will be half as many numbers generated before the sequence repeats. The other caveat is that there is a slight performance degradation by performing the second call to the random number generator. The solution to both these problems is shown in Code Sample 6.4, where only one call is made.

CODE SAMPLE 6.4 Single-call arbitrary sea level nHeightField generator.

```
    .
    .
    .

  for ( y = 0; y < HEIGHT; y++ )
  {
    for (x = 0; x < WIDTH; x++ )
    {
      nHeightField[x][y] = rand() % MAX_HEIGHT;
      if (nHeightField[x][y] % 100 > 49)
        nHeightField[x][y] = SEA_LEVEL - nHeightField[x][y];
    }
  }

    .
    .
    .
```

To the experienced programmer, the code above might seem a little tedious, but it is important to understand what each step *ON THE CD* entails and the reasoning behind each optimization or change. The result of such a technique can be seen in Figure 6.1; and it is not a pretty sight. The color version can be viewed by running the *RndTerr* software provided on the companion CD-ROM. The main legwork is made up of an abstract class, cTerrainGenerator, whose definition can be found in the cTGen.h header file. At the core of the actual class implementation is the cTerrainGenerator::RandomizeHeightField method, which initializes the heightfield in a random way using the technique in Code Sample 6.4 to generate the values.

FIGURE 6.1 Pure random heightfield.

Choosing colors from heightfield values is performed by assuming a three-color landscape—blue, green, and brown—which we can loosely assign to sea, land, and hills. The implementation is in Code Sample 6.5.

CODE SAMPLE 6.5 Color-choice algorithm implementation.

```
void cTerrainGenerator::GetCellColor(int x, int y, sRGB * oRGB)
{
  // This routine returns a looked-up or calculated color value
  // in red, green, and blue based on the height of the entry
  // in the heightfield.

  // Anything below the 'sea level' is blue, and anything
  // higher than twice the sea level is brown.  Everything else
  // is green.

  if (this->nHeightField[x][y] > this->nSeaLevel * 2)
  {
    oRGB->sRed = 128; oRGB->sGreen = 128; oRGB->sBlue = 0;
    return;
  }

  if (this->nHeightField[x][y] > this->nSeaLevel)
  {
    oRGB->sRed = 0; oRGB->sGreen = 0; oRGB->sBlue = 255;
    return;
  }
```

```
oRGB->sRed = 0; oRGB->sGreen = 255; oRGB->sBlue = 0;
}
```

Part of the reason that Figure 6.1 is so ugly is that there is no pattern; it is simply a random collection of colored squares. To correct this, we need to introduce a pattern, or at the very least break the irregularity of the pure random heightfield.

NEIGHBOR AVERAGE SMOOTHING

We shall begin with the simplest possible algorithm, which is based on the fact that every cell has eight neighbors. In order to group like values, we can simply examine the eight neighbors around the target cell (not forgetting that the height field is a torus) and set it to be the average of its neighbors.

Before we examine the implementation, let us look at the result, which is depicted in Figure 6.2, again a screenshot taken *ON THE CD* from the *RndTerr* software provided on the CD-ROM.

The code to produce a heightfield that leads to the representation in Figure 6.2 is split into two pieces. The first deals with finding a neighboring cell's value based on the target cell and the x and y difference (or offset) from the x and y position of the target cell. If this sounds a little convoluted, then it is because we want to be able to wrap around the grid in an efficient way, since the heightfield is a torus. The implementation is shown

FIGURE 6.2 Neighbor-smoothed random landscape.

in Code Sample 6.6, and the general algorithm does not require any additional embellishment.

CODE SAMPLE 6.6 Torus-based neighbor cell calculation.

```
int cTerrainGenerator::GetNeighborValue( int x, int y,
                                         int x_diff, int y_diff
    )
{
  int nX, nY;

  nX = x + x_diff;
  nY = y + y_diff;

  if ( nX < 0 ) nX = WIDTH - 1;
  if ( nX >= WIDTH ) nX = 0;

  if ( nY < 0 ) nY = HEIGHT - 1;
  if ( nY >= HEIGHT) nY = 0;

  if (this->nHeightField[nX][nY] > this->nSeaLevel * 2)
      return this->nMaxHeight;

  if (this->nHeightField[nX][nY] > this->nSeaLevel)
      return this->nSeaLevel;

  return 0;
}
```

However, note that the returned value is not the real value of the cell, but rather the extent of the value based on the scale that is established by the cTerrainGenerator class itself. The problem with using the real value is that the results are very closely clustered. That is, by the nature of the algorithm, there are many values that are close to a given limit (i.e., this->nSeaLevel − 1), which lead to clusters of closely related values. Designers might want to adjust the code slightly to return the actual cell value, and will notice results akin to Figure 6.3.

It seems that the 'high' values are not high enough to counteract the 'low' values, resulting in a predominance of 'low' values. Thus, the differences

FIGURE 6.3 Neighbor-smoothed random landscape.

between them were increased by returning values that are at the high end of the scale for 'high' values and at the low end of the scale for 'low' values.

The second part of the algorithm is shown in Code Sample 6.7.

CODE SAMPLE 6.7 Neighbor-smoothing main routine.

```
void cTerrainGenerator::NeighborSmoothing()
{
  int x, y;
  int nTotal, nAverage;

  for ( x = 0; x < WIDTH; x++ )
  {
    for ( y = 0; y < HEIGHT; y++ )
    {
nTotal  = this->GetNeighborValue( x, y, -1, -1);
nTotal += this->GetNeighborValue( x, y, -1, 0 );
nTotal += this->GetNeighborValue( x, y, -1, 1 );
nTotal += this->GetNeighborValue( x, y,  0, -1);

nTotal += this->GetNeighborValue( x, y,  0, 1 );
nTotal += this->GetNeighborValue( x, y,  1, -1);
nTotal += this->GetNeighborValue( x, y,  1, 0);
nTotal += this->GetNeighborValue( x, y,  1, 1);

nAverage = nTotal / 8;
```

```
        this->nHeightField[x][y] = nAverage;
      }
    }
}
```

Although this algorithm is simple enough to not need any great expla-
nation, it has a flaw: The algorithm always starts at the top-left corner and
works toward the bottom-right corner. Thus, the values above and left of
the target cell are prone to have already been adjusted by the time the al-
gorithm reaches the target cell. The exceptions are cases where the source
neighbor, which is used to average with the other neighbors, is located at a
point on the opposite side of the heightfield.

We shall deal with this later, but the key lies in a recursive approach,
much like the approach to be discussed next.

QUADRANT-BASED SMOOTHING

Neighbor-based smoothing tends to produce landscapes that are 'bitty.' By
this we mean that there is a grouping of like values here and another group
there; but these groups have none of the curves and other features often as-
sociated with naturally-formed landscapes.

The reason for this is quite simple. The relationship between neighbor-
ing cells is based on a difference in location of only plus or minus one cell.
That is, only cells directly adjacent to the target cell are taken into account
when attempting to derive a value for that cell.

The overall effect is that, eventually, the influence of a set of cells may
extend to others, but the overall pattern becomes diluted as it travels from
one part of the landscape to the other.

Quadrant-based smoothing ensures that patterns are retained over a
long distance by taking values at four corners of an imaginary square and
setting the value in the center of that square to a weighted average. This is
performed for a square with side WIDTH in the first instance and for squares
of diminishing size, dividing the side by 2 each time until the length is
smaller than 4. The value 4 is the smallest for which a given set of squares
has both corners and centers; a square of side 2 has only four corners. Fig-
ure 6.4 shows this theory in pictorial format.

In Code Sample 6.8, we can see how this theory is put into practice.

FIGURE 6.4 Quadrant-smoothing points.

CODE SAMPLE 6.8 Quadrant-smoothing main routine.

```
void cTerrainGenerator::QuadrantSmoothing()
{
  if ((WIDTH % 2 != 0) || (HEIGHT % 2 != 0)) return;
  if (HEIGHT != WIDTH) return;

  int nRowOffset = WIDTH;

  for (int nSquareSize = WIDTH; nSquareSize > 2; nSquareSize /=
  2)
  {
    for (int nX1 = nRowOffset; nX1 < WIDTH; nX1 += nSquareSize)
    {
      for (int nY1 = nRowOffset; nY1 < HEIGHT; nY1 +=
  nSquareSize)
      {
        int nX2 = ( nX1 + nSquareSize ) % WIDTH;
        int nY2 = ( nY1 + nSquareSize ) % HEIGHT;

        int nI1 = this->nHeightField[nX1][nY1];
        int nI2 = this->nHeightField[nX2][nY1];
        int nI3 = this->nHeightField[nX1][nY2];
        int nI4 = this->nHeightField[nX2][nY2];

        int nP1 = ((nI1 * 9) + (nI2 * 3) + (nI3 * 3) + (nI4)) /
  16;
        int nP2 = ((nI1 * 3) + (nI2 * 9) + (nI3) + (nI4 * 3)) /
  16;
        int nP3 = ((nI1 * 3) + (nI2) + (nI3 * 9) + (nI4 * 3)) /
  16;
```

```
    int nP4 = ((nI1) + (nI2 * 3) + (nI3 * 3) + (nI4 * 9)) /
16;

    int nX3 = ( nX1 + nSquareSize / 4) % WIDTH;
    int nY3 = ( nY1 + nSquareSize / 4) % HEIGHT;
    nX2 = ( nX3 + nSquareSize / 2) % WIDTH;
    nY2 = ( nY3 + nSquareSize / 2) % HEIGHT;

    this->nHeightField[nX3][nY3] = nP1;
    this->nHeightField[nX2][nY3] = nP2;
    this->nHeightField[nX3][nY2] = nP3;
    this->nHeightField[nX2][nY2] = nP4;
    }
  }

  nRowOffset = nSquareSize / 4;
 }
}
```

The two conditions at the beginning of the function are necessary to ensure that the area being dealt with is a square of even sides. Of course, this will be caught at compile time, in this case as a possible error since the conditions are always false; the compiler will swap out the constants and issue a warning.

Otherwise, this routine is fairly straightforward. It simply calculates a weighted average based on four corners of a square and then divides the square into four, and sets the center point of each to be equal to the previously calculated averages

In Figure 6.5, the result can be seen. It is not exactly perfect, but the curves and outlines of the land masses can be clearly seen.

Luckily, we have a way of smoothing out the irregularities by using our neighbor-smoothing algorithm. The result, Figure 6.6, is far more aesthetically pleasing.

So, when treating a purely mathematical random heightfield, our optimum solution is a two-pass filter—once to establish the key land forms, and again to group like cell values in order to solidify the results. Note, of course, that for larger ($10,000 \times 10,000$) landscapes, this second pass might not strictly be necessary. Of course, the additional advantage of performing the neighbor-smoothing pass is that it maps around the torus in a way that quadrant smoothing does not.

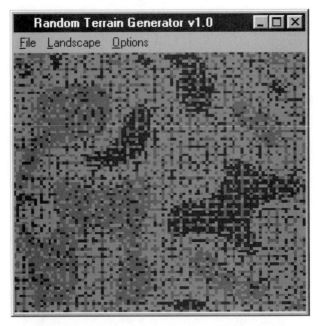

FIGURE 6.5 Raw quadrant-smoothed, random heightfield.

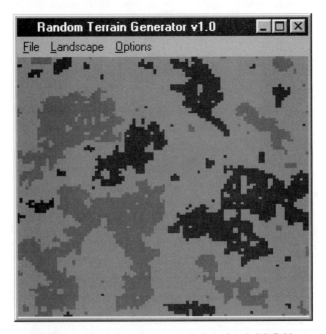

FIGURE 6.6 Treated quadrant-smoothed, random heightfield.

RANDOM TILE SMOOTHING

By way of a variation on neighbor smoothing, it might be nice to avoid the regularity with which we examine the heightfield. We have already noted that working from top left to bottom right might lead to some degree of favoritism toward values that are encountered first.

One easy way to get around this is to randomly attack the heightfield until all possible values have been hit at least once. There will be a degree of waste in this approach. More precisely, there is no easy way to ensure that, given a random sequence of cell locations, we do not hit many of them more than once.

CODE SAMPLE 6.9 Random tile smoothing.

```
.

.

.

  nHits = 0;

  while (nHits < (WIDTH * HEIGHT))
  {
    x = rand() % WIDTH;
    y = rand() % HEIGHT;

    this->nHeightField[x][y] = (int)this-
  >GetAverageNeighborValue(x,y);
    nHits++;
  }

.

.

.
```

This simple implementation can be seen above in Code Sample 6.9; no effort has been made to ensure that we either managed to actually sample the entire grid or prevented oversampling of certain areas of the grid. The effect, however, is not displeasing, as can be seen in Figure 6.7.

Code Sample 6.9 is the core of the algorithm included as part of the cTerrainGenerator class. We shall be extending the core algorithm as we proceed through the rest of this chapter. Therefore, it is worth noting

FIGURE 6.7 Random tile smoothing.

that we have implemented a new method, namely `GetAverageNeigh-borValue(x,y)`, which returns the average height of the eight cells surrounding the cell at grid location `x,y`, and returns a value of type `double`. This new method simply reuses the code from Code Sample 6.7 and has been implemented for reasons of efficiency (not of coding, but of reuse).

There is, however, clearly something inherently amiss with Figure 6.7; it is still very grainy. The cell value groupings are not as well-established as when other algorithms have been used. Based on previous experimentation that revealed that the more times we apply a given algorithm, the more closely the cells will group, we can augment the core algorithm presented in Code Sample 6.9 with a counter that ensures that we apply the core algorithm a certain number of times. The result, using a repetition factor of 6, can be seen in Figure 6.8.

While the landscape in Figure 6.8 is reasonable, it still lacks the touches of imperfection that make up a realistic landscape map. To improve on this aspect, while retaining the general patterns behind the landscape, we can modify our neighbor-averaging routine to choose which neighbors to average at random.

FIGURE 6.8 Random tile smoothing with a repetition factor of 6.

CODE SAMPLE 6.10 Random neighbor averaging.

```
double cTerrainGenerator::GetRandomAverageNeighborValue(int x,
   int y)
{
  int nTotal, nCount;
  int nXDiff, nYDiff;

  nTotal = 0;

  for (nCount = 0; nCount < 8; nCount++)
  {
    nXDiff = rand() % 3;
    if (nXDiff == 2) nXDiff = -1;

    nYDiff = rand() % 3;
    if (nYDiff == 2) nYDiff = -1;

    nTotal += this->GetNeighborValue( x, y,  nXDiff, nYDiff);
  }
```

```
return (double)nTotal / 8.0;
}
```

Code Sample 6.10 implements a possible algorithm for averaging a cell's neighbors on a random basis. It can be used in place of the standard averaging routine in Code Sample 6.9 above. Before proceeding, it might be useful to revisit Figure 6.8, which used the standard neighbor-averaging routine.

Comparing the landscapes in Figures 6.8 and 6.9, it is clear that Figure 6.9 is the most realistic because of the intricate blemishes that make up the feature's edges. It is slightly more detailed; the landscape in Figure 6.8 is a little too perfect to be real, with smooth, curving edges that do not seem to meander as much.

To recap, the final algorithm presented here is doubly random. Not only are random cells chosen with which to perform the core sampling operation, but the sampling itself is based on selecting neighbors at random. In both cases, there is the possibility that cells will remain that are not chosen by the selection algorithms, or that some cells will be chosen many times.

FIGURE 6.9 Random neighbor tile smoothing with a repetition factor of 6.

CONCLUSION

Random number generators are fascinating tools that can be used for a variety of tasks, and using them to generate maps, terrains, and landscapes are the most versatile examples of their use. Readers of *Infinite Game Universe: Mathematical Techniques* will know that the feature which makes them so useful is their repeatability. Every landscape that we have created in this chapter can be recreated simply by using the same seed (starting value) and algorithm.

This may seem obvious, but it also means that if we generate thousands of different objects (e.g., planets) using a given starting value, then we can also regenerate the exact same set of objects as many times as needed, and we only need to store one number, and the (very simple) number generating algorithms.

By themselves, though, random numbers are chaotic by nature. This means that we need to treat the sequences of numbers that we use and remove a certain proportion of this chaos so that a pattern emerges. This can even be done in a random fashion so that the end result, while having a discernable shape, also has a random form. The combination of techniques produces fairly realistic landscapes.

One final word on smoothed random landscaping and the way it can be used: It is appropriate to use the techniques either in the design stages to produce a data set that can be loaded (via some kind of compression, of course) at game time, or we can generate the landscapes on the fly. As in many cases, it is left to the game developer to decide which usage is most appropriate to both the game and play environment (platform).

FAULTLINE & MIDPOINT-DISPLACED LANDSCAPES

INTRODUCTION

Previously, we have detailed landscaping algorithms in which no attempt has been made to mimic the way in which landscapes can be formed naturally. Clever mathematics is almost never a substitute for modeling or simulation of a naturally-occurring phenomenon.

When a geologically active landscape actually forms, much hinges on the existence of *faultlines,* or areas where two land masses rub together. Without going into too much detail, we can use the theory of faultlines to good effect when designing landscapes.

The principle is that we are not modeling the actual faultlines themselves, but we are simulating the effect of them, using randomly placed lines to mimic the stress patterns on the landscape that result from nearby plate activity. We could model the plates themselves by splitting our heightfield into areas, but this is infinitely more complex.

STATIC FAULTLINING

Imagine for a moment a set of intersecting lines on a plane. Each line has a specific value, represented by a number. A high density of intersecting lines of similar values will yield a high concentration of like values. In Chapter 6, the basic algorithm for creating an aesthetically pleasing landscape from a random heightfield was based on a similar assumption.

Of course, if that was all there was to it, we would be left with a collection of lines, which is not aesthetically pleasing in the slightest. There is, therefore, one final step that we need to do, and it can be as simple as applying

either an averaging function to neighboring cells or a full-quadrant averaging, as was covered in Chapter 6. Either way, the heightfield will need to be smoothed so that it is no longer simply a collection of lines.

The simplest algorithm works as follows. Choose a point x,y that lies on an imaginary plane extending above and below the grid by a certain amount on the left-hand side. Next, choose a point a,b that lies on an imaginary plane on the right-hand side that extends past the top and bottom of the grid, as before, but such that the chosen point lies between the nearest horizontal plane and the opposite extreme of the vertical plane on the right-hand side. A line, of a given pixel value, can then be drawn from x,y to a,b and will inevitably pass through the grid. Figure 7.1 shows several possible such lines.

FIGURE 7.1 Intersecting faultlines.

Before considering the result of applying this algorithm (many times) to the basic heightfield, we need to take a look at the implementation side. The FaultLine function could be implemented, as in Code Sample 7.1.

CODE SAMPLE 7.1 The FaultLine function.

```
void FaultLine(int nHeightField[WIDTH][HEIGHT],
               int nMinHeight, int nMaxHeight)
{
    int x, y, a, b, height;
```

```
x = 0; a = WIDTH; // Left-hand or right-hand side

// Set the starting height to be somewhere between -HEIGHT
// and 2 x HEIGHT
y = rand() % (HEIGHT * 3);
y = y - HEIGHT;

// The ending height depends on the starting height such that
// it exists in either the top or bottom 2/3 HEIGHT
if (y < 0)
{
  b = rand() % (HEIGHT * 2);
}
else
{
  b = HEIGHT - (rand() % (HEIGHT * 2));
}

// Now pick a pixel height
height = (rand() % nMaxHeight) + nMinHeight;

 // And finally, draw the line
double start_x, start_y, end_x, end_y;

if (y < b)
{
  start_y = y; start_x = x;
  end_y = b;   end_x = a;
}
else
{
  start_y = b; start_x = a;
  end_y = y;   end_x = x;
}

// The above means that we are always traveling from low y to
// high y
// We need to know the delta x and delta y
double dx, dy;

dx = (end_x - start_x) / (end_y - start_y);
dy = (end_y - start_y) / (max(start_x, end_x) - min(start_x,
end_x));
```

```
while ( start_y <= end_y)
{
  // Is the current x,y point in the heightfield?
  x = (int) start_x;
  y = (int) start_y;

  if ((x >= 0) && (x <= WIDTH))
  {
    if ((y >= 0) && (y <= HEIGHT))
    {
      nHeightField[x][y] = height;
    }
  }

  start_x = start_x + dx;
  start_y = start_y + dy;
}
}
```

The result of this simple algorithm can be seen in Figures 7.2 through 7.4, where the effect of applying multiple faultlines and some quadrant smoothing shows the results possible using this technique.

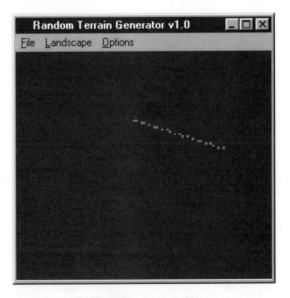

FIGURE 7.2 Single faultline.

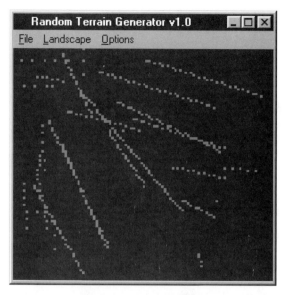

FIGURE 7.3 Multiple faultlines.

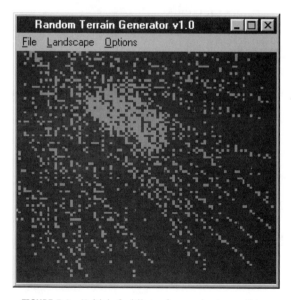

FIGURE 7.4 Multiple faultlines after quadrant smoothing.

This is a fairly fast technique, and the results are quite pleasing. It is not, however, the end of the story as far as faultlining goes. The algorithm presented here is called "static faultlining" because the height of the line is set

to the same value from start to end. In nature, this would probably not be the case; and if we look at it from a mathematical point of view, it cannot be the best approach.

WEIGHTED FAULTLINING

In fact, if we imagine a three-dimensional graph of the heightfield with the static faultlines drawn onto it, we can see that there are extremely sharp differences between neighboring cells. This is why the grid needs to be 'smoothed' afterward. We can reduce the amount of smoothing required by modifying the algorithm: We apply a multiplication of the existing cell value, starting with a nominal minimum and increasing up to a nominal maximum.

This is the goal of Code Sample 7.2, which shows the implementation of the `WeightedFaultLine` function. The code that *ON THE CD* is similar to the previous function in Code Sample 7.1 has been removed, and in the code on the CD-ROM (CTGEN.CPP), it has been placed in a set of utility functions.

CODE SAMPLE 7.2 The WeightedFaultLine function.

```
void WeightedFaultLine(int nHeightField[WIDTH][HEIGHT],
                int nMinHeight, int nMaxHeight, double dMult)
{
  int x, y, a, b, height;

  .
  .
  .

while ( start_y <= end_y )
  {
    // Is the current x,y point in the heightfield?
    x = (int) start_x;
    y = (int) start_y;

    if ((x >= 0) && (x <= WIDTH))
    {
      if ((y >= 0) && (y <= HEIGHT))
      {
```

```
      // If the cell height is less than the minimum, set it
      // accordingly
      if (nHeightField[x][y] < nMinHeight)
      {
        nHeightField[x][y] = nMinHeight;
      }
      else
      {
        // Multiply the existing value
        nHeightField[x][y] = (int)((double)nHeightField[x][y]
  * dMult;
        if (nHeightField[x][y] > nMaxHeight)
          nHeightField[x][y] = nMaxHeight;
      }
    }
  }
  start_x = start_x + dx;
  start_y = start_y + dy;
  }
}
```

Various values can be used for dMult, usually somewhere between 1.05 and 1.25 will work well; if it is too high, then strange effects can occur, such as sliced mountain tops. Figures 7.5 to 7.7 show the result of this new fault-lining routine.

Following this theory, we can apply many variations, such as incorporating a cosine wave into the line so that natural hills are formed. Of course, we can even apply the multiplier based on a cosine wave, as well, so that a naturally undulating landscape can be produced. The final step will always be to pass one of the smoothing filters over the grid afterward, just to ensure that there are not too many spikes or troughs.

FAULTLINE SHADING

As a final addendum to the theory of faultlining, there is a technique that is fairly processor-intensive, and which is probably not appropriate for real-time terrain generation. But this technique could possibly be put to good use for regenerated landscapes stored using one of the RLE (Run Length Encoded) storage style techniques from Chapter 1 of the book.

FIGURE 7.5 Single weighted faultline.

FIGURE 7.6 Multiple weighted faultlines.

The theory begins similar to our faultlines above; namely, a line is drawn from *x,y* to *a,b,* except that this time, it is not really drawn as such, just retained in memory. For each point that lies on a given side of the line (either

FIGURE 7.7 Multiple weighted faultlines after quadrant smoothing.

$\max(y,b)$ to HEIGHT or $\min(y,b)$ to 0), we decrease it by a given value, while keeping it above zero.

Before rushing off to implement the algorithm described here, there are a few points to watch for. First, the entire grid should really be set to 100 (if a percentage-based heightfield is being used) prior to drawing the first line.

Second, this technique was presented by Jason Shankel in *Game Programming Gems* (Charles River Media, 2000), and he notes that rather than just applying the same value each time for decreasing the cell values, we should instead use a formula:

$$\text{dHeight}_i = \text{dHeight}_0 + (i/n) * (\text{dHeight}_n - \text{dHeight}_0)$$

This gives a height for iteration i that will decrease linearly but will never reach zero. Actually implementing the algorithm in code is left as an exercise for the reader, but Code Sample 7.3 might be of some help.

CODE SAMPLE 7.3 Very simple filling algorithm.

```
void FillFromPoint(int x, int y, int ** oHeightField,
                   int value, int width, int height, side)
{
```

```
int nY;
if (side == 0) // Above (i.e., tending toward zero)
{
  for (nY = y; y > 0; y++)
  {
    oHeightField[x][nY] = oHeightField[x][nY] - value;
  }
}

if (side == 1) // Below (i.e., tending toward height)
{
  for (nY = y; y < height; y-)
  {
    oHeightField[x][nY] = oHeightField[x][nY] - value;
  }
}
}
```

The code above will fill above or below a point x,y by subtracting value from the cell value that is already there. It is probably not the best, most efficient, or neatest of implementations; but it does work.

Once the fill algorithm is implemented, results such as those seen in Figure 7.8 are possible.

The one problem to note is that the result is quite blocky and precise, especially at very high resolutions. Color shading can help to a certain extent, as can a certain amount of quadrant smoothing, or even erosion (see Chapter 10). In the end, the choice will be up to the programmer and will

FIGURE 7.8 Faultline shaded landscape.

depend largely on the algorithm's intended use. Some applications might be too processor-intensive to do any post-processing on the heightfield, especially if used in a real-time situation.

APPLYING TILING TECHNIQUES

As an alternative to actually post-processing the heightfield to blur the crisp edges, we can implement the game universe as a 'tile-based world.' This is a topic that will surface again and again, and revolves around using each value in the heightfield as a reference to a tile—a tile being either a graphically displayed object or a base upon which a graphically displayed object can be built.

If a tile is displayed, then it hides the fact that two cells of different colors lie next to each other (especially if the tile is used as a base), and the exact nature (color or shade) has changed subtly depending on whether the pixel to be displayed is closer to one side (tile) or the other. In this way, shading can be set up so that the difference is not so marked.

WIRE-FRAME LANDSCAPES

In addition to tiling, the heightfield can also be used as a basis for displaying a wire frame onto which colored shading can be applied. While this falls outside the scope of this chapter, it is easy to imagine how each point in the heightfield grid can be translated into an elevation on the heightfield as drawn on the screen.

Again, this type of technique can be used to remove the shock associated with a sudden height difference between two adjacent grid points.

MIDPOINT DISPLACEMENT

The theory behind midpoint displacement is very simple, and as the name implies, it simply requires taking the middle point of a line and pushing it either up or down. It is easiest to think of this in two-dimensional terms, and it is here that we shall begin to examine how it works in practice. If we assume, for the time being, that we are writing a sideways-scrolling game, such as the 1980s hit *Defender* (Atari), we can see the effect that we are trying to achieve.

As can be seen from Figure 7.9, it is a very simple line-based rendering technique. The best way to store the data for such a rendering is

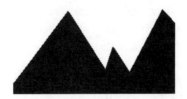

FIGURE 7.9 Simple 2D mountain range.

probably to store a simple array of height values. These height values will start off set to zero, and we will model the landscape step by step. Our model will largely depend on the required resolution and how many height values there are in the array. For example, if we wish to have a landscape that is four times our screen width, and if we wish to have a resolution of one pixel, we need to store 2560 values (assuming a screen width of 640 pixels).

If we look closely at a game like *Defender*, we note that there are probably only about five or six peaks per screen, so we can probably get away with a resolution of 128 pixels (five 'peaks' per screen), and hence store only 20 individual values. Having decided upon our representation, we can begin to populate the array with midpoint displaced height values.

CODE SAMPLE 7.4 Simple 2D point displacement.

```
void PointDisplace( int * oHeightArray, int nRepetitions )
{
  srand(time(null));  // Reset the pseudorandom number
                      // generator
  for (int n = 0; n < nRepetitions; n++)
  {
    for (int x = 0; x < sizeof(oHeightArray) / sizeof(int);
  x++)
    {
      oHeightArray[x] = oHeightArray[x] + (rand() % 10);
    }
  }
}
```

As can be seen from Code Sample 7.4, there are a number of decisions that have to be made regarding the parameters we want to apply to the al-

gorithm. First, the amount by which we wish to displace each point is quite important; the amount chosen here is arbitrarily set to 10.

Another important factor is the effect that the displacement is going to have on each point indirectly. This is not addressed in the above algorithm, hence the name of the function—PointDisplace. The next step, Mid-PointDisplace, needs to ensure that for each point that is affected, we take proper care to modify the intermediate points also.

The transition from point-displaced to midpoint-displaced landscapes is implemented in Code Sample 7.5, which defines the MidPointDisplace function.

CODE SAMPLE 7.5 2D midpoint displacement.

```
void MidPointDisplace( int * oHeightArray )
{
  int nIteration = (sizeof(oHeightArray) / sizeof(int)) / 2;

  while (nIteration > 0)
  {
    // nDiv is the current midpoint, and as such we need to
    // calculate the influence from nDiv - nIteration to nDiv +
    // (nIteration - 1), as well as the individual cell
    // at nDiv, which we'll do first.

    int nDiv = nIteration; // Start in the middle of the first
                           // section

    while (nDiv < sizeof(oHeightArray) / sizeof(int))
    {
      int nValue = oHeightArray[nDiv] + (rand() % 10);

      double dLeftHandGradient, dRightHandGradient;

      dLeftHandGradient =
        (oHeightArray[nDiv] - oHeightArray[nDiv - nIteration]) /
      nIteration;

      dRightHandGradient =
        (oHeightArray[nDiv - nIteration - 1] -
      oHeightArray[nDiv])
            / nIteration;
```

```
    // Now go from left to right, adjusting the height values
    // according to the gradient

    for (int nLeft = nDiv - nIteration; nLeft < nDiv;
  nLeft++)
      {
        oHeightArray[nLeft] =
          oHeightArray[nLeft] + (int) (dLeftHandGradient *
  (double) nLeft);
      }

    for (int nRight = nDiv + 1; nRight < nDiv + nIteration;
  nRight++)
      {
        oHeightArray[nRight] =
          oHeightArray[nRight] + (int) (dRightHandGradient *
  (double) nRight);
      }

    // Set up nDiv for the next iteration
    nDiv = nDiv + nIteration;
    }
    nIteration = nIteration / 2;
  }
}
```

In terms of actually using these algorithms, there are, as always, a few points to note, the first being that while point displacement can be done for an unlimited number of values on the fly, the midpoint displacement algorithm requires that the entire array is populated ahead of time. Incidentally, if the value used (10) for modifying the array is not high enough, multiple passes can be applied or the value increased.

The images in Figure 7.10 show four passes of the MidPointDisplace algorithm as applied to a terrain 240 pixels wide with a resolution of 4 pixels per peak, which yields an array of 60 values.

Having seen the two-dimensional effect, it is now time to look at how various three-dimensional variants can be implemented.

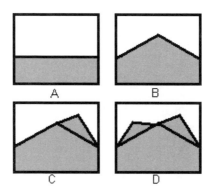

FIGURE 7.10 Multiple passes of midpoint displacement.

QUADRANT POINT DISPLACEMENT

The three-dimensional equivalent of the single-line midpoint displacement seen above is rather like building a pyramid in a desert. The idea is to split a square (rather than a line) into quadrants (instead of halves), and push up the center point of the quadrant. Next, we split the quadrant into quadrants, and do the same again.

Once we arrive at a single point (or a quadrant with a side equal to one unit) we can stop, since it is not possible to subdivide any further. Of course, depending on the resolution of the screen, this approach can lead to a slightly blocky landscape. Code Sample 7.6 shows how this can be implemented.

CODE SAMPLE 7.6 Three-dimensional midpoint displacement.

```
void 3DMidPointDisplace( int * oHeightArray, int nWidth, int
  nHeight,
                        int nMin, int nMax )
{
  int x1, y1, x4, y4;  // Top left and bottom right
  int width;           // Current width
  int height;          // Current height
  int value;

  width = nWidth / 4;
  height = nHeight / 4;
```

```
do
{
  for (y1 = height; y1 < nHeight; y1 = y1 + (height * 3))
  {
    for (x1 = width; x1 < nWidth; x1 = x1 + (width * 3))
    {
      x4 = x1 + (width * 2);
      y4 = y1 + (height * 2);
      // Push up each corner by a random amount between nMin
      // and nMax
      value = (rand() % (nMax - nMin)) + nMin;
      oHeightArray[x1][y1] =
        (oHeightArray[x1][y1] + value) % nMax;
      oHeightArray[x4][y1] =
        (oHeightArray[x4][y1] + value) % nMax;
      oHeightArray[x1][y4] =
        (oHeightArray[x1][y4] + value) % nMax;
      oHeightArray[x4][y4] =
        (oHeightArray[x4][y4] + value) % nMax;
    }
  }
  width = width / 2;
  height = height / 2;
} while (width > 1 && height > 1);
}
```

This implementation leads to landscapes that can be seen in Figures 7.11a through 7.11d, which show the landscape in question in various stages of displacement. It should be noted that the displacement is additive; that is, it is not absolute, which leads to the slightly unreal peaks that can be seen from time to time appearing on the surface.

Conclusion

In this chapter, we have seen plenty of techniques for building landscapes that are not as artificial as those in Chapter 6; but they are still not quite natural. They are based on the examination of the natural world, but are not as realistic as an actual simulation of the effects that they are trying to replicate. That, of course, would be far too processor intensive for a game.

FIGURES 7.11a–7.11d Multiple passes of 3D midpoint displacement.

Chapter 8 will take us one step closer to actually implementing quite realistic effects that are very closely modeled on the way in which a planet and its associated features are molded.

BALLISTIC DEFORMATION & PARTICLE DEPOSITION

INTRODUCTION

As we have seen in Chapters 6 and 7, the best way to generate a believable landscape is often to try and mimic nature in some way. It is now worth pointing out that almost every algorithm in this part of the book has its roots in the study of naturally occurring phenomena.

In fact, the Earth itself has been landscaped over the years, albeit gradually, by forces that gave rise to the faultline and midpoint displacement algorithms (see Chapter 7). If we were to apply these algorithms in conjunction with those about to be presented, we might come close to generating planets in our games that follow the same basic principles as those in the real world.

In a very real way, ballistic deformation and particle deposition are two sides of the same coin. Ballistic deformation relies on a series of impacts, while particle deposition relies on a build-up of impacted matter. Before we go on to describe the algorithms themselves, we should try to understand their natural counterparts.

Imagine that a planet has just been formed. It is a ball of cooling rock, almost completely featureless, and hurtling through a universe with very little atmosphere. It is bound to be struck by meteorites or other pieces of natural space debris. These impacts will, of course, make holes (craters) in the planet. Not only that, but the impacting object is likely to throw up debris of its own, which will likely come to settle on the planet's surface.

So, there are two distinct forces at work here: one that makes holes and another that builds piles of particles. Together, these forces form the lakes, seas, and mountains that eventually become features of the planet.

THE SIMPLE HEIGHTFIELD

Putting aside the colorful and exciting image of an infant planet being formed by the powerful forces of the real universe, programming these effects begins with deciding how to represent them in the digital memory of the computer. Put another way; there is a difference between what the player sees and the way this display is represented in places that the player cannot see. This slightly convoluted sentence simply means that we shall be ignoring how the image is eventually rendered on the screen. Instead, we will explain how the abstraction that stores the information needed to display the image works.

The technique chosen for this particular exercise is the heightfield. As described in Chapter 6, a heightfield is a collection of cells that each have a value identified with them. The value traditionally indicates a height above an arbitrary level; but it can, of course, be used for anything the developer wishes.

Looked at in an abstract way, a heightfield represents a three-dimensional view of a two-dimensional object. This implies a grid of a given width and height, but could in fact be a collection of any interconnecting shapes, such as hexagons, squares, or even triangles. Shapes other than squares pose difficulties in terms of referencing adjacent cells in the grid, as we shall see.

For the simplest of implementations, a heightfield can just be represented by a data-type array deemed most appropriate by the developer. Here, however, we want to provide as much functionality as possible and create a reusable object suitable for a variety of situations. Thus, the code in Code Sample 8.1 shows the definition for such a class: the CHeight-Field. We shall be extending the functionality of this object as we proceed through this book.

CODE SAMPLE 8.1 The CHeightField Class Definition

```
struct SCell
{
  int nValue;
};

class CHeightField
{
  private:

    SCell * oHeightField;  // The actual data
```

```
int     nHeight;        // Heightfield height (rows)
int     nWidth;         // Heightfield width (cols)

public:

    // Constructor and destructor

    CHeightField(int nWidth, int nHeight);
    ~CHeightField();

    // Inline member access functions

    int GetWidth()  { return this->nWidth;  }
    int GetHeight() { return this->nHeight; }

    // Generic data-access function

    SCell * GetCell(int x, int y);

    // Specific value access : add more functions as more
    // features are added to the generic struct SCell data type

    int  GetCellValue(int x, int y);
    void SetCellValue(int x, int y, int v);

};
```

Note that in Code Sample 8.1, each cell is represented by a struct. This has been chosen as the implementation method because it allows for more-efficient extension to the base object structure. In short, it enables us to implement the various initialization and access functions required, as defined in Code Sample 8.1, without worrying about the exact contents of the SCell data object. Code Sample 8.2 shows how these access and initialization functions could be implemented.

CODE SAMPLE 8.2 The CHeightField class implementation.

```
#include <stdlib.h> // Required for memory-access functions.

#include "CHeightField.h"
```

```
// Constructor — nWidth and nHeight must be greater than 0.

CHeightField::CHeightField(int nWidth, int nHeight)
{
  if ((nWidth <= 0) || (nHeight <= 0)) return;   // Do nothing

  // Attempt to allocate the memory required
  this->oHeightField = (SCell *) malloc(sizeof(SCell) * (nWidth
  * nHeight));
  if (this->oHeightField == NULL)
  {
    this->nWidth  = -1;   // If the allocation failed, set the
    this->nHeight = -1;   // width and height members to —1.
    return;
  }
  this->nWidth  = nWidth;
  this->nHeight = nHeight;
}

CHeightField::~CHeightField()
{
  // If memory has been allocated, free it up.
  if (this->oHeightField != NULL) free (this->oHeightField);
}

// Generic cell-access function

SCell * CHeightField::GetCell(int x, int y)
{
  if (this->oHeightField == NULL) return NULL;

  // Bounds check
  if ((x > this->nWidth) || (y >= this->nHeight)) return NULL;
  if ((x < 0) || (y < 0)) return NULL;

  // The memory that represents the heightfield can be
  considered to be
  // a contiguous lump, width * height cells in dimension, but
  as a
  // one-dimensional array.

  return this->oHeightField[x +(this->nWidth * y)];
}
```

```
// Specific value access : add more functions as more features
// are added to the generic struct SCell data type.

int CHeightField::GetCellValue(int x, int y)
{
  SCell * oCell;

  oCell = this->GetCell(x,y);
  if (oCell == NULL) return -1;

  return oCell->nValue;
}

void CHeightField::SetCellValue(int x, int y, int v)
{
  SCell * oCell;

  oCell = this->GetCell(x,y);
  if (oCell == NULL) return;

  oCell->nValue = v;
}
```

Depending on personal taste, developers might decide that a `class` might be better than a `struct` for the cell object implementation. This makes the initialization of the `oHeightField` object a little more complex and would require that a linked-list implementation be applied for efficiency and ease of use more than for anything else. It would, however, increase the transparency of the objects involved—a useful trait when considering reading from and writing to files.

Using a `CHeightField` object is an easy proposition. In Code Sample 8.3, a bare minimum for the instantiation and release of such an object is shown.

CODE SAMPLE 8.3 Using the CHeightField class.

```
#include "CHeightField.h"

CHeightField * oHeightField;
.
.
.
```

```
oHeightField = new CHeightField(10,10);   // For example
  .
  .
  .
delete oHeightField;   // Release the object and free associated
                       // memory.
```

ON THE CD

Of course, this is the bare minimum implementation for such an object. We do not have any utility functions for performing mass updates to cells, for example. For now, the bare minimum is enough; but we shall be adding functionality to the CHeightField class as we progress. (The full code is, of course, included on this book's companion CD-ROM.)

BALLISTIC DEFORMATION

We have already discussed ballistic deformation theory in slightly colorful terms. The basic principle is that an object hits a plain and makes a crater. There are a number of variables that have an impact on the resulting crater, such as the size of object, its inbound trajectory, the impact velocity, and the toughness of the rock that makes up the plain that the object strikes.

The scientists among you must forgive the oversimplification that is about to take place, but in our model, the size of object will translate into the area affected by the initial impact. The velocity will indicate the depth of impact crater, and the toughness of rock shall represent a limit to the effect of the impact over a larger area. For now, we shall concentrate on the first two of these basic variables.

In developing this simple model, there are a number of steps that must be taken, some of which are common to all uses of the CHeightField object, and which extend CHeightField functionality. The steps we need to take are:

1. Create the CHeightField object (common).
2. Set all cells to a given, initial value (common).
3. Create an impact crater of a given size and depth.
4. Repeat Step 3 as many times as required.

Of course, Step 3 could have some substeps that also make use of common functionality, but these will be tackled as we come to them. We have already seen how to create a `CHeightField` object, so let us jump straight in at Step 2. In fact, the function `CHeightField::Initialize` is very simple, as can be seen in Code Sample 8.4. The only comment that need be made is that if additional values are added to the `SCell` data storage object, then additional initialization will need to be added to the `Initialize` function.

CODE SAMPLE 8.4 Initializing the oHeightField.

```
#include "CHeightField.h"

void CHeightField::Initialise(int nValue)
{
  int x, y; // The cell position

  // Basic checking for correct construction
  if ((this->nWidth <= 0) || (this->nHeight <= 0)) return;

  for (y = 0; y < this->nHeight; y++)
  {
    for (x = 0; x < this->nWidth; x++)
    {
      this->SetCellValue(x,y,nValue);
    }
  }
}
```

So, now that we have the code to initialize the heightfield to a given value, we can tackle the next step—creating an impact crater. There is a quick way and a long way to implement this. The quick way is to create a filled square of a given dimension and value on the heightfield, and call it a crater. Done many times, this will yield a rather blocky terrain, as shown in Figure 8.1, which is a screen shot of one of the many possible runs of the HeightField Viewer software, which appears on the CD-ROM.

The code for this admittedly rather basic attempt at modeling an impact crater is included here for completeness, but it will only be of interest as a stepping stone toward more advanced techniques. This sort of modeling might, however, be useful in

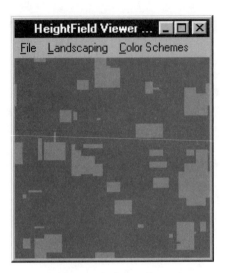

FIGURE 8.1 Blocky impact terrain.

processor-limited environments (see Chapter 24). Thus, Code Sample 8.5 (taken from the companion CD-ROM) implements this very simple approach.

CODE SAMPLE 8.5 Simple square craters.

```
#include "CHeightField.h"

void CreateSquareImpactCrater(int left, int top,
                              int size, int depth,
                              CheightField * oHeightField)
{
  int width  = oHeightField->GetWidth();
  int height = oHeightField->GetHeight();
  int x,y, value;

  for (y = top; y < top + size; y++)
  {
    for (x = left; x < left + size; x++)
    {
      // Wrap-around (pretend it's a donut ring)
      value = oHeightField->GetCellValue(
        x % oHeightField->GetWidth(),
```

```
          y % oHeightField->GetHeight()) — depth;

        oHeightField->SetCellValue(
          x % oHeightField->GetWidth(),
          y % oHeightField->GetHeight(),value);
      }
    }
}
```

While this produces results that are fairly basic, the process of setting a specific value to each cell will be the same no matter which algorithm is used. It is important to note that the cell value is not set to a specific value; rather, it is set to a value that takes into account the existing value of the cell. This means that a cumulative effect will ensue with some cells being 'hit' repeatedly, making them deeper and deeper.

Of course, as can be seen in Figure 8.2, a fairly high level of resolution can be achieved by setting the maximum impact size to be very small (of the order of one tenth of the heightfield width) and using a large number of impacts (somewhere in the region of width * height objects). This suffers from two drawbacks. First, this approach will take a long time to execute for large heightfields; and second, it lacks the rounded corners associated with the naturally occurring equivalent.

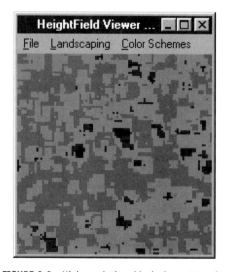

FIGURE 8.2 High-resolution, blocky impact terrain.

Of course, one huge advantage is that this approach does not require floating-point arithmetic and is almost fast enough to be done 'on the fly'; small, medium-resolution terrains can certainly be generated in this way during the play session. Larger, high-resolution terrains will, of course, take longer to generate.

Part of the 'rounded' effect that we spoke of as lacking in this approach can be obtained by making several less-deep craters near a deep crater. If, for example, a number of smaller craters are made on the edge of a larger one, it will break up the regularity of the straight edges and elicit a more random-edged, natural-looking shape.

If we then repeat the exercise with yet smaller craters around the edges of the medium-size ones, this effect will begin to look akin to the rounded edges we see in nature. Fractally speaking, we could continue in this way for some time, reaching ever higher levels of resolution with smaller and smaller craters, until we reached a point where each crater is 1×1 pixel in dimension. At this point, we can go no further, and we have taken a rather long time to generate the terrain.

KNOCK-ON EFFECTS

Valid though the ever-decreasing square crater approach described above would be, there is a better way to achieve rounded edges and more-realistic terrains, and that is to use circular craters. This might not seem like such a big deal, a few twists will be added along the way. However, let us first deal with the core algorithm that employs a cheap way to draw a filled circle.

The theory is rather simple. Given a bounding square of side x, we would like to draw a filled circle such that the edges touch the sides of the square (see Figure 8.3).

To draw a filled square, we would need to set each of the individual cells to a given value; to draw a filled circle, we need to adapt this so that we first

FIGURE 8.3 Circle in a square.

test whether the cell in question falls within the bounds of the proposed circle. Geometry maintains that the extent of a circle's edge comprises those cells that are all a given distance from the center of the circle. Pythagoras' theorem gives us the following formula for calculating the length of a line between two arbitrary points:

$$D = \sqrt{dx^2 + dy^2}$$

The above simply states that the distance is equal to the square root of the sum of the change in the horizontal axis, squared, and the change in the vertical axis, squared. It so happens that if we examine each cell within a square and find its distance from the center of that square, then all the cells that would fall within a filled circle with a radius of half the length of the side of that square are no further away from the center than the radius of the circle. Thus, if we calculate the distance from the center of the circle to the cell in question, we can say that it falls within the circle if that distance is less than or equal to half of the length of one side of the square.

The above is simply a long explanation for Code Sample 8.6; it is a lot more difficult to explain than it is to apply.

CODE SAMPLE 8.6 The DistanceBetween function.

```
#include <math.h>

#include "CHeightField.h"

double CHeightField::DistanceBetween(double x1, double y1,
                                     double x2, double y2)
{
  double dx;
  double dy;

  if (x1 > x2) dx = x1 - x2; else dx = x2 - x1;
  if (y1 > y2) dy = y1 - y2; else dy = y2 - y1;

  return sqrt((dx * dx) + (dy * dy));
}
```

Therefore, this function becomes part of the CHeightField core functionality and will be useful in a variety of situations. Notice, however, that

it does not handle wrapping around the heightfield, so the bounding box dimensions should be checked prior to entering a function that uses the above code.

This is exactly what the code for the `CreateCircularImpactCrater` function in Code Sample 8.7 is designed to do.

CODE SAMPLE 8.7 The CreateCircularImpactCrater function.

```
#include "CheightField.h"

void CreateCircularImpactCrater(int left, int top,
                                int size, int depth,
                                CHeightField * oHeightField)
{
  int width  = oHeightField->GetWidth();
  int height = oHeightField->GetHeight();
  int x,y, value;
  double radius, center_x, center_y;

  radius = (double) size / 2.0;
  center_x = (double)left + radius;
  center_y = (double)top + radius;

  // Check to see if the center is 'off the page'
  if ((center_x >= (double) width) || ((center_x < 0.0))
  return;
  if ((center_y >= (double) height) || ((center_y < 0.0))
  return;

  for (y = top; y < top + size; y++)
  {
    for (x = left; x < left + size; x++)
    {

      if (((x < width) && (x >= 0)) &&
        (y < height) && (y >= 0)))
      {
        if (oHeightField->DistanceBetween(
            (double)x, (double)y,
            center_x,  center_y) <= radius)
        {
          value = oHeightField->GetCellValue(x,y) - depth;
```

```
            oHeightField->SetCellValue(x,y,value);
        }
      }
    }
  }
}
```

This deals with the core of the problem. Remember, though, that a few twists were planned for this approach. The first deals with the fact that craters are never regular holes in the ground. Invariably, the point of impact is deeper than the rest of the crater, and the end result is more like a shallow cone in the ground than a single hole. Furthermore, it is fairly unlikely that the ripple effect that caused a crater is going to be applied in a uniform manner, so some variations should be introduced. Finally, it is equally unlikely that the force of the ripple effect will affect each particle in its path in the same way, so variations per cell should also be introduced.

The last of these twists requires only that we alter Code Sample 8.7 a little and introduce a variation—we will select a random value somewhere between the current value of the cell and the required depth. Code Sample 8.8 shows this simple method at work. Incidentally, the random number generator used here is the standard ANSI pseudorandom number generator provided in the C++ `stdlib.h` library. It should be seeded with a given number using the `srand(n)` function, where *n* is the seed used to generate the number sequence. If using these terrain generation techniques in real game time, it is important to remember that the same seed will create the same terrain every time, which is useful for level building.

CODE SAMPLE 8.8 The Revised CreateCircularImpactCrater function.

```
  .
  .
  .

          value = oHeightField->GetCellValue(x,y) — (rand() %
    depth);
          oHeightField->SetCellValue(x,y,value);
  .
  .
  .
```

The other two twists can be dealt with in one piece of code that calls the `CreateCircularImpactCrater` defined in Code Sample 8.7; it can be described as rendering a 'rippling out' from the center of the impact. Since this core algorithm takes into account the current state of each cell prior to setting a new value, the ripple can be performed in one of two ways: from the outside in, or from the inside out. Each will have a slightly different result, as can be seen in Figure 8.4, even when beginning with the same seeded random number generator.

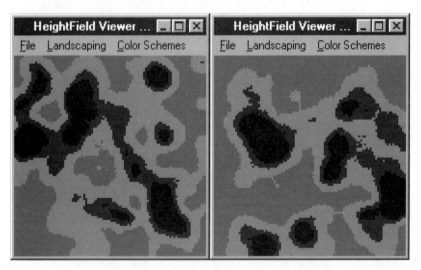

FIGURE 8.4 Inside-out versus outside-in crater creation.

In Code Sample 8.9, the code for the inside-out variation is provided; the outside-in implementation is left as an exercise for the reader.

CODE SAMPLE 8.9 The InsideOutCrater function.

```
Void InsideOutCrater(int x, int y, int extent, int depth,
                     CHeightField * oHeightField)
{
  int left, top, size, ripple_depth;

  size = rand() % (extent / 8);
  ripple_depth = depth;
```

```
  while (size < extent)
  {
    // Set up the top left of the crater bounding box
    left = x - size;
    top  = y - size;

    // Create the crater
    CreateCircularImpactCrater(left, top, size, ripple_depth,
                               oHeightField);

    // Alter the size, with reference to the maximum extent
    size = size + (rand() % (extent / 8));

    // Change the depth, with 0 being the minimum.
    // Negative values lead to mountains!
    ripple_depth = ripple_depth -
              (rand() % depth - ripple_depth);
    if (ripple_depth < 0) ripple_depth = 0;
  }
}
```

This brings us to the end of the methods used to create single circular craters. Of course, the reader can use these in any way they see fit, but the recommended approach is probably to 'bomb' an initially high terrain map initialized to a high value with craters of varying sizes and depths. Use as many as required to hit every single cell at least once, and the result should be fairly realistic.

FROM HOLES TO HILLS

One last aspect that can be implemented is to invert the craters so that they become hills. It is a simple matter and can be quite effective. The two approaches actually produce quite different landscapes, especially when viewed in three dimensions. The craters that are turned into mountains can tend to be quite spindly and pointed.

Of course this can be easily rectified by a minor enhancement to the above algorithm. In fact, all that is required is to create craters with a larger center. Care must be taken, though, to ensure that flat-top mountains do not become too numerous.

SIMPLE PARTICLE DEPOSITION

A better way of producing mountains is to use a technique known as "particle deposition." In nature, this can be likened to an impacting object (e.g., meteor or comet) that, upon hitting the planet, throws debris up into the air; the debris eventually settles back down to the planet surface and builds up there. This building up of particles creates mounds, hills, and finally mountains. The same phenomenon can be seen underwater.

In a two-dimensional situation, a collection of falling particles can be built up into a hill in the following way. Consider each block as a particle that falls from the sky. It travels toward a given point and lands. The particle might fall either to the left or the right a number of times before coming to rest. Each following particle might behave in the same way. Figure 8.5 shows a few stages in this building-up of a two-dimensional hill using particle deposition.

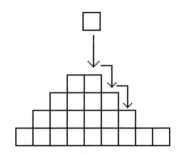

FIGURE 8.5 2D particle deposition.

Before we consider this further, a good exercise would be to model the two-dimensional particle deposition under discussion. The reader might find the following technique useful in a sideways-scrolling game; in essence, we are going to be using the same CHeightField object that we designed originally for top-down landscapes and adapt it for a sideways-on version.

A simple particle deposition algorithm for the sideways-on game is shown below in Code Sample 8.10, which embodies the TwoDParticleDeposition function. This takes a CHeight-Field object, blanks it out, and subjects it to extensive particle deposition. The result can be seen in Figure 8.6, which is the output from the Win32 software included on the companion CD-ROM.

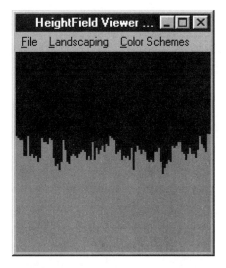

FIGURE 8.6 2D particle deposition landscape.

CODE SAMPLE 8.10 The core 2D particle deposition loop.

```
nCol = rand() % oHeightField->GetWidth();
// Drop the particle from row 0.
nRow = 0;
do
{
  // If we are already on the last row, stop here.
  if (nRow == oHeightField->GetHeight() - 1) break;
  // If there is nothing here, we drop straight down,
  // otherwise we need to make a decision to move left
  // or right...
  if (oHeightField->GetCellValue(nCol, nRow + 1) != -1)
  {
    // Left, right, or straight down?
    switch (rand() % 10)
    {
case 0 : nXDiff = -1; break;
case 1 : nXDiff =  1; break;
default : nXDiff =  0; break;
    }
    // If the new position is off-grid, wrap around
    nXDiff = nCol + nXDiff;
    if (nXDiff < 0) nXDiff = oHeightField->GetWidth() - 1;
```

```
    if (nXDiff >= oHeightField->GetWidth()) nXDiff = 0;
    // If that cell is full, we cannot go on
    if (oHeightField->GetCellValue(nXDiff, nRow + 1) != -1)
break;
    // Otherwise, we move to that cell
    nCol = nXDiff;
    }
  nRow++;
  } while (nRow < oHeightField->GetHeight());
oHeightField->SetCellValue(nCol,nRow,50);
```

Figure 8.6 might not look particularly convincing, but it makes for an effective, if slightly simple sideways-viewable mountain range. There are a few features of the code that are interesting to note. The core of the TwoD-ParticleDeposition function is reproduced in Code Sample 8.10.

The first point that the code shows is that in order to produce a landscape with a high level of variation, we need to specify that in 8 out of 10 cases, the particle does not fall farther than the point at which it finds itself. Of course, this approach tends to lead to quite 'spiky' landscapes, such as that in Figure 8.6, which is not ideal.

On the other hand, we can consider using this approach in conjunction with another algorithm that can offer a degree of resolution to an otherwise regular shape (such as a square) by introducing variable and unpredictable amounts of noise. Bearing this in mind, let us now turn to the three-dimensional counterpart, ThreeDParticleDeposition. Of course, it is not truly three dimensional in the top-down view that is implemented by the HeightField Viewer application on the CD-ROM, but it is a good starting point.

As in the two-dimensional version, applying the algorithm necessitates a decision to be made as to where the particle will fall next. However, in this case, we cannot simply let it rest with a static value; we need to assign a height value. This also means that it may be possible for particles to 'sink' into existing cells, increasing the height value of that cell.

So, we can begin with a heightfield of height zero (blue, in this case, indicating sea) and drop particles from an imaginary height (say 100), and allow them to fall until they come naturally to rest. It is this last part that is the most difficult to simulate. How does one decide when the particle is in its final resting position?

The answer in nature is that the particle will stop falling when it hits a flat surface—that is, one in which it is impossible to fall in any given direction

because there is no height difference between where it is and its surrounding terrain. In our simulation, this means that for a given cell, we should check to see where the 'cheapest' route lies and fall into that cell. Of course, should there be more than one possibility, a random decision must be made.

Furthermore, should the particle find itself in a position where the current height value of the cell that it inhabits is equal to or less than the lowest cell that surrounds it, it cannot fall any further, and must be at rest. These are the rules that we must play by, as they provide a basis for the model that parallels the real world and therefore will enable us to build realistic virtual counterparts.

The image in Figure 8.7 shows a typical terrain built by particle deposition. In fact, it is not nearly as spectacular as the one produced by ballistic deformation, since it tends to succumb to the same problems as the two-dimensional equivalent. This is partly due to the assignment of blue, green, and brown colors. Compare it to the grayscale version in Figure 8.8.

Particle deposition can be considered as a kind of landscape filter. In other words, this means that an additive effect can be applied to other (ballistic) techniques to introduce some random noise variation. This combination can be seen in Figures 8.9 (color) and 8.10 (grayscale).

So, now that we have seen the results, let us look at the source code that creates them. Code Sample 8.11 is the core of the algorithm; it chooses a random cell that is cheaper than the current one (not, as we said before, the

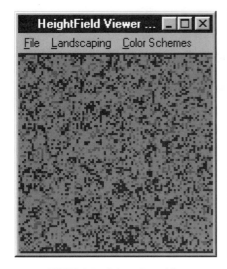

FIGURE 8.7 Color, 3D particle deposition landscape.

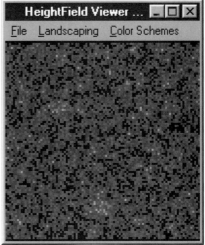

FIGURE 8.8 Grayscale, 3D particle deposition landscape.

FIGURE 8.9 Color, 3D combination landscape.

FIGURE 8.10 Grayscale, 3D combination landscape.

cheapest, although this could easily be worked into the code, but one that is cheaper). Experimentation will be the key to finding the exact mix that matches the requirements of the game designer.

CODE SAMPLE 8.11 The FindCheapestCell function.

```
int FindCheapestCell(int x, int y, CHeightField * oHeightField,
                     int &nDeltaX, int &nDeltaY)
{
  int nThisCellValue = oHeightField->GetCellValue(x,y);
  int nDX[8], nDY[8];

  // This is just housekeeping so that we can eventually test
  // for the cost of moving to each cell.
  int i;
  for (i = 0; i < 8; i++)
  {
    nDX[i] = 0;
    nDY[i] = 0;
  }
  // Fill out the array with the eight possible neighbor cell
  // offsets. There is probably a neater way to do this.
```

```
nDX[0] = -1; nDY[0] = -1;
nDX[1] =  0; nDY[1] = -1;
nDX[2] =  1; nDY[2] = -1;
nDX[3] = -1; nDY[3] =  0;
nDX[4] =  1; nDY[4] =  0;
nDX[5] = -1; nDY[5] =  1;
nDX[6] =  0; nDY[6] =  1;
nDX[7] =  1; nDY[7] =  1;

// Now we can actually work out the cost of each cell
int nCurrentCost, nNewX, nNewY;
for (i = 0; i < 8; i++)
{
 nNewX = x + nDX[i];
 nNewY = y + nDY[i];

 // Assume a donut — wrap around in each axis.
 if (nNewX > oHeightField->GetWidth()) nNewX = 0;
 if (nNewY > oHeightField->GetHeight()) nNewY = 0;
 if (nNewX < 0) nNewX = oHeightField->GetWidth();
 if (nNewY < 0) nNewY = oHeightField->GetHeight();

      // Get the cost of that cell, and use it if it's
      // cheaper.
 nCurrentCost = oHeightField->GetCellValue(nNewX, nNewY);
 if (nCurrentCost >= nThisCellValue)
 {
     nDX[i] = -1; nDY[i] = -1;
 }
 else
 {
     nDX[i] = nNewX;
     nDY[i] = nNewY;
 }
}
// Pick a starting direction at random.
int nStart, nSelected;
nStart = rand() % 8;
nSelected = nStart;
do
{
  if ((nDX[nSelected] != -1) && (nDY[nSelected] != -1))
```

```
   {
     nDeltaX = nDX[nSelected];
     nDeltaY = nDY[nSelected];
     return 0;
   }
   // Keep going around until we are back where we started.
   nSelected = (nSelected + 1) % 8;
 } while (nSelected != nStart);

 // There were no possible cells, so we have to end our search
 // here.
 return -1;
}
```

Using this function is a simple proposition, and Code Sample 8.12 shows how it can be done. In fact, only part of the code is shown, since the steps have to be repeated for as many particles as we need to simulate. The full code is on the companion CD-ROM as part of the HeightField Viewer application.

ON THE CD

CODE SAMPLE 8.12 Using the FindCheapestCell function.

```
     .
     .
     .

   // Pick a random starting point
   x = rand() % oHeightField->GetWidth();
   y = rand() % oHeightField->GetHeight();
   // Drop the particle
   while (FindCheapestCell(x,y,oHeightField,nDeltaX,nDeltaY)
   != -1)
   {
       x = nDeltaX;
       y = nDeltaY;
   }
   // We settle here
   nValue = oHeightField->GetCellValue(x,y);
   nValue = (nValue + (rand() % nImpact) + nImpact);
     .
     .
     .
```

This brings us to the end of our discussion of these two fascinating techniques. It is quite possible to tweak and adjust the algorithms for hours and see just what kinds of landscapes can be built. Naturally, deep water can be added, as can trees (darker green), mountain tops (with snow), and even climate variations where there is more snow at the poles and more brown plains at the equator. A hint for those who wish to extend the model in this way—use bands of differing height changes so that the poles are effectively higher than the rest of the globe. Then, use two heightfields, one with the true height and the other as a color map. This way, true 3D projections will work properly.

SIDEWAYS ON LANDSCAPES

Our final foray into physically simulated landscaping in this chapter deals with looking at landscapes in a sideways-on fashion. To date, we have looked only at top-down displays (with the exception of the rather simple two-dimensional particle deposition example above); we have neglected discussing the making of a sideways-scrolling game. For that matter, we have also neglected 3D landscape-based games; but we must learn to walk before we can run.

Sideways-scrolling games take a variety of different views of landscaping, ranging from simple line-based terrains (as in *Defender*) to more-complex terrains including all manners of different features (such as *Worms* or *Lemmings: Tribes*). Exactly how these were built is something of a mystery, but we can make some intelligent guesses as to what techniques might lie at the heart of the algorithms.

LINE-BASED TERRAINS

As the least assuming of the possibilities, line-based terrains tend to consist of nothing more than a line that zigzags up and down the screen as the player travels from left to right or from right to left. It is a contiguous entity that can be imagined as a line that loops around in a circle. All sideways-scrolling techniques have their root in this kind of landscape, so it is worth spending some time at conjuring up an image that will help clarify the subsequent examples.

Imagine two cylinders, one inside the other. The outside cylinder contains a hole in the front that functions as a window that looks in on the inside drum. If we paint a landscape on the outside surface of the inner drum, we can turn it while keeping the outer drum static. The landscape will then move before our eyes, but we will only be able to see one section

of landscape at a time. Spinning the inner cylinder to the right or left at different speeds will give the respective effects of traveling over the landscape.

With this in mind, let us consider how we might code such an effect, based on the assumption that we have a variety of libraries available to us for plotting lines on the computer screen. The important point is that we have a contiguous line of varying heights whose beginning and ending points are connected so that it wraps around.

Storing the information required to actually perform this needs nothing more complex than a single-dimension array of height values; that is, a heightfield with a single row. Populating this heightfield will create the landscape, and in the simplest form, we can simply use code similar to that in Code Sample 8.13.

CODE SAMPLE 8.13 Simple wrap-around array population.

```
    .

    .

    .

  nHeight = rand() % MAX_HEIGHT;

  for (n = 0; n < NumberOfPoints; n++)
  {
    switch (rand() % 3)
    {
      case 0 : nNewHeight = nHeight + (rand() % MAX_HEIGHT);
break;
      case 1 : break;  // Do nothing, height is level
      case 2 : nNewHeight = nHeight - (rand() % MAX_HEIGHT);
break;
    }
    nNewHeight = (nHeight + nNewHeight) / 2;
    nHeight = nNewHeight;
    LandscapeArray[n] = nHeight;
  }
    .

    .

    .
```

The code itself is simple and reasonably effective, but probably would not win any prizes for realism. We shall cover more-realistic techniques for

sideways-scrolling landscapes in Chapter 10, but it is important to begin with the simplest possible approach.

There are a few points to note. First, the code in Code Sample 8.13 is only really useful for circumstances requiring a small number of hills. Increasing the number of elements will produce quite spiky and unrealistic landscapes. Second, there will be a fair amount of flat lines in the landscape, which might or might not suit the game designer. Last, Code Sample 8.13 has the advantage of speed. The array can be built very quickly, and if a suitable pseudorandom number generator is used, a variety of repeatable landscapes can be created, perhaps with varying numbers of hills and less flatness.

Using the array is also a simple proposition, but we shall tackle it in stages. The first stage is being able to depict each possible section of the landscape, one after the other. This requires that we know where the landscape window starts, where it ends, and what happens when we move it. Barring the scrolling that will inevitably need to be performed to move around the landscape, the algorithm in Code Sample 8.14 shows how each possible window can be drawn.

CODE SAMPLE 8.14 The DrawLandscapeWindow algorithm.

```
void DrawLandscapeWindow( int nStart, int nWidth, int *
  nLandscape )
{
  int nHeight, nCell;
  nHeight = nLandscape[nStart];

  MoveTo(0, nHeight);
  // Set up the drawing to begin from x, y

  nCell = nStart;
  while (nCell < nStart + nWidth)
  {
    nCell++;
    nHeight = nLandscape[nCell];
    LineTo( nCell * (SCREEN_WIDTH / nWidth), nHeight);
  // Draw the line
  }
}
```

In Code Sample 8.14, there are a number of assumed library functions that are loosely based on the way in which old pen-based drawing languages such as LOGO used to work. We assume that if we execute the MoveTo function, the pen will move to the required position. Subsequent calls to the LineTo function will draw to the new position and leave the pen there for the next function call.

Also, the existence of a SCREEN_WIDTH constant is also assumed so that the resolution of the drawing can be ascertained. The developer will need to use their own specific drawing functions and either define the relevant constant or hard-code the value (not recommended). Code Sample 8.15 shows the next stage, being able to move around the array in such a way that the window can be repositioned and different parts of the landscape displayed.

CODE SAMPLE 8.15 Moving the landscape window.

```
 .
 .
 .

// Keypress/Joystick/Mouse dependent code
switch (KeyPress)
{
  case LEFT  :
    nStart = (nStart + SPEED) % LANDSCAPE_WIDTH;
  break;

  case RIGHT :
    nStart = (nStart - SPEED);
    if (nStart < 0) nStart = LANDSCAPE_WIDTH - nStart;
  break;
}
 .
 .
 .
```

Again, there are some aspects of Code Sample 8.15 that will depend on the actual platform, but the principles remain the same. It might seem a fairly obvious way to implement the required functionality, but we state the obvious for the good reason that in this way, we all begin from the same degree of complexity.

The final stage is knowing how to scroll the screen from point A to point B. Since this will be extremely platform dependent, only the theory will be discussed here. The secret to smooth sideways scrolling is to base everything on a buffered screen—that is, have a window that is two positions larger than the actual displayed screen. In other words, if we want to show four lines on the screen, we should draw six—one extra on the left and one extra on the right.

When we want to move to either the left or right, we can then uncover as much of the line on the left or right as we need until we have run out of lines to display. At the same time, we also make sure that if the player keeps on moving right or left, we have more lines to display by the time the last line moves onto the screen.

Juggling this information is quite a chore and fairly processor-intensive, so it is a good idea to base everything on a virtual screen, which has only a portion of the display visible at any one time. This can often be arranged by using a bitmap that is drawn on the screen as needed. Again, this is very platform dependent, but the brief theory given here should be enough to get you started.

CONCLUSION

We have traveled a long way in this chapter, which was designed to give an introduction to natural techniques for building landscapes. The discussion on sideways-scrolling displays applies equally well to techniques in Chapter 7 as well as in Chapter 9, which deals with the mathematical counterpart to the techniques proposed here.

Landscapes produced using techniques from this chapter as well as those in Chapter 9 provide the basis for adding features to the basic landscape, thus enabling complex terrains that contain all manners of natural features, such as rivers and lakes, and buildings and roads.

PURE MATHEMATICAL LANDSCAPES

INTRODUCTION

We first encountered landscape-generation techniques based purely on number theory in Chapter 6 when we looked at random heightfields and ways in which to smooth them to look as realistic as possible. Now it is time to return to the realm of number theory in search of other algorithms that can be used to produce landscapes.

One might be tempted to ask why we go through so much trouble, when we have already seen effective landscape-building techniques that use algorithms based on naturally occurring phenomena. The answer is, of course, speed. It is not very likely that there will be enough processing power to build large landscapes on-the-fly if techniques such as those discussed in Chapters 7 and 8 are used. On the other hand, the final finishing touches, such as rivers and lakes, can be added to any of these landscapes (see Chapter 10).

So, purely mathematical landscaping has the advantage that landscapes can be built so fast that even the largest landscape (providing there is ample storage space) is feasible to generate during or just before the play session.

FROM NATURAL TO ALGORITHMIC

The first question we need to ask is what kind of result are we looking for, and what mathematical phenomena can be exploited in order to achieve that result. Again, we turn to nature in order to ascertain existing patterns that make a landscape recognizable.

Looking at any map, we can see that the relationship between hills and dales, mountains and cliff faces all follow patterns that relate them to each other. By way of example, there are no cliffs without hills, and the contour lines that indicate the presence of a cliff are those that are closest together, but which follow the general form of the surrounding hillside. This can be seen in Figure 9.1, which shows a make-believe contour map.

FIGURE 9.1 Simple contour map.

In his book, *The Fractal Geometry of Nature,* Mandelbrot (most famous for the Mandelbrot fractal) notes, when deciding upon a specific style of mathematical algorithm that can be used for the generation of contour-based landscapes: "The point of departure is the notion that mountains' surfaces are scaling shapes" (p. 256).

He goes on to say that this principle had never actually been scientifically explored, but was still generally accepted as fact. One particular example that Mandelbrot cites, which is reprinted here from Edward Whymper's book, *Scrambles Amongst the Alps: In the Years 1860–69,* is worth repeating. It first appeared in Mandelbrot's *The Fractal Geometry of Nature* (p. 256).

> *It is worthy of remark that . . . fragments of . . . rock . . . often present the characteristic forms of the cliffs from which they have been broken . . . The same causes which produce the small forms fashion the large ones: the same influences are at work—the same frost and rain give shape to the mass as well as to its parts. (p. 88)*

This self-similarity is the key to understanding the mathematical phenomena coined by Mandelbrot—the realm of fractals. All fractals are, to one extent or another, self-similar; that is, the greater the detail used to ex-

amine them, the more fluctuations are seen in the patterns; and eventually, smaller representations of the original pattern will be seen within the details of that pattern.

In other words, if we look at a fern, the general shape is repeated with the shape of each frond, and each leaf of each frond, more or less *ad infinitum*. A fern is therefore a naturally occurring fractal and can also be mathematically modeled.

So, the first mathematical theories that fit the bill would appear to be fractals because of their relationship to self-similarity in nature. There also exist a number of fractals that are termed "attractors," in which a specific set of paths can be generated that follow set mathematical principles, such as the orbits of dynamic systems of planets or even particles.

Even considering that these algorithms are based on dynamic systems, the paths described by the orbiting points can be traced and lines formed that follow contour-like patterns; and therefore, they can be used to generate landscapes.

Finally, we can yet again take a look at nature—and clouds. Lie on your back in a field on a sunny day, and observe the clouds moving across the sky. Ever-changing objects can be discerned. This slightly poetic description hides an important point; the clouds themselves mimic land forms and are also fractal in nature, and as a bonus can be modeled mathematically.

Clouds, therefore, can also be used to produce landscapes by color-coding the densities of the objects that make up the clouds (dust, droplets, or plasma). If we briefly go back to our repose in the grass, it becomes apparent that the clouds themselves are built up from individual particles, which cluster together to form shapes. The higher the density of particles, the more solid the shape; and the lower the density, the more detail can be seen around the edges. It is no coincidence, either, that there are fewer particles at the edges of the cloud than in the center, since particles tend to attract each other and therefore accumulate in the center of the cloud, while simultaneously being blown around by wind.

Based on what we have discussed thus far, we can say that our cloud is likely to be composed of particles that form shapes that are similar to the whole in the same way that a piece of mountain resembles the general form of the range from which it has arisen. According to these theories, A. K. Dewdney introduces an iterated function system (IFS) for a generic cloud (*The Tinkertoy Computer and Other MacHinations: Computer Recreations from the Pages of Scientific American and Algorithm*. W. H. Freeman & Co., 1993, p. 120).

Without going into too much detail, an IFS is used to map scaled and rotated duplicates of the original image into the plain that will display the image. The first step is to draw the actual image on some graph paper, and then divide it up into regions where the shape is similar to the whole. Next, we need to define the various transformations that map the large image onto each of the smaller ones.

Then, we pick a point at random and a transformation, and apply the transformation to the point. We then plot the result. Perform the same actions on a new point, and continue until the desired resolution is reached. Eventually, by applying the transformations that we derived from our analysis of the cloud, we will build up a cloud (if we imagine each point to be a particle) that will look like (but not be identical to) the generic cloud that gave birth to it. We can build a whole sky full of substantially similar but nonidentical clouds using a purely mathematical formula—the Affine Transformation.

Of course, there is a lot of manual processing involved in actually setting up the transformation data, and the models that this processing produces could be stored, for example, on the CD-ROM that contains the game itself; and they could be accessed when needed. Despite not being truly mathematical (because of the model-building manual work required), we are nonetheless going to give a little more attention to the general theory introduced above. First, note that an Affine Transformation usually takes the form (*The Tinkertoy Computer and Other MacHinations: Computer Recreations from the Pages of Scientific American and Algorithm*, p. 121):

$$x' = ax + by + e \text{ and } y' = cx + dy + f$$

So, to translate x,y to x',y', we need only apply the formulae that appear above. Arriving at values for a, b, c, d, e, and f is not a trivial matter. We need to first establish how much smaller the target subshape is compared to the whole shape, and whether we need to rotate it at all. Taking the scaling factor s and rotation r, Affine Transformation theory leads us to the following calculations:

$$a = s * \cos (r) \qquad\qquad b = s * \sin (r)$$
$$c = s * \sin (r) \qquad\qquad d = s * \cos (r)$$

Which leaves us with e and f, which are translations of the center point of the figure as a whole to the center of the smaller figure, with e as the dif-

ference between x' and x (the horizontal distance), and f as the difference between y' and y (the vertical distance).

These are quite obviously self-mapping fractals, as discussed earlier. With this in mind, we could even pick totally random transformation data and generate shapes. The cloud that Dewdney proposes is split into six subclouds, yielding six possible variations of the Affine Transformation, of which one is chosen at random to apply to point x,y to arrive at x',y'.

Storing the data can be done as an array that will have at least enough columns to store the transformation data for one transformation (a through f) and enough rows to encapsulate enough transformations to actually generate something that looks like the original. Code Sample 9.1 performs one such transformation at random.

CODE SAMPLE 9.1 Affine Transformation code.

```
void AffineTransform( int   x, int   y, SAffineTable *
  oAffineTable,
                     int & new_x, int & new_y ) // x' and y'
{
  int n = rand() % oAffineTable.nMaxEquations;

  new_x = (int)((oAffineTable.dA[n] * (double) x) +
               (oAffineTable.dB[n] * (double) y) +
               (oAffineTable.dE[n]));

  new_y = (int)((oAffineTable.dC[n] * (double) x) +
               (oAffineTable.dD[n] * (double) y) +
               (oAffineTable.dF[n]));
}
```

Of course, this code relies on the implementation of `SAffineTable`, which could look something like that detailed in Code Sample 9.2.

CODE SAMPLE 9.2 The SAffineTable object.

```
struct SAffineTable
{
  int nMaxEquations;
```

```
   double * dA;        // These are the affine transformation
   double * dB;        // factors that need to be randomly
   double * dC;        // generated or even calculated using
   double * dD;        // the AffineCalculate function,
   double * dE;        // and represent rotations, scalings,
   double * dF;        // and transformations.
};
```

As is noted in Code Sample 9.2, we need to actually arrive at some quite intricate values for dA to dD that can be calculated based on the scaling factor and rotation (in degrees) using the code from Code Sample 9.3.

CODE SAMPLE 9.3 The AffineCalculate function.

```
void AffineCalculate( double scaling, int rotation,
                      double & dA, double & dB, double & dC,
   double & dD )
{
   // First, get the rotation in radians, since the mathematical
   // library functions acos and asin don't use degrees.
   // There are 2*pi radians in 360 degrees.
   double dRotation = (((22.0 / 7.0) * 2.0) / 360.0) *
   double(rotation);

   dA = scaling * acos ( dRotation );
   dB = scaling * asin ( dRotation );

   dD = dA;
   dC = dB;
}
```

Finally, the AffineCalculate function should be called with the components from the SAffineTable object, such that the required row is specified and that all values (including the new_x and new_y variables (from Code Sample 9.1) are passed by reference.

The method of choosing a specific equation to apply, as implemented in Code Sample 9.1, assumes that there is an equal probability of each Affine

Transformation equation being applied. This is quite simply not true in real life. There is an intrinsic probability associated with each equation that has an effect on the overall shape of the resulting cloud.

In Code Sample 9.4, the rand() function is extended and based on a different definition of the SAffineTable that includes these probabilities on a scale from 0 to 99, and will return a value that is chosen by the weighting of those probabilities.

CODE SAMPLE 9.4 The RandomProbability function.

```
int RandomProbability( SAffineTable * oAffineTable )
{
  int n = rand() % 100;

  // Calculate where the new probability falls
  int nOngoingSum = 0;
  for (int j = 0; j < oAffineTable.nMaxEquations; j++)
  {
    nOngoingSum = nOngoingSum + oAffineTable.nProbability[j];
    if (nOngoingSum > n) return j;
  }
}
```

Of course, the probabilities must all add up to 100, otherwise the function will not evaluate the equation to be chosen properly. Sometimes, the function might not even return if they do not add up to 100. Figure 9.2 shows the effect of using the cloud transformations given by Dewdney and reproduced on the image.

As a counterpoint to the above, and employing software provided on the companion CD-ROM, a set of six Affine equations ON THE CD can be produced completely at random (or pseudorandom, using the seed 210674) with the result shown in Figure 9.3.

It is fair to say that choosing the angles and scaling factors at random is probably not such a wise idea, although it does have ON THE CD the advantage of speed. The complete set of functions for storing and using (although not for plotting) these Affine landscapes is included on the CD-ROM.

FIGURE 9.2 Dewdney's Affine clouds.

FIGURE 9.3 Lecky-Thompson's random Affine art.

Plasma Clouds

Anyone who has played with the freeware program Fractint (www.fractint.org) will be familiar with these strange fractals that can (again, using Fractint) be mapped onto a pseudo-3D wire-frame grid, or even onto a beautifully shaded height sphere. Figures 9.4 to 9.7 show the various plasma mappings possible.

FIGURE 9.4 Basic plasma map.

FIGURE 9.5 3D grid.

FIGURE 9.6 3D solid mapping.

FIGURE 9.7 3D spherical mapping.

The plasma cloud fractal (Figure 9.4) is a basic subdivision averaging algorithm, as the Fractint authors note:

A recursive algorithm repeatedly subdivides the screen and colors pixels according to an average of surrounding pixels and a random color, less random as the grid size decreases.

ON THE CD By now, the reader should have ample clues as to how plasma clouds can be built, and experimentation can be carried out using the version of the Fractint included on the companion CD-ROM. For the more adventurous among you, the source code is also included. But before you run off to take a look at it, be warned that the

source code does not make for easy reading; it is quite complex. (Even *IGU*'s author found the Fractint code hard-going.) The following code for a plasma cloud could be a possible implementation.

CODE SAMPLE 9.5 The PlasmaCloud function.

```
void PlasmaCloud( int ** oHeightField )
{
  int nWidth, nHeight;
  int x, y;

  nHeight = HEIGHT;
  nWidth  = WIDTH;

  while (nWidth > 1 && nHeight > 1)
  {
    for (y = 0; y < HEIGHT; y = y + nHeight)
    {
      for (x = 0; x < WIDTH; x = x + nWidth)
      {
        // Figure out the average of neighboring squares
        int nTotal = 0;
        for (int ny = y-1; ny <= y+1; ny++)
        {
          for (int nx = x-1; nx <= x+1; nx++)
          {
            int cellx = nx;
            int celly = ny;
            if (cellx < 0) cellx = WIDTH + cellx;
            if (celly < 0) celly = HEIGHT + celly;
            if (cellx >= WIDTH) cellx = WIDTH - (cellx %
WIDTH);
            if (celly >= HEIGHT) celly = HEIGHT - (celly %
HEIGHT);
            nTotal = nTotal + oHeightField[cellx][celly];
          }
        }
        nTotal = nTotal + (rand() % nTotal);
        nTotal /= 10;
      }
    }
```

```
    nWidth /= 2;
    nHeight /= 2;
  }
}
```

Many of these techniques return to using subdivision of the target square and a certain amount of averaging to generate, in this case, a landscape.

CONCLUSION

This has been a relatively short chapter, and it only scratches at the surface of the possibilities from using purely mathematical phenomena to create landscapes. It does, however, give an introduction to fractal techniques that can be used to create landscapes.

As in Chapter 6, we can choose either to apply these techniques in game time or in the design process (to generate an external data set). For the latter, a great tool to use is Fractint, which was released into the public domain in the early 1990s, along with the source code.

Using a tool such as Fractint, or a custom built equivalent, we can create a data set that can be compressed and loaded for use in the game. The data set can be modified using techniques from other chapters to add features such as rivers, which can be overlayed to produce a complete terrain.

By a similar token, we can examine the code used to generate the various Fractint pseudo-landscapes and apply it in our game during the play session, which will enable us to generate multiple random landscapes.

RIVERS, LAKES, AND CALDERAS

INTRODUCTION

In Chapters 6 through 9, we looked at a number of techniques that can be used to create reasonably realistic landscapes at generation speeds good enough for real-time; that is, they are constructed fast enough to create pseudorandom landscapes during the play session. What they lack in realism, they make up for in utility.

For most games, this will be enough. Sometimes, though, we will want to go a little bit further, especially if we are trying to create landscapes that are fully fleshed out with all manners of natural and man-made (or alien-made) features. Such landscapes make the transition to being full-fledged terrains and are usually not created fast enough for real-time use.

Of course, the speed at which these terrains can be created is largely limited only by the processor speed. As a general rule, platforms such as consoles and handheld devices will not be able to create full terrains on the fly, but full-fledged PCs can. It is up to the developer to decide whether it is worth going the extra distance to create fully realistic, terrain landscapes.

This chapter will offer a number of techniques that will enable the developer to simulate nature and create ever-more realistic landscapes. These terrains should ideally be precreated and stored on CD-ROM (or disk) and loaded as required. Chapter 11 ("Terrain Building Blocks") gives more substance to these theories along with some valuable pointers for their use in a variety of platform environments.

COLOR-CODED LANDSCAPES

When we created our first landscapes back in Chapter 6, we dealt with very limited forms of color coding. In fact, only two schemes were adhered to: grayscale landscapes or blue/green/brown pseudorealistic variants. Neither approach has proved completely satisfactory, however; and it is now time to take a look at extending these basic approaches.

While traditional color coding (as in *SimCity*) has dictates that water is blue, land is green, and hills are brown, this is not entirely true. Though based on cartographic conventions (which is all well and good), this convention ignores reality to a certain extent. When creating a top-down map, we would probably choose to stick with the general idea of color coding in this way; only a slight twist will be required to enable us to use the same color coding for both top-down maps and full, 3D shaded terrains.

A good starting point when examining a color scheme for representing a heightfield, such as those presented in Chapters 8 and 9, is to aim for a reduction in nested `if` statements. These become unwieldy and are time consuming to execute and debug. It is better to try and use a representation based on the values that are to be contained within the heightfield itself. The most common of these can be seen in grayscale landscapes, for which a simple algorithm is presented in Code Sample 10.1.

CODE SAMPLE 10.1 Grayscale heightfields.

```
struct sRGB
{
  int nRed, int nGreen, nBlue;
}

void GetRGBValue( int nMin, int nMax, int nValue, sRGB * oRGB)
{
  // Grayscale values have the same values for red, green, and
  // blue components.
  oRGB->nRed   = ((nMin - nMax) / 255) * nValue;
  oRGB->nGreen = oRGB->nRed;
  oRGB->nBlue  = oRGB->nRed;
}
```

There is very little additional commentary required on Code Sample 10.1, except to say that a pixel contains red, green, and blue components that usually run from 0 to 255, with 255 being the maximum intensity. Figure 10.1 shows the grayscale terrain map.

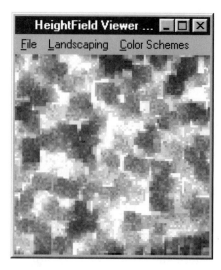

FIGURE 10.1 Grayscale terrain map.

Those familiar with HTML will be aware that this means that white is represented by the hexadecimal value FFFFFF (RGB: 255, 255, 255) and black by the hexadecimal value 000000 (RGB: 0, 0, 0). Dark gray lies somewhere in the middle at hexadecimal 808080 (RGB: 128, 128, 128).

With this in mind, we can see from Table 10.1 what the various hexadecimal and RGB values are for common landscape-based color schemes.

TABLE 10.1 Color Schemes and RGB/Hex Values

Color	Feature	R	G	B	Hex
Dark Blue	Sea	0	0	128	000080
Medium Blue	Lake	0	0	255	0000FF
Light Blue	River	128	128	255	8080FF
Dark Brown	Earth	128	64	0	804000
Light Brown	Sand	128	128	64	808040
Dark Green	Trees	0	128	0	008000
Medium Green	Grass	128	255	0	80FF00
Dark Gray	Rocks	128	128	128	808080
Light Gray	Mountain	192	192	192	C0C0C0

While stated above that the goal is to reduce the selection process based on the numeric height value of the cell to be encoded, a quick first glance

at Table 10.1 shows that this will be a difficult task at best. After much trial and error, graphing various red, green, and blue intensities against the arbitrary heightfield scale (running from 0 to 100), we can establish a set of formulae that appear to bring us close to being able to map each heightfield value to the necessary color intensities.

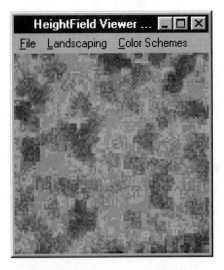

ON THE CD

The reader is welcome to take this further and try to establish better formulae. The Heightfield Viewer software on the companion CD-ROM can produce these mapped colors, and the formulae are as follows:

red = sin (value * 0.45) * 255

green = sin (value * 0.9) * 192

blue = sin (((value * 1.8) + 180) + 1) * 255

By way of example, the blue component uses that part of the sin curve between 180° and 360°, which varies from 0 through –0.71, –1.0, –0.71, and back to 0. To this, we then add 1.0 to ensure that the blue component is not negative. The red and green components work in a similar fashion. This kind of coloring is called "pseudocoloring" because it is impossible to tell in advance exactly what color will fall where. Nonetheless, the result is often quite close to reality, as shown in Figure 10.2.

Depending on the application, an algorithmic approach similar to the one presented here might or might not prove useful. Selecting colors in this

FIGURE 10.2 Pseudocolored terrain map.

way could be faster for large numbers of shades, but the calculations required for each pixel might be beyond the capabilities of the platform. In the end, it could prove just as effective to simply generate the heightfield using values between 0 and 100, and apply either ballistic deformation, particle deposition, or a mathematical algorithm (or a combination of these techniques), and then rescale each pixel to represent a specific color value, such as 0 for water, 1 for grass, or 2 for trees.

It is then a simple matter to use a `case` statement to select the appropriate color value for the cell in question. The only slight caveat is that all the possible values must be known in advance if each landscape is to be generated on the fly.

GRID OVERLAYING

While the above is adequate in many cases, in order to generate truly realistic terrains, we need to use a technique called *"grid overlaying."* In essence, all this means is that for a given landscape, we use more than one grid to represent each aspect or feature of that landscape. Imagine the landscape (as generated by the algorithm of choice from preceding chapters) to be a Styrofoam model. We can then overlay grids to add features such as colors and objects to the landscape to turn it into a true terrain.

One of the advantages of using grid overlays is that if the terrain must be rendered in true 3D (as opposed to a top-down mapping approach), then the height of each cell is retained in the master grid, while if we were to use a single grid, this information would be lost, and the eventual height value of the cell would need to be recalculated.

Of course, in terms of storage, a grid overlay requires more space than a single grid, but do not forget that all the techniques presented in this book are designed so that combinations can be used—in other words, if static storage is a concern, then only the principal heightfield grid need be stored; the features that we place onto it can all be inferred at run-time. In fact, the master heightfield grid can also be inferred, but there will always be cases where this is either not practical or desirable.

Another reason for using grid overlaying is that we have previously based our color mapping on blue representing water at 0–25 (meters), green being grass at around 50 (meters), and brown hills that lie at 75 (meters) or more. But we have neglected the possibility that we can have mountain lakes or rivers that quite clearly do not lie at sea level. Grid overlaying allows us to

make distinctions between seas, lakes, rivers, and other water features without modifying the underlying heightfield grid.

One final note about using overlays: Each one increases the amount of storage space (either memory or hard disk space) needed to store the entire terrain. Imagine, for example, a terrain that is 500 × 500 cells in size (which is a fairly decent map) and uses the CHeightField class (see Chapter 8). The space required is 500 × 500 bytes, which works out at roughly 244Kb.

To add some kind of overlay to contain seas, rivers, and lakes, we need another 244Kb, and adding roads and buildings requires yet another 244Kb—and then there are other objects we can add. . . .

Eventually, we estimate that the original grid plus five overlays are needed, coming to a total of about 1.5Mb, which must be stored somewhere. This may not sound like much, but if we want to effectively manage an online game with tens of thousands of players, 1.5Mb of data becomes something of a more-cumbersome quantity, especially since in an online situation we would probably be talking in terms of a grid that is 1000 × 1000 cells in size (or nearly 1Mb of data for each grid).

Besides, most consoles or handheld game platforms probably cannot spare quite that much memory. The moral of the tale: Combine the various features as far as possible so that the game requires less overlaying, especially if the game is designed for the handheld or online markets. In Part V, we will look further into ways of implementing fast compression and decompression techniques for larger volumes of data.

RIVERS

One of the easiest natural features to model is a river. We need only evaluate how rivers are formed in nature and apply the same (or a similar) principle to our grid heightfield. In fact, we shall be applying it to an overlay created specially for the purpose: the *water overlay*. In the interest of combining heightfield overlays of different types, we place anything that is based on water into this overlay.

In nature, water falls as rain onto the landscape, whereupon it either pools on the lowlands, flows down the hillsides, or flows into the sea. We notice that, as an additional feature, water always follows the path of least resistance. Should the water find a place that is bounded by paths of greater resistance, it will begin to form a pool. When the water gets to a certain level, it might overflow and follow the path of least resistance once again.

So, in our model, we follow a series of steps. First, we generate a landscape using one of the techniques from Chapters 6 through 9, storing it in a CHeightField object known as the *master grid*. At this point it is merely

a heightfield with no display characteristics associated with it. Once we have the master grid, we can begin to create various feature overlays, of which the first will be water-based, in this case rivers.

Note at this point that the behavior of water flowing down a hillside bears a remarkable resemblance to the behavior of particles being deposited. Thus, we can hijack the source code from Code Sample 8.11, which implements the `FindCheapestCell` function.

As an added bonus, the `FindCheapestCell` function also provides for the pooling effect because it returns −1 when no cell cheaper than that which is currently occupied can be found.

In fact, the only differences between the particle deposition algorithm from Chapter 8 and the one that we are creating to mimic the behavior of water is that we are applying the changes to an overlay grid, and our choice of starting point will be algorithmically guided and not just picked at random.

This choice can be based on the relative heights of the 'peaks' that will adorn the landscape either by choosing the highest and calling it the starting point or by selecting several peaks that might or might not be close to each other (or even a given distance away). However, we choose to determine the starting point for our river, the general principle remains the same, and is shown in Code Sample 10.2.

CODE SAMPLE 10.2 The CreateRiver function.

```
void CreateRiver(int StartX, int StartY,
                 CHeightField * oMasterGrid,
                 CHeightField * oWaterGrid)
{
  int nRiverX, nRiverY;
  int ndX, ndY;

  nRiverX = StartX;
  nRiverY = StartY;

  while (FindCheapestCell(nRiverX, nRiverY, oMasterGrid, &ndX,
                 &ndY) != -1)
  {
    nRiverX = ndX;
    nRiverY = ndY;

    oWaterGrid->SetCellValue(nRiverX, nRiverY, 1);
  }
}
```

Of course, when we represent this on the screen, it is of no use shading the cells as was done previously, because this will lead to two unwanted effects. First, the river's width will always be the same, which is almost never the case in nature; rivers tend to become wider as they near their end (be it a lake or the sea). Second, the river's width will be the same as one cell of 'land.' This can result in a strange-looking landscape with extremely wide rivers, again something that is not quite natural.

We can tackle both of these issues at once by plotting the river in such a way that the relative width is proportional to the difference between the start and end point of the river; that is, the end point contains a line that is a certain fraction of the width of one grid cell. Microsoft Windows programmers will probably be aware that this can be achieved by using a variety of pen widths, and Code Sample 10.3 uses this technique.

CODE SAMPLE 10.3 The DrawRiver function.

```
        .
        .
        .
#include <windows.h> // Needed for all Windows Apps
        .
        .
        .

void DrawRiver(int StartX, int StartY, CHeightField *
  oMasterGrid,
                HDC hCanvas, int nMaxHeight, int nMinHeight)
{
  int nRiverX, nRiverY;
  int ndX, ndY;

  double dPenProportion, dPenWidth;

  HPEN hPen, hOldPen;

  nRiverX = StartX;
  nRiverY = StartY;

  dPenProportion = (0.5 / (nMaxHeight – nMinHeight));

  while (FindCheapestCell(nRiverX, nRiverY, oMasterGrid, &ndX,
                &ndY) != -1)
```

```
{
  // Create a blue pen of the appropriate width
  dPenWidth
    = (0.6 – (dPenProportion * oMasterGrid->GetCellValue(ndX,
ndY)));

  hPen
    = CreatePen(PS_SOLID, (int) (dPenWidth * CELL_WIDTH),
RGB(0,0,255));

  hOldPen = SelectObject(hCanvas, hPen);
  MoveTo(hCanvas,
         (nRiverX * CELL_WIDTH ) + (int) (CELL_WIDTH  / 2),
         (nRiverY * CELL_HEIGHT) + (int) (CELL_HEIGHT / 2));

  LineTo(hCanvas,
         (ndX * CELL_WIDTH ) + (int) (CELL_WIDTH  / 2),
         (ndY * CELL_HEIGHT) + (int) (CELL_HEIGHT / 2));

  SelectObject(hCanvas, hOldPen);
  DeleteObject(hPen);

  nRiverX = ndX;
  nRiverY = ndY;
  }
}
```

The DrawRiver function defined in Code Sample 10.3 assumes the existence of several defined values, such as CELL_WIDTH and CELL_HEIGHT, along with appropriate functions for finding the maximum and minimum heights so that they can be passed to the DrawRiver function.

Of course, it is clear that DrawRiver as defined above is simply an illustration of how it *can* be done, but in certain circumstances, it will not prove efficient to actually do it in this way. This is largely because we are effectively generating the river twice—once for the grid and again for display. There are a number of ways around this, ranging from storing the width information for the water feature (from 0.1 x CELL_WIDTH for a stream through to 1.0 x CELL_WIDTH for a river) in the grid, to making the calculations based on the height of each square of water encountered on the overlay grid.

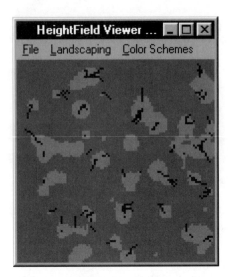

FIGURE 10.3 Rivers.

The exact choice will depend largely on the platform for which the game is designed. In some cases, the solution should favor storage over calculation—hence, use a grid of floating-point values, and others will need a solution geared toward calculating river depths on the fly. Be careful when using such a solution, as converging river paths need to be treated explicitly, which means testing for river forks before drawing in the lines.

All of the above was used to generate the image in Figure 10.3, which also shows the existence of a few pools or lakes in the lowlands. Of course, we can also have high-lying lakes, which often occur in a basin left after a volcano has erupted. These are called *"calderas,"* which are formed when the lava retreats back into the earth.

THE CALDERA THEORY

The definition above was taken from an article written by Jason Shankel in the book *Game Programming Gems* (Charles River Media, 2000). He also indicates how such natural phenomena can be simulated. In fact, it is a fairly simple proposition in theory, which raises quite interesting implementation questions. First, though, we will examine the theory.

In Figure 10.4, the basic theory for creating a caldera can be seen. We first select a given height value as being the 'caldera line'; choosing a percentage of the maximum height is often a good approach. For each point

FIGURE 10.4 Creating a caldera.

that is higher than the caldera line, we invert the value around the caldera line. We can do this for every point that is above the caldera line.

Shankel notes that there is the possibility that, when applied to an entire heightfield, applying the caldera cutoff in this way can lead to interference between peaks. There are two solutions to this. The first is to perform the caldera cutoff filter on a flood-fill basis beginning with one cell and applying the inversion to neighboring cells recursively in turn until no more can be found that need to be inverted.

The other solution can be seen in Code Sample 10.4.

CODE SAMPLE 10.4 The CalderaFilter.

```
void CalderaFilter(CGrid * oHeightField, int nMaxHeight)
{
  int x, y;
  CGrid * oNewHeightField;

  int nCalderaLine = nMaxHeight * 0.9;

  for (x = 0; x < oHeightField->GetWidth(); x++)
  {
    for (y = 0; y < oHeightField->GetHeight(); y++)
    {
      // Is the grid cell higher than the caldera line?
      int nValue = oHeightField->GetCellValue(x, y);
      if (nValue <= nCalderaLine)
      {
        oNewHeightField->SetCellValue(x, y, nValue);
      }
```

```
      else
      {
        // Calculate the new value based on the inverse of the
        // caldera line
        nValue = nCalderaLine - (nValue - nCalderaLine);
        oNewHeightField->SetCellValue(x, y, nValue);
      }
    }
  }

  // Copy the grid back again
  for (x = 0; x < oHeightField->GetWidth(); x++)
  {
    for (y = 0; y < oHeightField->GetHeight(); y++)
    {
      oHeightField->SetCellValue(x, y, oNewHeightField-
  >GetCellValue(x, y));
    }
  }
}
```

This is the 'simple' solution. The flood-fill solution mentioned is only a little more difficult. It hinges, however, on making a good choice of starting peak. As in the choice of starting cell for generating rivers in the preceding section, we leave this up to the developer. The rest of the function is implemented in Code Sample 10.5.

CODE SAMPLE 10.5 The recursive FloodFillCalderaFilter.

```
int Rebase (int n, int dimension)
{
  if (n < 0) return dimension + n;
  if (n > dimension) return n % dimension;
  return n;
}

void FloodFillCalderaFilter(CGrid * oHeightField, int
  nMaxHeight
                               int nStartX, int nStartY)
{
  int x, y;
```

```
int nCalderaLine = nMaxHeight * 0.9;

for (x = nStartX - 1; x <= nStartX + 1; x++)
{
  for (y = nStartY - 1; y <= nStartY + 1; y++)
  {
    // We don't want to do anything if the current cell is
    // the same as the starting cell.
    if (x != nStartX && y != nStartY)
    {
      // Rebase, just in case the neighboring cell falls
      // outside the grid.
      int nX = Rebase(x, oHeightField->GetWidth());
      int nY = Rebase(y, oHeightField->GetHeight());

      // Recurse if the neighbor falls below the caldera
      // line.
      int nValue = oHeightField->GetCellValue(nX, nY);
      if (nValue <= nCalderaLine)
      {
        FloodFillCalderaFilter(oHeightField, nMaxHeight, nX,
nY);
        nValue = nCalderaLine - (nValue - nCalderaLine);
        oHeightField->SetCellValue(nX, nY, nValue);
      }
    }
  }
}
}
```

The two functions in Code Sample 10.5 enable the caldera filter to be applied on a flood-fill basis with a bias toward the top-left corner. In Figure 10.5, we can see the effect of the recursive caldera filter, while Figure 10.6 shows the identical source landscape modified with the regular (non-recursive) caldera filter.

EROSION

Whenever we attempt to mimic nature with an algorithmic approach, we can usually count on it being unrealistic in some way. In the case of some of the algorithms presented in Part II, the main problem is that the height differences between adjacent cells can seem to be unrealistically large.

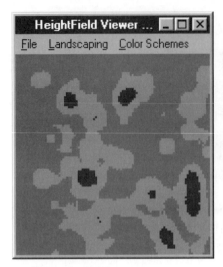

FIGURE 10.5 Recursive caldera filter.

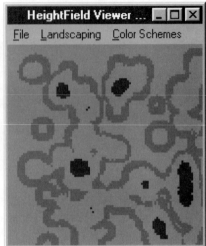

FIGURE 10.6 Nonrecursive caldera filter.

We counteract this by introducing variations, usually of a random nature, as in the particle deposition algorithm from Chapter 8 (see Code Sample 8.10). Another way of introducing variations is to use erosion, such as a simple, low-pass filter. Robert Krten, writing in *Dr. Dobb's Journal* (1984), suggests a FIR filter that applies the following formula to a series of numbers $x_1, x_2, x_3 .. x_n$ to yield a series of numbers $y_1, y_2, y_3 .. y_n$:

$$y_i = k_{y-1} + (1 - k)x_i$$

This formula needs to be applied in both directions of the heightfield in order to be effective. It allows the rows to affect the columns as well as the columns affecting the rows, so that it is not just a case of taking either in isolation. The filter itself is controlled by k, which is a constant between 0 and 1, with values closer to 0 leading to a lower degree of erosion. The function in Code Sample 10.6 will apply this FIR erosion filter to a continuous stream of numbers.

CODE SAMPLE 10.6 FIR erosion filter function.

```
void FIRErosionFilter( int & nLast, int & nThis, double k )
{
  nThis = (int) ((k * (double) nLast) + ((1.0 - k) * nThis));
}
```

Using the FIRErosionFilter requires that we pass through the heightfield, beginning at the second row (or column, depending on which way we are currently attacking it) and providing a stream of nThis and nLast values to the filtering function. Code Sample 10.7 shows each possible pass.

CODE SAMPLE 10.7 Applying the FIRErosionFilter function.

```
void FilterGridRows( CGrid * oHeightField, double k )
{
  int x, y, nLastValue, nThisValue;

  for (y = 0; y < oHeightField->GetHeight(); y++)
  {
    for (x = 1; x < oHeightField->GetWidth(); x++)
    {
      nLastValue = oHeightField->GetCellValue(x-1, y);
      nThisValue = oHeightField->GetCellValue(x, y);
      FIRErosionFilter(&nLastValue, &nThisValue);
      oHeightField->SetCellValue(x, y, nThisValue);
    }
  }
}

void FilterGridCols( CGrid * oHeightField, double k )
{
  int x, y, nLastValue, nThisValue;

  for (x = 0; x < oHeightField->GetWidth(); x++)
  {
    for (y = 1; y < oHeightField->GetHeight(); y++)
    {
      nLastValue = oHeightField->GetCellValue(x, y-1);
      nThisValue = oHeightField->GetCellValue(x, y);
      FIRErosionFilter(&nLastValue, &nThisValue);
      oHeightField->SetCellValue(x, y, nThisValue);
    }
  }
}
```

It should be noted that the FIRErosionFilter presented here comes into its own if applied to the landscape rendering just prior to display. This is because it relies on a high level of resolution (a grid measuring +/– 1000 × 1000 cells or pixels) to be effective. The best approach is to generate the terrain on a smaller grid and magnify each cell so that it covers a larger number of pixels, and then apply the filter before displaying each pixel.

The images in Figures 10.7 and 10.8 show the effect that this has on a particular terrain.

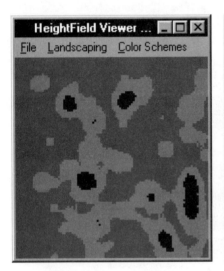

FIGURE 10.7 Before erosion.

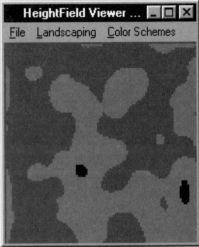

FIGURE 10.8 After erosion.

ON THE CD The way in which this is implemented will vary from platform to platform. The source code on the companion CD-ROM uses the Windows approach with an off-screen bitmap used to draw the initial image, which is then copied to the screen (as in Figure 10.5); or it is filtered and then copied (as in Figure 10.6). Alternative renderings can be performed to generate, for example, a 3D version.

CONCLUSION

In this chapter, we have seen many techniques that will add a touch of realism to the base landscapes generated using any of the algorithms from this part of the book. In addition, we have seen a very basic erosion rout-

ing that can be used, instead of the particle deposition algorithm presented in Chapter 8, to remove the clear-cut edges that mathematically-generated terrains exhibit.

We can now begin to flesh out the generated landscapes and terrains, and see how these techniques can be used in the real world, both on-the-fly and for pregenerated terrains. In Chapter 11, we will use these techniques as building blocks to generate the complete picture.

TERRAIN BUILDING BLOCKS

INTRODUCTION

We have almost finished our tour of terrain and landscape techniques for generating, storing, and manipulating different kinds of terrains for different situations. While each technique has been described in isolation, a few things have been left out that can serve to render landscapes even more realistically. Also, we have not discussed the artificial aspects; buildings, roads, paths, and other features of real-life terrains.

This chapter, then, will pull together all of the threads begun in the preceding chapters in an attempt to direct their usage toward complete terrains that can be quickly and easily rendered. In addition, we shall be adding some new ideas to the melting pot while using the basic techniques that have already been defined as a basis for extending the realism of generated terrains.

ADDING NATURAL FEATURES

In Chapter 10, we saw that mountains (or hills) and water (either lakes or rivers) were the basis for most natural features that can be added to the landscape in order to render a natural-looking terrain. These are not the only mechanisms by which we can make the terrain look more natural, but they are the foundations for other techniques.

EDGING FEATURES

There are a number of natural features that can be employed, which will be called 'edging' features—that is, they form edges to other features. For

example, sandy beaches might be found near a sea or lake. Or, there might be cliffs that edge the base of hill features. Creating edging features is an easy prospect in theory, but it is less than straightforward in practice.

The most complex task is to identify an edge—a change from one type of tile to another—in such a way that it adds to the effect. The simplest way this can be achieved is by treating the grid in terms of scan lines. This means that we can travel across the grid from one side to the other, and when we encounter a predefined border condition (e.g., land/water transition as sand), we can change that grid cell (or tile) to something else.

Code Sample 11.1 is an example of processing the scan lines such that every time we encounter a border condition, we change the cell to some other value. The CHeightField object from Chapter 8 is used for the heightfield storage.

CODE SAMPLE 11.1 ScanlineBorderDetection function.

```
void ScanLineBorderDetection(CHeightField * oHeightField,
                        int nBorderTile1, // These are
the two tiles
                        int nBorderTile2, // involved
in border detect.
                        int nReplacementTile // The
value to be used)
{
  int x, y;

  for (y = 0; y < oHeightField->GetHeight(); y++)
  {
    for (x = 0; x < oHeightField->GetWidth(); x++)
    {
      // There are two border conditions, left to right, and
      // right to left
      int nRight, nLeft;
      nLeft = x;
      nRight = (x + 1) % oHeightField->GetWidth();
            // Wrap around
      if (((oHeightField->GetCellValue(nLeft, y) ==
nBorderTile1) &&
          (oHeightField->GetCellValue(nRight, y) ==
nBorderTile2)) ||
          ((oHeightField->GetCellValue(nRight, y) ==
nBorderTile1) &&
```

```
            (oHeightField->GetCellValue(nLeft,  y) ==
    nBorderTile2)))
        {
           oHeightField->SetCellValue(nRight, y,
    nReplacementTile);
        }
      }
    }
}
```

The `ScanLineBorderDetection` routine described in Code Sample 11.1 works from left to right, but it could very easily be adapted to deal with top-to-bottom scan lines also. For the best possible effect, the scan should be done on both axes. In order to do this, we need to test the grid cells based not on adjacent squares, but based on target neighbor cells, as shown in Figure 11.1.

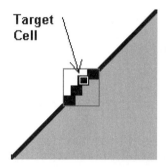

FIGURE 11.1 Neighboring cell scan border detection.

An example of the basic code for doing this is shown in Code Sample 11.2, which is an extract from a more completely coded function.

CODE SAMPLE 11.2 Neighboring cell border detection extract.

```
  .
  .
  .

// There are four corners, starting from point x,y as the
// center.
```

```
// Assume that we are testing based on the average of the
// four neighbors.

int nTotal = oGrid->GetCellValue(x - 1, y);
    nTotal = nTotal + oGrid->GetCellValue((x + 1) % oGrid-
>GetWidth(), y);
        nTotal = nTotal + oGrid->GetCellValue(x, y - 1);
        nTotal = nTotal + oGrid->GetCellValue(x,(y + 1) % oGrid-
>GetHeight());

if (nTotal / 4 > nThreshold) oGrid->SetCellValue(x, y,
nReplacementTile);
```

.
 .
.

There are many assumptions in Code Sample 11.2, but it still serves to illustrate the general principle, which is not that different from many of the techniques discussed thus far. In fact, any time that we use a grid as the basis for our world representation, we will pay close attention to cells' neighbors. One thing to note, however, is that the grid scan should begin at cell 1,1, since there is no test for either the x or y component being less than zero.

As an additional level of reality, we can also incorporate a certain level of randomness into the calculation such that the existence of edging cells matching the given criteria only indicate a probability of the replacement tile being used in place of one of the edging tiles. Assuming that such a probability is governed on a percentage basis, we could use the following formula:

```
if (nTotal * ((rand() % 100) / 100) > nThreshold)
```

In order to ensure that the decision is repeatable (i.e., that the same cell will be changed each time that the algorithm is used), the random number generator should be seeded using a formula similar to:

```
srand( (y * width) * height)
```

where x and y are the coordinates of the cell in question (either one of the edge-detection squares or the center of a neighbor-edge grid) and

the width and height values represent the width and height of the entire grid.

We have suggested setting an edge between water and land to indicate sand (or even mud) to increase the reality of a landscape. We can also use the neighbor-edge detection scheme to add other features, such as snow to mountain peaks, which require a certain set of surrounding tiles to be a given value.

We can take the algorithms presented here one step further and introduce conditions based on the cell under scrutiny so that the end effect is determined by the surrounding grid cells as well as the cell itself. To take the neighbor edging to its logical extreme, we can use all eight neighbors instead of the four used in Code Sample 11.2.

ADDING ARTIFICIAL FEATURES

The above terrain features are entirely natural; that is, they occur within the scope of the landscape being generated because of conditions that are inherent to that landscape. Some features that we might like to add, however, are artificial. That is, they do not occur as a result of the values assigned to the cells in the grid that lead to the landscape itself.

Instead, the values are added afterward in the same way that man-made features arise as a result of human impact on the landscape. These features could include villages (be they simple or advanced) with roads or paths, or even fields, castles, or orchards. Such features depend on the genre of the game, but the features dealt with here are common to all genres and share the conceptual code and techniques with which the reader can generate features for use in their own games.

ROADS AND PATHS

We have already seen how a 'cheapest path' algorithm can be used to trace the probable path of water from a hilltop to form a lake. Roads are a similar proposition. Given a possible line connecting two points, it is highly unlikely that road builders will build a straight road from point A to point B. This is especially true if the proposed route passes over some rivers, through hills, or around wide areas of water. Occasionally, we might be able to bridge water or tunnel through hills, and these will also have to be taken into account.

First, however, let us look at the theory behind building a simple road or path from point A to point B. There are two aspects that model the path of

a road—besides avoiding the occasional water feature or mountain, that is. The first of these is to determine the 'easiest' path at each step of the way, while the second is to base a decision on the cell that takes the road closer to the target by the biggest degree from the current cell.

We can achieve both of these in one algorithm that weights each possibility according to the cost associated with the cell and the distance from the proposed cell to the target. We also need to bear in mind that, faced with the possibility of building the road in a given direction that involves a steep gradient up the side of a mountain (or through the mountain) and a series of cells around the base of the mountain, 'real' road builders would probably opt for the path of least resistance, even if it makes for a longer road.

So, much like our path of least resistance maze-building technique from Part I (see Chapter 2) or the river algorithm from Chapter 10, we begin with an array containing the eight possibilities (really nine, but we do not need the center 'neighbor'—it is our current tile) and weight each one with a value derived from a specific property of that tile.

ON THE CD Code Sample 11.3 shows the general principle, and Figure 11.2 puts the principle into practice. The actual executable application and source code that produced the image in Figure 11.2 is included on the CD-ROM that accompanies this book.

CODE SAMPLE 11.3 Road-building algorithms.

```
// The main algorithm is based on several criteria, the
// first part being respective values of the cells that
// might be #defined as follows....

#define LAND  1    // Assumption : cheapest possibility
#define WATER 10   // Assumption : crossing water is
                   // expensive
#define HILL  100  // Assumption : mountains are very
                   // expensive

// Next, we need some way of deciding if a particular cell
// takes us closer to the target, and by how much....

// This function corrects the location so that it falls
// inside the grid dimensions....
void CorrectLocation(sLocation * oLocation, int nWidth, int
nHeight)
{
```

FIGURE 11.2 Virtual road building.

```
  if (oLocation->x < 0)
oLocation->x = nWidth - oLocation->x;
  if (oLocation->y < 0)
oLocation->y = nHeight - oLocation->y;

  oLocation->x = oLocation->x % nWidth;
  oLocation->y = oLocation->y % nHeight;
}

int DistanceDifference(sLocation oCell,
                       sLocation * oNeighbor,
                       sLocation oTarget)
{
  // Assume that oNeighbor could be 'incorrectly' positioned
  CorrectLocation(&oNeighbor);

  // We need a negative number if oNeighbor is closer to
  // oTarget than oCell
  return DistanceBetween(oNeighbor, oTarget) -
       DistanceBetween(oCell, oTarget);
}

// Calculate the weighting for the eight neighbor cells and
// decide upon one that is destined for the oNextCell
void (sLocation oCurrent, sLocation * oNextCell,
CHeightField * oGrid,
```

```
        sLocation oTarget)
{
  int nMin = 1000; // Should be enough
  int nValue;
  int x,y;
  sLocation oNeighbor;

  for (y = oCurrent.y - 1; y <= oCurrent.y + 1; y++)
  {
    for (x = oCurrent.x - 1; x <= oCurrent.x + 1; x++)
    {
      if (x != oCurrent->x && y != oCurrent->y)
      {
        oNeighbor.x = x;
        oNeighbor.y = y;
        CorrectLocation(&Neighbor);

        nValue = oGrid->GetCellValue(oNeighbor.x,
oNeighbor.y);
        nValue = nValue + DistanceDifference(oCurrent,
&oNeighbor, oTarget);

        if (nValue < nMin)
        {
          oNextCell->x = oNeighbor.x;
          oNextCell->y = oNeighbor.y;
        }
      }
    }
  }
}
```

The reader will recognize the call to the DistanceBetween function as well as the sLocation structures that contain *x* and *y* coordinates from Chapter 2 (see Code Sample 2.11). They prove very useful in the above implementation, especially when the CorrectLocation function is used to ensure that the *x* and *y* coordinates remain within the confines of the CHeightField object, which has been borrowed from Chapter 8. This might seem slightly tedious, but the references above do, at least, avoid repeating code unnecessarily.

Thus, we can build a road from point A to point B. Choosing these points is left up to the reader; the conditions that lead to choosing specific

points from which to begin and end a road will differ depending on the goal of the designer and the individual game terrain.

VILLAGES AND CITIES

One set of artificial features that is related to road building are villages and cities. Cities, for example, might be located at point A or B (or both). There are a variety of ways in which artificial cities can be constructed—from a purely random smattering of buildings to a more-organized arrangement of habitats, shops, inns, or other types of buildings related to the genre of the game.

Individual dwellings, such as houses or inns, can also be built and will usually be located next to a road. Determining how the interior of such a building is represented to the player is largely a question of the game style. *Rogue*-style adventure (or role-playing) games tend to shift the viewpoint of the player to the extent that the playing perspective zooms into the feature being explored. The layout of the buildings themselves can be derived using techniques from Chapter 2.

FARMLAND AND ORCHARDS

By the same token, organized plantings of crops and trees are other artificial features that have been introduced by habitation. While buildings have an organized layout—from the point of view that they can be explored and can have an irregular form—fields and orchards have at least the advantage of regularity. As with buildings, agriculture will most probably occur next to roads, towns, or cities.

SIMULATION

Before we move on to some techniques for generating terrains and landscapes on the fly (the ones described here are designed to be pregenerated), we should take a brief look at how we can affect the basic landscape and simulate a changing environment over the passing of time—be it the result of an event caused by the player or a random, natural event, such as rainfall.

In fact, rainfall is a very good place to begin. It is an example of how, over time, a specific event within the game universe can have a visible effect. This is not to say that a player will necessarily appreciate the rising of the water table over a period of 200 years (game time), but it is an example of modeling a recurring event that might have parallels in other games.

Other variations could be seasonal. In a game like *SimCity* (Maxis), which often runs into decades of game time, the passing of seasons could be simulated with changes in the climate, such as snow falling on the hills in winter. In these cases, it is important to retain congruency year after year; that is, if snow falls on a certain cell one year, then if the next winter is similar in climate, snow should fall there again.

Two mechanisms will be put into action, then, to illustrate how similar techniques might work. Rain and snow have been chosen for two reasons: First, they are both examples of precipitation that will eventually have an effect on the game universe. Snow will eventually melt and flow into rivers and seas, so that even if it never rains (or rarely does) we are still guaranteed an effect. Rain, of course, will flow directly into the rivers, and the effect is somewhat more immediate.

The second reason for this choice is that one has a direct effect on the representation (cells or tiles), while the other (rain) does not to the same extent. Snow can immediately be spotted, but the overall effect takes longer to 'accumulate.' Rain, on the other hand, might not have such an outwardly, obvious appearance (especially from the top-down point of view), but the effects can be seen almost immediately; lands flood and rivers swell.

The eventual effect of both types of precipitation is that whatever water levels exist, they will rise. Based on the grid overlay technique discussed in Chapter 10, we can assume that we have assigned a 'water grid' that contains the lakes and seas, and probably a separate 'river grid' to deal with rivers. The reason to keep rivers separate is simple; rivers can flow along paths without pooling, whereas lakes and seas are large bodies of water with depths that are below sea level. Rivers flow above sea level.

It is a trivial matter to ensure that this sea level rises, as can be seen in Code Sample 11.4.

CODE SAMPLE 11.4 Rising water levels.

```
// Assume three CHeightField objects of equal dimensions:
// oGrid, oWater, oRiver
```

```
// For the time being, we just need to raise the sea level
// nLevel represents the number of passes to be made

void RaiseSeaLevel ( int nLevel, CHeightField oWater )
{
  for (int l = 0; l < nLevel; l++)
  {
    for (int x = 0; x < oWater->GetWidth(); x++)
    {
      for (int y = 0; y < oWater->GetHeight(); y++)
      {
        if (oWater->GetCellValue(x,y) != WATER) continue;
        for (int cell_x = x - 1; cell_x <= x + 1; cell_x++)
        {
          for (int cell_y = y - 1; cell_y <= y + 1;
              cell_y++)
          {
            if ((cell_x == x && cell_y != y) ||
                (cell_x != x && cell_y == y))
            {
              sLocation oLocation;
              oLocation.x = cell_x;
              oLocation.y = cell_y;
              CorrectLocation(&oLocation,
                            oWater->GetWidth(),
                            oWater->GetHeight());
              if (oWater->GetCellValue
                            (oLocation.x,
                            oLocation.y) != WATER)
              {
                oWater->SetCellValue
                            (oLocation.x,
                            oLocation.y, WATER);
              }
            }
          }
        }
      }
    }
  }
}
```

Of course, the code above's drawback is that it makes absolutely no effort to take into account the main grid. It applies a strict growing algorithm that adheres to the principle of selecting the direct neighbors to each cell (i.e., not diagonally adjacent) and turns them into water if the central cell is also water. By not considering all of the neighbors, we retain the spirit of the shape of the water features. If we took in all possible neighbors, then the shape would quickly become exaggerated. This is shown in Figure 11.3.

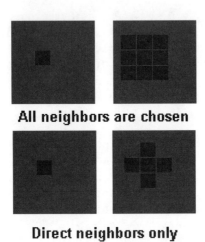

FIGURE 11.3 Direct versus indirect neighbors rendering.

A more time-consuming, but slightly more-realistic approach is to advance the water in only one direction: the cheapest. This is shown in Code Sample 11.5, which is adapted from the four-neighbor function in Code Sample 11.4. An eight-neighbor counterpart to this function could also be written.

CODE SAMPLE 11.5 Rising water levels II.

```
// Assume three CHeightField objects of equal dimensions:
// oGrid, oWater, oRiver

// For the time being, we just need to raise the sea level
// nLevel represents the number of passes to be made
```

```
void RaiseSeaLevel_II ( int nLevel, CHeightField oWater,
                                     CHeightField oGrid )
{
  for (int l = 0; l < nLevel; l++)
  {
    for (int x = 0; x < oWater->GetWidth(); x++)
    {
      for (int y = 0; y < oWater->GetHeight(); y++)
      {
        if (oWater->GetCellValue(x,y) != WATER) continue;
        int nMin = 10000;
        sLocation oMinLoc;
        for (int cell_x = x - 1; cell_x <= x + 1; cell_x++)
        {
          for (int cell_y = y - 1; cell_y <= y + 1;
               cell_y++)
          {
            if ((cell_x == x && cell_y != y) ||
               (cell_x != x && cell_y == y))
            {
              sLocation oLocation;
              oLocation.x = cell_x;
              oLocation.y = cell_y;
              CorrectLocation(&oLocation,
                             oWater->GetWidth(),
                             oWater->GetHeight());
              if ((oGrid->GetCellValue
                             (oLocation.x,
                              oLocation.y) <= nMin) &&
                   (oWater-GetCellValue
                             (oLocation.x,
                              oLocation.y) != WATER)
              {
                nMin = oGrid->GetCellValue
                             (oLocation.x, oLocation.y);
                oMinLoc.x = oLocation.x;
                oMinLoc.y = oLocation.y;
              }
            }
          }
        }
      }
      oWater->SetCellValue(oMinLoc.x, oMinLoc.y, WATER);
    }
  }
```

```
        }
}
```

Interestingly, going the other way, drying the terrain out requires that we reconvert the highest peaks first; thus, instead of finding the cheapest neighbor, we would need to look for the most expensive.

Finally, let us look at the theory behind temporary features, such as snowfall. The idea is simple. We want to allocate a specific value to certain cells. In the case of snowfall, the highest ones will probably be the first targets. Task one, therefore, is to scan the oGrid heightfield and find the highest peak. With this in hand, we can then evaluate each cell, and for those that are higher than a certain percentage of the highest peak, alter the properties such that there is snowfall.

Once the winter is over, we can then look at the quantity of snow that has fallen as a percentage of the number of land-based cells (as opposed to sea-based) and increment the sea levels by a given amount. Further simulation parameters, such as temperature affecting the height above which it will snow, can be factored in so that some years the water levels will rise by a lot, and other years the water level will not rise at all. Of course, in the summer, there is always the possibility that the water will dry up.

CONCLUSION

Coupled with some of the design techniques presented in the first five chapters, we can build very complex landscapes that have both artificial and natural features with very little need to store vast amounts of data. There is probably a combination of algorithm and seed techniques that will give rise to a close approximation to the structure of the planet Earth, although finding the exact mix of parameters and landscaping techniques goes far beyond the scope of this book. To 'sow a seed,' however, once the landscape is in place, it is evident that rivers will follow the path of least resistance; therefore, actually storing their paths is unnecessary. The landscape will give rise to the rivers in an evolutive way.

Indeed, the landscapes will also change. They are not static arrangements of green and blue tiles; they can be flooded, dried out, even made to follow the seasons. We can imagine dusting them with snow in the winter, for example. In doing this, we move into the complex realm of simulation; and in turn, we increase the realism of the core game.

SOUND & MUSIC

INTRODUCTION

Other books that deal with games programming often give a mere, short glance to the various sound effects and background music that form a very important part of the tapestry upon which a game's success is often based. Instead, they deal with more 'obvious' pieces of the game universe: 3D graphics modeling, for example.

This is a pity. Good sound effects and music can add a really immersive aspect to the game—ask any film maker about the importance of balance between the sound track and on-screen reactive sounds. Perhaps the reason that these topics have never been given the detailed analysis that they deserve is because they are less 'sexy' than the other ingredients of a good game.

In the market as a whole, ID Software has always stood out from the crowd for their overall excellence in the choice of music and sound effects, a detailed attention that has made their hit games, like *Doom,* rise to cinematic heights. It is not just that the soundtrack is good or that the sound effects are varied and well timed. Their success is also due to the progression of the background music, which changes to suit the current game situation.

SOUND EFFECTS

Probably the first aspect of sound and music that springs to mind when considering which sounds should accompany the game are those effects that will herald specific events in the game universe as it is being played. These effects fall into many categories, depending on the game style. Each specific weapon in a first-person shooter like *Doom* or *Quake* has its own unique sound that depends on whether the weapon is being reloaded, shot, or fired with an empty magazine (consisting of projectiles, energy, or whatever makes them useful as means of destroying the enemy).

Each enemy will also have a distinct set of associated sounds that depends on their style of movement, number of legs (or wheels), and general state of health. Whatever the game object, the sounds associated with it will add to the player's sense of reality.

SAMPLING

There are many ways in which we can obtain a sound from the real world and insert it into a game. The easiest is probably by finding something that sounds similar and recording it into a computer where it is stored digitally. This is known as "sampling." Sampling converts the sound in the air that would eventually reach our ears (an analogue wave transport) into a series of numbers that describe that sound wave in a way that the computer can process (digital transport). And by computer processing, we mean storing, manipulating, and eventually playing back the sound via a sound card format suitable to a wide range of platforms.

Sampling is done by using specialty pieces of software, such as *Gold Wave* or *Cool Edit*, in conjunction with a standard sound card. Most sound cards will enable the user to plug in a microphone and record sounds that can then be modified in strange ways so that the exact sound that is required can be manufactured using the sample as a base.

It is important to note that samples vary in quality and size. Traditionally, the higher the frequency of the sample, the more data needs to be stored; and therefore, more space is required to store the sample. Samples are one of the reasons that WAD files, such as those used to store level information in *Doom*, are so large. Sometimes, we might be tempted to sacrifice quality for quantity, but as we shall see in this part of the book, there are a few tricks and techniques to avoid this undesirable aspect of sampling.

MUSIC

Music adds mood. Mood is a manipulation of feelings that results in a psychological change. Music is, therefore, one of the most important aspects of a game. As a player, you will not find the dulcet tones of a Puccini opera associated with a character in a Formula 1 racing game; the two clash horribly.

The Ride of the Valkyries would be appropriate, as used in *Frontier: Elite II*, or something vaguely techno, such as music written by The Prodigy for *WipeOut* on the Sony PlayStation.

Bad music will kill a good game. Good music will not, however, make a poor game into an average one. Nevertheless, ignore the importance of background music at your peril.

SEQUENCING

Just as important is the way in which music should change depending on the evolution of the player's situation within the game universe—for example, fast action movie music for shooting scenarios and slow, heartbeat attenuated music for exploration.

The way in which music is sequenced will influence the player and enhance the immersive feeling. This, in turn, will ensure that the game has an extended shelf life.

NOTES & ENVELOPES

Before we start out on our journey through the various sound creation possibilities, we need to take a brief look at some key points in the development of audio techniques over the years. Everything up until now has described these sounds and music in an abstract way.

Historically, computers started out with tinny, built-in loudspeakers. Many, if not all, still have them, but they are largely ignored. Nonetheless, it is perfectly possible to use them to produce sound, music, and even sound effects. In describing how this is done, we will also be learning the basics of sound, which we can take with us into deeper discussions.

If a device can produce a note, then it can produce a series of notes. This is the basic premise. A note is simply a way to describe the effect of moving the cone of a speaker (for instance) a given number of times per second. The faster the cone moves, the higher the note.

A sound envelope describes the transformation of a given note over a period of time so that the overall sound can be reproduced at any frequency. A piano, for example, has a given sound envelope, as does a human voice. The latter is, of course, extremely complex.

The reasoning behind using sound envelopes is that if we sample a piano, as described above, we can play given notes at any frequency using the sample. However, the higher the note, the shorter the duration, because the sample is simply being played more quickly, and it is a finite length. Likewise, the lower the note, the longer the sample will play for. Sound envelopes can be used to minimize this unwanted effect, as we shall see.

MULTICHANNEL SOUND

It is also historically important and quite useful to think in terms of channels—that is, a channel for sound effects, for music, for drums and other percussive instruments, and so forth. If a note is ready to be played on

each of the channels at once, then they will all play at once. If two notes are ready on the same channel, then they will play one after the other.

This seems logical and almost superfluous, but when designing a game engine, it is a good idea to extend the channeling idea to encompass the various sounds that will be needed as the game is played.

MIDI & MODULE

Luckily for game programmers, there are two extremely well-supported standards for sequencing a collection of sounds to provide music. The MIDI format allows multiple channels of computer-generated sounds to be played sequentially. It dates back to the beginnings of computer music and is widely supported on electronic keyboards. Although there are authoring tools available, the basic file format is nonproprietary text.

The MODule (or MOD) format allows the sequencing of a series of samples, thus assembling them into a tune. There are many supported functions, such as left-right panning, volume control, and the basic ability to play a sample at a given frequency. Playback libraries are available, many of them freeware, and freeware authoring tools are also abundant.

Recommended players and authoring tools are the ModPlug player and ModPlug Tracker originally written by Olivier LaPique. The most recent versions are available from http://www.ModPlug.com. Music can be found at http://www.TraxinSpace.com; but as always, ask permission to use a specific tune, in whole or in part, to enhance your own compositions.

MACHINE & OTHER ARTIFICIAL SOUNDS

INTRODUCTION

Some of the most important sounds used in modern games will be those made by machines or engines, or sounds that result from them exploding or being destroyed by a weapon of some kind. It is fairly easy to embark on an in-depth explanation of how to obtain samples of these kinds of sounds for use in games.

However, many types of sounds can be generated without the need to record them from an outside source for adaptation to a game. Recording them and using real samples is, of course, the best way to produce the necessary sounds, but sometimes the exact sound just cannot be found in the real world.

GENERATING, STORING, AND MANIPULATING SOUNDS

Before we progress onto what kinds of artificial sounds can be created, we need to take a brief look at how we are going to manipulate sounds using the computer. There are many formats that use a variety of different compression techniques. (This section is not really the place to go into any depth about possible compression schemes for sound waves; they require special treatment, and are quite unlike other data that can be compressed.)

The most common sound file format, and the one that has the best native support under a variety of operating systems via freely available libraries such as DirectX, is the WAV file format. WAV files are a variant of the Resource Interchange File Format (RIFF), which treats a file of data as a series of self-contained chunks, each of which are described by header

information that also contains information pertaining to the exact nature of the samples themselves.

Looking at the source code provided on the companion CD-ROM (WavFile.CPP), which was inspired by Timothy J. Weber (E-mail: jtweber@lightlink.com, Web site: http://www. lightlink.com/tjweber), we can derive the format for the WAV file, which resembles the following:

ON THE CD

```
+-Riff Chunk————————————————————————————————————————————-+
|                                                                |
| "RIFF" (4 bytes)                                               |
|  Size of WAVE Chunk (4 bytes)                                  |
|                                                                |
| +-WAVE Chunk ————————————————————————————————————+ |
| | |                                                          | | | |
| | "WAVE" (4 bytes)                                          | |
| | |                                                          | |
| | +-WAVE Header Chunk————————————————————————+ | |
| | | |                                                      | | |
| | | "fmt " (4 bytes)                                      | | |
| | | Chunk Length (4 bytes)      [The length of this (Header) Chunk | | |
| | | Format Type (2 bytes)       [Usually 1 : Pulse Code Modulation | | |
| | | Number of Channels (2 bytes) [1 - 4 : Mono - Surround Sound | | |
| | | Sample Rate (4 bytes)       [Number of samples per second | | |
| | | Bytes per Second (4 bytes)  [Number of bytes to process / second| | |
| | | Bytes per Sample (2 bytes)  [Number of bytes per sample | | |
| | | Bits per Channel (2 bytes)  [8 = Lo-Fi ; 16 = Hi-Fi   | | |
| | | |                                                      | | |
| | +————————————————————————————————————————+ | |
| | |                                                          | |
| | +-WAVE Data Chunk————————————————————————————+ | |
| | | |                                                      | | |
| | | "data" (4 bytes)                                      | | |
| | | Chunk Length (4 bytes) [Length of all the data in this chunk | | |
| | | |                                                      | | |
| | | The data section contains either one or two byte values depending| | |
| | | on the bits per channel member, with the channels interleaved. | | |
| | | |                                                      | | |
| | +————————————————————————————————————————+ | |
| | |                                                          | |
| +————————————————————————————————————————————+ |
|                                                                |
+————————————————————————————————————————————————+
```

It is probably worth mentioning that each RIFF chunk can contain multiple WAVE chunks; but generally, a WAV file (.WAV) will contain a single RIFF chunk. The data is encoded as a series of numbers that indicate a specific amplitude, or level, for each sample. The quantity of such numbers is given by the sample rate member. This usually ranges from 11,025 (telephone quality) through to 44,100 (CD quality), and it is not likely that one will see rates outside this range.

The actual quality of the sample is also affected by the range of values that can be expressed by each individual sample. This is given by the bits-per-channel member. Eight bits per channel indicates that each sample

will contain one byte, giving a granularity of 256 (0-255). Using 16 bits per channel means that we can represent about 65,536 values, which represents much better quality sound.

Since as game programmers we are obsessed by efficiency, it is worth noting that at a 16-bit sampling rate at CD quality and in stereo sound, each second of sound requires 176,400 bytes. This is given by multiplying the sample rate (2 bytes / sample) by the number of channels (2 * 2 = 4), and then by the number of samples per second (44,100 * 4 = 176,400). This is not a very efficient encoding scheme and explains why only 74 minutes of audio can be stored on a standard music CD—(176,400 * 60) * 74 = 747Mb.

However, the advantage of using this pulse code modulation (PCM) format is that it is very easy to manipulate, even in real time, so that we can generate sounds on the fly or mix sounds in real-time, or even take a sample base and modify it to create and play new sounds. The reason it is so easy to manipulate PCM sounds is that they are stored as uncompressed 'raw' data. We can therefore mix two WAV files by applying the following to each individual sample:

new_sample = (old_sample_1 / 2) + (old_sample_2 / 2)

Or, we can raise the volume of the WAV by applying the following:

new_sample = old_sample * 1.6

On top of this basic manipulation of existing files, we can also generate WAV data according to mathematical formulae, something that for many machine-like and other artificial sounds will be more efficient than sampling and storing real-life sounds. However, in order to do this, we need one of two things: a hard disk to store the WAV files on, or enough memory to allow setting aside some of it for the purpose of storing generated WAV file data. So long as one of these criteria are met, we can generate WAV files as we need them.

It we do not have any temporary storage space available, then we can still generate WAV data, but it will be much more clumsy because we will need to try and devise a way of playing the sound using direct calls to the API that supports our gaming environment. The techniques described here can, however, be used to generate WAV files that can be shipped with the game on the distribution media.

Prior to discussing the various artificial sounds that can be generated using mathematical formulae and manipulation of PCM data, we need to spend a little more time on creating and writing WAV files. Pulse code

modulation works by splitting a sound wave into frames of information, in which a sound is generated by varying the strength of the pulses—as many times per second as is required by the frequency of the sound being stored.

This means that in order to produce a pure sound that oscillates at 440Hz, we need to send a pulse once every 1/440th of a second. If we have a sampling frequency of 44,100Hz, there will be a gap of 100 nonpulses every second. Thus, we have 440 equally spaced pulses of a given intensity (amplitude). This is the basis for the important relationship between frequency and amplitude that is key to creating sound waves.

In order to manipulate WAV files at the low level, Code Sample 12.1 gives the class definition for the `WAVFile` interface class to a memory-based WAV file. The data block is held in memory until such time as the `WAVFile::Save` member is called. This approach is acceptable for small samples, and it is worth noting that large WAV files are usually streamed from disk rather than being loaded all at once into memory; the `ulBytes-PerSecond` member tells the calling application how many bytes to hold in reserve for one second's worth of sound data.

CODE SAMPLE 12.1 Key WAV file data elements and functions.

```
class WAVFile
{
  private:
                                   // The RIFF Chunk
      char szRIFF[5];              // 'RIFF'
      long lRiffChunkLength;       // Size of data + 44
                                   // bytes
      char szWAVE[5];              // 'WAVE'

                                   // The FMT Chunk
      char szFMT[5];               // 'fmt '
      long lFmtChunkLength;        // 16 or 10 Hex
      short nFormatTag;            // 1 = Pulse Code
                                   // Modulation
      unsigned short nChannels;    // 1 = Mono, 2 = Stereo
      long ulSamplesPerSecond;     // Sampling frequency
      unsigned long ulBytesPerSecond; // Average bytes per
                                   // second
      unsigned short nBlockAlign;  // Bytes per sample
      unsigned short nBitsPerSample; // Bits per sample
```

```
                                  // The DATA Chunk
    char szDATA[5];               // 'data'
    long lDataChunkLength;        // Size of pData
    unsigned char * pData;        // Memory block

  public:
    WAVFile(long lSamplingFrequency, int nSoundLength, int
nChannels);
    ~WAVFile();

    // Example: oWavFile = new WAVFile(44100, 1, 2);
    // This is a 44,100Hz stereo, 1-sec. sample

    long GetNumberOfSamples();

    void Save(char * szFileName);

    void SetSamplePoint(long lSamplePoint, unsigned char
nData);

};
```

Using the WAVFile class is very easy, as we shall see in the next section. There is one point worth noting about the WAV file format, however. It is a Microsoft variation on the RIFF, which has been widely adopted. The PCM scheme that has been implemented here is also not the only possibility; there are other schemes, including compressed-data versions that might be more suited to a particular application.

WHITE NOISE

In the early days of home computing, most machines had a noise channel. Usually Channel 0, it produced a pseudorandom series of notes that hovered somewhere between hissing and crackling, rather like the sound produced by an untuned television set.

This 'white noise' can be generated by a machine in a number of ways, the simplest being just to generate a set of random pulse amplitudes as many times per second as the sampling frequency allows. Code Sample 12.2 uses the WAVFile class to create one second of 8-bit stereo sound sampled at 44,100Hz, which is close to CD quality (albeit 8-bit).

CODE SAMPLE 12.2 White noise generation.

```
  .
  .
  .

    long lSamplingFrequency = 44100;
    int nSeconds            = 1;
    int nChannels           = 2;

    oWAVFile = new WAVFile(lSamplingFrequency, nSeconds,
    nChannels);

    for (i = 0; i < oWAVFile->GetNumberOfSamples(); i++)
    {
      oWAVFile->SetSamplePoint(i,rand() % 255);
    }

    oWAVFile->Save("white.wav");

    delete oWAVFile;

  .
  .
  .
```

White noise uses the entire frequency range, which for 8-bit sound is between 0 and 254, the limits of the unsigned char data type. For 16-bit sound, the values can range from –32,768 to +32,768, the limits of an unsigned int data type. Other types of noise include 'red noise,' which uses the lower end of the frequency range. The white noise produced here is a hissing sound; red noise is more of a grumble.

WAVE FORMS

White noise is in some ways the easiest form of sound. It can be used for a variety of purposes, such as primitive explosions. In times when sound was very much more archaic, the noise channel of computers (e.g., the BBC Microcomputer or Commodore 64) used different frequencies of noise for explosions, drums, and other game or musical sounds.

Most sound, however, arrives at our ears as regular waves; and those sounds that we associate with music (notes) are most often based on mathematically reproducible formulae. The reader is invited to play with the WavGen software that is provided on the CD-ROM. The source code is also provided as a reference for the production of different types of sound.

ON THE CD

The important point here is twofold. First, if we can create a sound from scratch using mathematics, then there is no need to sample a lot of instruments and store resource-hungry samples on the distribution media, thus leaving plenty of space for the important thing—the game. Second, by understanding the sound-production process, we can also manipulate them. So, a sample for a guitar can become a distorted guitar, a bass guitar, or some other string instrument.

PURE TONES

A pure tone is created by a speaker vibrating at a given *frequency*, measured in hertz. On the piano, middle C, for example, produces a sound that oscillates at 440Hz. In other words, the string vibrates at around 440 times per second. The closest waveform to this vibrating string is a sine wave. For nonmathematicians, the best way to approach the formula for a sine wave (and its counterparts, the tangent and cosine waves) is by understanding each separate component in turn.

The standard C mathematical functions, such as `sin`, are based on radians, and there are `2*pi` radians in a complete circle, which is also the number of radians in one cycle of a sine (or cosine/tangent) wave. So, if we need a wave lasting for one second at a sampling frequency of 11kHz, we will have 11,000 sampling points. A one-cycle wave would therefore be split over 11,000 sampling points, meaning that there would be `(2*pi)/11,000` radians per sampling point.

Following on from this, if we need a 440Hz sine wave to use as a pure tone from which we would like to construct more-complex sounds, we would need `((2*pi) * 440)/11,000` radians per sampling point. The reason we are going into this much basic detail is because the actual formula for deriving the value for each sample point is not obvious at a first glance, but is derived from the above steps:

```
(( 2 * pi) * frequency) / number_of_sampling_points ) *
current_sample_point
```

This gives the number of radians to feed into the `sin`, `cos`, or `tan` function. The astute observer will note that the above does not give us

values between 0 and 2pi, rather 0 and 1382. Luckily for us, the standard C libraries are such that these values are treated in a circular fashion so that the wave can be produced without forcing each value into a scale between 0 and 2pi.

In case the reader is in any doubt as to what `sin`, `cos`, or `tan` waves look like, Figures 12.1, 12.2, and 12.3 give the WavGen screenshot renderings of each one. Figure 12.4 is the graphical depiction of the white noise discussed earlier in this chapter.

What, however, do these waves sound like? The sine and cosine waves represent pure tones, while the tangent wave is a mixture of almost random and regular values that leans toward white noise. Such tangent waves can be quite useful in providing distortion.

Sine and cosine waves produce very pure tones, but they are computationally expensive to generate. Waves of lesser quality but similar properties can be generated that require much less processing power. These are

FIGURE 12.1 Sine wave.

FIGURE 12.2 Cosine wave.

FIGURE 12.3 Tangent wave.

FIGURE 12.4 White noise.

triangle, square, and saw waves. Examples can be seen in Figures 12.5, 12.6, and 12.7.

Where the power of these waves lies is in the combining their different types to generate new sounds. Once the exact mix of waves has been

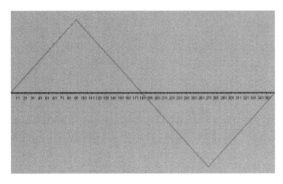

FIGURE 12.5 Triangle wave.

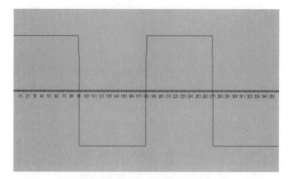

FIGURE 12.6 Square wave.

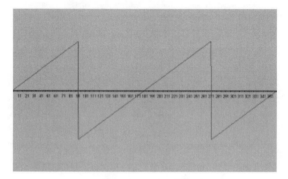

FIGURE 12.7 Saw wave.

determined, we can simply store the parameters used to create the sounds (instead of large samples) and create either temporary samples in memory or on hard disk, or just produce the music or sounds as we go along, and play them through the multimedia extensions provided by the underlying operating system.

It is also worth pointing out at this point that early games systems, such as those produced by Nintendo, provided three kinds of sound channels—sine wave, square wave, and noise.

Pure Tones & Sound Envelopes

Pure tones can be modified by the use of sound envelopes that change the sound as it is being played. Such envelopes have existed as far back as the first home computers in the 1980s. In the *Acorn Electron User Guide*(Acorn Computers, Ltd., 1982), the BBC BASIC command ENVELOPE is discussed as a way of changing the pitch of a sound over time based on three phases, each with a defined number of steps of equal length, with a certain pitch

change per step. This becomes easier to understand if we consider the following example:

ENVELOPE	n	s	Pi1	Pi2	Pi3	Pr1	Pr2	Pr3
	ID	No. Steps	Phase 1/2/3 Pitch Increments			Phase 1/2/3 Number of Pitch Increments		

We should mention (before those who remember the BBC/Electron years remind us) that there are six other parameters that have no relevance for the Electron, but which are relevant for the BBC Micro. These do not concern us right now, since with three phases of pitch increments, we have enough to write our own WAV file based on the pitch envelope function, which is discussed below.

Although in this context we shall be using envelopes to modify pure tones, we shall also be using it later on to modify real sounds that will then be used for a variety of tasks. For example, if we want to adjust the footstep of a dinosaur to sound like a smaller, lighter beast, we can manipulate the pitch envelope so that it is faster with different attack, sustain, and fade phases.

Pitch Envelope

Programming a pitch envelope with attack, sustain, and fade phases relies on being able to alter the frequency of each portion of the sound wave. We are going to base the envelope on a ratio of attack, sustain, and fade phases, rather than a discrete number of steps. This is because changing the frequency of a sample involves changing the length of time in which the sample plays. Since the sample is prerecorded and not generated, it is easier to deal with a ratio based on the number of samples.

Applying the pitch envelope requires that we modify the sample by adjusting the frequency of the wave according to the description stored in the structure defined in Code Sample 12.3.

CODE SAMPLE 12.3 Pitch envelope definition.

```
struct sPitchEnvelope
{
   double dAttack, dSustain, dFade;
   int nAttackRatio, nSustainRatio, nFadeRatio;
}
```

The fastest way to apply a pitch envelope involves *resampling,* which will increase or decrease the time taken to play that portion of the sample. If we want to increase the pitch of the sound, we simply discard the appropriate number of samples; to decrease, we 'play' each sample twice. The result can sound slightly metallic, but for computer-generated pure tones, this is not a big problem. Code Sample 12.4 shows a very simple method of resampling.

CODE SAMPLE 12.4 Pitch envelope resampling.

```
void ApplyPitchEnvelope
                        (WAVFile * oWaveIn, WAVFile *
                        oWaveOut, sPitchEnvelope
                        oPitchEnvelope)
{
   if (oWaveOut != NULL) delete oWaveOut;  // New wave buffer

   int nTotalRatio = oPitchEnvelope.nAttackRatio  +
                     oPitchEnvelope.nSustainRatio +
                     oPitchEnvelope.nFadeRatio;

   long int lSamplesPerRatio = oWaveIn->GetNumberOfSamples()
/ nTotalRatio;
   long int lNewWaveLength;

   lNewWaveLength =  oWaveIn->GetNumberOfSamples() *
oPitchEnvelope.dAttack;
   lNewWaveLength += oWaveIn->GetNumberOfSamples() *
oPitchEnvelope.dSustain;
   lNewWaveLength += oWaveIn->GetNumberOfSamples() *
oPitchEnvelope.dFade;

   oWaveOut = new WAVFile(oWaveIn->GetSamplingFrequency(),
                          lNewWaveLength,
                          oWaveIn->GetChannels());

   long int lSample, lNewSample;

   lNewSample = 0;

// Attack Phase
   for (lSample = 0;
        lSample < lSamplesPerRatio *
```

```
oPitchEnvelope.nAttackRatio;
      lSample++)
  {
    if (oPitchEnvelope.dAttack > 0)
    {
      if (lSample % (int) oPitchEnvelope.dAttack == 0)
      {
        oWaveOut->SetSamplePoint(lNewSample,
                oWaveIn->GetSamplePoint(lSample));
        lNewSample++;
      }
    }
    else
    {
      // Ok, there are better ways of testing whether a
      // number is whole

      if ((double)lSample * oPitchEnvelope.dAttack ==
          (double) ((int) ((double) lSample *
oPitchEnvelope.dAttack)))
      {
        oWaveOut->SetSamplePoint(lNewSample,
                oWaveIn->GetSamplePoint(lSample));
        lNewSample++;
      }
    }
  }

  // Sustain & fade phases are identical...
  // example:
  //    while (lSample < lSamplesPerRatio *
  //    oPitchEnvelope.nSustainRatio)
  //    { . . .
  //        lSample++;
  //     . . . }
}
```

Only the attack portion has been coded in Code Sample 12.4. The others follow the exact same template, and the reader is free to implement variations in the algorithm as is required. The code presented here is only designed to give an idea of how this (admittedly crude) algorithm could be implemented.

Note, however, that we need to retain two buffers of sound; so we require twice the actual storage—the advantage being that we do not lose the original data. This is important because there are other techniques whose implementation relies on advanced techniques that are in themselves worthy of whole books; and quite often they are not appropriate for real-time use because of the weight of processing required.

However, one variation involves averaging between sample points rather than brutally removing them. This variation uses a 'clipped' version in conjunction with the version still available in memory. As each sample point is added or removed, it is done so with a variation that takes into account the value of the current sample point and the next one, and the difference between the two is minimized. This enhances the naturalness of the sound.

Volume Envelope

Compared to a pitch envelope, a volume envelope is trivial. This is because we are only changing the values and not the frequency of the sample points that make up the sound. Hence, the actual length of the sample does not actually change, and the only alteration is in the discrete values of the sample points. No resampling is necessary, at least not in the traditional sense.

The principle remains the same, we define the range of sample points over which we intend to have an effect, begin at zero, and add the appropriate amount to the multiplication factor each time for the specified number of sample points. Code Sample 12.5 defines the volume envelope structure and the presents the code that alters a wave file based on the envelope.

CODE SAMPLE 12.5 Volume envelope definition and usage.

```
struct sVolumeEnvelope
{
  double dAttack, dSustain, dFade;
  int nAttackRatio, nSustainRatio, nFadeRatio;
};

  .
  .
  .

  sVolumeEnvelope oVolumeEnvelope;

  oVolumeEnvelope.dAttack = 0.1;
```

```
oVolumeEnvelope.dSustain = 0.0;
oVolumeEnvelope.dFade = 0.2;

oVolumeEnvelope.nAttackRatio = 1;
oVolumeEnvelope.nSustainRatio = 2;
oVolumeEnvelope.nFadeRatio = 3;

int nTotalRatio = 6;

long int lSample;
double dCurrentMultiplier = 0.0;

for (lSample = 0; lSample < oWavFile-
>GetNumberOfSamples(); lSample++)
  {

    oWavFile->SetSamplePoint(lSample,
      oWavFile->GetSamplePoint(lSample) *
dCurrentMultiplier);

    if (lSample <
      (oWavFile->GetNumberOfSamples() / nTotalRatio) *
      oVolumeEnvelope.nAttackRatio)))
    { dCurrentMultiplier += oVolumeEnvelope.nAttack;
continue; }

    if (lSample >
      (oWavFile->GetNumberOfSamples() / nTotalRatio) *
      oVolumeEnvelope.nFadeRatio)))
    { dCurrentMultiplier -= oVolumeEnvelope.nFade; continue;
}

    dCurrentMultiplier += oVolumeEnvelope.nSustain;

  }

  for (i = 0; i < oWAVFile->GetNumberOfSamples(); i++)
  {
    oWAVFile->SetSamplePoint(i,rand() % 255);
  }
  .
  .
  .
```

Of course, Code Sample 12.5 uses very simple additive functions for the shape of the attack and fade phases; they could also be exponential or sinusoidal, or any other function. The point is that the volume changes. The sustain change is nominally 0.0; this is left open as an option for effects such as tremolo or vibrato (pitch or volume changing rapidly during sustain phase). Such experiments are left to the reader.

SAMPLE BASE

In practical terms, it will almost always be slightly more realistic to build up a set of samples that sound good and fulfill the needs of the game. This way, the designers can be sure that the sounds that they use in the game will be realistic, either because they are recorded from real life-sounds (e.g., explosions, engines) or 'designed' to simulate real sounds (e.g., laser fire, etc.).

This set of samples is called the "sample base"; it can be used to generate all manners of variations using the techniques for modifying sound data that we have already discussed. Here are a few examples.

THE EXPLOSION

Mainly made up of white noise of varying degrees, an explosion has a volume attack phase with a high rate of change followed by a fairly short sustain period and a variable fade. The frequency of the sample can be dropped to produce a lower, bassier 'crump' sound, but the entire length will have to be shortened accordingly to prevent the sample's becoming too long.

LASER FIRE

Usually a single, short sound of varying pure-tone pitch, a good laser effect has a pitch envelope that has a high rate of change in the attack phase, almost no sustain phase (or at least one that doesn't change), and a low rate of change fade phase. The pitch usually rises in the beginning and falls toward the end, although reverse laser fire could be experimented with.

MOTORS & ENGINES

These are regular, almost square wave noises that can be generated quite easily from pure tones. Depending on the exact pitch envelope and waveform used, sounds like a spluttering car or a powerful motor boat can be

created, or even electrical whirring noises. A pure tone could be used, modified by a pitch envelope in which the wave form is almost triangular.

CONCLUSION

This chapter has dealt mainly with the way in which the machine can be persuaded to make sounds, both simple and complex. Every game will probably use a mixture of sound types, and how these are mixed together is up to the game designers. In the PC environment, for example, we have sound cards that are capable of producing two types of sound simultaneously—MIDI and WAV.

A game such as *Elite* uses both types, MIDI for the sound track and WAV for everything else. However, we can also mix different waves together with a sound track and generated simple sounds (based on modified tones with volume/amplitude envelopes) to create the final accompaniment. The same can be said for mixing in other samples and changing them as required. The only aspect to watch for is that the correct waves are modified and that the volume of the final wave is pushed up slightly each time two waves are mixed together so that the sound track does not become muffled.

In the following chapters, we shall deal with how to generate other types of sound, all of which can be represented using the WAV file definitions that we have seen here. We shall also look at actual music, our view aimed at being able to generate a sound track to go with the game.

THE SOUND OF NATURAL DISASTERS

INTRODUCTION

One interesting sound category exists somewhere between the natural and unnatural—sounds that accompany some natural events. Earthquakes, for example, can almost be considered natural stone wall (or floor) movements. Although, as previously stated, it is possible to take some expensive recording equipment to a geologically active location and record these sounds, it is not always practical (or safe) to do so.

Ideally, we would like either to record such as sound once and use it to simulate the others, or we could just simulate all of them using the noise channel of our sound generator (see Chapter 12). It is, however, usually more effective to establish a sample base of natural (real) sounds and mix them with generated sounds to achieve the end result.

Not only does this technique reduce the amount of sampling necessary, it also reduces the number of samples that we have to store.

In addition, we can generate all manners of different sizes of sounds—a large earthquake, a breeze, or even a cracking forest fire. Also, we can generate different variations on the sounds and play them through different speakers to impart a desired effect, such as the player being surrounded by fire.

WIND, RAIN, AND FIRE

These three elemental, natural sounds will be of varying importance from one game to another. They are three very different noises, and yet they can be combined to produce sequences of auditory data that the player will instantly be able to associate with reality. This is important, because if we

want to create games that will capture the emotion of a player, then sounds are going to play an important part in the whole design of the game.

These three sounds are different for other reasons. Wind and rain, for example, will surround the player. It is impossible to have wind 'over there.' It can be raining in a different place than the player, either as artificially falling water or the result of nature being influenced in some supernatural way. Wind, however, has no sound; the sound that is associated with wind is as result of its interaction with the surrounding physical world.

In fact, by themselves, neither wind, rain, nor fire have any sound. Rain is drops of water hitting the ground. Wind is air rushing through gaps in or around features in the landscape, or even around human ears. Fire only makes sound when it destroys or consumes something in the physical world. This also means that for each of the elemental natural sounds, there are different flavors, depending on what physical objects they are having an effect on.

WIND

The key to generating realistic wind is to remember that it should be based on white noise. It is rare that wind whistles with a pure tone. Wind does, however, to a certain extent whistle somewhat tunefully; we therefore need to *modulate* the white noise with a wave of varying frequency. A sine wave will do the job; but triangle and square waves can also be used if processing power is at a premium.

As was first introduced in Chapter 12, and as a concept that we will be returning to in the future, modulation it is the act of combining a known frequency wave with another sound. This is called "frequency modulation" (FM), and the known frequency wave is sometimes called the "carrier signal." FM radio waves as well as FM synthesizer chips use frequency modulation to either carry information or synthesize information, as in the case of the FM synthesizer that is a part of most sound cards.

In this case, the frequency and amplitude of the modulation change randomly with time, which by itself would produce a varying whistle. This would sound almost like wind, but not quite. It needs to be roughened up by adding some white noise. Using 'pure' white noise on its own is not really a good idea because it contains sounds from the whole spectrum. Instead, the white noise is passed through a filter that removes some of the variations.

A very simple, low-pass filter can be created by taking the average between two values and using that as the new value. This would seem to be a simple proposition, but in the frequency domain, it is not quite such an easy task to implement. Since all that the filter is designed to do is restrict

the frequency of the white noise to higher values, we can simulate white noise passed through a filter by simply restricting a randomly chosen frequency to a high value (e.g., >600Hz).

This alone will not be enough; if we choose two values next to each other that are close in values to each other, then the effect will be as if we had selected a frequency half as great as the desired frequency. In order to remove this unwanted effect, we should always ensure that the values chosen are significantly different from one another. We can apply two algorithms to ensure this. The first is to simply create values in pairs.

For white noise of 600Hz, we generate (per second of sound) 300 pairs of samples. The second value should always be the inverse of the first. Thus, for the 8-bit sound that we worked with in Chapter 12, where values run from 0 to 255, for a given value of 80, the first value should be 208 (128 + 80), while the second should be 48 (128 – 80).

The second algorithm to apply consists of making sure that each pair or pairs contains a first value that is significantly different from the other. We can do this by limiting the choice of random numbers to a range that satisfies this constraint; for example, limit the choice to the upper half of the spectrum if the first value was in the lower half. Again, for an 8-bit sample using 80 as the selected value, we would limit the first value of the second pair to a range from 0 – 64 (128/2), since 80 appears in the upper spectrum of possible values.

Now that we have a reliable source of high-frequency white noise, we need to turn our attention to actually generating some wind. The key to actually implementing a wind sound is in varying the modulation frequency and the white noise frequency. We shall concentrate on generating a WAV file that contains one second of varying wind. The first step is to create a sine wave that represents the modulation frequency, which varies a given number of times over the second of sound produced. Code Sample 13.1 performs this task for one second of 8-bit sound.

CODE SAMPLE 13.1 Varying sine wave.

```
void GenerateVaryingSineWave(int HiFreq, int LoFreq, int
nChanges,
                              WAVFile * oWave)
{
  double pi = 22.0/7.0;
  double frequency;
  int nChange;
```

```
// Function assumes that oWave is set up for a one-second
// buffer of 8-bit sound with a frequency that changes
// every nChanges cycles

nChange = 0;
frequency = (rand() % (HiFreq — LoFreq)) + LoFreq;

for (long int n = 0; n < oWave->GetNumberOfSamples(); n++)
{
  oWave->SetSamplePoint(n,
    ((( 2.0 * pi) * frequency) / oWave-
>GetNumberOfSamples() ) * n)
      * 128) + 128);

  nChange++;

  if (nChange > nChanges)
  {
    frequency = (rand() % (HiFreq — LoFreq)) + LoFreq;
    nChange = 0;
  }
}
}
```

We now need to add the low-pass filtered white noise using a slowly varying frequency over time. To do this, we can use a function known as a "ramp" function, which produces a gentle, saw-tooth variation over time. Code Sample 13.2 presents a function that produces a wave of white noise that can simply be mixed with the wave produced by the code from Code Sample 13.1 to produce the final wind sample.

CODE SAMPLE 13.2 Randomly ramped white noise.

```
void GenerateWhiteNoise( int nCutoffFreq,
                              WAVFile * oWave)
{

  // We are using an algorithm that relates the frequency to
  // the number of samples, with random frequency ramping,
  // from cut-off to the max frequency for the sample.
```

```
    int nLastValue, nThisValue, nCurrentFreq, nFreqDiff,
nMaxFreq;

    nCurrentFreq = nCutoffFreq;
    nLastValue = (rand() % 128) + 128;
    // Assumes 8-bit samples
    nMaxFreq = nCutoffFreq;

    for (long int n = 0; n < oWave->GetNumberOfSamples(); n =
n + 2)
    {
      if (nCurrentFreq >= nMaxFreq)
      {
        nFreqDiff = rand() % 10;
// Maximum of 10Hz jumps
        nCurrentFreq = nCutoffFreq;
        nMaxFreq = (1.0 +
          (((double)n+1) / (double) oWave-
>GetNumberOfSamples()))
            * nCutoffFreq;
      }
      nThisValue = (rand() % 128);

      if (nLastValue > 128)
        nThisValue = 128 - nThisValue;
      else
        nThisValue = 128 + nThisValue;

      oWave->SetSamplePoint(n, nThisValue);
      oWave->SetSamplePoint(n+1, (nThisValue - 128) * -1);
      nLastValue = nThisValue;
      nCurrentFreq += n FreqDiff;
    }
}
```

Using these two algorithms, trial an error will enable the reader to produce all manners of wind sounds, from gentle breezes to howling gales. For a more advanced implementation, the JSyn site at http://www.softsynth.com/jsyn/ examples/ has wind sounds, rain sounds, and more.

RAIN & FIRE

Rain sounds can be generated in a variety of ways—many small waves, for example sine waves, which are multiplied by a wave generated by a parabolic function. Those with a mathematical bent should be able to take the building blocks that are presented here to generate the short bursts of sound that mimic rain falling into puddles. The inspiration for this technique can also be found at softsynth.com.

The decision as to when to trigger a parabolic arc is based on the probability of a white noise source reaching a prescribed value by continually adding together values until a threshold is exceeded. At this point, a sine wave of a given frequency (determined at random) is triggered along with a parabolic arc that determines the amplitude of the sine wave burst. This process continues many times per second.

Fire follows a similar process, except that the bursts are slightly less frequent and are sharper—more akin to crackles and pops than a rumble. In fact, triangle waves are best suited for fire; and, rather than a parabolic arc, an exponential attack and delay shape works better if the amplitude rises sharply at the beginning and then fades sharply afterward.

This information, along with the water algorithms given above, should be enough for the game designer to begin writing their own generation of software. Paying a visit to the JSyn site is also recommended. A slightly more advanced addition to these techniques involves using multichannel sound.

Multichannel WAV Sound

Until now, we have dealt with simple 8-bit mono sound, with one byte per sample and only one channel of information. However, the WAV format allows for as many channels as the sound device can handle, from stereophonic (two channels, left and right) to quadraphonic (four channels, left and right, front and back). Sixteen-bit quadraphonic sound is defined as using 2 bytes per sample point, and four interleaved channels.

As noted in our preliminary discussions on computer sound in Chapter 12, this gives us the possibility to represent amplitudes with a much smaller granularity, given a higher definition, but at the expense of storage requirements. A single second of 16-bit surround sound sampled at almost-CD quality (44,100Hz) has an uncompressed size of 352,800 bytes. Bearing this in mind, using multiple channels can increase the reality of sounds like rain.

Rain drops fall at a rate that is far beyond the capacity of a machine to match. Therefore, rather than trying to simulate an infinite number of rain drops hitting the ground at once, the approach above attempts to mimic the sound of a finite number of drops falling in close proximity.

To achieve the all-encompassing sound of rain falling all around the player requires a little piece of audio trickery. Rather than forcing the sound into one channel (mono) and then playing back the same sound through two channels during the play session (simulated stereo), it makes more sense to generate the sound during the play session and use up to four channels.

The key to the technique lies in 'choosing' a channel at random, per wavelet, and generating sound for that channel. By itself, this technique will produce a sound that is fairly confusing; the brain will try to focus on one channel before being abruptly diverted by the sound coming from another channel.

To avoid this, the sounds have to be played simultaneously with a slight time differential. In this way, the brain will treat the sounds as a continual stream and situate itself 'in the middle' of the sound in much the same way as when listening to music through headphones—the listener has the sensation of being in the middle of the music.

EARTHQUAKES

Finally, an earthquake can be simulated using low-frequency random noise (red noise) that has a bass index greater than the treble index. This means that although the sound may contain high register frequencies above a certain threshold (say, 150Hz), the base waves that produce the sound are generally lower.

Again, we use a wavelet-like model that will produce bursts of sound. Sine waves are used as the base frequency. Wind, rain, and earthquake sounds are all more or less similar in the real world and can all be modeled with this pseudowavelet theory. The reader can experiment with these for hours, generating different strange sounds that will range from water and fire to pure noise.

CONCLUSION

Experimentation with the sound-generation techniques presented here is the key to achieving satisfactory results. In fact, there is no substitute for

the human ear in discerning whether or not a particular sound is 'realistic.' In this, one has to be very careful in selecting how the sounds are to be generated and try to limit the range within which parameters can be chosen to avoid the embarrassment of producing a raspberry instead of an earthquake.

The theories hold, however; and it is up to the designer and programmer to take them and turn them into true techniques. The next chapter takes these theories and applies them to the animal kingdom, where we shall simulate all manner of birds and beasts.

NONHUMAN SOUNDS

INTRODUCTION

In Chapter 13, we looked at using white noise as a trigger and also used white noise as a base sound for other waveforms. We also varied the frequency and amplitude of waves (such as sine waves) using a variety of techniques for modifying the way in which such variations were introduced. We did not state them explicitly, so we shall do so now. Most can be applied in either the frequency or time domain.

RAMPING

Values that are ramped change in a predefined manner (usually based on a simple addition or subtraction) until they reach a certain limit, at which point they are reset. The value that they are reset to can itself be based on a ramped scale until it, in turn, reaches a critical level and is reset. Nesting more than two ramped sequences becomes unwieldy, but it is occasionally useful.

MODULATION

In this book, we use frequency modulation to provide a carrier wave for another sound—white noise, for example. The result is that the white noise varies in pitch following the carrier wave (we have used a sine wave), whose frequency can vary with time. Again, the wind-generation algorithm in Chapter 13 is a prime example.

AMPLITUDE ADJUSTMENT

Broadly speaking, the amplitude of a given wave (assuming it is consistent), is directly related to the perceived level of sound that the wave makes

(more commonly known as the sound's volume). However, when the amplitude is changing in a manner that is not consistent, some interesting effects occur. When two regular, out-of-phase waves are added together, the result could very possibly be complete silence, for example.

We used some of the qualities of adjusting the amplitude in this way in Chapter 13's discussion of fire and rain. Busts of sound were generated using a parabolic arc to control the level of sound (the amplitude) in such a way that there were occasional busts of silence between drops, which has the effect of producing miniature waves or wavelets. They are not true wavelets, because true wavelets have the fractal quality of self similarity; that is, each wavelet has a mathematical similarity to the 'mother' wavelet that spawned it.

All of these techniques can be used in the generation or manipulation of sounds with varying degrees of success. Unlike pure machine sounds or even sounds of natural phenomena, some animal sounds are subtly complex and cannot be based on either random noise or pure frequency sound.

BIRDS

Bird sounds fall into two broad categories. The first category is 'singing,' an often melodious sound that is almost musical in nature. The second is an altogether different sound—a kind of scream, like that associated with some varieties of parrots or eagles. We have also lumped together real screams with the cries of some birds that are between singing and screaming.

Of these two categories, the first can be generated using pure tones, while the second cannot and must be based on reality. In fact, given a powerful enough system, it is probably possible to generate the cries and screams of birds that fall into the second category, but it will prove more efficient to record real cries and adjust the WAV file before it is played back.

GENERATING BIRDSONG

While this author is no expert on ornithology, several categories of birdsong come to mind. The three that we shall look at here are tweets, chirps, and whistles. We shall base our generation algorithm on two types of sound wave, the sine wave and the triangle wave. (Keep in mind that the names given to the different bird sounds are largely subjective when considered in a nonscientific manner, as presented here; any real ornithologists will know the correct terminology, and any misuse of scientific terms is purely accidental.)

A tweet sound can be represented by a short burst of pure sine wave, which has a frequency that diminishes sharply but regularly with time. Choices for the starting frequency and rate of change can be made on a trial-and-error basis to find the lowest and highest pitches that will be acceptable. Once these have been found, it is a fairly simple matter to generate tweets on demand. Each tweet should be different, but each individual bird will probably have a restricted range of 'notes.'

A chirp has a slightly different envelope than the tweet, largely because it starts at a lower frequency and rises to a higher frequency where, depending on the programmer's choice, the frequency might fall slightly. Again, peak frequency values and frequency ranges can be found by experimentation. Either a sine or triangle wave can be used, depending on whether a sharp or soft sound is required.

Finally, a whistle is again different, because unlike tweets or chirps, it is a fairly continuous sound that changes frequency in a fashion usually dictated by another, underlying wave. A sine wave can be used as the principle sound-generation medium, while the frequency can be varied using either a triangle wave or another sine wave. Although the whistle has been described as continuous, it will have to break from time to time so that the bird can breathe.

Any of these sounds can be combined to produce a steady stream of bird song, and the JSyn site (Web site: http://www.softsynth.com/jsyn/examples/) has five or six variations on the bird song theme. Using the spectrogram to analyze the waves, one can distinctly see the envelopes described above.

BIRD CRIES

As previously mentioned, bird cries cannot really be simulated. This is because they are too complex. And, like the human voice (which we shall cover shortly), bird songs vary greatly from species to species; generating them is impossible in an efficient way. If, however, we record several possible bird songs, and store them on the distribution media, they will not take up too much space and can be adapted in real-time by using any of the enveloping techniques discussed in Chapter 12.

BEASTS

Like bird sounds, it is unlikely that noises such as growls and roars can be generated from scratch during the play session. It is worthwhile noting,

however, that some of the more common noises that animals make, such as the purring of a cat, can be simulated using complex combinations of waves.

There are many different forms of noises that animals make with much more variety in general sounds than bird noises. This is largely due to the diversity of noise-production apparatuses that animals are equipped with. Take for example, cats versus elephants. Cats use a variety of different sounds to represent their moods and produce a wide range of meows and purrs. An elephant mainly uses its trunk as a means of creating sounds and produces different types of sound than a cat, but with as much diversity. Whales also have an entire communication system based on whistles and squeaks, as do other sea-faring mammals, like dolphins.

Some sounds, like an elephant's trumpeting, can be simulated using a similar musical instrument algorithm (such as a trumpet). These are rare, however. But the first step is always to look at all of the possibilities so that the best approach can be selected.

Assuming that no purely algorithmic approach seems to fit, the next stage is to either rush out and record the required animal sound, or (if you do not live near a safari park) find some royalty-free samples for use in your project. The Internet has a slew of sites that provide these kinds of samples, some royalty-free, some not. If in doubt, always ask before using the sample. Some good sites are http://www.Wavhounds.com, http://www.MusicRobot.com, and http://www.A1FreeSoundEffects.com, all of which provide royalty-free sounds for your own use.

Once some suitable samples have been acquired, the best should be chosen for inclusion in the project and used as the sample base. Of course, we could store as many as needed for all the animals that are going to be encountered in the game, but it makes more sense to store one or two good-quality samples, and then use the enveloping and associated techniques from this book to modify the sounds during the play session.

There will, of course, be many more animal sounds that might be used in a game, and it will be up to the designer to decide how those sounds should be developed, while always being aware that the richness of the sounds that are used to accompany the game rely on there being enough storage space for the media and enough processing power to play them back.

An extension of the techniques in this book for generating animal noises that mimic real-life creatures is to apply techniques to make the sounds more alien. One example is reversing the sample while keeping the same amplitude envelope. This is tricky and requires resampling the sound effect so that the exact amplitude envelope can be mixed with the reversed wave. Thus, some of the unwanted effects of reversing the wave can be avoided;

those who have tried this will understand the difficulty of its explanation, but the technique will give the sample a strange, unnatural sound.

INSECTS & REPTILES

Finally, the animal kingdom also plays host to a variety of other, smaller beasts that produce their own range of sounds, from hissing to that odd noise that grasshoppers make by rubbing their legs together in the summer. It is up to the designer and programmer to determine the best way to generate the required sounds, but there are a few fairly obvious pointers.

A hissing sound can be created using high-frequency white noise. Although it might not be perfect, it will be recognizable. The frequency has to be kept reasonably high with just enough variation so that it is not a pure tone.

Most insects make noise only when they move. Ants, for example, do not have an audible cry, but when a lot of fairly large ones decide to move at once, the result can be impressive. Some small reptiles also make most noise when mobile. These sounds can be generated by using a wavelet algorithm with a slightly higher frequency than that used for rain. This approach can also be made to sound like rustling if the parabolic arcs are close enough together.

CONCLUSION

While it is hoped that this qualitative look at animal sounds has given the reader inspiration and a break from some of the more technical aspects of sound production. There are also many practical pointers that should aid the designer in creating the ambient sound effects for a game. It is important to remember, though, that these are only ambient much of the time. Unless a strange beast appears that needs to be slain, many of the bird calls and reptilian sounds discussed here are added to the game universe to impart 'atmosphere'; the designer should not get carried away.

A final note on the sound generator is design: The JSyn approach uses the idea of building blocks; take a sine wave with varying frequency, add some white noise, and we have wind. This is a good approach because all the tools we need are in one place. Whether we want to mix a sampled wave with a generated pure-tone frequency or create a piano sound, the basic wave—the sine wave—will be the same, so there is no point in developing it twice.

This may seem obvious, but if several people are working on different parts of the game engine, such as audio/video rendering and the sound track, then it can be easy to lose track of who needs what. A good, real-time wave player can be shared by the system responsible for playing the sound track, the system handling full-motion video, and also the sound effects generator.

Before we take a look at music, we shall see how it is possible to use the above techniques to reproduce our most complex sound yet: the human voice.

HUMAN &
HUMANESQUE SOUNDS

INTRODUCTION

Generating human sounds (or at least sounds akin to human sounds, known as "humanesque" sounds) is not something that can be easily done algorithmically. There has been a lot of research into speech synthesis over the years, and until now, no results have been yielded that can be used to completely generate human and humanesque sounds from scratch.

The recourse is to sample real-life human sounds and use them to either generate artificial voices (after the sampling has been converted into formulae that generate sound waves that are a close match to the samples), or combine them with algorithms that enable the base samples to be used in new ways.

Furthermore, we can also create a sample base comprised of specific phonetic particles called *phonemes*, which represent the majority of sounds in a given language. It is possible to record (or synthesize, if we wish) all the sounds needed in order to satisfy the requirements of a specific language, and then string them together to produce a steady stream of sound—speech.

This chapter details how different sounds can be manipulated to generate variations on the sample base to match differing situations. In this way, we can reuse the sample base and save time and resources by applying some algorithmic alterations to the data.

SCREAM & SHOUT

In Chapter 14, we looked at some simple techniques for using a certain profile or envelope to modify a sound over time. We used both volume and

pitch envelopes to alter the properties of a sound so that it resembled a connected, but different sound.

Take for example a cry that could be expressed in textual form along the lines of: "Aaaaaaaargh!" We might like this shouted. It could be a war-cry. Add a question mark at the end: "Aaaaaaaargh?" and it has a totally different meaning. We could record many of these sort of samples, and then record more for male, female, and child versions. By the time we had enough to cater for every eventuality, we will probably have used up much more storage space than we can reasonably afford.

However, record the sound without emotion and sample it at a reasonably high level, and we have a workable base that can be altered in volume and pitch to become something else. If we alter the volume or pitch in a nonuniform manner, we can even make the question format of the sound too; simply simulate the raising of the voice at the end of the last syllable.

TALKING & WHISPERING

If we do not require intelligible speech—only some noises that sound like voices—then we can take some humanesque sounds and run them together at low volume in the background. This approach can use some, or all of the techniques mentioned in this chapter; and it will prove quite realistic.

What has to be borne in mind when embarking on any project that contains human sounds or real speech is that there are two ways of creating the sounds: either sample-based, which uses a lot of storage space but achieves high levels of realism; or model-based sounds that are generated by mathematics, which will be efficient in terms of storage space required, but ultimately the realism will depend on the processing power available to crunch the numbers.

REAL SPEECH

Earlier, phonemes were mentioned—how they represent the sounds that are strung together to create speech. A good phonology text, such as *English Phonetics and Phonology* (P. Roach. U.K.: Cambridge University Press, 1983) will give a complete list of the phonemes in the English language. *English Phonetics and Phonology* lists approximately 44 phonemes that represent a large proportion of the sounds necessary for generating English speech.

Each phoneme has a specific symbol associated with it, which is used to associate a specific sound with a part of a word (or segment). Words are formed from segments and based on rules that enable the computer to create a phonetic version of the plain-text word fed to it by another part of the game engine. In future chapters, we shall cover specific ways in which words are chosen or generated. For now, all we are concerned with is being able to reproduce these words as speech.

However, if we simply play the WAV files that correspond to the phonemes making up the word in question, one after the other, the speech will be stilted, since there will be gaps between each phoneme, resulting in unnatural speech. Even if the cropping of the recorded wave is perfect, there is no escaping the fact that there will be one of two problems: Either, the wave will be cropped to the extent that it seems cut off before it has finished, or it will fade to a quiet sound, which causes a discernable pause between sounds.

The solution lies in being able to merge the sound data in real-time before each word is played, thus ensuring that there is a continuity from sound to sound. The basic algorithm follows the combination calculation from Chapter 12:

```
new_wave.point[n] = (wave_1.point[n] / 2) + (wave_2.point[n] / 2)
```

This is a simple average that will merge two sounds. The next decision involves knowing exactly where to begin the merging process, or phoneme concatenation. If we assume that the WAV file has been manually cropped such that only the 'meaningful' sound remains, then we can run the sounds together by fading between them. The calculation then becomes:

```
new_wave.point[n] =
((wave_1.point[n] / 2) * fade) + (wave_2.point[n] / 2)
```

where `fade` is a value that decreases linearly. The exact point at which the decay begins will depend on the usage; but for now, let us assume that the decay begins at 90% of the length of the first sample. We could also fade in the second sample as the first is faded out, but this is left for the reader to experiment with. Code Sample 15.1 shows the fade between two samples, which could be used in a variety of situations, but it is quite well adapted to concatenating phonemes.

CODE SAMPLE 15.1 Sample fading.

```
void FadeBetween(WAVFile * oFirst, WAVFile * oSecond,
WAVFile * oTarget)
{
  // First, set up the target WAV file, assuming oFirst and
  // oSecond are both similar
  if (oTarget->pData != NULL) delete oTarget;
  oTarget = new WAVFile(
    oFirst->lSamplingFrequency,
    (oFirst->GetSampleLength() * 0.9) + oSecond-
>GetSampleLength(),
    oFirst->GetNumberOfChannels());

  long lTargetSamplePoint = 0;
  long lFirstSamplePoint;

  // Do the first sample up to 90%

  for (lFirstSamplePoint = 0;
       lFirstSamplePoint < oFirst->GetDataLength() * 0.9;
       lFirstSamplePoint++)
  {
    oTarget->SetSamplePoint(lTargetSamplePoint,
      oFirst->GetSamplePoint(lFirstSamplePoint));
    lTargetSamplePoint++;
  }

  float fDecay = 1.0;
  long lSecondSamplePoint;
  unsigned char nSampleValue;

  // Do the second sample
  for (lSecondSamplePoint = 0;
       lSecondSamplePoint < oSecond->GetDataLength();
       lSecondSamplePoint++)
  {
    fDecay = fDecay - 0.1;
    nSampleValue = oSecond-
>GetSamplePoint(lSecondSamplePoint);
    if (fDecay > 0.0)
    {
      nSampleValue = nSampleValue / 2;
```

```
        nSampleValue =
          nSampleValue +
          (oFirst->GetSamplePoint(lFirstSamplePoint * fDecay)
  / 2);
        }
      oTarget-
  >SetSamplePoint(lTargetSamplePoint,nSampleValue);
      lTargetSamplePoint++;
      lFirstSamplePoint++;
    }
}
```

The assumption is that to a listener, the sounds emanating from the speaker's mouth are a sequence of phonemes that run into each other. That is, at a given moment in time, the effect of one phoneme will be starting to fade even while another is beginning. Granted, this is a fallacy; but considering that we wish to record single sounds, it is the best we can do. Combining single sounds will always be a less-suitable substitute for recording groups of sounds; but if we were to try and record every possible group of phonemes, then we might as well just record all the words that are to be used during the game and be done with it.

Naturally, we can do this, and in many cases it will be a good approach—simulated football commentaries for example. But the same WAV file-merging process should still be followed—using words instead of phonemes. Words, however, are less prone to the effects of clipping the WAV files; when we speak, we naturally pause between words as a sentence progresses.

Of course, the drawbacks are that a lot of WAV data needs to be stored, especially if we want to store enough to be able to recreate as many real words (and even some invented ones, as we shall see in Part IV) as possible. This means that with the processing required and the storage needed, we are excluding from game play all but the most powerful of platforms.

MECHANICAL SPEECH

One of the earliest examples of synthetic computer speech in the home computer arena was the phrase "Welcome to *Repton 3*," which was spoken once the game had finished loading from cassette. Considering that the

platform was a BBC Model B with 32Kb of memory and that the game was completely loaded into the computer, we can dismiss the idea that the speech was a real sample, albeit a very poor-quality sample.

Clearly, the speech was generated using some kind of synthesis algorithm and played through the speaker. The domain of speech synthesis is huge; and like many of the topics in this book, we can only skim the surface here. Much of the work that has been done is academic and gives rise to solutions that, while elegant and sophisticated, are not practical for real-time gaming.

Let us take a trip down memory lane and a revisit an old friend—the BBC Micro. David Hoskins, a programmer working for Superior Software, was a pioneer in the field of home computer speech synthesis. In an article in *BBC English* (January 1986, Web site: http://www.nvg.ntnu.no/bbc/doc/Speech.html), he explains a very efficient software-only solution that fits into about 7.5Kb of memory. A good treatment of the concept of phonemes is also given in the article, and (in case the reader is in any doubt about the previous section of this book) Hoskins sums up the concept with aplomb: "The answer is in phonemes: the sounds that we string together in order to make speech."

Hoskins' software, "Speech!," used 49 phonemes to represent the tapestry of sounds that is the English language. So far we are in familiar territory; sampling phonemes was covered in the previous section. The advantage of mechanical speech is that we can make the machine say anything we want. There are drawbacks, of course, and as Hoskins points out:

> *The trouble with the English language is that it is occasionally very illogical. For instance, the word "laughter" almost completely changes pronunciation when an "s" is prefixed to make "slaughter."*
>
> —*BBC English*, "Your Computer," January 1986

Hoskins goes on to note that the entire language can only be represented if we allow for at least 400 rules, which have thousands of exceptions. We can get around this by modifying the representation of the words in such a way that phonemes are chosen that combine to produce the correct sound, resulting in fairly realistic speech that also uses less samples. The wave forms are mixed together in much the same way as in our combination calculation above, except that the splicing is dependent on the number of repetitions required for each phoneme. Hoskins explains:

With the phonemes "AA" in "Yard" and "EE" as in "Feet" the merging was achieved as follows. When the "AA" phoneme starts, 128 samples are played and then 0 samples of "EE." Then 127 samples of "AA" are played and 1 of "EE." This continues until the end of the "AA" phoneme when 0 samples are played of "AA" and 127 of "EE," you see!

This merge is timed to finish exactly when the first phoneme has finished its cycle, no matter how long it is played.

— BBC English, "Your Computer," January 1986

It sounds complex and does require a lot of sampling, even for mechanical speech. The advantage is that each phoneme recording will be very small and require very little storage space. Furthermore, each one can actually be represented as a modified sine wave.

The sine wave is modified by using complex envelopes that can alter the basic wave to make any sound from a squeak to a croak. These new envelopes, rather than being fixed to three phases, can be multiphased and have a varying number of phases, each having different properties. In this way, we can recode the samples as purely numerical data, which is then used to modify a basic sine wave.

For those readers who really want to experiment with this kind of synthesis at a detailed level, research should start with the **ON THE CD** Klatt Cascade-Parallel Formant Speech Synthesizer. A detailed breakdown of the Klatt software (originally written by Dennis Klatt in FORTRAN and since ported to C++) can be found at http://www.cs.bham.ac.uk/~jpi/klatt304.html. The original Klatt article appeared in the *Journal of the Acoustic Society of America* (March 1980, pp. 971–995). In 1993–1994, Jon Iles of Birmingham University (U.K.; E-mail: J.P.Iles@cs.bham.ac.uk) and Nick Ing-Simmons (E-mail: nicki@lobby.ti.com) modified a version and posted to the Internet newsgroup comp.speech, which closely adheres to the original. It was released under the GNU Public License, and a copy appears on the companion CD-ROM.

The implementation details of the Klatt model go far beyond the reach of this book, and all that we are really concerned with is that it works. How it works is the result of years of research, which boils down to the basic premise that vocal sounds are produced by resonance. To this end, there is a mathematically modeled resonator that modifies a base (or fundamental) frequency using a number of equations that produce realistic results.

Looking at the source code (parwave.c) there is also a large quantity of predefined data, such as that which helps to model a natural-voice source. There are plenty of comments in the code, along with excellent references to the original theories for those who are interested. Most of us, however, will just want to adapt the code (which is allowed under the GPL (GNU Public License)) for our own use.

Therefore, here follows a (very brief) summary of the parameters that can be used with the `parwave` function. First, we assume that the members of the `klatt_global_ptr`, which is passed to the `parwave` function, have been defaulted according to the contents of the `klatt.c` file and use the default natural samples array as defined therein.

Each call to the `parwave` function needs these globals and a set of parameters stored in the `klatt_frame_ptr` variable. These are what gives the sound its shape, which in turn makes it sound human. They are based on six frequency values and six associated bandwidth values that can be fed into the Klatt function. Ignoring all the other possibilities (which have to do with molding the synthesized voice), we can now simulate English sounds using a table of values published in 1980 by Klatt along with the original research.

The actual values for selected vowels and consonants appear on the companion CD-ROM in the files vowel.par, son.par, *ON THE CD* fric.par, affr.par, plos.par, and nas.par. The fric.par, affr.par, and plos.par files contain values for three frequency/bandwidth pairs, plus some values representing the shape of a fricative or plosive burst, sounds which are associated with consonants.

These parameter files can be used to simulate words by looking up the appropriate entry in the file, based on the input text, and generating a piece of WAV file that can be concatenated together with the others to produce the word. The WAVs could also be mixed together using techniques described in this chapter.

Implementing these changes is a trivial exercise, and the original code can be easily adapted. The most complex operation will be to determine the exact mix of sounds that make up a given word. In the end, it will come down to knowing which sounds to use for which sequences of letters; a lot of trial and error will be involved, and a large, rule-based system will result—that is, a big database of words.

CONCLUSION

What became apparent from the research conducted into the various techniques that have been established over the years that deal with producing human sounds, including actual language, is that it is a science all to itself. This book cannot begin to delve into some of the more-advanced techniques that can be used to generate speech. This chapter is presented to offer some hints as to how some of the freely available, existing techniques can be used.

Exactly what mix of data-to-program code is used will depend on the desired result; but in the end, it is vital that some target model be used for the same reasons as those for generating sounds of natural disasters like earthquakes: Realism must be upheld at all times.

MUSICAL THEORY

INTRODUCTION

In this chapter, we shall take a look at how computers can be persuaded to play music—from simple tones to sounds that mimic string, wind, and percussion instruments. Also, we shall be examining how music integrates with the game and how music can be generated based on themes in both a structured and pseudorandom fashion.

In fact, readers without any musical capability will find themselves able to arrange simple computer-written pieces by using a few simple rules and, above all, mathematical formulae. So structured are these rules that the music can also be created on the fly during a play session (instead of being stored in one of the many available formats), thus making each piece entirely fluid and of unlimited length.

This is an important distinction: Music created by a human composer (sampled and recorded) usually has to have a beginning, middle, and end. Once the end is encountered, we must go back to the beginning and play the whole lot again. Computer-generated music, on the other hand, can have a beginning, middle, extended middle, possibly an ending, or perhaps a clever segue into the middle again, a change of pace, or possibly even an interlude of mayhem and destruction, depending on the circumstance.

Since generated music is based on mathematical formulae and algorithms, there is no limit to their creativity, and patterns are guaranteed. Before we take a look at the world of computer-generated game music, however, we should look at the tools we will use—the instruments.

INSTRUMENT TYPES

There are several different classes of instruments and many subclasses that encompass all kinds of instrument, of which a very few are shown in Figure 16.1.

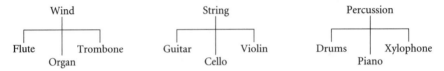

FIGURE 16.1 Instrument types and classes.

Each of the above has its own sound, and while in general the same note produced by each is identical in tone, the texture changes from instrument to instrument. Take a harp, for instance. A harp is plucked and produces a certain sound. Place a harp on its side and strike the strings with a little felt-tipped hammer, and we have an instrument that approximates a piano (or harpsichord). The sound that each produces is very different, yet both instruments are almost identical in certain aspects.

NOTES & SAMPLES

The waveforms that we have been discussing in previous sections are known in the computer music world as samples. Creating a sample is not a difficult task for those who have access to a computer with a reasonably good-quality sound card and, of course, the instrument to be sampled. Sampling is often a slightly tricky business, requiring a good microphone, a quiet room, and plenty of patience.

Sampling is essentially recording a single note played on an instrument and then cleaning up the recording so that only the note itself is stored within the sample. The sample can be a single musical note or a chord made up of several notes played together on the same instrument, multiple instruments, percussive elements, or any combination of instruments. Some examples of single-instrument samples are a single key struck on a piano or a string of a guitar being plucked. Compound samples are more complex, such as the popular synthesizer sound Orchestra Hit, which is available on most electronic synthesizers and is a single note played by multiple instruments simultaneously.

Preparing to sample an instrument is not, however, just a hardware problem. It is also a software problem. There are many pieces of specialty software for recording and altering sounds, and they often come packaged with modern sound cards. For example, shareware package GoldWave is an all-in-one recorder and editor with many useful features.

Before we embark further into samples and sampling, we should cover a little more theory on converting analog sound waves to digital data sets that can be manipulated by a computer. When a sound wave is recorded and examined using an editor such as GoldWave, the image is something akin to Figure 16.2.

FIGURE 16.2 A sound wave.

The image represents time on the *x*-axis with frequency up and down the *y*-axis. The frequency of a sound wave can be loosely defined as the number of clicks per second. The musical note middle C, for example, has a frequency of 262Hz, which represents 262 clicks per second. Why 'clicks'? If we were to take a loudspeaker and connect it up to a device that made it beat in and out, for each in-out movement, we would hear a click. If we were to alter the behavior of the device so that the speaker was made to move in and out 262 times per second, the sound filling the room would be the pure tone middle C.

Then, if we record this sound for one second using a computer, assuming it would register a 1 for the presence of sound and a 0 for silence, we would have a wave one second long with 262 peaks. To exactly reproduce the sound, we would need to test for the presence of sound 262 times per second. The sampling frequency would therefore be 262Hz.

This is the minimum sampling frequency; and we are, of course, free to sample more or less times per second than is strictly necessary. If we sample more times, then the quality remains the same. Sample less, and the quality begins to deteriorate. Somewhere, though, there must be another factor at work, since if we were to sample at half the frequency, we might expect only to play back the sound at 131.5Hz, which would produce a lower note.

In fact, samples usually take place at around 44kHz, which means testing for a pulse 44,000 times per second. At these rates, a 262Hz pure note can be captured in a much smaller fragment of a second, roughly 0.0059 seconds (5.95 milliseconds).

When we sample actual sounds (be they instruments or noises like those covered in Chapters 12–15), the rate of change of the sound is much higher than a pure note. This rate of change is expressed in terms of both the pitch of the sound and the volume. A piano, for example, is a percussion instrument and has a very loud and sudden attack phase (the beginning of the note), which then fades at a more or less constant rate.

A flute, on the other hand, has a smoother attack phase and a sharper fade; if the person playing the instrument stops blowing, then the note also stops fairly abruptly. It is this rate of change that gives each instrument its unique characteristic, although all instruments (even drums) can be tuned to the same note.

Finally, once we have our sample in hand, we can play back the sound at a given frequency to simulate the same instrument played at a given note. This is where our theory from above takes shape. If we play back our pure note, 262Hz recording at twice the recording frequency (524Hz), then the pitch will be twice as high. Of course, it will last for half as long—0.5 second. The same applies for any sample; the length will be proportional to the difference between the sampling frequency and playback frequency.

There is a technique, however, to get around this, which might or might not be suitable for the gaming environment. It enables us to extend the sample playback time by stretching the sample as required. There is, however, a certain degradation in quality inherent in resampling a recorded sample in this way, and it is better to have several samples at different frequencies available so that the most appropriate one can be chosen.

From Pure Note to Instrument

The previous section detailed the best possible quality of sampling and playback. Most owners of electronic synthesizers are aware, though, that

this is not always adhered to. In fact, in most cases, the instruments are simulated using a study of their unique waveforms so that the mathematical description can be applied, like a filter, to a pure tone in order to get the same sound as an instrument playing at the same pitch.

DISTORTION & OTHER ENVELOPES

Besides altering the shape of the pure tone to arrive at a specific instrument sound, there are also a range of other filters that can be applied to change the nature of the sound. A guitar, for example, comes in many different flavors of sound, from the pure string pluck to distorted, 'crunchy'-sounding chords.

In the same way that a chord played on the guitar is several strings played at once (meaning that we do not have to store both a chord and each string separately), we do not have to store a distorted version of the string sample either, since there are various mathematical formulae for describing such filters.

PATTERNS & BEATS

Mood is an important ingredient in both music and games. Those who have played *Doom,* for example, will be well aware of how heartbeat and breathing samples play and important part in setting the ambiance of the game. The music is fairly consistent, unlike in *Elite II: Frontier,* which allows the player to specify different musical pieces for various events during the play session, such as going into battle, docking, and even hyperspace jumps.

The technique of using the beat of background music lies somewhere between these two examples, since it can be used in conjunction with a well-chosen musical genre to provide a soundtrack that adds a movie-like atmosphere to the game. As the adage goes, "Real life is not set to music." But in movies and games, music can be used to great effect for adding atmosphere and a sense of drama to the viewer's/player's perspective.

Music can also clue us in on what is to come—in a film, when a certain arrangement of music is heard, we know that something is going to happen. Fast-paced music often precedes a car chase or violent melee scene, whereas love scenes are prompted by an entirely different kind of softer music. Either way, music can not only add to the mood, but can also serve as an audible, early warning vehicle for the player.

This is the theory behind adding music to a game. The practice, however, often forces game developers to make some tough decisions when faced with how much variety they can afford to musically add to a game. Constraints are often severe in terms of the number of samples that can be crammed into memory along with all the other graphics and effects that the designers wish to throw into the melting pot.

We have already seen how this might not necessarily be the case. Samples can be reused and tweaked on the fly, as long as a healthy balance can be struck between the processing power required and storage requirements. The same theories can also be applied to musical pieces. We do not have to store the whole score to the game in a soundtrack, we can generate it as we go along.

We are, however, getting ahead of ourselves. In this section, we shall be looking at the beats and patterns that make up the rhythm section of the music. It is this rhythm that often precedes the actual melodies that add volume and body to the musical pieces. Later on, we shall be adding more musical theory to this basic beat theory in order to build an entire picture.

Before we move on with beats, though, note that if we generate these pieces using the rhythm section to manage all the rest of the musical score, as opposed to just playing them back, we can link the flow of the game to the music in a much more cohesive manner. For example, the end of the race, which cannot really be predicted, can have a certain piece of music that notifies the player of the success or failure of their race (win or lose). The music is attached to this final status and can be worked into the tapestry of the background music so that it is practically seamless.

Without going into a detailed discussion of beats and their general place in music, we can make a few fairly sweeping statements about how the percussive elements of a drum kit can be combined to provide the backing beats for music. The elements of the basic kit are the bass drum, snare drum, hi hat, cymbal, and low and high tom-toms. No doubt, these go by different names in the music world, but these names are the 'popular' ones for the different pieces of the standard drum kit.

Of course, there are variations, such as the rim shot (hitting the rim of the snare drum), open and closed hi hat, and the position of the 'rattle' underneath the snare drum that alters the sound of each instrument. These variations are quite important and will be discussed as and when they occur. Owners of synthesizer keyboards will be quite aware of the basic drum patterns that can be used and the classes that they fall into.

For each style, we shall talk in terms of the different instruments used and the tempo at which the beat is to be played. Usually, the tempo can be varied at will; although in some cases, too slow a tempo will result in gaps of an unacceptable length between instrument events. And too high a tempo might result in a cluttered sound that does not resemble a beat at all.

FROM DRUM TABLATURE TO COMPUTER BEATS

We shall be giving examples of each beat based upon a grid or tablature (tab for short). This is similar to the regular musical stave, with the exception that there are as many positions on the stave as required for the number of individual instruments. The complete drum stave is shown in Figure 16.3.

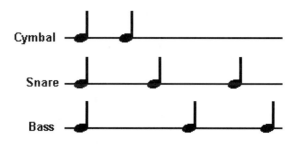

FIGURE 16.3 The drum stave.

Although the drum stave is used in the real world as a fairly easy-to-read way of depicting which instrument in the drum kit to hit at each beat, computers cannot read music that is represented in this way without quite a lot of advanced optical-recognition technology.

For our convenience, we shall derive a format for storing drum beats (and later on tunes as well) that is based on rotating drum music boxes—essentially a series of metal pins that extend from a drum and pluck a comb-like arrangement, which in turn produces music. Many systems for tabulating music use a system that is essentially a series of 'tracks' that contain, at each beat, a code that represents the identification of the sample to be played along with the pitch at which it is to be played.

The first application of this kind of tracking representation will be to assign a track for each of the instruments that make up the drum kit.

The track itself is composed of notes, each with an associated length, pitch, and sample reference. Sample references lower than 999 represent

MIDI instruments (but more on that later). The note data type, then, will look something like:

```
typedef struct SNote
{
  long lLength;
  int nPitch;
  int nSample;
};
```

This will tell the part of the game system responsible for sound to play sample nSample at a given nPitch (usually expressed as a frequency) for lLength milliseconds. (We shall be looking at how we convert from notes to frequencies later on. For now, we are more concerned with the theory.)

We say that each piece of music is comprised of tracks, and these are more or less equivalent to the channels on old-style, 8-bit machines; that is, they are finite in number (4–64) and can all be played at the same time. The logical way to break up music, however, is not really by channel, but by instrument, since in cases where there are more instruments (samples) than tracks (channels), each track will contain notes from multiple instruments.

In order to not confuse the concepts of tracks used for musical playback and tracks used to actually write the music, we need to invent a new terminology to distinguish between these 'instrument tracks,' which contain all the music for a particular instrument or collection of instruments (like a drum kit), and a track that contains samples from a wide range of instruments. For want of a better word, we can use the term *stave*, which has connotations in the music world (the actual place where the notes for an instrument are written down). Thus, we can define our stave in its simplest form as an array:

```
typedef SNote OStave[9999];
```

Or, if we require more information to be stored and a nonspecific number of notes:

```
typedef struct SStave
{
  SNote * oNotes;
  int nTrack;
  char szInstrument[25];
};
```

Clearly, there is going to be a fair amount of redundant information stored, such as the sample number and possibly note length (the pitch will

tend to change with each note), and so the usual RLE-style compression can be applied. Always remember, of course, that since the stored music will be needed in a real-time environment, it should be decompressed into memory before use, and music that is generated will not need to be compressed at all.

TEMPO AND NOTE LENGTHS

In addition to setting the play length of a sample, we also need to set its 'tempo.' Tempo enables the same piece of music, transcribed in the same way, to play at two or more different speeds. In other words, the lLength member of the SNote structure is just a guideline.

Real music is broken up into beats. Each beat lasts for a nonspecific, arbitrary length of time that is governed by the tempo. When we say that there are four beats in a bar, this is a guide to the relative note lengths, or 'cadence.' The tempo at which the piece is played will determine the length (in time) of the bar being played. We can look at lLength being similarly arbitrary and alter it in real-time depending on the tempo.

Of course, the drum kit does not suffer from this timing conflict, nor does the piano or any percussion or plucked instrument, since it is very difficult to extend the length of time for which a note lasts once the string or skin has been hit or plucked. For these instruments, the lLength value is absolute.

With all of this in mind, we are ready to look at an example beat: rock. The basic rhythm is borrowed from Dewdneys book, *The Tinkertoy Computer and Other MacHinations: Computer Recreations from the Pages of Scientific American and Algorithm* (W. H. Freeman & Co., 1993).

ROCK BEAT

The drum beat notation used here, which is derived from the drum stave in Figure 16.1, relies only on being able to know if an instrument is being struck at a given point in time. Bear in mind also that there will be a period of silence between each beat while the instrument that has just been played is allowed to fade out. The length of this period of silence is what allows us to vary the tempo, although it does not actually figure in the notation. For a standard rock beat, we have the following:

```
1 0 1 0 1 0 1 0 1 0 1 0 1 0 1 0   CYMBAL
0 0 0 0 1 0 0 1 0 1 0 0 1 0 0 1   SNARE DRUM
1 0 1 1 0 0 0 0 1 0 1 1 0 1 0 0   BASS DRUM
```

The zeros in the above notation specify beats for which there could, but should not be an instrument restruck. This is different from the beat 'white space' that we talked about earlier because there is also a pause between the zeros, which gives the tempo.

We can build this pause into the notation by using other values than 1 for the presence of a beat in each slot, such as a table of values along the following lines:

$$1 = 1/1 \qquad 2 = 1/2 \qquad 3 = 1/3 \qquad 4 = 1/4$$
$$5 = 1/5 \qquad 6 = 1/6 \qquad 7 = 1/7 \qquad 8 = 1/8$$
$$\text{etc.}$$

During playback, all that is needed is to insert a piece of beat 'white space' after each note that is played, the exact length of which depends on the relationship between the tempo and the length of beat. The odd-numbered values are not used quite as often as the others. Using this new notation, we can rewrite our rock beat as follows:

```
4 0 4 0 4 0 4 0 4 0 4 0 4 0 4 0   CYMBAL
0 0 0 0 4 0 0 4 0 4 0 0 4 0 0 4   SNARE DRUM
4 0 4 4 0 0 0 0 4 0 4 4 0 4 0 0   BASS DRUM
```

Tempo is measured in beats per minute, and a solid rock beat runs somewhere between 100 and 120 beats per minute (bpm). At 120bpm, each beat lasts for about 0.5 second (or 500 milliseconds), which means that each beat in our rock pattern above lasts for 125 milliseconds (ms). So, we need 125ms of pause after each beat that is denoted by a 4 in the above grid and 125ms of total pause for each 0. The actual playing of the sample is assumed not to last for a discernable length of time.

BARS, PHRASES, AND PIECES

A bar is a convenient grouping, time-wise, of a group of notes. In *The AB Guide to Music Theory* by Eric Taylor (U.K.: The Associated Board of the Royal Schools of Music, 1989), there is a reason given for this:

> It is usual to think of them (beats) in groups, with some beats stronger than others. Marching feet, for example, naturally make groups of two beats— LEFT right, LEFT right. (p. 3)

The stronger beat on the left foot is, of course, of particular use in drum beats. The next largest grouping of notes that we shall analyze is the *phrase*.

Again, referring to the *AB Guide,* the official definition from *Chambers 20th Century Dictionary* (W&R Chambers, 1998) is: "a short group of notes felt to form a unit."

When we move on to generated music toward the end of this chapter, we shall begin to see how important phrases can be and how important it can be to construct them properly. In classical music theory, phrases can be used to build up sentences and paragraphs, which in turn are grouped together to form the piece of music.

However, from the point of view of our discussion, we shall effectively skip sentences and paragraphs, and state that for our purpose, a musical piece comprises a collection of phrases. With this information in mind, we can continue with the theme of the chapter: computer-generated music.

COMPUTERS AND MUSIC

As we have established, computers are a digital phenomenon, while music is strictly analogue. Thus, it is necessary to convert digital streams of information into an analogue representation that can be (in this case) heard by the user or player. We have also examined how this is done using a loudspeaker that is caused to vibrate thousands of times per second, thus producing a sound.

The simplest form of sound that can be created is a pure tone, which has very little character and can sound quite 'tinny' when produced by a computer's internal speaker. To generate a pure tone, we simply make the computer's internal speaker vibrate at a known frequency for a certain length of time.

However, we need to establish a relationship between numbers that can be generated by the computer and tones that have musical properties. In Table 16.1, we can see this relationship as a graphical representation.

The algorithm that we need to devise will convert between a simple numerical value (between 0 and 12) to the frequency that will be used to play the note (sound). If we wish to transpose the note up or down, we remain with the same scale of 13 values, but we change the multiplication factor so that the frequency steps up or down accordingly. The base equation suggested by Dewdney (*The Tinkertoy Computer*, p. 194) leads to the following:

$$\text{base_frequency} * 2^{\text{step}/12}$$

TABLE 16.1 Computer Music Chart

```
Freq.      Notes : Semitone     N-S
           +---------
262      C |  0   ---             0
   277     +----| 1   C#
294      D |  2   ---             1
   311     +----| 3   D#
330      E |  4   ---             2
           +---------
349      F |  5   ---             3
   370     +----| 6   F#
392      G |  7   ---             4
   415     +----| 8   G#
440      A |  9   ---             5
   466     +----| 10  A#
494      B | 11   ---             6
           +---------
523      C | 12                   7
           +---------
```

The base frequency can be any value chosen from the set of possible values that represent real notes; for example, 262 represents middle C. If we wish to play the note F, the equation would look something like:

$$262.0 * 2.0^{5/12} = 349.7$$

Thus, the tone played at 349.7Hz on the speaker is, in fact, the note F in the diagram in Table 16.1. We have arbitrarily chosen 262 as the base frequency; we could have used any other frequency value.

GENERATED MUSIC

Now that we can convert from a numerical scale (base 12) to musical tones, we are ready to use this knowledge to generate music based on mathematical formulae. Music has a number of specific qualities. The first of these qualities that we need to be aware of is its 'pattern.' Dewdney (*The Tinkertoy Computer*, p. 193) quotes Arthur Davidson: "To maintain your interest, music must represent some sort of pattern that you recognize."

Writing or generating music for computer games is no different than classical composing in this respect. There are a number of algorithms that

prescribe patterned behavior, the simplest of which is the logistic equation suggested by Davidson and represented by the equation:

$$x \leftarrow x * (a - x) \tag{16.1}$$

Experimentation shows that the starting values for x should be less than a. Other than that, the most interesting results lie in a set of values labeled as "chaotic." This chaos begins with values for a exceeding 3.57, with a being the static value in equation 16.1 that determines the level of chaos in the system. Values of 0 to 3.57 generate numerical sequences that fall into patterns very quickly and converge on a single value.

These two algorithms can be incorporated into the simple program listed in Code Sample 16.1.

CODE SAMPLE 16.1 Chaotic tone generator.

```
x = 3.59
a = 3.60

FOR I = 0 TO 100

  x = x * ( a - x )

  tone_step = INT(14 * x / a)
  tone      = INT(262 * EXP(LOG(2) * (step_tone / 12 )))

  SOUND tone, 3

NEXT I
```

Unlike many of the code samples in this book, the above is written in BASIC, simply because for this kind of low-level sound production, the Windows C++ API is simply too complex. We shall be looking at how to use the DirectX sound interface later on, along with the Windows API. For now, though, we shall be sticking with the tone generator-style note production of RapidQ Basic. The RapidQ compiler is freeware, and contact details are included in Appendix C.

Before we proceed with the theory behind arranging these strings of notes into musical passages, there is a second type of musical formula that should be examine, one which is nonchaotic. It produces melodies that are

repetitive for the most part, but which sometimes consist of wild runs and leaps from melody to melody without any apparent pattern. Experimentation is the key, although programmers with a mathematical bias will probably be able to predict the general nature of the music before the program is run. The formula is as follows:

$$x \leftarrow (a * x + b) \bmod 13 \qquad\qquad (16.2)$$

The actual behavior of the system is dependent on the choice of input parameters x, a, and b. The modulo (in this case 13) depends on the range of notes we wish to generate. In line with Code Sample 16.1, we are covering the entire 13-note scale from high C to low C. Implementing this new type of music is as simple as swapping out one formula for another, as in Code Sample 16.2.

CODE SAMPLE 16.2 Linear congruential tone generator.

```
a = 37
b = 12
x = 958

FOR I = 0 TO 100

  x = ( a * x + b ) MOD 13

  tone_step = x
  tone      = INT(262 * EXP(LOG(2) * (step_tone / 12 )))

  SOUND tone, 3

NEXT I
```

With our choice of two algorithms, we can now begin the path toward generating music in a pseudorandom way. The key is in devising a way in which we can be sure that the randomized parameters will always produce a pleasing tune. Experimentation will, as usual, be paramount in finding the correct combination, but the following seems to work fairly well:

```
x = RND(21474)
a = RND(x / 3)
b = RND(x / 2)
```

Of course, for those who are musically inclined, this discussion will serve merely to inspire some new ideas and hopefully provide some creative input for creating new pieces of music. For the rest of us, we now have one third of the ingredients required to start making music using the computer as the composer.

THE RHYTHM SECTION

The next important ingredient is the patterns and beats that can be used as a background to our music. Music, whatever the genre, can be built up from three distinct and separate parts—the percussive rhythm, the bass line, and the melody. The flavor of each genre is given by both the mixture of these parts and the style that each part embodies.

It is also fairly important to remember that it is usual for the rest of the instruments to take time from the rhythm or percussive section of the band. Thus, it is appropriate to begin with the rhythm section when creating a piece of music. Furthermore, it is the bass drum in a drum kit that offers the main driving beat, so we shall begin with an analysis of how this instrument should be used.

First, we need to pick a tempo that is in keeping with the actual pace of game play at the point at which the music should be played. (We shall cover exactly how a pace should be chosen in Chapter 17.) For now, let us just assume that the piece should be played at the tempo of the game atmosphere; for a fast-paced action game, around 120bpm with a solid bass signature, for example. A more sedate adventure game could be served by a less-frenetic 80bpm with a lighter bass signature. Taking these two examples, we could set a bass beat (over 1 phrase of 4 bars) to be the same as the rock beat (above) as:

```
4 0 4 4 | 0 0 0 0 | 4 0 4 4 | 0 4 0 0   BASS DRUM
```

The vertical lines indicate where we have chosen to (arbitrarily) break the phrase up into bars. Now that we have the basic bass line, we can add other components mathematically. There are simple rules as to how beats can be built up, and it is necessary to study the genre-appropriate pieces of

music before the algorithm is designed. We might decide, for instance, that the snare drum plays every five beats, which would give us the following:

```
0 0 0 0 | 4 0 0 0 | 0 4 0 0 | 0 0 4 0    SNARE DRUM
4 0 4 4 | 0 0 0 0 | 4 0 4 4 | 0 4 0 0    BASS DRUM
```

The final component is the hi-hat, which we could equally decide is hit open and then closed after half a bar, as in:

```
0 0 0 4 | 0 0 0 4 | 0 0 0 4 | 0 0 0 4    HI HAT CLOSED
0 4 0 0 | 0 4 0 0 | 0 4 0 0 | 0 4 0 0    HI HAT OPEN
0 0 0 0 | 4 0 0 0 | 0 4 0 0 | 0 0 4 0    SNARE DRUM
4 0 4 4 | 0 0 0 0 | 4 0 4 4 | 0 4 0 0    BASS DRUM
```

Now that we have a reasonable beat, three quarters of which is mathematically generated (thus saving storage space), we might decide to add a pseudo-random bass signature. In a rock band, this would be played by the bass player and would be a solid, plucked sound. Tradition rock music and heavy metal bass lines yield the revelation that the same note is played for two bars and then changes twice over two bars. In total, this means we need to generate three notes (if we are only marking the changes) in the bass guitar's range. Using our generator from Code Sample 16.2, we obtain the following notes:

```
349  F
524  C
330  E
```

Adding the bass guitar to our tracked view, then, we have the following:

```
F    F    | F    F    | C    C    | E    E      BASS GUITAR
0 0 0 4 | 0 0 0 4 | 0 0 0 4 | 0 0 0 4    HI HAT CLOSED
0 4 0 0 | 0 4 0 0 | 0 4 0 0 | 0 4 0 0    HI HAT OPEN
0 0 0 0 | 4 0 0 0 | 0 4 0 0 | 0 0 4 0    SNARE DRUM
4 0 4 4 | 0 0 0 0 | 4 0 4 4 | 0 4 0 0    BASS DRUM
```

Note that the tablature for the bass guitar in this case is a little different than the drum's in that it lacks both timing information and also the designation of octave. However, for illustrative purposes, it serves quite well.

The Melody Line

The principle behind generating the melody line is simple. The premise is that it should follow the bass line; and, for the sake of this last example, we shall use the same algorithm so we can be sure that the fractal properties of self similarity can be used to synthesize the melody line. To do this, we need to ensure that the notes are generated using the same values for x as were arrived at for the bass line.

The following table shows the relationship between the note frequencies and x with a remaining constant at 3.6.

```
349  F       3.08155773
524  C       1.397614800
330  E       1.28268433
```

For the first two bars, we use the value that generated the F; for the third, that which generated the C; and finally, the fourth will use a melody line based on the value that gave rise to the E. Based on the usual algorithm, we achieve a melody that follows the bass line:

```
F C E B | G C E B | C E B G | B G C E  MELODY
F   F   | F   F   | C   C   | E   E    BASS GUITAR
```

There are endless variations that can be applied to these techniques, but with this as a starting point, we are ready to look at how the basic techniques can be modified toward more-complex and useable pieces of music. In Chapter 17, we shall be looking at interlude and segue techniques that enable us to follow the game play with interesting musical backdrops.

Conclusion

There have been some attempts at generating endless variations on particular tunes, and the theory given here nudges us toward this type of endeavor. In fact, game music lends itself to being generated in an endless loop, provided that the rules of musical theory are adhered to. Like many of the techniques presented in this book, deviation from these rules leaves the designer open to embarrassing results that bear little resemblance to actual music.

INTERLUDE AND SEGUE TECHNIQUES

INTRODUCTION

At the end of the last chapter, we saw how a complete phrase of four musical bars can be created, beginning with the bass drum tapping out a beat and ending with a melody line. Of course, there is often much more that makes up musical pieces, such as background string washes and a range of different instruments all playing in harmony.

It is important to remember that actually creating pieces of music that need to stand up on their own is a vastly more complex operation than can be discussed here. Indeed, it often requires inspiration as well as sound mathematical or musical theory. The simplistic music represented by the algorithms in Chapter 16 serves only as 'throwaway' incidental music, a backdrop to the game.

This chapter will look at the role of generated music in games and how different techniques can be applied to stitch different pieces of music together so that there is a continuous theme that runs throughout the play session. Before we look at this in detail, however, we must be aware of several vital variations.

Musical phrases can be created by a musician and then, using the techniques in this chapter, be woven into the tapestry of sound that makes up the game music itself. These phrases can also be generated during game-design time by a mathematical algorithm and then turned into music by a musician. Again, the resulting musical pieces can be stitched together during the play session.

At the other extreme, the musical phrases themselves can be generated during the play session and also woven together on the fly using techniques from this chapter. This last technique comes with the caveat that

the algorithm used must be tested with every possible seed before it is placed into the game itself—there is nothing worse than ill-formed musical phrases in a game.

Finally, and perhaps the best of the bunch, is to have a musician think up some phrases of music—just the melody line will suffice. Then, a variety of musical techniques from both this chapter and Chapter 16 can be used to place the music into the play session and weave the phrases together.

First, though, we need to look more closely at 'parts of music'—the discrete units of music that make up a specific song or piece of music.

PARTS OF MUSIC

If we look at the way in which the lyrics to a particular song are printed on the inlay sleeve that accompanies a music CD or tape cassette (or vinyl record, for that matter), we can see that even if there is no explicit notation used, each song follows a pattern, for example:

Introduction

Verse 1

Chorus

Verse 2

Chorus

Bridge

Verse 3

Coda (ending)

This, of course, is not a strict rule. In fact, a song can have different choruses, verses, and even different bridges. The point is that there is always a flow from one part to the other, and each chorus has the same musical properties, as does each verse. The bridges can all be different, and the introduction and coda can be opposites. Often, the end is simply a fade to silence, but it can also have other properties.

Now, imagine applying a similar theory to a racing game. On the grid, we want some kind of warm-up music, something to get the adrenaline pumping—probably drums, with some heavy bass and either distorted guitar (if a rock theme is to be used) or traditional techno sound (if a dance track is more to the designer's liking), with a tempo around 80–100bpm. This is the introduction.

Once the race gets under way, we can lapse into a verse that just runs along at 100–120bpm, and which has the occasional variation, but nothing very distracting. At some point, the player's car might crash, at which point we can change the music to a bridge—this gives the game a chance to reset and also provides for a variation in the game music.

Coming toward the end of the race, either verse or chorus music can be used; but once the player crosses the finish line, the music should segue into the coda, or wind-down music, which will allow the player to feel that they are retiring from a fever pitch of concentration.

There are probably many variations that can be used over and above this, and the requirements of each game will be different. It is, however, usually easy enough to find parallels to musical parts in every game.

BACKGROUND MUSIC

In the car-racing example above, the music provides a background to the game. But it should not be so overpowering that it drowns out the sound of the engine, for example. Most games have music that runs along in the background, and it might or might not follow the action on the screen.

The earliest games, for example, had a simple melody that followed the player's progress through level after level, and some incorporated the sound effects of the game with the background music. Some games do not require music, since there is quite enough variation in the sound effects, such as *PacMan*.

ATMOSPHERIC MUSIC

The key to atmospheric music is that it must follow the game. It is there not to provide some kind of background soundtrack, but is an integral part of the game universe tapestry. For example, should the player find themselves in a creepy forest, then it would be a mistake to play an upbeat pop track in the background. Instead, there should be string washes and slow, ominous drumbeats, with the musical score peppered with forest sounds.

In the same way that the action on the screen is supposed to provide visual clues to the player, the music also provides auditory clues to what is going on. So, if there is danger nearby, we can change the music to reflect that fact. If we move from a dank cave to open sunlight, then we can also (just like in a film) change to a bright orchestral score.

Providing atmospheric music is also as much about instrument choice as it is about choosing the actual score, though the background music need

not worry about such intricacies. The main difference between the two is that background music is not an integral part of the game. A game can contain both, of course, which in themselves can provide clues to the player.

Now that we have more of an idea of how music is used in different gaming situations, we should look a little more closely at how the music can be changed to reflect the game sequence being played.

SPEEDING UP

Increasing the tempo is useful for conveying a sense of urgency. If it is subtle enough, the player will not even notice that the tempo has increased, but will naturally alter their playing style and become more involved in the game. We can also speed up the music for other reasons, such as in response to something the player has done, like driving instead of walking or going faster in their vehicle.

Technically speaking, speeding up requires a little more thought than simply playing the music faster. We can only change the tempo of a piece of music that is being played if we are in control of the mechanism that we are using to play the music. If the operating system is playing the music, as it would be if we have chosen to use the Windows Multimedia API (such as mciPlaySound), then the only way we have of actually changing the music speed is if we have a faster version of the music on-hand. This alternate version can be cued to play once the current piece of music has finished.

Of course, by the time the first piece has finished, there is always the possibility that the tempo-changing event has also come and gone, making the new music irrelevant. This, however, is the price we pay for letting the operating system handle our music for us.

Here is a much better idea: Deal with the music as a completely integral part of the game engine, and design the real-time portion. Of all the events in the game universe that need take place in the space of a second, music is at the top of the priority list. This is because it is quite possible that there will be musical events that occur two or three times per second, especially at faster beats (e.g., 120bpm). We can still use the operating system to play the samples if we wish, as long as we have the power to stop it at will.

SLOWING DOWN

The opposite to an increase in tempo is a decrease in tempo. Slowing the music can be used to calm the player or provide some kind of atmosphere—slow orchestral music is often used in films to denote flying over green meadows, then cliffs, and then out over the sea.

Again, we need to be in control of the musical subsystem to do this, and we need to ensure that there are fewer events per second by a certain degree. But apart from these differences, the actual mechanism for changing the tempo does not change.

CHANGING PITCH

In fact, in musical terms, there is more than one way to change pitch. We can transpose the entire phrase up or down by a certain degree, which is quite easy, as long as it likens the musical scale to a piano, as Code Sample 17.1 shows.

CODE SAMPLE 17.1 Transposing notes based on the piano keyboard layout.

```
/*
  A simple way of denoting notes numerically, based on the
  following:

      C#    D#        F#    G#    A#
    C     D     E   F     G     A     B
    1  2  3  4  5   6  7  8  9  10 11 12
*/

struct SNote
{
  int note;
  int octave;
};

void Transpose ( SNote * oNote, int nStep )
{
  oNote.note = oNote.note + nStep;
  if (oNote.note > 12)
  {
    oNote.octave++;
    oNote.note = (oNote.note % 13) + 1;
  }
}
```

The code for transposing the notes yields a result that can be converted into a frequency at which to play the sample (or sound a note) using the

same formula as seen in Chapter 16 (Equation 16.2). One slight change will need to be made, however, to ensure that the `SNote.octave` member (see Code Sample 17.1) is taken into account.

Instead of choosing to transpose the entire phrase by a musical interval, we could also simply increase the frequency of each note. It is here, however, that we see the importance of the logarithmic function used in the frequency-calculation algorithm.

It turns out that if we just increase the frequency of each note by a certain amount, we will obtain certain values (such as for E and F) that do not correspond exactly to the perfect notes. For this reason, increasing the pitch of the music in this way is only advised for steps that are less than a few notes at a time. Otherwise a 'proper' transposition should be performed.

LINKING PHRASES

If we assume that we have two phrases of music, how can we link them together? The answer is, as usual, many faceted. If they are simply two phrases of equal musical properties that contain different notes, such as the same tempo or octave, then moving from one to the other is easy.

In the first instance, we need not do anything. This is the simplest approach, and it will work almost every time, since it is unlikely that the last note of the first phrase and the first note of the second phrase will be sufficiently far removed to make the transition sound out of place.

However, if the two phrases are musically different, there are several approaches, and what works best depends on the exact differences between the two phrases. For example, if there is a large ($\frac{1}{2}$ octave to 1 octave) difference between the last note of the first phrase and the first note of the second phrase, then we need to devise a musical link between the two notes.

One way to do this will be to create a small phrase of a length dictated by the tempo of the music, but certainly no more than half of one of the phrases. Next, we determine the number of notes that we will place in this phrase. Depending on the length of the phrase, the number will be different; but there must be at least two.

Finally, we need to assign actual musical notes to the placeholders we have just inserted into the musical phrase. There are three main musical constructions that can be used for this purpose. In this discussion, we shall assume that the first note is higher than the second; but it is equally possible that the reverse is true, in which case the inverse of the three techniques can be used.

The first technique was based on the bass lines of tracks written by the band Marilyn. In some tracks, usually slow ones, there is a step from one note to another by stepping up by a certain amount, and then down to the second note. Variations include stepping above the current note and then down, lower than the target note, and up to the target note.

The second technique is to step down to the target note by moving down two tones, and up one for a certain number of steps, and then either up or down to the target note. This should be used with care, however, and is usually best done over extended numbers of notes, since there is an increased possibility of hitting an 'off' note.

Finally, the most simple technique: Given the number of notes and the distance (in notes) between the initial and target notes, we can work out what step up or down is required so that the path from the initial note to the target is made up of evenly spaced notes.

In cases where the tempo changes from one phrase to another, we can use a break to mask the change in tempo. That is, we can artificially use the drums or another percussive instrument to slightly increase the number of notes in the linking phrase so that when the second phrase begins at the new, faster tempo, it does not sound as if there is a big difference.

LOOPING MUSIC

Using all of the above techniques, it is possible to generate or combine different pieces of music to create a score that never ends. Of course, we can also create individual phrases that can be connected together so that they never end. This cannot be done artificially in a way that will be efficient enough to use in a real game; it must be done manually by a musician.

Nonetheless, once done, it is possible to have a music library that can be merged together to produce the final result. These special pieces of music can also be looped together into one continuous piece of music that is fairly repetitive.

CONCLUSION

This chapter has taken some of the theory from Chapter 16 and combined it with new ideas that will hopefully provide the aspiring game designer with some very useful techniques for creating music for their game

universe. However, it is not the end of the story, and these ideas deserve to be taken further in the practical application of music generation.

As a way forward, the reader might ponder how the game mood can be influenced by the music, and vice versa. The event sequencing ideas from Chapter 5 could be a starting point for creating a tapestry for the game universe backdrop, much like the way in which music is used in *Elite: Frontier* to signify a change in the play state—there is music for docking, battles, and other specific events in the game.

WORDS & PICTURES

INTRODUCTION

So far, we have dealt with many aspects of game programming interface components—terrains and other graphical objects, music, and sound. These make up, to a large extent, most of the atmosphere experienced by the player in the course of the game. Indeed, in some cases, it could be argued that the sound and graphics are the game, and that all else is secondary.

As far as pure action games are concerned, this view is largely justifiable. However, there is also a large market for adventure-style games, which contain static pictures and words to tell an interactive story that leads the player through the game universe to explore, solve problems, and eventually (hopefully) succeed in a specific quest or mission.

Arguably, this genre, the graphical adventure game with user interaction, began with the release of *Twin Kingdom Valley (TKV)* in 1983, written by Trever Hall. For its time, what was unique about this game was that it involved talking to the characters in an intelligent way, rather than the predictable, noninteractive way that preceded *TKV* in the adventure game genre. Descriptions, pictorial and textual, combined with an intelligent user interface and the ability to talk with other characters made these games different.

This approach is not limited solely to adventure games, and with the advent of ever more powerful machines, even rough and tough action games can now be accompanied by all the bells and whistles that come with a top-quality adventure games.

THE MMI

In the MMI (Man-Machine Interface), much of the application of words and pictures are used to reach out to the player in such a way as to immerse

the player in a universe envisaged by the game's creator. This includes being able to view objects, scenes, and other characters in an intuitive way, as well as being able to move pieces of the universe around.

Much can be achieved solely by using a joystick or mouse, and little icons can depict the various actions that can be performed on objects that the player encounters. There comes a time, though (especially when communicating with nonplayer characters), when only words will do.

LANGUAGE

This extension of the MMI, which facilitates communication between the computer and (human) player, requires both the creation and manipulation of language, as well as an understanding of what the player would like to do.

As a means of communication, language is fairly complex. Part IV of *Infinite Game Universe: Level Design, Terrain, and Sound* will attempt to give the reader a basic foundation in some techniques that facilitate the implementation of a realistic and useful language-processing component. This foundation will of necessity be built in two phases: that which deals with the understanding of language, and that which deals with the generation of language.

The understanding of language is fairly easy to justify; after all, it is necessary to be able to isolate the key components of a phrase before the game can accurately perform the required action. This 'understanding' phase can be useful in determining the difference between phrases such as:

"Put the book on the red chair" and

"Put the red book on the chair"

Confusion between these phrases can only be avoided if the sentence can be accurately parsed and the meaning put into the context of the player's immediate environment and surrounding objects.

The second phase, that of generation, is slightly more difficult to justify. We can, of course, simply store a stock set of phrases to deal with every likely eventuality. Besides being wasteful and extremely time-consuming to implement, this approach puts large restrictions on the way in which the player is allowed to interact with the game universe. It also inhibits the universe's description for the player.

It is much less restrictive and (interestingly) less time-consuming to implement if we model language in such a way as to make each phrase

reusable, depending on the circumstances. This can be either a partial model, such as using simple template phrases and replacing certain words with reference to the current situation, or a full-blown model of the language.

A Picture...

Of course, there are times when a picture must be used. This can be for a number of reasons—lack of space to display many lines of text, or when pure interaction via a graphical interface is simply more efficient or aesthetically pleasing.

As with phrases, pictures can be built by using separate objects that are linked together, usually against a backdrop of some kind. The same two approaches as in the section above hold here also: Use a template that can be customized, or build a picture from scratch by using an accurate model.

Where the two approaches differ is that there is not usually a need to recognize a picture when programming games. It can be useful in other applications, but that falls out of the scope of this book. Instead, we shall concentrate on natural and artificial pictures, either those that are built from components, or those that are built from scratch.

NATURAL LANGUAGE

INTRODUCTION

In the games industry, language can be used for a variety of tasks. The most common is for communicating with the player. Often, the extent to which language is used is limited to static text, conveying status messages to the player. This can be extended to cover stock phrases denoting specific events within the game. A classic example of this can be seen in the game *Elite*, where the player is offered a 'tribble,' which they can buy for a slightly elevated price.

Each time the player takes a look at their inventory, the tribble changes its description. Examples include "a small furry tribble," and "a large happy tribble." This adds a cute, 'hidden' dimension to the core game that is merely included as a fun distraction and has no real bearing on the game itself.

Natural language can also be used in games as a medium with which the player can communicate with the machine; it forms part of the MMI (Man-Machine Interface).

Looking at the way in which the basics of a foreign language are learned can give very telling pointers as to how the MMI can be enhanced by using natural language. The cornerstone principle is the use of the 'stock phrase.' A stock phrase is one that conveys a given meaning, such as a student learning to order a cup of coffee in French, which can be adapted accordingly to a change in circumstances to cover ordering another snack item, such as tea.

As in the preceding tribble example, this can be used to good effect when describing game objects. In addition, stock phrases can be used to match against player input for meaning, and a resultant action can be carried out. As an extension to this, each object can store stock phrases to which they might react, either in whole or part. Some of these objects can use stock

phrases from a central repository and customize them, or they can have their own phrases that they 'understand.'

PARTS OF SPEECH

Before we begin to examine how natural language can be exploited as a tool for interfacing with a computer, it is worthwhile to take a refresher course in basic linguistic principles. While many of these principles hold for most, if not all languages, the exact implementation will depend on the language being used. A classic example is the position of the verb in a sentence; in German, for example, verbs are usually found at the end of sentences; while in English, the verb is usually placed in the middle.

The key words that we use in everyday communication have specific linguistic names with which most readers will be familiar. Collectively, these are known as "parts of speech." Although there are many different parts of speech, we will only deal with enough to establish a simple bridge from the human world to the electronic world.

Taken from Jacques Van Roeys' book, *English Grammar* (Didier Hatier, 1982), the following is a list of the most common parts of speech that can be used to build the various components of a sentence:

Verbs	be, have, become, can, may, study, sing, hesitate, …
Nouns	book, house, dog, master, poetry, idealism, scissors, …
Pronouns	personal: I, you, … myself, yourself, …
	possessive: mine, yours, …
	demonstrative: this, these, that, those, …
Determiners	article: a, the
	possessive: my, your, …
	demonstrative: this, these, that, those, …
Adjectives	good, big, pretty, difficult, …
Adverbs	well, quietly, naturally, very, there, …
Prepositions	at, in, by, through, without, …

These basic building blocks of language can be arranged into recognizable prose via the use of 'phrases.' Not to be confused with actual entire sentences, a phrase in this case is simply a convenient way of dividing up the logical structure of a sentence. As Van Roey says: "Two or more words

which are (thus) syntactically connected are word-groups or phrases"
(*English Grammar*, 1982).

Roey goes on to give five examples that use words from the list given
above:

Noun phrase	a phrase that has a noun as its basic constituent
Verb phrase	defined in a narrow sense as the main verb with its auxiliary forms
Adjective phrase	an adjective as head and usually with an adverb or a prepositional phrase as modifier
Adverb phrase	an adverb as head and often also an adverb as modifier
Prepositional phrase	introduced by a preposition: of tea, of books, in England, under control

As can be seen, there are fairly strict rules that must be adhered to when
we wish to use linguistic principles to generate or analyze textual informa-
tion. While this might seem at first glance to be unnecessarily complex for
a computer game, the application of the theory comes at such a low price
once the basic rules are understood that the benefits outweigh the invest-
ment by a substantial amount.

These benefits extend to being able to model language in a generic and
reusable way—from being able to generate prose, to being able to parse
user input. Such techniques also allow an implementation that can distin-
guish between sentences, where the order of phrases and words within
those phrases might change depending on the exact usage and even the lin-
guistic preferences of the player.

In order to tackle these issues, we must first understand how phrases can
be built from words and how interchangeable words within phrases can be.

FORMING A PHRASE

In the preceding section, we covered five phrases that can be used as the
basic building blocks for communication: nouns, verbs, adjectives, ad-
verbs, and prepositional phrases. Using these, we can construct sentences
that convey meanings. Humans, when they use language, do it in an auto-
matic way, rather like catching a ball. When they speak, a human need
never distinguish a noun from a verb, nor how to use trigonometry to cal-
culate the trajectory of an incoming fly ball in order to catch it.

In the computer world, however, we must first understand the basic principles before we can convey this information; we must implement a model that fits the problem at hand. Before we define the problem by looking at a concrete example, we should tackle a little more theory.

LINGUISTIC NOTATION

This is not the place to cover the complexities of the specific pseudolanguage that linguists have designed specifically for the purpose of describing sentences. Instead, we shall use its base principles and adapt it slightly so that we can describe simple phrases and sentences. First, we need some kind of shorthand for the parts of speech. Conventionally, linguists tend to use:

verb	**noun**	**pronoun**	**determiner**	**adjective**	**adverb**	**preposition**
verb	*noun*	*pro*	*det*	*adj*	*adv*	*prep*

These can be combined, using linguistic rules, to create phrases. A noun phrase, for example, might be represented by:

NP = det + noun

or a prepositional phrase by:

PP = prep + noun

Phrases can be combined, of course, using the same kind of representation to produce descriptions that can be expressed in a diagram, as follows:

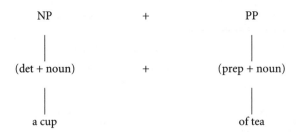

In computer terms, the process of deriving the representation for a phrase from the actual words is known as "parsing." Over the years, much energy has been expended in educational institutions all over the world in an attempt to persuade computers to parse sentences and obtain some kind of meaning from the result. This is neither the time nor the place to discuss the ins and outs of language parsing in any kind of detail; all we want to do is devise some way of representing language so that we can construct

phrases and be able to identify the parts of speech in simple phrases without restricting the player to a rigid MMI representation of actions.

FROM PHRASES TO SENTENCES

If we want to use this new knowledge in the gaming arena, we must be able to take entire sentences entered by the user and match them to actions that the game system knows how to carry out. Therefore, we need some kind of rule-based system to parse the sentence into its component parts.

However, we do not necessarily want to have to store every single noun that we are going to use. Therefore, we would like the ability to be able to deduce a certain amount of information from the context of the sentence. We shall concentrate here on missing nouns, but it could be any other part of speech that is not present in the word database.

Rule-Based Pattern Matching

Consider a simple example, such as: "get the tribble."

The noun "tribble" might not exist in our database of words, and it certainly does not exist as a real-world word. The game engine probably has a trigger for the verb "get." (We will find ways of dealing with trigger words in Chapter 19.) Triggers, however, also need to be identified by their part of speech in order to avoid any misinterpretation.

If we want to create a suitable pattern that will correctly identify the components of the above phrase, we could come up with something like:

VERB + "the" + NOUN

Our first reaction might be to attack this using the built in C++ text-processing functions and write something like:

```
sscanf ( szString, "%s the %s", verb, noun );
```

which might actually work for this particular case, but it will fail if there is more than one tribble, and we want to parse something like: "get the green tribble."

In fact, this example causes us to rethink our rule and change it to something more like:

VERB + "the" + [ADJECTIVE [...]] + NOUN

Where [ADJECTIVE] is an optional word and [...] indicates that there might be more than one. Phrases can be built up in the same way. Consider, for example, "get the green tribble and eat it." This could be parsed into a rule such as:

VP + "and" + VP

where each phrase needs to be defined as:

VP = VERB + NP | "it" NP = "the" + [ADJECTIVE [...]] + NOUN

With this last set of rules, we are deviating from the traditional linguistic theories that have enabled many linguists to successfully parse natural language. We do this because the above is easier to implement in a gaming system than traditional rule-based parsers. After all, we only have a very limited-problem domain, and a full parser is not practical given the platform that we wish to run it on; and besides, we do not have time in either the development cycle or during game time to use a system for parsing real, natural language.

A basic parser can be written in Prolog, which is a language that supports the Boolean logic that we need to perform this kind of simple rule-based pattern matching, using "definite clause grammar." This extension of the Prolog language enables us to write code like that in Code Sample 18.1.

CODE SAMPLE 18.1 Prolog-style definite clause grammar.

```
/*

Adapted from original code
(c) 1996 A. Aaby, Walla Walla College WA, USA
http://www.cs.wwc.edu/~cs_dept/KU/AI/AI1.4.html

*/

sentence -> noun_phrase, verb_phrase.

noun_phrase -> noun.
noun_phrase -> determiner, noun.

verb_phrase -> verb.
verb_phrase -> verb, noun_phrase.
```

```
% Vocabulary

determiner -> [the].

noun -> [tribble].

verb -> [get].
```

The above will be capable of parsing "get the tribble," but will fail on "get the green tribble." But we could add the following lines in the appropriate places to allow for adjectives:

```
noun_phrase -> determiner, adjective, noun.
verb -> [green].
```

If the program is capable of parsing the sentence, then as it stands, it will simply return the value true. This does not exactly serve our needs because we also need to attach some meaning to those words that the system has been able to identify. For example, we would like to be able to write a statement like:

```
sentence ( V, N, S, [] ).
```

to retrieve the verb (V) and noun (N) from a given sentence (S) using the grammar, and with the possibility that the noun does not exist in the predefined vocabulary. For those who are interested in pursuing the Prolog implementation of this exercise, a reasonable example can be found at http://www.cs.wwc.edu/~cs_dept/KU/AI/AI1.4.example.html, which is an extension of Code Sample 18.1.

The problem with Prolog in a gaming environment is twofold. First, the performance is not really up to the requirements of a full gaming system, since the majority of implementations need to be interpreted and not compiled. Second (and a related issue), Prolog is not really a mainstream language and therefore suffers from lack of support.

Parsing in the C++ world, however, can be a little more difficult than the Prolog equivalent because C++ does not naturally develop rule-based systems. However, it does have the advantage of being fast and well supported, not to mention an established game programmers' favorite. We

shall look at a C++ implementation of a real-world rule-based parser in Chapter 19, but some of the hurdles are worthy of an introduction here.

The first programming hurdle is turning a string into words. Standard ANSI C++ implementations offer the strtok function, part of the string.h library, which can be used to turn a string into a list of words, as in Code Sample 18.2.

CODE SAMPLE 18.2 C++ tokenizer.

```
struct sWord
{
  char szWord[30];
};

int Tokenize(char * szString, sWord * szWordList)
{
  char * tok;

  // Free up szWordList, if not NULL
  if (szWordList != NULL) free (szWordList);

  int nWords;

  nWords = 0;

  while ((tok = strtok(szString," ")) != NULL)
  {
    nWords++;
    // Allocate storage for the word
    if (szWordList == NULL) szWordList = (sWord * )
malloc(sizeof(sWord));
    else szWordList = realloc(szWordList, nWords *
(sizeof(sWord));

    // Copy the data into the structure
    sprintf(szWord[nWords-1].szWord,"%s",tok);
  }
  return nWords;
}
```

Next, we need to be able to match the word list to a given pattern and extract any unknown words that can be inferred from a given pattern. There are a number of reasons why we might want to do this, some of which we have already covered, and some less obvious. For example, we might want to be able to eliminate some words as having no meaning (or at least no impact), such as determiners and articles, but which are required by the use of natural language to be there. For example, "get the tribble" contains the determiner "the," but it does not convey any additional meaning.

There are a number of ways in which we can implement this kind of pattern matching (and Chapter 19 adds another to the melting pot). Like many artificial-intelligence (AI) topics, there are almost as many ways to implement the theory as there are people implementing it, and many people have spent years researching the best way to do it.

As usual, this is not the place to really give natural language processing a thorough treatment, but what we have covered above is enough to give an insight into the possibilities. Hopefully, this very brief introduction to natural language has whetted your appetite and started the gears rolling toward some interesting and efficient engines for the next generation of (possibly speech-controlled) games.

GENERATING BELIEVABLE PROSE

The complement to turning natural language into a machine-readable or understandable format is converting information generated by the machine into recognizable language—that is, turning a stream of numbers into real language or prose. The Prolog parser, which we briefly discussed above, can be used either to match patterns for parsing or generate simple sentences.

The theory, then, should be obvious. Rather than taking a sentence and reducing it to its component parts, generating a sentence requires only that we make a structure into which we can drop our prose that is tied to the state of the game universe. The actual implementation of any system that achieves this will be specific to the problem domain; in this case, it will depend on the game itself. A general algorithm is not really possible considering the speed at which it must execute.

CONCLUSION

This chapter has given a very rough-and-ready overview of the mechanics of natural language and how the various pieces that we take for granted can be connected to form human communication. It is clear that the problems of understanding language (or at least being able to pick out the key parts of a phrase) and generating prose are related but very different. It is not possible to offer enough detail (in a book aimed at broader techniques) to do justice to the research that has gone into some of the more-sophisticated natural language-processing techniques.

However, we can look at some basic ideas, which should provide pieces that can be glued together to form part of the finished product; and the starting point has been this brief analysis of natural language—in this case English—but the principles apply to many other languages, too.

Chapter 19 complements this analysis, and it deals with the way in which language can be used to impart a semblance of intelligence to the human-machine interface as applied to games. It plays its part in providing more blocks that can be used to create the finished product—the glue being the game structure and imagination of the game designer.

ARTIFICIAL LANGUAGE VERSUS AI

INTRODUCTION

There is a temptation to link artificial intelligence (AI) to artificial language, if only because of the age old adage that "if it looks like a duck and sounds like a duck, then there is a good chance that it is a duck." The same can be applied to a seemingly intelligent machine; if it understands language and can reply in the same language, then it could be intelligent.

Of course, AI also encompasses many aspects that are not linked in any way to natural language, such as the ability to match visual patterns or plan the best route from point A to point B. However, a large part of the internal processing of these problems uses techniques that could be also applied to the problem of understanding and producing natural language.

Before we look at this in more detail, it is important to note that we have thus far defined natural language as language that uses words. This is fairly narrow, even in human terms. Imagine, for example, what the ancient Egyptians would have said if we had pointed at their hieroglyphics and told them that this was not an intelligent form of natural language. We should always bear in mind that there are a number of ways in which a game can communicate with the player, and language based on words is just one facet.

"UNDERSTANDING" NATURAL LANGUAGE

In Chapter 18, we saw how language can be processed (or parsed) into its component building blocks, such as nouns and verbs, and also how they can be glued together to make simple linguistic phrases; and those in turn

can be used to generate sentences, and eventually prose. However, processing the elements of language is only the first step. We also need to understand what the user or player is attempting to convey by their use of language.

To a large extent, this understanding is limited by the domain of the game; that is, the machine will only need to cope with problem statements that fall within the current knowledge domain. A side effect of this is that the machine will not be able to cope with (or react intelligently to) any problem statement that falls outside this domain.

The concepts of knowledge domains and problem statements are common to all facets of AI programming; it does not detract from the appearance of intelligence so long as the filtering process is performed with the outcome or result in mind. The aim, after all, of incorporating intelligent communication with the user interface, is to ease communication between the player and the game as well as add reality to the experience.

Deviating slightly from the main theme of this chapter, consider the world-famous ELIZA program, as discussed in Dewdney's book, *The Tinkertoy Computer and Other MacHinations: Computer Recreations from the Pages of Scientific American and Algorithm* (W. H. Freeman, 1993). ELIZA is a program designed to interact intelligently with the user so that the user gets the impression that ELIZA has understood their problem and sympathizes with them. The knowledge domain of ELIZA is extremely simple; and as a psychoanalyst, the reactions of ELIZA are based on the theory that the best therapy is simply to talk out your problems. Hence, the session starts with something akin to:

ELIZA: Please tell me your problem.

The user can then form a sentence and type it in. It might be something along the lines of:

HUMAN: I don't like my job.

which is a fairly benign and probably quite common reason to seek therapy. What ELIZA does next can either be viewed as intelligent or extremely dumb, depending on your point of view. Some language processing yields the following:

ELIZA: You don't like your job?

The way in which ELIZA arrives at this sentence can be implemented in one of two ways: quick and simple, or complex and time-consuming. The

quick and simple method simply takes the incoming phrase, changes all the "I"s to "You"s and "my"s to "your"s, and puts a question mark at the end.

Of course, one tends to end up with a fairly irritating conversation, which is quickly ended (by the user, that is; ELIZA can go on all day). The advantage is that no knowledge of language is required. And at first, the result is quite pleasing and will astound the user, until it is explained how the program works, after which all the magic is lost.

KEYWORD MATCHING

At the very basic level, processing natural language can be described by simply checking the user input for keywords and performing some actions based on that input. For example, if the user enters the words "Go to the North," the machine need only pick out the words "Go" and "North" (or even just "North"), since the rest is (if not meaningless) superfluous. (Of course, it is only superfluous to the machine. For the user, it is natural to form the sentence in this way.)

There are a number of ways in which this style of keyword-matching interface can be implemented, and perhaps the earliest general-purpose example was created by Incentive Software in 1986 with their title The Adventure Creator (AC). As the name implies, The Adventure Creator was conceived from the ground up as an environment in which the budding game designer could build their adventure games without any knowledge of programming.

From Chapter 18, we know that natural language can be broken down into a number of discrete components, such as nouns and verbs. This terminology is adhered to within AC, although only verbs, nouns, and adverbs are actually required.

The actual rules that govern the processing of commands issued to AC are stated in Section 3.2, Player Commands, of the *AC User Guide* published by Incentive Software:

> *Each command line consists of one or more simple commands, which in turn consist of a verb, and maybe an adverb and one or two nouns. Any word which the command interpreter does not understand as being a noun, verb or adverb is ignored.*

Obviously, the core of the language processing provided by AC is the storage of a collection of nouns, verbs, and (what the AC developers call) adverbs, which are not always strictly adverbs, but can also be prepositions

(e.g., "in," as used in the phrase "put it in the box"). The sentence offered by the manual's writer is nontrivial:

"Get the gold, examine it, put it in the box then go north."

However, by applying the previously stated logic, we can reduce this to a more palatable:

"Get gold, examine gold, put gold in box, go north."

We assume that the nouns "gold" and "box" exist in the collection of nouns, as well as a rule mapping "it" to the last used noun. Furthermore, we require that the verbs "get," "put," and "examine" exist, along with the pseudoverb "north" (as in "go north"). Finally, we need a pseudo-adverb, "in." So long as these exist, we can dismiss the superfluous words to arrive at the second set of phrases.

There is one last step, which is to break the phrases at the commas; we placed these in place of the unmatched, superfluous nonkey words in the example sentence. This leaves us with four discrete phrases that all convey meanings that can be matched with our knowledge domain. Thus far, we can 'understand' what the player has typed, but this knowledge needs to be translated into something that can be processed by the computer.

AC uses a simple programming language to achieve this, which uses constructions such as:

"IF (VERB 1 AND NOUN 1) GET NO1 END"

If, as in the above example, VERB 1 happens to be "get" and NOUN 1 is "gold," then the built-in GET command is executed, in conjunction with the value NO1, which is equal to the first noun in the phrase being analyzed. The GET command, unsurprisingly, adds the object (actually the reference number attached to the object) to the collection of objects that the player is currently carrying (their inventory).

A further clue as to exactly how the matching process operates is given by a table in the *AC User Guide*, of which one line is the following:

Phrase	VERB	ADVE	NOUN1	NOUN2
Put it in the box	8	1	3	7

With this on-hand, we arrive at the implementation stage. We are not going to implement an AC program, all we need to do is create some kind of library that can be used in any implementation. There are two sides to

this kind of problem. The first is the core functionality—that is, the functionality associated with the management of the internal state of the game in progress.

The second is the interface, which in this case is natural language, but could just as well be an artificial language interface that uses buttons or other graphical objects, which need to be translated in some way and passed to the core. Both this wrapper and the core itself will change with each implementation, but we shall remain with our text-based adventure game for the moment in order to illustrate the principles.

To keep it simple, we shall deal only with the inventory-management side of the problem, and Code Sample 19.1 shows a simple array-based approach to inventory management.

CODE SAMPLE 19.1 Simple inventory management.

```c
// Simple array-based function to initialize a fixed chunk
of memory

int CreateEmptyInventory(int * nInventory, int nSize)
{
  // Allocate the memory
  nInventory = (int *) malloc ( sizeof(int) * nSize );

  // Oh dear, out of memory!
  if (nInventory == NULL) return OUT_OF_MEMORY;

  // Set the memory to be empty
  memset ( nInventory, NO_OBJECT, nSize );

  return OK;
}

// Add an item to the inventory carried by the adventurer

int AddItem(int * nInventory, int nObject)
{
  // Find a free slot
  int nItem = (sizeof (nInventory) / sizeof (int))-1;
  while (nItem >= 0)
  {
    if (nInventory[nItem] == NO_OBJECT) break;
    nItem—;
```

```
    }
    if (nItem < 0) return INVENTORY_FULL;
    nInventory[nItem] = nObject;
    return OK;
  }

  // Get an item from the inventory and free up the space

  int DeleteItem(int * nInventory, int nObject)
  {
    // Find the slot containing the object
    int nItem = (sizeof (nInventory) / sizeof (int))-1;
    while (nItem >= 0)
    {
      if (nInventory[nItem] == nObject) break;
      nItem-;
    }
    if (nItem < 0) return NOT_IN_INVENTORY;
    nInventory[nItem] = NO_OBJECT;
    return OK;
}
```

Code Sample 19.1 represents the core inventory management. It assumes that a number of macros are defined, and for completeness, these are defined in Code Sample 19.2.

CODE SAMPLE 19.2 Definitions for inventory management.

```
  // System level : memory, files, etc.

  #define OUT_OF_MEMORY       -1

  // Core game: inventory, movement, etc.

  #define OK                   0
  #define NO_OBJECT          -10
  #define INVENTORY_FULL     -11
#define NOT_IN_INVENTORY     -12
```

There are two interfaces to this core code, at the programming level and at the interface level; the interface level handles the player-machine interface. We wish to allow the player to pick up and drop objects as basic functionality, which means that they should be able to place these objects in their inventory and remove them from their inventory via simple, natural language commands.

We shall implement this using keyword matching, and so the next stage is to implement the code that takes the player's input and places it in a predefined structure, which could resemble that in Code Sample 19.3.

CODE SAMPLE 19.3 Command structure.

```
struct SCommand
{
  int nVerb;          // This style of command structure
                      // mirrors that which
  int nAdverb;        // is presented in the Adventure
                      // Creator User Guide,
  int nNoun1;         // (c) 1986 Incentive Software, Ltd.
  int nNoun2;
};
```

Assuming that the player enters commands as simple strings, we need to be able to match what the player types with some predefined values, which will be placed in the structure put forward in Code Sample 19.3. In Code Sample 19.4, we define some values and some simple interface functions that allow us to parse a simple phrase entered by the player.

CODE SAMPLE 19.4 Simple command line parsing.

```
// Define some known verbs
#define GET 101
#define DROP      102

// Define some adverbs
#define IN  201

// Define some nouns
#define GOLD      301
```

```
// Look up a verb
int LookUpVerb(char * szText)
{
  if (strcmpi(szText,"GET") == 0) return GET;
  if (strcmpi(szText,"DROP") == 0) return DROP;
}

int LookUpAdverb(char * szText)
{
  if (strcmpi(szText,"IN") == 0) return IN;
}

int LookUpNoun(char * szText)
{
  if (strcmpi(szText,"GOLD") == 0) return GOLD;
}

// Process the command line, token by token, and place the
// command in the command structure defined in
// Code Sample 19.3

int ProcessCommandLine(char * szCmdLine, SCommand *
oCommand)
{
  char * token;

  // Spin through the command line, assigning parts of
  // speech as required
  token = strtok(szCmdLine, " ");
  while (token != NULL)
  {
    int nValue;

    nValue = LookUpVerb(token);
    if (nValue > 0) oCommand.nVerb = nValue;

    nValue = LookUpAdVerb(token);
    if (nValue > 0) oCommand.nAdverb = nValue;

    nValue = LookUpNoun(token);
    if (nValue > 0) oCommand.nNoun1 = nValue;

    nValue = LookUpNoun(token);
```

```
        if (nValue > 0) oCommand.nNoun2 = nValue;

        token = strtok(NULL, " ");
    }
    return OK;
}
```

All that remains is to evaluate SCommand and perform the actions that it details. This can be easily accomplished in a fairly generic way by the use of macros. In Code Sample 19.5, we see that a combination of command words can be evaluated. It is, in effect, a small programming language it itself, which is similar in construction to that found in The Adventure Creator.

CODE SAMPLE 19.5 Simple condition matching.

```
#define IF          if
#define EXISTS      > 0
#define IS          ==

#define VERB                oCommand.nVerb
#define ADVERB      oCommand.nAdverb
#define NO1         oCommand.nNoun1
#define NO2         oCommand.nNoun1

#define AND         &&

#define GET_ITEM(o)       return AddItem(nInventory, o);
#define DROP_ITEM(o) return DeleteItem(nInventory, o);
```

These macros allow us to use, in our code, something along the lines of:

```
IF ( NO1 EXISTS AND VERB IS GET ) GET_ITEM ( NO1 )
```

which would effectively translate into something looking like:

```
if ( oCommand.nNoun1 > 0 && oCommand.nVerb == 101 )
    return AddItem( nInventory, oCommand.nNoun1 );
```

The point of this exercise is to illustrate that once the core has been designed and created, the actual adventure game can be built from macros—there is no need to rewrite any of the tested, debugged, and (hopefully) fully operational code. As an added bonus, it is also much easier to write the above code than to actually write 'proper' C++, so the game designers can be involved at this level also, which reduces the work required by the programming team.

EXPRESSING MACHINE STATE USING NL

As in the previous section, conveying the state of the player's knowledge domain depends largely on the contents (or extent) of the game universe. In the last section, we restricted ourselves solely to a text-based adventure game environment, and the examples contained here will also use this example.

When we say that we wish to express the machine state, we mean that we want to inform the player that they have done something that has affected the state of the game universe, or that the game universe has done something to affect them. To return to the way in which The Adventure Creator deals with these events, there are three sets of conditions that might be specified: room conditions, low-priority conditions, and high-priority conditions. Generally speaking, room conditions are executed after the player has entered a command in a specific room. Low-priority conditions are general conditions that are tested for after a command has been typed in any room. High-priority conditions are those conditions that are checked for in each and every room *before* the player has had a chance to enter anything in the way of commands.

Using sets of conditions (or rules) in this way, the player is kept informed, in a rudimentary way, of the current state of the immediate game universe's current state. An enhancement offered by AC is a number of variables (or markers) that can be set/unset, offering the ability to retain certain global pieces of information. In addition, it is possible to define up to 255 messages for use in the adventure game.

In conjunction with the system of markers, using messages and conditions at the same time enables quite complex rules to be built up, which lead to complex command conditions such as:

```
IF ( VERB IS LOOK AND MARKER 1 SET ) LOOK END
IF ( VERB IS LOOK AND MARKER 1 UNSET AND MARKER 2 SET )
   LOOK ELSE MESS 251
END
```

The above example assumes that there are two markers in existence that indicate whether the room is lit or not (MARKER 1) and whether the player is holding an independent light source (MARKER 2), along with a message stored at position 251 that reads something like "It is dark. You cannot see." Of course, the light-dark marker will need to be set with a series of room conditions.

This example also highlights something we have not yet touched upon: allowing the user to query the machine state. The verb used above—LOOK—should be fairly self-explanatory, but the important point is that it has many possible functions, as well as a possible sibling EXAMINE, which can be applied to objects.

Faced with this verb, the game system can react in a number of possible ways. The simplest reaction is to display the description of either the room or the object, depending on the verb. This is the most basic possibility and allows the player to be able to find out where they are, what exits there might be, and, above all, what objects or nonplayer characters might be in their immediate vicinity.

There are several ways we can approach the description of rooms and objects; again, the simplest is to just store a decryption for each room and object individually. However, we can take a slightly different approach by using our knowledge of natural language (NL) to create descriptions from subsets of carefully chosen words. This is especially useful for dynamic objects and locations, those that come into existence at a discrete moment in time and have a temporary life span. A room, for example, could be created from a template and exist only as long as the player inhabits it, or it contains objects with which the player has interacted.

A dynamic object could simply be a nonplayer character that interacts briefly with the player before going away or being slain (for example) by the player. Other dynamic objects include food, drink, money, or other expendable items, which can also be created from templates.

This theory also allows us to build collections of locations that contain objects or not, entirely on the fly, with very little (essentially no) storage requirements, so long as we have a structure (such as a maze) into which to drop them. We could have a forest, for example, whose boundaries are known, which consists of a series of locations that could be described based on a single template for a forest-type room. Each location can be generated using pseudorandom techniques. It is far more efficient to store large numbers of similar game universe artifacts based on templates, especially where NL descriptions are concerned.

NONTEXT-ONLY GAME UNIVERSES

Where these techniques come into their own is in the management, or interaction with game universes based entirely on textual information. Adventure games may seem to be a little passé to the majority of game players, but they remain an important genre, especially in the online world of multiuser dungeons (MUDs).

WORDS, VOCABULARY, AND STOCK PHRASES

David Braben comments on the original *Elite* (Frontier Developments, Web site: http://www.frontier.co.uk), noting that we can match these techniques for generating object descriptions with some others used by Braben and Bell in the *Elite* incarnations. He states that the driving algorithm behind the generation of many textual pieces of information, from star-system names through to descriptions of their inhabitants, is a Fibonacci number sequence. An example taken from the original game might be:

```
System Name : Reorte      Inhabitants : Black Fat Felines
```

The formula for the Fibonacci sequence is defined in *AS Mathematics* (J. Berry, et al., p. 201) as:

$$u_{k+1} = u_k + u_{k-1}$$

We can seed this formula in much the same way as we would a pseudo-random number generator, but with two terms instead of one, and then produce a stream of numbers. We can then use this stream of numbers for a variety of different tasks, from creating words, to word sequences, and eventually entire sentences. Code Sample 19.6 shows a possible implementation for the core Fibonacci generator.

CODE SAMPLE 19.6 The Fibonacci generator.

```
class CFibonacci
{
  private:
    long lUk, lUkm1; // uK and uK-1
```

```
public:
    CFibonacci(long lOne, long lTwo) { lUk = lOne; lUk1 =
lTwo; }

    long GetNext();
};

long CFibonacci::GetNext()
{
    long lUkp1; // lUk+1, the next in the sequence

    lUkp1 = lUk + lUkm1;

    lUkm1 = lUk;
    lUk   = lUkp1;

    return lUk;
}
```

Using 3 and 4 as input numbers, we get the sequence 7, 10, 17, 27, 44, 71, 115, 186, 301, 487, 788. By themselves, these numbers are not particularly useful. But if we use them to generate strings of letters, the first five letters of the above stream produces the 'word':

Gjqar

Obviously this is not terribly enlightening. As a word, it does not seem to reflect any known language. A cursory look at words in the English language might lead us to try to construct some rules that would govern our generation of words, such as:

A consonant must be followed by a vowel. If we apply this simple rule, our generated 'word' now becomes:

Gaqir

which is almost a real word. Code Sample 19.7 shows a cheap and easy way to achieve this. It uses the CFibonacci class from Code Sample 19.6, represented here as a global entity, populated by two long integers, lOne and lTwo, which are assumed to be set by the calling software.

CODE SAMPLE 19.7 The Fibonacci name generator.

```
        .
        .
        .

CFibonacci oFibGen = new CFibonacci( lOne, lTwo );

        .
        .
        .

void GenerateName( char szName[255], int nLetters )
{
  char szVowels[] = "AEIOU";
  char nLast;

  nLast = ' ';

  for (int n = 0; n < nLetters; n++)
  {
    if ( nLast == ' ' )
    {
      nLast = ((oFibGen->GetNext() % 26) + 'A') - 1;
      szName[n] = nLast;
    }
    else
    {
      szName[n] = szVowels[(oFibGen->GetNext() % 5) + 1]
      nLast = ' ';
    }
  }
  szName[n] = '\0';
}
```

This technique can also be used with groups of words to create phrases, such as descriptions of entities in the game universe. In the simplest case, we need only respect some of the principles that we arrived at in Chapter 18 for the construction of phrases, such as:

Description = adj + adj + noun(pl)

which states only that the description phrase is formed by two adjectives and a noun in the plural. In principle, at least, we can store as many adjectives and nouns (singular) as we wish and use these to produce an almost unlimited number of combinations. Assuming three lists of equal length n, each containing a unique set of words, we can calculate the total number of possible combinations as:

$$n^3$$

So, from the following:

Adjective 1	Adjective 2	Noun
Black	Fat	Feline
Red	Thin	Canine
Pink	Tall	Human

We can say that there are a possible 3^3 combinations, or 27. The efficiency of this arrangement can be estimated by taking the average number of letters per word (40/9 = 4.44) and multiplying this by the number of words per phrase (3 * 4.44 = 13.33). This gives us the character length of the average phrase. We can then multiply this number by 27 (the total number of phrases) to give 360.

So, it has taken 40 bytes of storage to store enough data for 360 bytes of game universe data. If we wish to arrive at enough data to cover 100 game universe objects, then we would need approximately 100 * 13.33 bytes of game universe data, or 1333 bytes. Calculating the percentages, we note that this requires (40/360) * 1333 bytes, which is about 148 bytes.

Taking the cube root of 100, we can arrive at the number of words that there should be in each list: between four and five. Erring on the side of caution, we choose five words. Assuming 4.44 letters per word, we can calculate that for the 15 words (3 columns of 5 words) that we need to store, we need 15 * 4.44, or 67 bytes.

Adjective 1	Adjective 2	Noun
Black	Fat	Feline
Red	Thin	Canine
Pink	Tall	Human
Orange	Brusque	Frog
Green	Ugly	Lizard

There are 72 characters in the above set of 15 words, which is an average of 4.8 letters per word. Using the same calculations as before, we arrive at a figure for the number of bytes that we can generate as roughly (3 * 4.8) * 125, or 1800 bytes. All of this cross-checking leads us to a number of conclusions that can be used to avoid mis-estimating storage needs.

First, between 9 and 15 words, the average number of letters per word rose from 4.44 to 4.80, which means that the average phrase length rose from 13.33 to 14.40. This shows that before we estimate storage space, we must be aware of the type of data being stored: The average can be much smaller for shorter pieces of data and much longer for longer pieces. This may sound obvious, but it is often overlooked.

Second, you will almost always end up storing more data than you need in order to avoid not having enough data. However, it is sometimes acceptable when generating random phrases to generate the same phrase twice. The trick is to know when it is not acceptable and build safeguards into the code to ensure that this does not happen. The point is that just because you store thousands of bytes more than you need, you will not necessarily avoid repetition. Clever algorithms are often a good substitute for large amounts of data—but they do increase processing time.

Lastly, calculations are no substitute for analysis. As our first conclusion shows, always take the largest possible population (either real or generated) before attempting any calculations. In the final analysis, the entire data set should be generated for those pieces of information that absolutely must be stored so that the 'real' storage requirements can be set in stone. When this is done, there will be a natural increase in storage space, usually by n bytes, where n is the number of data elements.

This increase occurs because everyone (even the author) occasionally forgets to factor in the byte of data needed to separate data elements. Whatever mechanism is used, whether it be the length of the data element or a space character indicating a break in the data stream, game and level designers simply might not be aware of the fact that a separation byte is needed; programmers often forget it until the last minute and thus arrive at erroneous estimations of storage requirements.

CODE SAMPLE 19.8 The Fibonacci descriptive phrase generator.

.
.
.

```
CFibonacci oFibGen = new CFibonacci( lOne, lTwo );

    .

    .

    .

// Not terribly good coding style: only valid for *this* set
// of data, however, it can easily be adapted to cater for
// data that is read in from a file.

char szAdjective1[] = "fat thin tall brusque ugly";
char szAdjective2[] = "black red pink orange green";
char szNoun[]       = "feline canine human frog lizard";

char * GetEntry( char * szData, char * szSep, int nEntry)
{
  int n = 1;
  char * tok = strtok(szData, szSep);
  while (n < nEntry)
  {
    tok = strtok(NULL, szSep);
    n++;
  }
  return tok;
}

void GeneratePhrase( char szName[255] )
{
  sprintf(szName,"%s %s %s",
    GetEntry( szAdjective1, " ", oFibGen->GetNext() % 5),
    GetEntry( szAdjective2, " ", oFibGen->GetNext() % 5),
    GetEntry( szNoun     , " ", oFibGen->GetNext() % 5));
}
```

The above produces phrases such as "brusque red lizard" for descriptive use. Pluralizing can be achieved by simply adding an "s" to the noun, and it is probably a good idea to make the first letter of the first word a capital, also. A period at the end of the phrase would help as well. The final phrase "Brusque red lizards." is quite acceptable.

MULTILINGUAL CONCERNS

If the game is designed to be multilingual as well as multiplatform, then it is a good idea to keep the processing and storage required for each market very separate from the main game. This is because language construction varies from culture to culture. French word ordering, for example, follows the following rule:

Description = adj(pl) + noun(pl) + adj(pl)

By this, we can see that there are in fact two differences. First, the second adjective follows the noun, whereas in English it precedes the noun; the two nouns are together. Second, the adjectives must be made to 'agree' with the noun. That is, if the noun is plural, then the adjectives must also be plural. French, incidentally, also has the concept of gender for objects, so that a frog (*grenouille*) is a feminine noun, meaning that we have extra work to do to make the adjectives agree with a noun that is feminine as well as plural. For the curious among you, "fat red frogs" translates as:

"Des grosses grenouilles rouges"

Which highlights another grammatical difference between the two languages—a sort of article, like "the" or "some," is required at the beginning of the phrase. In English, this is not necessary. So, the rule becomes:

Description = art(pl) + adj(pl) + noun(pl) + adj(pl)

Language differences also have a big impact on storage requirements. Since in French there are four variations for each adjective—masculine singular, masculine plural, feminine singular, feminine plural—we have to devise a way to store this information plus the gender of each noun. A cheap way to do this is, of course, to store only adjectives that follow a specific rule for the formation of their plural and feminine forms (add an "e" for feminine, or an "s" for plural, or "es" for feminine plural), and thereby avoid any issues relating to 'irregular' adjectives that do not follow any rules.

We still need to store extra information, though, to determine the gender of each noun that we choose to use in our game, unless we choose all masculine nouns, in which case we do not need to worry about specifying the gender in the data file or even make feminine forms of the adjectives.

This will, however, be terribly restrictive and probably not what the designers envisage.

All these decisions need to be made at the design stage of the project. It is no good making an English version and then trying to map it onto, say, a German version and hope that all will be gracefully transferred across. As a minimum, keep all language information (including layout) separate so that if and when the time comes, at least the structure is clear, so you can find what needs to be adapted.

Other aspects that will be impacted are things like storing generated phrases: They might need more storage then in the original language, or even less. There might be a more efficient way to store the data because of a higher redundancy in the letter arrangements.

CONCLUSION

This concludes our brief two-chapter incursion into the discussion of language and its place in the computer gaming industry. Of course, all of these theories and techniques can be expanded further to provide more complex and involved ways in which the machine and the human player can interact using the medium of language.

As a footnote to the discussion, combinations of natural language and other communications channels, such as graphics and sound, will always be more effective than their component parts. The World Wide Web is a good example of this—many graphics have alternative text attached to them that clarify or expand on the themes of the graphics in question. These kinds of synergies can also be explored in the game arena to provide a much more intuitive user interface.

DIGITAL IMAGING

INTRODUCTION

Images and graphics make up a large part of any game. Games without graphics exist, but they are not generally as immersive as those that involve a pure text interface—with the possible exception of multiuser dungeon (MUD) derivatives.

Nonetheless, many games could not exist without graphics, particularly those in the handheld and console arena. Graphics are used in a variety of ways and take a large number of forms. They also swallow a large proportion of the resources dedicated to the game's storage space. Any required graphics must be stored somewhere and in some form, and usually in a way that will lend itself to rapid access.

We have already seen how collections of graphics can be used to make up a level-based game environment. This is a very limited example of the use of graphics in a game: In isolation, the graphical icons do not mean much, but put them together and a whole world can open up.

This technique is one example of an approach known as "tiling," and will be covered in detail in this chapter. Each tile can be either a specific graphical object or an element known as a "texture." Textures can be used to cover entire areas, and each textured 'tile' fits with its neighbors. Textures will be the first specific technique we shall cover.

TEXTURES

In the real world, everything is textured—from the grain in wood to the weave of a reed mat, examples of textures are all around us. It is the visual texture of an object that gives a clue as to how that object would 'feel' were

we to touch it. In an artificial world viewed through a television or monitor screen, we cannot actually touch the objects, so the visual texture becomes all the more important.

In two-dimensional terms, a textured plane can be constructed by taking a pure color and adding, or overlaying, a texture on top of it. Textures, which are the illusion of three-dimensional planes in two dimensions, are recognized because there is a certain shadowing of the color (or light) that exists in the plane. This shadowing relays information to the brain, telling it that there must be a raised portion of the plane that we are looking at. Consider, for example, a standard button in a graphical user interface:

FIGURE 20.1 Button shadows clue a raised or lowered status.

The button on the left is raised, or unselected, while the button on the right is recessed (clicked or selected). (See Figure 20.1.) All that has changed is the shadow that is around the edge of the button. The recessed button has a shadow along the top and left of the object, with a light tint along the right-hand side and bottom of the button. On the other hand, the raised button has the opposite shading.

Textures adhere to the same theory of light and dark shading, depending on the position of the light source, but always on opposite sides. It is this shading that, as shown in the button example above, gives a three-dimensional aspect to whatever plane is being textured. Of course, not all textures rely on this shading, such as grain-based shading (e.g., sand), which can be simulated by using speckling to dot the plane with random dark pixels.

The image in Figure 20.2 shows an area of speckled, yellow-brown 'sand' with a portion that has been enlarged to show the individual pixels. As can

FIGURE 20.2 Speckled sand effect.

be seen, the effect is achieved by a static scattering of speckles of varying shapes and sizes, some of them two-pixels in diameter, some of them single pixels, and other two-pixel groupings oriented either horizontally or vertically.

The exact density of speckles, as well as their shapes and sizes, all contribute to the texture that is represented by the speckled surface. The pixel size visually relates to the density of the speckles, which in turn has an effect on the perceived nature of the texture. However, it is the orientation of the individual pixel groupings, where each 'speckle' comprises more than one pixel, that dictates the pattern that exists within the speckled surface.

If all the groupings are oriented in the same direction, then a regular pattern will be discerned, which creates a nonspeckled appearance. Code Sample 20.1 shows how a memory-mapped bitmap can be speckled in a random way.

CODE SAMPLE 20.1 Random tile speckling.

```
// Pixel-based data structure
struct sRGB
{
  int nRed;
  int nGreen;
  int nBlue;
};

void PixelDarken(struct sRGB * oPixel, int nPercent)
{
  double dF = 1.0 - ((double)nPercent / 100.0);

  oPixel->nRed = (int)((double)oPixel.nRed * dF);
  oPixel->nGreen = (int)((double)oPixel.nGreen * dF);
  oPixel->nBlue = (int)((double)oPixel.nBlue * dF);

  if (oPixel->nRed < 0) oPixel->nRed = 0;
  if (oPixel->nGreen < 0) oPixel->nGreen = 0;
  if (oPixel->nBlue < 0) oPixel->nBlue = 0;
}

void PixelLighten(struct sRGB * oPixel, int nPercent)
{
  double dF = 1.0 + ((double)nPercent / 100.0);
```

```
    oPixel->nRed = (int)((double)oPixel.nRed * dF);
    oPixel->nGreen = (int)((double)oPixel.nGreen * dF);
    oPixel->nBlue = (int)((double)oPixel.nBlue * dF);

    if (oPixel->nRed > 255) oPixel->nRed = 255;
    if (oPixel->nGreen > 255) oPixel->nGreen = 255;
    if (oPixel->nBlue > 255) oPixel->nBlue = 255;
}

void SpeckleBitmap(struct sRGB * oBMP, int nWidth, int
nHeight,
                      int nSpeckleLength, int nSpecklePercent)
{
  for (int x = 0; x < nWidth; x++)
  {
    for (int y = 0; y < nHeight; y++)
    {
      int dx, dy, ds;
      dx = rand() % 100;
      dy = rand() % 100;
      ds = rand() % 100;

      if ((dx >= 0) && (dx < 33)) dx = -1;
      if ((dx > 33) && (dx < 66)) dx = 0;
      if (dx > 66) dx = 1;

      if ((dy >= 0) && (dy < 33)) dy = -1;
      if ((dy > 33) && (dy < 66)) dy = 0;
      if (dy > 66) dy = 1;

      if ((ds >= 0) && (ds < 33)) ds = -1;
      if ((ds > 33) && (ds < 66)) ds = 0;
      if (ds > 66) ds = 1;

      int px, py;

      px = x; py = y;

      for (int n = 0; n < nSpeckleLength; n++)
      {
        if (px < 0)        px = nWidth - 1;
        if (px > nWidth)   px = 0;
        if (py < 0)        py = nHeight - 1;
        if (py > nHeight)  py = 0;
```

```
        if (ds < 0) DarkenPixel(&oBMP[(nWidth * py) +
px],nSpecklePercent);
        if (ds > 0) LightenPixel(&oBMP[(nWidth * py) +
px],nSpecklePercent);

      px = px + dx;
      py = py + dy;
    }
  }
 }
}
```

The structure presented in Code Sample 20.1 is one that we will carry through to the other sections in this chapter and build on gradually. It is, however, worth mentioning that this method is not necessarily designed to be used on a large bitmap. Rather, it should be used on several small bitmaps that are then 'stitched' together to form the final bitmap, which can then be used in any way that the game calls for.

Another technique that we shall be using is the lightening or darkening of pixels based on their mix of red, green, and blue (RGB) components. For simplicity, the bitmap in Code Sample 20.1 is assumed to be comprised of pixels that are each represented by three numbers, which are stored in the sRGB structure. Other encoding techniques have been explored in Part I; however in this chapter, the techniques will be easier to understand if we continue to use the sRGB structure. The manipulation of the pixels is provided by the PixelLighten and PixelDarken functions.

As the loop inside the SpeckleBitmap function progresses, some pixels will be either lightened or darkened several times if the nSpeckle-Length variable is greater than 1. Otherwise, each pixel will be lightened, darkened, or left alone depending on the value of ds, which is derived from a random value in the same way as dx and dy, the values that determine the speckles' orientation.

In Figures 20.3, 20.4, and 20.5, the effect of using speckle lengths of 1 pixel, 3 pixels, and 5 pixels can be seen. Which one to use is left to the game developer, but there is a speed issue that needs to be addressed—the longer the speckle length, the longer it will take to process the tile.

In addition to any performance issues, the longer speckle lengths tend to create a pattern in the texture, which, being random, cannot produce tiles that lock together. The more-random the pattern is in the tile, the more visually uneven will be the end result when several are placed side by side, as can be seen in Figure 20.5.

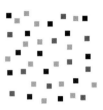

FIGURE 20.3 1-pixel speckling.

FIGURE 20.4 3-pixel speckling.

FIGURE 20.5 5-pixel speckling.

REGULAR PATTERN TEXTURES

The speckling algorithm above is an example of an *irregular pattern* texture. That is, there is a pattern, but it is not regular, and therefore the edges of the tiles will not match, leaving a clear line between each tile. *Regular pattern* textures have such a repeatable and regular pattern (over a small area) that, once applied, the pattern can be replicated without any discernable border between tiles.

This also means that the texture tile can be much smaller: only as large as a single repetition of the texture pattern needs to be. In some cases, this can be a matter of pixels. Take, for example, the very simple pattern in Figure 20.6.

When the pattern in Figure 20.6 is replicated over a comparatively large area, an image such as that in Figure 20.7 emerges.

The tile (Figure 20.6) that gives rise to this pattern is only 8-pixels square, yet the result gives a slightly recessed texture that almost looks like recessed squares on a white background. We can enhance this pattern by using a modified version of Figure 20.6, which uses scaled gray pixels to form a slightly different tile, as in Figure 20.8.

Applying this tile to a large area yields a pattern that consists entirely of recessed squares, and can be seen in Figure 20.9. This new figure is an enhanced version of Figure 20.7, which merely suggested the existence of a

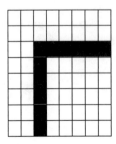

FIGURE 20.6 Simple regular pattern.

FIGURE 20.7 Tiled regular pattern.

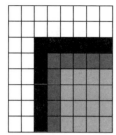

FIGURE 20.8 Complex regular pattern.

FIGURE 20.9 Tiled complex regular pattern.

three-dimensional pattern. Our pattern now has enough shading so we can very clearly discern where the ridges and troughs actually are.

On their own, these patterns can be used for a variety of purposes, such as tiling virtual floors or walls (for which a brick-like pattern can be created, if required), but this is requires that they are colored in some way. This use, however, is only the tip of the iceberg. We can also use the pattern tiling theory to create templates that can be applied to existing bitmaps, which might themselves be the result of applying a pattern or texture template. The next section in this chapter will deal with the use of such templates.

THE TEXTURE TEMPLATE

If we wish to turn one of the tiles into a bitmap pattern, we need to start at the top-left corner of the bitmap and copy the tile across from left to right, top to bottom. This is performed by setting each pixel of the bitmap according to the status of the corresponding virtual pixel on the tile. In fact, the technique is easier to explain with a simple quad-loop algorithm:

```
for (y = 0; y < bitmap_height; y++)
{
  for (x = 0; x < bitmap_width; x++)
  {
    for (tx = 0; tx < tile_width; tx++)
    {
      for (ty = 0; ty < tile_height; ty++)
      {
        SetBitmapPixel(bitmap, x, y, GetTilePixel(tile,
tx, ty));
      }
    }
  }
}
```

The two functions `SetBitmapPixel` and `GetTilePixel` should be fairly self-explanatory, and we have seen enough coded examples of how to manipulate such objects that we do not need to repeat ourselves here. There are also more-efficient ways to code the algorithm, such as:

```
for (y = 0; y < bitmap_height; y++)
{

  for (x = 0; x < bitmap_width; x++)
  {
    SetBitmapPixel(bitmap, x, y,
  GetTilePixel(tile, x % tile_width, y % tile_height));
  }
}
```

The above code is easier to understand once the more-verbose version has been seen. It is left up to the programmer to decide if the second version is really any more efficient in terms of processor cycles, remembering that the two modulo operations will involve some complex mathematics.

This code will serve to create a bitmap from a tile, but the template can be used in a more creative way by combining it with an existing bitmap to create a textured version rather than simply a tiled one. To make the function as complete and versatile as possible, we need to be able to specify a tile definition, as well as define how each value that makes up the tile should be interpreted.

We assume that each entry (pixel) in the tile specifies a grayscale value ranging from 0 (black) through 100 (white). The range is not a coincidental; it allows us to reuse the `PixelLighten` and `PixelDarken` functions from Code Sample 20.1 by treating each pixel value as a percentage. If we were to recode the image in Figure 20.8 as a table of percentage figures, we would arrive at a representation that would resemble Figure 20.10.

We have, even at this early stage, an implementation decision to make. The choice is whether we treat the 100% figures as a nonevent (leave the pixels as they are) or enhance the existing pixel values by 100%. On the one hand, if we use the `PixelDarken` function with a percentage value of 100 `-tile_percentage` essentially for a value of 100%, we are saying "darken by 0." Of course, this does mean that for a 0% value, the pixel will invariably become black. If this is too severe, then the gray and black percentages can be scaled to avoid this happening.

On the other hand, we can use the `PixelLighten` function with a percentage value of `tile_percentage`, which will lighten all the pixels to

FIGURE 20.10 Complex regular pattern percentage map.

varying degrees—for 0 (black), no effect will be applied at all. This means that any pixel modified by 100% will run the risk of becoming white, and the entire texture will be lighter in shade than the source bitmap.

To achieve a more-even result, we can also use an option that we have not yet mentioned. Instead of using either the `PixelDarken` or `PixelLighten` functions in all cases, we can choose between them, depending on the percentage we require. The best way to do this is to apply the `PixelLighten` function with a percentage value of `tile_percentage / 2` for all values above 50% and the `PixelDarken` function with a percentage value of `(100 - tile_percentage) / 2` for percentage values above or equal to 50%.

CODE SAMPLE 20.2 Texture template mapping.

```
void TextureBitmap(struct sRGB * oBMP, int nWidth, int
nHeight,
                    int * nTexure, int nTextureWidth, int
nTextureHeight)
{
  for (int x = 0; x < nWidth; x++)
  {
    for (int y = 0; y < nHeight; y++)
    {
      int nPixelReference  = (nWidth * y) + x;
      int nTextureReference =
        (nTextureWidth * (y % nTextureHeight)) + (x %
nTextureWidth);
```

```
       if (nTexture[nTextureReference] > 50)
         PixelLighten(&oBMP[nPixelReference],
                       nTexture[nTextureReference] / 2);

       if (nTexture[nTextureReference] <= 50)
         PixelDarken(&oBMP[nPixelReference],
                     (100 - nTexture[nTextureReference]) / 2);
     }
   }
}
```

This technique can be adapted to any size template—all the examples here use an 8 × 8 grid. Be aware, though, that the larger the texture template, the less benefit is gained from its use.

GENERATING TEXTURES

We mentioned above that the larger the texture template is, the less benefit is gained from its use; this is because we are trying to save space by reducing a large amount of repetitive data into a smaller data set that can just be applied a number of times to achieve a good approximation of the original data set. It will never be the same, because when we reduce information in this way, we lose some of what makes each subset of the data unique.

Consider, for example, a wall made up of bricks. Each brick follows the same format in terms of color, size, and even texture. The mortar that holds several bricks together also has the same qualities, no matter which bricks it is holding together. No two bricks or collection of bricks are the same, however. Even if we examine a single brick, we can isolate the style of texture and create a template, which we can then apply throughout the brick. It will not quite look like the original, though, because no two pieces of brick are the same.

The above discussion attempts to point out that a small template will lead to very artificial textures with limited uses, while a large template that captures all the essence of the original might not be appropriate because of space limitations. There are some solutions, however, that use the template in conjunction with mathematical operations. The first of these solutions is an old friend—the random number generator.

If we were to just apply the random number generator so that we change the amount (percentage) by which each pixel was randomly altered, we would only achieve half of the desired result. There would still be a regular pattern that would give away the presence of a simple texture template, and

the result would look less artificial, but it would still not look perfect. In many cases, this will be enough; and a simple variation function is implemented in Code Sample 20.3.

CODE SAMPLE 20.3 Random variation function.

```
int RandomVariation(int nPercent, int nMaxVariation, int
nMinVariation)
{
  int nOut;

  int nVariation =
    (rand() % (nMaxVariation - nMinVariation)) +
nMinVariation;

  if (rand() > 49)
    nOut = (int)((double)nPercent * (1.0 +
((double)nVariation / 100.0)))
  else
    nOut = (int)((double)nPercent * (1.0 -
((double)nVariation / 100.0)))

  return nOut;
}
```

In order to use this function in the context of our texture template function from Code Sample 20.2, an example of the required function call would be:

```
if (nTexture[nTextureReference] > 50)
  PixelLighten(&oBMP[nPixelReference],
    RandomVariation(nTexture[nTextureReference],5,0) / 2);
```

To break the pattern a little more if required, we can also introduce a variation so that the lightening or darkening is no longer solely dictated by the texture map, but also by a random choice to either apply one or the other. However, by going this far, we should keep the variations to a minimum, otherwise the result will tend toward the speckling algorithm encountered above.

One last point to note: We have restricted ourselves to fairly static texture templates. True, we have altered them slightly so that they vary with

usage each time, but the templates remain static. If we wish (and have the computer power available), we can generate textures entirely from scratch. Some fractals, for example, can be used to generate textures. It is just a case of finding the correct algorithm that fits your need.

This is not the place to examine different algorithms; in the end, it is up to the developer to find the algorithm that best fits the usage. *The Fractal Geometry of Nature* (B. B. Mandelbrot. New York: W.H. Freeman, 2000) goes into much detail (Ch. 31–34), and covers many different formulae that can be used for textures. It is worth the investment if texture generation is your chosen implementation path.

In coding terms, there is very little difference between the `TextureBitmap` function and one that uses math to determine the effect applied to the current pixel on the bitmap. In fact, we can combine many techniques in order to arrive at the desired effect. This can be additive: A stone floor, for example, can be generated by applying an algorithmic texture for 'stone' to a suitable color plane. Then, a 'tiling' texture could be applied to the 'stone' to arrive at a suitably textured and tiled floor.

It is important also to remember that the applicability of textures changes depending on how close the player is to the object. A flagstone floor, arranged regularly, is a texture if the player sees it from a distance; but then again, once the player arrives at the stone floor, there will also be the texture of each individual flagstone to generate. If the player examines a specific stone, its texture becomes more important.

Texture Mapping

No matter what the eventual application of a particular texture is, it will probably have to be mapped to a surface at some point. But, the reader should be aware of a few general issues about texture mapping.

Regular textures are the easiest to map to an object because only a small example is needed to produce a large mapped area. This is because each piece of texture will fit in seamlessly with its neighbors. So, we can effectively tile the entire plane with little samples and achieve a good, if slightly mechanical result.

However, irregular textures, due to their nature, can not be mapped easily in this way. There are a few solutions to this problem, some requiring substantially more storage than others. Starting from the cheap end of the scale, we can design a selection of tiles that can be attached together seamlessly (e.g., by having nontextured borders) and scatter them at random over the plane that needs to be textured.

Clearly, this will require a small amount of storage space on the distribution media, but it will require some temporary space that can be used to store a texture map at least as large as the object that is to be covered. Failing this, some heavy processing will be required to ensure that the textured pieces are managed cleverly enough so that each object on the screen remains uniformly textured.

In the middle range is a technique that defines a large enough texture map to cover the largest object that it is associated with. This will need to be stored on the distribution media either in raw format, taking up as much space as is necessary, or compressed, in which case it must be decompressed to temporary storage.

Finally, we can create the texture algorithmically, based on a formula; this approach takes up very little storage space, but it needs either a lot of temporary storage space or some heavy processing power. This last option is the most flexible and can even be combined with any of the others, such as providing random variations of each small texture sample (as with the texture templates and random variation algorithms above), which can still be stitched together seamlessly.

CONCLUSION

Computer graphics are a powerful medium, and since a picture can often replace a thousand words, the inclusion of graphics in any game ranges from desirable (for very reduced-resource platforms) through to expected—for the high-end platforms. When adventure games first began to offer a graphical portion, static pictures for example, they were billed as advanced; but the goal posts have moved since then. And if a game has no graphics these days, people will be less enthusiastic about it, even if the game play is superior to others in the same genre.

The techniques offered here have hopefully convinced the reader that even high-resolution graphics need to necessarily be ruled out of games designated for smaller platforms, such as handheld or low-power desktop machines. We shall build on this theory in Chapter 21, which looks at specific pictures, rather than graphical components that can be applied to game objects.

ARTIFICIAL PICTURES

INTRODUCTION

In addition to trying to mimic the real world when we generate graphics, we can also generate entirely new objects that might or might not have a parallel in the 'real' world. Spacecraft and monsters, strange plants from other worlds, art hanging on a virtual wall, or even something so unique that it does not even have a name are all examples of entirely new objects that we might need to try and create a picture of by using the computer.

When we talk about artificial pictures in this context, we have to consider two aspects—how we define and store the object, and how we reproduce it. Artificial pictures can be based on generating the resulting picture from a coordinate system, or mathematical formulae, or based on variations of data derived from real-life models. How ever we arrive at the final result, it can be used as a game object or a backdrop, or anything that is required. An artificial picture is subtly different from a natural picture in that the natural picture strives to replicate the stored version as closely as possible, whereas an artificial picture might have no other version than itself.

It is also important to note that there are a few terms that will be used in this chapter and Chapter 22 that should not be confused. For example, the *realism* of artificial pictures will be discussed. In our context, "realism" simply means that the end result is believable—not realistic. Natural pictures are expected to be realistic; to consider nonrealistic natural pictures is to admit failure in the implementation of the storage and reproduction techniques employed.

LINE ART

Part I of *Infinite Game Universe: Level Design, Terrain, and Sound* briefly addressed line art, but now it is time to review this materials and place it in the context of being able to generate artificial pictures and objects. Line art objects are based on vector graphics with either two-dimensional or three-dimensional coordinate representations.

We shall begin with two-dimensional line art. By now, the reader should be familiar with the coordinate system that we have been using, which is based on each pixel having an x and y coordinate. Thus, a specific point on a bitmap is referred to as x,y. There is a certain redundancy in the system, which can be overcome by a knowledge of geometric shapes.

For example, if we want to represent a square, we can store four sets of x,y coordinates (about 8 bytes worth) as one corner (2 bytes), the length of one side (1 byte), and the identification of it as a square (1 byte), which comes to 4 bytes instead of 8 bytes. We have saved half the storage space just by altering the representation slightly. This is 1 byte more efficient than the obvious solution of storing two opposite corners and the identification of the shape as a square (5 bytes).

Of course, for rectangles, the best solution is to store two opposite corners and the identification of the object as a rectangle. All the other alternatives (involving such mechanisms as one corner, the diagonal length between two opposite corners and the angular orientation of this diagonal, and the rectangle identification (5 bytes)) cannot do better than the 5 bytes required for the basic storage technique and will also require more computationally expensive mathematical calculations.

However, most line (or vector) art objects are comprised of triangles, the triangle (or a collection of triangles) being able to most closely approximate any kind of complex shape without the stepping that would occur if squares or rectangles were used. Imagine, for example, a triangle made up of rectangles; the sides would be stepped, unless a great many were used. On the other hand, if we use a triangle, we can build any other shape. Squares and rectangles can be made up of two triangles, for instance.

A triangle can be stored (or defined) in a variety of ways, the easiest being a simple set of three points using 6 bytes of storage in a two-dimension plane, or 9 bytes for a set of three x,y,z coordinates to describe the same triangle in three-dimensional space.

If we can depend on the triangle being regular, then we can bring other techniques for defining triangles into play. For example, given the orientation of the first line of a triangle and assuming an equilateral triangle, we

can place it anywhere we like. Equilateral triangles are those whose three sides are of equal length, which also means that the three angles between the sides are of equal size.

Given that there are 180° in a triangle, each angle is 60°. So, with a little mathematics, we can generate a two-dimensional triangle from 4 bytes of data; the starting point (2 bytes—*x* and *y* coordinates), length of the sides (1 byte), and initial orientation (1 byte).

Before we go on, note that representations of this nature use a different coordinate system than that used up until now. The simple *x,y*-based system is known as the Cartesian coordinate system, and the one that we need to exploit is based on angles and lengths, and is called the "polar system." In fact, polar coordinates are based on circles, with the center of the circle as reference. Luckily, there are a set of mathematical relationships that relate triangles to circles, which makes the conversion fairly understandable.

In Figure 21.1, the theta symbol, θ, refers to the number of degrees (in radians) of the angle between the center of an imaginary circle and the point in question. The circle has a radius (*r*) that denotes the length of a given line. Thus, if we place the beginning of a line at *x,y* and wish to extend the line for 10 units at an angle of 45°, we first need to convert into radians, which is:

$$((2 * pi) / 360) * angle$$

Since (for reasons beyond the scope of this book) there are 2 * pi radians in a circle of 360°. The value of pi can be hard-coded or approximated

FIGURE 21.1 Triangles and the polar coordinate system.

by the value 22/7, depending on the desire for accuracy. Once we have the angle, we can obtain the *x* coordinate:

10 * sin (angle)

and the *y* coordinate:

10 * cos (angle)

If we keep a track of the angle turned through, we can draw a triangle using code similar to Code Sample 21.1.

CODE SAMPLE 21.1 Equilateral triangle-drawing function.

```
void Triangle ( int x_start, int y_start, int length, int
orientation )
{
  MoveTo(x_start, y_start);
  int nAngle = orientation;
  while (nAngle < orientation + 180)
  {
    LineTo(x_start + (length * sind (nAngle)),
           y_start + (length * cosd (nAngle)));
    nAngle += 60;
  }
}
```

Of course, Code Sample 21.1 assumes the availability of some functions, such as `sind` and `cosd` that convert `nAngle` into radians automatically, and two simple drawing functions, `MoveTo` and `LineTo` that allow the programmer to draw on a given surface. Each triangle in a given list that makes up the 2D line art representation of the required object will require 4 bytes of storage.

The natural extension of this is to create models consisting of *n-sided* polygons. To do this, we need to derive a relationship between the number of sides and the angle of each corner. Luckily, this is easy enough because there are 360° in the entire shape (if we want to end up where we started, pointing in the direction that we started out in, that is). We can use a formula such as:

```
double dAngle = 360 / nSides;
```

Essentially, this is just a generalization of the equilateral triangle formula from above. Code Sample 21.2 is adapted from Code Sample 21.1 and highlights the similarities between the two.

CODE SAMPLE 21.2 N-sided polygon-drawing function.

```
void Triangle ( int x_start, int y_start,
                int length, int orientation, int nSides )
{
  MoveTo(x_start, y_start);

  double dCurrentAngle = orientation;
  double dAngle = 360 / nSides;

  while (nCurrentAngle < orientation + dAngle)
  {
    LineTo(x_start + (length * sind (dCurrentAngle)),
           y_start + (length * cosd (dCurrentAngle)));
    dCurrentAngle += dAngle;
  }
}
```

The purists might like to add a final:

```
LineTo ( x_start, y_start );
```

So, in the event of an error in the accuracy of the calculations, the polygon is sealed. The *n*-sided polygon, then, requires 5 bytes of storage instead of 4 bytes. Depending on the application, one or the other might be chosen. Strictly speaking, however, it will be easier to not use polygons of differing numbers of sides for large objects, since the calculations required to keep all the sides matching will prove quite processor-intensive.

3D LINE ART

The 3D equivalent to 2D line art is known as modeling—using simple shapes that are connected together to create models of what is trying to be created. The key principle to modeling is knowing which shapes share which vertices. That is, we construct a model from smaller parts in such a

way that the relationship between each individual piece is either expressed or implied.

In this context, the term, "expressed or implied" (borrowed from a free-ware contract the author once read), means that either each shape exists as a set of vertices that are uniquely defined, or it means that the shapes are defined as being relative to each other, with some vertices that are calculated with clever mathematics. For example, consider a spacecraft whose design is extremely similar to the Viper spacecraft design from the game *Elite*. Figure 21.2 shows a wire-frame model of the Viper spacecraft.

Rear View

Top View

FIGURE 21.2 Wire-frame model of the Viper spacecraft.

It is no mistake that we have chosen the very symmetrical Viper spacecraft for this example, since all we need to do is define two triangles in three-dimensional space that have an assumed relationship, such as when connecting the closest vertices. Thus, generating the entire shape requires only two triangles; the rest of the shapes, the two sides of the ship, and the rear panel are inferred and not defined.

FILLED LINE ART

When games such as *Cholon* and *Elite* first moved from their original 3D line art implementations toward something a little more sophisticated, it was by simply filling (or shading) the objects. Setting aside the complexities associated with hidden plane removal (as opposed to hidden line removal), filling a plane is fairly easy. First, let us consider simple 2D-plane filling.

The simplest method of filling a plane is a straight horizontal or vertical flood fill. Figures 21.2a and 21.2b show each variation.

FIGURES 21.3a/b Horizontal and Vertical Flood Fills.

As can be seen, the idea is to start in the center of the figure and fill out toward the sides, stopping when the outer boundary of the shape is reached. This outer boundary can be calculated for regular shapes such as rectangles, triangles, or ellipses. There are two methods that can be used to flood-fill regular figures in this way. The first is by drawing successive lines of a given dimension until the figure is filled. This works well for rectangles, since we know exactly what the dimensions are.

Triangles and circles require a slightly different approach. To be honest, it is a good thing that most actual transformations of this nature have been encoded in the hardware of modern gaming machines. It does not hurt to know the theory, however, which is based either on calculation or hit-testing.

Calculation-based flood filling can only be easily applied to regular shapes that have an easily calculated boundary. Triangles and noncircular ellipses, for reasons that we shall see when we look at a coded example, are best viewed as irregular for the purpose of flood filling. Circles, however, are easy; and Pythagoras' theorem makes our work almost trivial. Based on Figure 21.1 above, we can say that:

$$z = \text{sqrt}(\ (x * x) + (y * y)\);$$

Where z is the length of the hypotenuse, and it just so happens that we can use this relationship to find out the distance between two points, in this case x and y. This assumes, of course, that the center of the circle is at coordinates

0,0. If it is not (and most probably will not be), then we need to use a function similar to that in Code Sample 21.3.

CODE SAMPLE 21.3 Distance between two points.

```
int DistanceBetween ( int x1, int y1, int x2, int y2)
{
  int nXDiff = max(x1, x2) — min(x1, x2);
  int nYDiff = max(y1, y2) — min(y1, y2);

  return (int) sqrt ( (nXDiff * nXDiff) + (nYDiff * nYDiff)
  ) ;
}
```

To flood fill a circle, we just need to know the center and radius, and we can determine if a given point *x,y* is inside the boundary of the circle. All we have to do is start at the center and work in quadrants, as in Figure 21.4.

For each point, we calculate the distance between it and the center of the circle, and if it is less than the radius, we plot a point. Interestingly, this gives an alternative way to plot a circle—if the distance is exactly equal to the diameter and we plot a point, we shall only plot those points on the edge of the circle. Thickening the border only requires that we settle for a point between, say, the radius divided by 8 and the radius. A final use for this kind of algorithm is to work out, based on an overhead map of a specific part of the game universe, what the player is able to see, so that the surrounding landscape can be built up accordingly.

FIGURES 21.4 Quadrant-based circle flood fill.

Finally, we have the least-efficient algorithm, which, rather than attempting to calculate whether a point lies within a boundary, tests to see if the boundary has been reached, assuming that it is in a different color than the color already present at that point. This method is also the most error-prone and only allows a flood fill of a given granularity. On the other hand, it enables the filling of irregular objects that have no calculable boundary.

Choosing the most suitable algorithm will be a decision made by the game designer, programmer, or both together. In the end, regular shapes will be faster, but most modern game console hardware will support rendering speeds of up to around 12 million filled, textured, and lit polygons on-screen per second.

CONCLUSION

There are many different techniques that have been explored in this chapter, all of which have their place in the game programmer's armory. Entire books, however, have been written that cover some additional ground, particularly when it comes to the mathematics behind specific techniques, techniques that will reduce the amount of processing power needed.

This chapter, then, should be considered a springboard toward other, more-advanced techniques, for which many books are available. The core theories, however, remain the same. Even more importantly, most games programmers will find that libraries exist on the open market (and some even freely available) that take the drudge work out of filling polygons or creating three-dimensional, shaded objects. It is important be aware of how the hardware works, though, for an appreciation of just how close the game demands lie to the limits of the hardware's abilities.

NATURAL PICTURES

INTRODUCTION

In the previous two chapters, we looked at some forms of imagery that can be used in game programming. Based on either models or artificially generated planar textures, these graphics can add reality to the game, but they will always look slightly artificial, in the same way that MIDI sound always seems like a poor alternative to real instruments, but not to the same extent.

Part of the problem is the sheer quantity of visual data present in the natural world. Even the most-simple surfaces, such as painted walls or floors, contain, upon close inspection, very intricate patterns. There are times, however (particularly when presenting realistic landscapes and other related scenes to the player), that it would be a distinct advantage to be able to define, store, and use this natural-information data in a practical way.

In order to be usable, any scheme to store and retrieve the data must be efficient. This is particularly true of textures. Since textures will be wrapped around a model or other object, or multiplied to fill a plane, then the speed at which they are recreated from the numerical data that represents them on the distribution media will be a critical bottleneck.

This chapter presents several encoding and compression schemes that are efficient enough for practical use and also have their place alongside other 'infinite' techniques, involving real-time level generation. In fact, many of the techniques can be combined with pseudorandom and related algorithms to generate pictures that follow the theme, if not the detail of the original.

DIGITIZATION REVISITED

We have established that the act of turning an analog representation of a real-world object into a form that the computer can understand is known as digitization. The object can either be intangible, a sound wave for instance, or a tangible structure, such as a tree. It is not really important from a general point of view whether the object is tangible or intangible, except that a representation of the object in some analog form must be available. Thoughts, memories, and emotions are very difficult to represent using analog means and nearly impossible to represent digitally.

The actual digitization of an image has aspects with analogies to sound digitization; the concept of sampling a frequency, for example, is the same, at least from a theoretical point of view, as refining the resolution of a digitized image. Both represent the number of samples taken per a given unit of measurement.

Sound sampling frequency is measured in 'times per second,' or hertz (Hz), while graphical resolution has two representations. The first is the width and height of the image, measured in pixels. A pixel does not have a real-world value; it is wholly dependent on the display medium. That is to say, sound frequencies map very easily between the real world and the computer world simply because they share the same base measurement unit, the second.

Graphical images, however, are based around an arbitrary measurement unit—the pixel. A pixel on a printer might not be the same size as a pixel on the screen, and a scanner pixel might not be the same as the display pixel. This means that images with the same pixel dimensions can have very different real-world dimensions.

For example, if you have a 17-inch monitor screen, and the resolution is set to 1024 × 768, the pixels will be a different size than if you set the resolution to 640 × 480. By the same token, a 640 × 480 image on a 15-inch screen will be smaller (in inches) than the same image on an 17-inch screen, even though it has the same pixel dimensions.

Therefore, before the images are digitized, a standard has to be established between artists and programmers to define the actual dimensions of a device-independent pixel. Sadly, this has never actually been set in stone, and a resolution measurement known as "dots per inch" (dpi) has become the customary way of expressing the quality of a picture.

Clearly if we equate a 'dot' with a 'pixel,' then an image measuring 640 × 480 pixels at 400 dpi is going to be a different size than an image measuring 640 × 480 pixels at 600 dpi. In the end, however, so everyone understands

the same basic premise, it will be easiest to adopt a scheme whereby an image is expressed by three numbers: its width, height, and resolution.

It really does not matter what units the measurements are in—as long as they all have the same base unit. If an image measures 1.5 × 1.5 inches, then the resolution should be expressed in dots (pixels) per inch. The actual size represented on the screen will vary, but we will have to live with this inconvenience—there is no way of automatically detecting screen dimensions.

Given these slightly far-reaching assumptions, we can begin to lay the foundations for an image-storage class, such as that in Code Sample 22.1.

CODE SAMPLE 22.1 Image-storage class.

```
struct sRGB_Pixel
{
  int nRed, nGreen, nBlue; // RGB Pixel
};

class cImage
{
  private:

  int nWidth;  // Width in dimensional unit, i.e. inch
  int nHeight; // Height in dimensional unit

  int nResolution; // Image quality in pixels per
                   // dimensional unit, i.e. dpi

  int nPixelWidth;  // The eventual width and height of the
                    // image in pixels. Initially, this
  int nPixelHeight; // will just be a simple formula.

  RGB_Pixel * oPicture; // The image data, initially raw

  public:

  cImage(int width, int height, int resolution);
  ~cImage();

  void SetPixel(int x, int y, int red, int green, int blue);
  void SetPixel(int x, int y, int red, int green, int blue);
```

```
void GetPixel(int x, int y, RGB_Pixel oRGB);
void GetPixel(int x, int y, RGB_Pixel * oRGB);
```

```
};
```

We have seen classes very similar to cImage in Parts I and II, so there is no need to go into much detail; it is fairly self-explanatory. The implementation appears on the companion CD-ROM, along with the source code for Code Sample 22.1. However, the rest of this chapter should be studied before reading through the code because the code covers a lot more than the basic implementation given thus far.

ON THE CD

In order to better explain the relationship between nResolution and the dimensions of the picture, consider the definition of the initial values for nPixelWidth and nPixelHeight. (Incidentally, these give the actual pixel-based dimensions of the picture, and not the width and height of the actual pixels that make up the stored image, as the name might suggest.) They are calculated thus:

```
nPixelWidth = nResolution * nWidth;
nPixelHeight = nResolution * nHeight;
```

Some swift arithmetic leads us to estimate that for a standard photograph measuring roughly 4×5 inches at a fairly modest resolution of 200 dpi, we need some 800,000 pixels, which translates into 2.4Mb of storage if we use the 3-byte RGB representation in Code Sample 22.1. Considering that we are just loading the image into memory prior to applying some compression to it, we can assume that this is good enough.

For those on the Windows platform, there are already some macros for dealing with RGB values, and these macros might be tempting to use. The RGB macro gives us a clue as to why this *might* not be a good idea for storing the raw image, and is *certainly* not a good idea for storing a compressed version:

```
#define RGB(r, g ,b)  ((DWORD) (((BYTE) (r) | \
    ((WORD) (g) << 8)) | \
    (((DWORD) (BYTE) (b)) << 16)))
```

The result of this macro is a DWORD value, which is 32 bits, or 4 bytes. This means that for 800,000 pixels, 3.2Mb of memory (or other storage) will be required. While this might not seem important right now, consider

how many raw-format photographs can be placed on a CD-ROM: the difference between 203 for pixels specified with `DWORD` values and 270 for those specified with 3-byte values.

These raw-format pictures are the ones that should be used as the starting point for any further work, and they should be kept so that the original is always preserved. The reason for this is that any subsequent processing will likely be 'lossy.' Lossy means that when the image is encoded, a certain amount of information will be lost between the original version and the encoded one. The opposite is lossless—an encoding scheme that does not lose information between the original and the encoded version.

Run length encoding (see Part I) is a lossless encoding scheme, since the data that is extracted is exactly reproduced. By and large, all of the schemes that we are about to present are lossy: The truth of the matter is that in all but the most complicated algorithms, some data loss is inevitable. The most complex ones that preserve nearly all of the data are too time consuming to consider using in the game-programming arena.

ENCODING & GENERATION

Although we have looked at a variety of information-reduction schemes throughout this book, the nature of using such complex pictures in the real world means that we now have to look beyond the simple algorithms (such as RLE) that we have already encountered. It is now time to earnestly consider compression algorithms as applied to pictures.

The Windows BMP format uses straight RLE to achieve a modest amount of compression. This format works well for information streams that do not contain very much variation (as we have already seen). Natural pictures, however, contain so much variation that RLE does not offer a high enough level of compression for it to be useful under normal circumstances.

However, RLE does offer an example of one of the two principle components behind compression theory—redundancy reduction. As Subhasis Saha (*ACM Crossroads,* Web site: www.acm.org/crossroads) states: "Redundancy reduction aims at removing duplication from the signal source..."

He goes on to offer a second form of data reduction, irrelevancy reduction, which, as he puts it: "...omits parts of the signal that will not be noticed by the signal receiver..." ("Image Compression From DCT to Wavelets: A Review," 2000).

To illustrate the second principle, imagine taking the full 24-bit color picture and reducing the number of colors in some way, such as using 8 bits per pixel, either color or grayscale. The viewer might not notice the color reduction, especially if they have never seen the original, but the storage requirements will be substantially smaller.

REDUNDANCY

In the same article by Saha, he notes that there are two main forms of redundancy that can be applied to static (i.e., nonmoving) pictures. These are spatial redundancy, which is using the relationship between neighboring values to reduce the amount of information needed to describe those values (e.g., RLE), and spectral redundancy. Spectral redundancy is slightly more difficult to quantify; it deals with the relationship between the colors in the picture. (For the sake of completeness, we should also mention the third type—temporal redundancy. Temporal redundancy relates purely to video and is the relationship between values over time. We briefly deal with this in Part V.)

Most lossy compression techniques take advantage of both spatial and spectral redundancy to a greater or lesser extent. An image's colors can, for example, be restricted to a known palette—to 16 colors, for example. If we use a 16-color encoding scheme, then we can store colors at a rate of 2 pixels per byte, with each nibble containing a value between 0 and F, representing an index into the palette. In this way, an 800,000-pixel image can be stored in 400,000 bytes, plus the palette (which will contain 16 RGB entries), and require approximately 48 bytes.

The information loss between 24-bit and 4-bit encoding schemes can be seen as the difference between the ranges of values possible—in this case, a reduction from some 16.5 million to 16 colors. But is there a middle ground? Yes, there is, in the form of 8-bit and 16-bit color, which require 1 byte and 2 bytes per pixel of storage, giving 256 and 32,768 total colors, respectively. Going the other way, simple images can be constructed in monochrome (two colors) using 1 bit per pixel (on or off), which is usually translated as black and white. This is good for text, for example. Sharing the 8 bits-per-pixel middle ground is an extension of monochrome, allowing for shades of gray, which we have already covered in Part II.

In traditional bitmap formats, a palette is used for 8 bits-per-pixel (bpp) color and for 16-bit color—three groups of 5-bit values used to represent the red, green, or blue component of each pixel, with the 16th bit not actually being used. A palette version of 16-bit color also exists that uses a sophisticated masking technique outside the scope of this book.

Storage requirements for 8bpp and 16bpp color can be calculated much as before, yielding results for an 800,000-pixel image of 800,768 bytes (image plus palette) and 1.6Mb, respectively. These reductions in spectral redundancy are at the expense of image quality, but they render an image with fewer differences of shade, which it turn make it easier to compress using techniques such as RLE.

We have already looked at how to implement standard RLE techniques, they figured prominently in Parts I and II of this book. When encoding a natural image, other forms can be used, such as encoding the red, green, and blue components of each pixel separately. Depending on the range of colors in the picture, this will yield a further reduction in the image storage requirements.

However, in the end, RLE will probably not be enough if we want to store near-photographic-quality images for use in creating true virtual environments. Compression will probably be required, and a trade-off between speed and storage efficiency reached.

Compression, as noted by Saha, falls into two categories: predictive coding and transform coding. Predictive coding encodes the data by storing the difference between previously available data and the data to be encoded. Images can be encoded easily and efficiently using predictive methods. Transform coding requires that the representation is converted to another form before coding and gives greater compression ratios, but in a computationally expensive way.

Entire books extolling the virtues of the different varieties of compression and encoding techniques could be, and have been written. Here, we shall concentrate on some simple, but efficient predictive coding techniques for lossless image compression.

The basis for our predictive techniques is the assumption that in a natural image, there will be groupings of like colors. It is unlikely that there will be an enormous difference in color (or shading) between two neighboring pixels. For some pictures, there will be very little difference between any of the pixels (for example, textures). In order to encode the image, then, we simply scan it and find out the minimum, maximum, and average values for each pixel. Code Sample 22.2 shows a fairly aggressive function for scanning an arbitrary chunk of memory, which must then be cast to an integer type.

CODE SAMPLE 22.2 Difference quotient function.

```
struct sDiffQuot
{
  int nMin, nMax, nAverage;
};

void GetDifferenceQuotient( int x, int y, int width, int
height,
                            sDiffQuot * oDiff, int * nMemory
)
{
  int a, b;
  unsigned long int lTotal;

  oDiff.nMin = 32000;
  oDiff.nMax = 0;
  oDiff.nAverage = 0;

  for (a = x; a < x + width; a++)
  {
    for (b = y; b < b + height; b++)
    {
      int v = nMemory[(b * width) + a];

      lTotal = lTotal + v;
      if (v < oDiff.nMin) oDiff.nMin = v;
      if (v > oDiff.nMax) oDiff.nMax = v;
    }
  }

  oDiff.nAverage = lTotal / (width * height);
}
```

We can encode the image in memory by comparing each value with the DifferenceQuotient value and store that information rather than the actual pixel value. The first point that will be immediately obvious is that, for this to result in any compression, we have to reduce the storage factor by an order of magnitude—for example, from 24 bits to 16 bits, or 16 bits to 8 bits.

In other words, the value (nMax − nMin) has to be capable of being stored in a representation that is an order of magnitude smaller than the

current representation. Clearly, with a possible 16 million colors, this will be almost impossible; even up to 32,000 colors, this appears to be unlikely. If, however, we apply the same theory to a small part of the image, then the chances increase significantly.

A quick and dirty implementation of the encoding part of the theory can be seen in Code Sample 22.3, which also defines some data structures to contain each 'tile.'

CODE SAMPLE 22.3 Difference encoding.

```
struct sBlock
{
   int nXPos, nYPos;
   int nWidth, nHeight;
   int nBase;
   int * nDifference;
}
```

Of course, due to the fact that we have used an integer representation for the data blocks in Code Sample 22.3, the most compression we can hope to achieve is from 24 bit to 16 bit, and even that is optimistic. However, these examples will give the reader a good starting point for better implementations. But be advised: Be wary of over-complicating the issue, because processor time will always be limited.

SATELLITE PHOTOGRAPHY

Finally, we should mention that if we wanted to store every single possible natural rendering of a landscape covering a large area, it is quite possible that we would run out of space after the first square mile. Maps provide an extremely efficient way of encoding landscapes. We saw one application of artificial mapping when we examined different terrain- and landscape-generation routines in Part II.

CONCLUSION

If you really have to use actual photographs or video in a game, then a certain amount of compression is going to be required. In addition, some loss

of information is going to occur. The trick is to minimize the redundancy of the information stored while ensuring that, in turn, the amount of information 'lost' is also kept to a minimum.

Of course, this might not always be possible, and it is up to the designer to ensure that the hardware is not taxed too highly; while it is up to the programmer to use the most efficient algorithm possible. Sometimes, a decision might even have to be made that favors leaving out some graphics because the cost is just too high.

LIMITED-RESOURCE ENVIRONMENTS

INTRODUCTION

Throughout this book, we have looked at techniques for defining and storing game data in such a way that the space required is reduced as far as possible, thus freeing space for game data or other important aspects, such as clever programming (e.g., artificial intelligence). Much of the time, these techniques have relied upon a fair amount of intensive number crunching—decoding chunks of data on the fly or actually generating game data as the play session progresses.

Of course, processor-intensive techniques will only be applicable some of the time; the choice of which technique to apply will be depend on a few other parameters, such as the target platform, portability concerns, and proportions of processing power, memory, and storage media available. Games written for the Game Boy will be constrained in different ways than those written for the PC.

NOT EVERYONE OWNS THE SUN...

Something that should be foremost in the minds of programmers and designers alike—from the earliest stages of the design and implementation of the game product, the difference between the development platform and target machine must be considered. By way of example, many Game Boy developers use a PC and emulator before copying the game to the cartridge and actually beta-testing the finished game.

There are good reasons for using powerful machines for the development of the game: the relative ease with which the programming can be

achieved, and the wealth of tools, compilers, and supporting utilities that are available. It is natural to approach the design and programming in this way; but since we are using 'traditional' techniques for game-data definition and storage, the impact is minimal.

However, there is always the danger that because these platforms offer such a high level of performance, the programmer will be lured into a false sense of security; in the end, it is not worth economizing a small amount of space if the processing required to recreate the data is too intensive for the target machine. Thus, even when the basic design decisions are being made, we need to be sure that we do not fall prey to this oversight.

In addition, just because the target platform is a PC, we cannot assume that everybody owns the latest, state-of-the-art system. The market is complex enough that there will be some gamers who cannot afford another upgrade simply because this specific game needs an extra gigabyte of memory; also, the market is competitive enough—these people cannot be cut out of the target audience.

HANDHELDS

Possibly the most restrictive of platforms, but also one of the most popular by virtue of the relatively low cost of ownership and its high portability (you can take them anywhere), this category includes machines such as the Nintendo Game Boy and Game Boy Advance, the ill-fated Atari Lynx, and more recently (and at the higher end of the scale), an adaptation of the Sony Playstation I (PSOne), as well as the true handheld computers such as Psion Organizer and Palm-OS based machines.

All of the above have different requirements and constraints, but they have one thing in common—they run on batteries. This means that they have low power consumption, slow (but efficient) processors, and reduced support for graphics and sound. The two exceptions are the PSOne and Palm-OS based systems, such as the Handspring Visor.

CONSOLES

There are four main contenders in the console arena at the time of this writing—the two stalwarts of the console community, Sega and Nintendo, and the two newcomers, Sony and Microsoft. Sony has already entered into its second generation of consoles with the Playstation II (PSII), and Microsoft has released their own Xbox.

Sega's last offering, the Dreamcast console, has some unique and innovative features, such as the ability to have controllers with separate proces-

sors integrated into them and a little LCD display that can be used to play simple games offline.

It might seem at first glance that none of these have any constraints at all, and that they are the perfect gaming machines. From the player's point of view, this is probably true; but from the designer's and programmer's end of the table, things look a little different. For example, although there is a whole subsystem in the PSII that handles texture-mapped polygons independently of the main processor, there is no hard drive; so decompressing vast quantities of RLE polygon vertices data files is probably going to be a waste of memory.

INTERNET & ONLINE GAMES

This category of games has its own set of very special constraints, if only because the target platform is transparent. The games are usually designed to be run anywhere, at least anywhere with an Internet connection. The constraints range from the obvious (e.g., download times should be kept to a minimum) to the slightly less obvious, such as managing server file updates from multiple players at the same time by using lock files.

Part V, then, will attempt to guide the design and implementation decision process toward the best technique for the target platform—or, in many cases, how to achieve the best balance between definition, storage, and generation.

CHOOSE YOUR PLATFORM

INTRODUCTION

Game-programming theory is a complete science. It is often said that an advanced game is the best test of the capabilities of both the platform and the programmers involved. There is a synergy between the designers and programmers that pushes the limits of the technology to the maximum.

Having said that, designers and programmers alike need to set themselves realistic goals; having the best game idea in the history of the genre is all well and good, but if it cannot be realized, then there is the very real risk that time and money will be wasted on trying to 'fit' the game to the platform.

So—choose a game to match the platform, or a platform to match the game. Luckily, the techniques that we have been perfecting during the course of this book can be applied to *any* platform and can be optimized to provide excellent results on even the lowliest of handhelds.

PLATFORM TYPES

In the current market, there are basically three types of platforms: handheld, console, and home computer (PC or Mac); and there is not a great deal of gray area between platforms, either. There are, however, many different subclasses within the platforms, and indeed, with some clever technology, even some overlap. Table 23.1 shows many of the options available at the time of this writing.

TABLE 23.1 A Selection of Current and Ancient Game Platforms

Handheld

	Nintendo	Game Boy Advanced (*)
		Game Boy Color (*)
		Game Boy (*)
	Atari	Lynx
	Sony	PlayStation + LCD Screen (*)

Console

	Sony	PlayStation II (*)
		PlayStation (*)
	Sega	Megadrive (Genesis in the U.S.)
		Dreamcast
	Nintendo	NES
		Super NES
		GameCube (*)
	Microsoft	Xbox (*)

Home Computer

	Various	IBM PC or Compatible (*)
		Apple Macintosh
		Atari
		Commodore Amiga (*)
		Commodore 64/128
		BBC Micro Model B
		Electron

The entries in Table 23.1 are considered by the author to be of historic interest only, since they are no longer sold, and games are no longer in production for them. Of course, this does not mean that they are no longer used—the author still gets a lot of entertainment out of his Sega Genesis,

and *IGU*'s copy editor has sworn allegiance to her Commodore 128. Those with an asterisk are the current 'survivors.'

The platforms can be categorized according to their capabilities. Handhelds have very little memory, no standard hard drive or external storage media (although some can use cartridges for play data), low-speed processors, and small, medium-resolution screens. Consoles and home computers typically have more memory and power, with very high-definition graphics systems. The one aspect that sets the home computer apart is that it is a multifunctional device with plenty of external storage options (hard drive, floppy drive, etc.).

While the platform choice itself will be based partially on the type of game, there are also other factors that will come into play—such as the target audience age group and general game-playing experience. These factors will fall in the realm of market research more than anything else. However, the platform type also has to be linked to the game, or at least the game creators perception of the perfect implementation. It is no use designing a graphics-intensive game with highly capable AI if it is destined to run on a handheld—the platform will simply be too restrictive.

In addition to the platform type, the environment under which the game is to run should be considered. For example, an online game might very well run on a high-end PC, within a browser, probably sand-boxed in a Java virtual machine (VM). This same game might also be run in a Java VM on another platform, which could be either more- or less-highly specified. The two platforms will share some facets and have others that come into play, which might impact the way in which the game is developed.

If game developers are working toward a game that can be played anywhere, and which offers the same features regardless of the platform or operating environment, then they must be aware that different techniques will apply to different platforms. This means that not only must the game be 'ported' to another platform (e.g., 16-bit color to 16 color), but certain areas—especially in terms of the way objects are defined and stored—will be different from one platform to another.

GAME TYPES

Some platforms are better suited to specific game types. In fact, some platforms are less suitable for games in general; the PC, for example, was never designed as a games machine. That is not to say that the most recent PCs

are not game-capable; it is just that they offer fewer facilities than dedicated game machines.

For this reason, most games-development companies develop a game engine that will handle the game-specific aspects of the software application, which can be reused, extended, and enhanced as the company develops more games. In addition, commercial (and freeware) game engines can be used that will handle this functionality, since PCs do not actually support much in the way of advanced graphical constructs and effects.

On the other hand, most dedicated game machines have support for all manners of advanced game-programming chores. The Game Boy, for example, despite being a small handheld device, contains support for sprites and tiles (sprites over a complex background), as well as drawing and plotting.

Given this advanced support, you might assume that any game could be created for the Game Boy, but this is not the case. In fact, given the advanced support for sprites and tiles, it is no surprise that the majority of games for this platform are of the ladders-and-levels type that we discussed at the very beginning of this book.

This should not be a surprise if we stop to consider the difficulties inherent in writing a game based on line art. It is clear that in the case of the Game Boy, if there are no advanced helper routines programmed into the system itself, then it simply does not have the power to run a game engine capable of performing these functions. In fact, the chances are good that without the sprite-handling capabilities, the Game Boy would have been so underpowered that it would never have become popular.

Game consoles, on the other hand, have moved from a more-primitive phase (e.g., Sega Genesis, Nintendo Entertainment System, Super Nintendo Entertainment System), which still retained these sprite- and tile-processing capabilities, to much more powerful systems in which realism and realistic graphics are so important that sprites have fallen by the wayside.

Strangely, this means that game developers who wish to write sprite-based games (and there have been many very successful ones) might have to write a sprite engine to replace the facilities that were previously available 'for free.' What we see is that while game devices become increasingly more sophisticated, the simple tasks have become increasingly difficult.

So, choosing a platform will come down to a trade-off between the amount of processing power required and the facilities the platform has to offer. Sprite games will play better on platforms that support sprites, and no matter how fast the processor, line art (or polygon art, for that matter), although achievable, will never look good on a sprite platform.

On a less-technical note, the game type and console choice will go together in an entirely qualitative way, too. We are, of course, talking about marketing. While this is not the place for a full discussion on how to market a title, the designer needs to try and pitch to the target market. Sprite games and high-end consoles do not necessarily go together. Similarly, flight simulators and handheld machines (even those as powerful as the Game Boy Advance) might not strictly be a good match.

Even though much of this book has been purely technical, no game designer should ignore the nontechnical side of writing games. It goes beyond simple marketing—quite simply, what looks good on paper might not look good on the screen, and what looks good to the designer (even on the screen) might not excite the audience.

RESTRICTIONS

The majority of games consoles do not have hard drives, which means that any game relying on using a large quantity of disposable memory—for expanding video or audio data, for example—will have to find another way to do it. The same goes for loading or saving game data on behalf of the user. Since any amount of RAM available for this purpose will, by definition, be small, unique and adaptable ways have to be found for saving and restoring game data. A Game Boy cartridge, for example, can have a maximum of either 256Kb or 32Kb.

Screen size poses a definite restriction, especially for handheld machines. Even powerful handheld machines such as the Game Boy Advance or Playstation (with optional LCD screen) have screens that are generally smaller than a television. This means that if a game is to be portable across different platforms, then possible differences in dimension or orientation have to be taken into account.

Power consumption is an often-ignored, but quite important restriction of the handheld genre. Programmers should be aware that some aspects of the game, such as those concerned with analog interfaces (e.g., sound), will consume battery power. Color schemes that are intentionally dim will also provoke the user into turning on the backlight, leading to battery drainage. Quite often, the machine will provide power-saving options, and it will be well worth the programmer's while to research these options.

These are just a few of the basic restrictions that handhelds have over consoles. Even large consoles, such as the GameCube or Playstation 2, will

have some restrictions, even if it is just the lack of sprite support, which make a given game unsuitable for that platform.

All platforms will share some of the more obvious restrictions, such as limited numbers of buttons and/or button combinations. This might not sound like a big restriction; after all, plenty of games only use a four-way controller and a fire button, and do not require other methods of input.

However, if we delve a little deeper, we can think of games (specifically strategy games and those aimed at a slightly more-mature audience) that would become cumbersome if ported from a PC with keyboard to a console. WIMP (Windows Icons Mouse Pointer) environments can bring another dimension to the standard interface, but these can only go so far before the screen becomes cluttered.

PUSHING THE BOUNDARIES

Once the specific restrictions of each platform have been evaluated with respect to the initial game design, there are several possible paths that can be taken. Clearly, if the two are completely incompatible, then either a different game, or a different platform has to be chosen.

There are, however, some other choices for near matches. If programmers have not been involved in the design process, then they should be consulted prior to discarding an otherwise good game simply because support for one feature is not available at the operating-system level.

A good example of this is Jeff Frohweins' support for all-points-addressing graphics on the Game Boy series. Strictly speaking, the Game Boy has no line-art capabilities whatsoever. But there is an interface for changing sprite and tile data during the play session. Thus, a passable line-art interface can be provided using techniques for setting the tile data over the entire background, faithfully tracing out the lines and points as required.

CONCLUSION

Using this information, we should be in a position to make an informed choice about the specific requirements of a game with respect to the performance of the desired platform. We shall see that some platforms are ideally suited to some types of games by virtue of the capabilities offered by the operating system. The Game Boy, for example, has an integrated sprite manager that takes care of displaying the sprites on behalf of the programmer.

But there is no substitute for research. Most hardware manufacturers are more than happy to provide information on the exact capabilities of their platform, and this information will also help in planning the end product. If multiple platforms are to be catered to, this information will help the designers make better decisions about how the code should be constructed; for example, it might be necessary to create modules with similar capabilities and interfaces to hardware-supported functions that can be used on platforms that do not have this functionality built into them.

PROCESSOR-LIMITED ENVIRONMENTS

INTRODUCTION

Games programmers tend to aspire to creating the next *Doom* or *Quake*, or even *SimCity*, or any of the more recent God games on the market. While it is true that the most impressive and often most immersive games are developed exclusively for the PC market, there is a huge following for other platforms.

These platforms include general-purpose machines (similar to PCs) as well as purpose-built games machines, such as consoles or handhelds. The design philosophy of such specialized equipment, however, tends to preclude the use of high-end PC processors. This is attributable to several factors, of which the key ones are cost, power consumption, and size.

Even for a high-end console such as the Sony Playstation II, a high-performance, general-purpose processor would push the price out of the reach of the target consumer base. The key here is that they are capable of performing a variety of tasks in a variety of circumstances; such versatility increases the cost of the processor. This means that it is often a cheaper option to use a lower-end, customized processor (usually subcontracted to a third-party chip manufacturer). These less-complicated chips are cheaper to produce in bulk than high-end Intel or AMD processors.

When the handheld market is considered, power consumption as well as price becomes an important issue. A Pentium-IV processor comes in two flavors: a 5V and 3.3V mobile model. Add to this the fan and heatsink, and the power requirements begin to climb—not to mention the graphics processors, the screen, and power for the motherboard. Clearly, it is not practical to use these in handheld devices.

Size is also important, not only for handheld machines, but also for consoles. A large box would be required to house a fan, heatsink, fast

processor, CD-ROM drive, and motherboard—not quite the size of the Nintendo N64.

All in all, developers for the handheld and console markets can be assured that the processing power available will be much lower than that for a PC platform. It is true, however, that much of the work that is traditionally done by the main processor on the PC platform is farmed out to graphical and sound subsystems on a console or inside the handheld device.

Also, even those developers who do not intend to ever delve into other areas, but intend to remain true to the PC platform, should not rest on their laurels and rest content that they will always have sheer power on their side. One good reason is because if the game proves popular, it may well be ported to a 'lesser' platform, and so it is good to get into the habit of doing as much as possible with as little as possible to make this task easier.

One fact remains, however. These machines might be considered to be limited when compared to the PC world, but this is only because they are designed to do one thing—play games. Make no mistake, though; they do this well and are helped in the task by specialty subcomponents that take much of the heavier processing work away from the main processor.

Thus, this chapter will not deal with any specific tricks, tips, or techniques for fast graphics coding or related areas, as these will vary from platform to platform depending on the exact mix of components used on that platform. Rather, this chapter will contain particular coding examples for game and game-universe management.

THE SMALL-HANDHELD MARKET

There is no doubt that, worldwide, Nintendo seem to have the handheld market cornered with three machines: the Game Boy, Game Boy Color, and Game Boy Advance. Actual specifications for the Game Boy and Game Boy Color are hard to come by. (You must become an official Nintendo Developer and sign a nondisclosure agreement.) There is, however, nothing to keep you from opening up your Game Boy and taking a look inside.

THE GAME BOY & GAME BOY COLOR

The original Game Boy was released in the early 1990s as a handheld console based on a small black-and-white, dot-matrix liquid crystal display (LCD) screen. The processor inside was a 4MHz, modified 8-bit Z80. According to popular opinion, the processor actually operated at 1.05MHz. This means that the processor can actually execute at around 1,000 cycles

per second, although it depends on the actual instruction lengths how many cycles are required for a particular purpose. Not surprisingly, the Game Boy Color runs faster at 2.10MHz (with an 8MHz Z80 processor).

GAME BOY ADVANCE

Information about the Game Boy Advance (GBA) is similarly hard to come by, and owners seem a little reluctant to open up their shiny toys to check out the processor. Nintendo's official site (Web site: www.nintendo.com) gives no indication of chip speed, but they do indicate that it is a 32-bit ARM processor with embedded memory. This gives us two possible indications of speed: The instruction size has widened by four times, from 8 bit to 32 bit.

This inherently means that we can use larger data types with values up to 2^{32} in a single instruction. In an 8-bit world, only values up to 2^8 can be processed in this way. To avoid confusion, 2^8 is equal to 256; and 2^{32} is equal to 4,294,967,296. Being able to process larger values means that we save time performing calculations (since the operand width also affects the accuracy of floating-point calculations); and hence, although for the same processor speed there is no increase in cycles per second, we need less cycles than before.

OTHER MACHINES

Although we are concentrating on Nintendo machines in this section simply because they are the most popular, they are not the only handhelds in existence. It is hard to give much space to the others, since their development has all but ceased. However, from a historical point of view, it is worth mentioning them; it will at least give interested parties a starting point if they wish to conduct further research into the handheld world.

In response to the Game Boy, Nintendo's arch rival, Sega released a machine called the Game Gear, which was a little larger and had a color screen. It was a much more powerful system, but being more expensive and larger, it failed to dent the Game Boy's sales. Resources cite that it is no longer in production and that there are no software titles being developed for the platform. With the arrival of the GBA, it seems that 'the Boy' will remain in its top slot.

Atari also tried their hand with the Lynx. This was another black-and-white handheld, but the screen was wider than taller, as opposed to the Game Boy's taller-than-wider display. Otherwise, it was molded in the same way as the Game Gear, being larger, faster, but also more expensive and less portable than the Game Boy.

PROCESSOR SPEEDS

The overall throughput of a processor is measured both by its clock speed (cycles per second) and bit width. It is clear that a processor capable of performing more instructions per second will execute a piece of software faster than another processor executing the same piece of software. What is less clear is that a 32-bit processor running at the same clock speed as an 8-bit processor will not necessarily run the software any faster unless it is optimized to take advantage of the 32-bit features of that processor.

Some of the more obvious processor-hungry aspects of games programming are the mathematics and graphics that provide the actual visual and immersive aspects of the game. All aspects of games programming eventually come down to mathematics, especially those concerned with collision detection (both 3D and 2D) and level control, and even simple graphical interfaces such as Game Boy sprites require many calculations.

In order to understand just how mathematics can become a processor bottleneck, we need to dig a little deeper than usual and look at how a Game Boy sprite is displayed. If a Game Boy application is run in an emulator (see Appendix B) with debugging switched on, the program flow can be watched as it unfolds.

Without going into the assembly language details of the process, the general flow can be expressed as a double loop in C++:

```
for (y = 0; y < SPRITE_HEIGHT; y++)
    {
  for (x = 0; x < SPRITE_WIDTH; x++)
  {
    plot_pixel (x + sprite_left, y + sprite_top)
  }
}
```

The above code snippet does not quite give the entire story; even on the Game Boy, there are considerations such as the color of each pixel and the palette to which the color belongs, and hence the actual color that should be displayed. Like any color graphics interface, the Game Boy Color (GBC) uses a palette-based system in which each pixel has a reference number, and a palette attached to the sprite allows the system to look up the actual color components in the palette, using the reference number in the pixel.

For the sake of simplicity, we shall assume that each sprite definition consists of an 8 × 8 grid of numbers that refer to densities of gray (0 =

white, 3 = black)—a simplified version of the way in which the Game Boy handles sprites. Our double loop from above, then becomes:

```
for (y = 0; y < SPRITE_HEIGHT; y++)
    {
  for (x = 0; x < SPRITE_WIDTH; x++)
  {
    plot_pixel (x + sprite_left, y + sprite_top,
        sprite[x][y])
  }
}
```

where `sprite[x][y]` refers to the color in the sprite 'map' that is to be displayed. Naturally, the function `plot_pixel` is assumed to be offered by the system. In fact, all of this processing that leads to the display of the sprite in question is hidden behind a simple Game Boy system call:

```
move_sprite ( sprite_number, x_position, y_position );
```

We have seen the process that this evokes, but have not yet discussed what this means in terms of processing power and CPU cycles. The double loop that we have already seen requires some very simple mathematics. Nonetheless, for each line that has to be displayed, we need to perform an addition and a comparison, followed by eight additions and comparisons in sequence. The actual plotting of the pixel requires two additions to arrive at the x and y coordinates of the pixel, plus some memory mathematics that extracts the actual color information from the 8×8 memory array that contains the pixel data.

To arrive at a rough estimate of what this means for a given processor, we need two vital pieces of information. This information is available in either the standard documentation or (most probably) available upon consent to a nondisclosure agreement. The first piece of information is an instruction-timing table, which gives the clock count for each instruction; and the second piece of information is the processor clock period, often referred to as the processor speed.

Programming the 80386 (J. H. Crawford and P. P. Gelsinger. Sybex, 1987) is a wealth of information for any programmer on two counts. First, it gives a complete analysis of the first 32-bit processor in the Intel range; and second, it provides a reference that illustrates the differences between the 16-bit and 32-bit architectures. Appendix G of *Programming the 80386* has this to say about calculating the elapsed time for an instruction:

To calculate the elapsed time for an instruction, multiply the instruction clock count, as listed in Table G.1, by the processor clock period (e.g., 62.5 ns for an 80386-16 operating at 16 MHz CLK signal).

With all due respect to the assembly-language experts, the following pseudo-assembly language listing reflects the plotting of a pixel fairly accurately, if not efficiently, including the actual plotting action, which is done via an interrupt. Note that the code will not work on any known platform. It is just an illustration that is loosely based on Intel 80 × 86 opcodes.

Instruction	C/C	Time (ns)	Comments
begin:	0	0.0	Labels are assumed to have a negligible CC
MOV AX, 0x00	2	125.0	
outer_loop:	0	0.0	
MOV BX, 0x00	2	125.0	
inner_loop:	0	0.0	
MOV CX, BX	2	125.0	
ADD CX, xpos	7	437.5	
MOV DX, AX	2	125.0	
ADD DX, ypos	7	437.5	
PUSH AX	2	125.0	
PUSH BX	2	125.0	
MOV AX, plot_vector	2	125.0	This assumes that the vdu interrupt is 13h
MOV BX, CX	2	125.0	with AX determining the action, and BX, CX
MOV CX, DX	2	125.0	representing the x and y coordinates for
INT 13h	37	2312.5	the plot action.
POP BX	4	250.0	
POP AX	4	250.0	
INC BX	2	125.0	
CMP BX, 0x08	2	125.0	
JNE inner_loop	10	625.0	Inner loop 87 Cycles; 5437.5 ns
INC AX	2	125.0	
CMP AX, 0x08	2	125.0	
JNE outer_loop	10	625.0	Outer loop 18 Cycles; 1125.0 ns
TOTAL	105	6562.5	

Therefore, the whole operation has taken 357,000 nanoseconds (ns) to plot a single sprite, using a machine equivalent to an 80386 running at 16MHz. For those who (like the author) find it difficult to translate this to the real world, it represents about 0.4 seconds. Even this is a little abstract, so if we consider that a regular VGA screen can contain about 80 × 60 sprites, then to fill every single pixel would take about 1920 seconds (640 × 480), or for a Game Boy-size screen (20 × 18 sprites), about 144 seconds.

This analysis shows two things. First, it is clear that this is *not* how to plot a sprite, since it takes far too long; and second, jumping around in memory and performing interrupts is an expensive business, and accounts for roughly half of the time spent in the above example. Manipulating the video memory (where the image is stored) to set pixels 'manually' is far more efficient, requiring only a MOV instruction. If this had been done in the above example, it would have taken 2368 cycles less, or around 0.15 seconds per sprite. For the Game Boy screen, this is a total of 54 seconds.

DESIGN RESTRAINTS

The above exercise highlights another point: The choices that influence the number of calculations needed in order to make the game tick are done at the design phase. In fact, the entire available screen real estate would rarely be used to perform these kinds of operations. Besides, there is always the need to make areas of fairly static graphics or text that can be used for status information, leaving an area in which the sprites can be displayed.

One approach, which at first glance seems to go against the bulk of the theories in this book, is to reduce the amount of cycles that are tied up in performing calculations, decisions, and accessing memory. However, choosing the correct algorithm and an efficient implementation can go a long way to ensuring that cycles are not wasted; each and every one counts toward making the game better.

SAVING CYCLES

One classic sprite-oriented way in which processing cycles can be saved is by only plotting those pixels that have changed from the last time that the screen was refreshed. Plotting by difference in this way is great for sprite-based games, but less efficient for games in which the display changes many times per second.

Other tricks include using modulo operators instead of comparisons for wrapping around the screen, always using direct video memory access rather than setting pixel attributes via an interrupt. Above all, extensive use of system calls instead of trying to write your own routine is a must.

It is surprising how many game developers assume that some quite clever algorithms (especially high-end lighting and alpha correction) will not be present in the system itself, and so they rewrite them. Reading the platform's programming documentation is not especially interesting, but it will help in saving valuable and vital CPU cycles.

REAL-WORLD SPEED REPRESENTATION

One final point to make is that specifications of machines are usually expressed in real-world (or at least gaming) terms. It is here that we see substantial differences in the various processor types and capabilities. The most common figure given to represent performance is the number of textured polygons that can be displayed per second, with or without graphical effects being applied. This also gives a key as to how the graphics can be stored and processed for these platforms. Clearly, lists of polygons are being used rather than direct pixel-to-pixel correlated maps.

Nintendo claims up to 12 million textured polygons per second in real game conditions, with a clock speed of 485MHz and using a customized IBM PowerPC chip for the GameCube. Considering the array of graphical functions packed into the GameCube, it is clear that this represents an unprecedented amount of game processing power.

If the official comparison figures released by Microsoft in 2000 are to be believed, the Playstation 2 (PS2) manages 66 million polygons per second, while the Xbox is rated at around 300 million! Both of these systems have separate graphics processors, a 300MHz nVidia/Microsoft chip for the Xbox, and a 150MHz Sony GS chip for the PS2. This goes some way toward explaining the difference between the GameCube and these machines.

The comparison between these machines and the Sega Dreamcast and Saturn is probably only of historical interest, although games are probably still being developed for them. The Dreamcast manages 6 million polygons per second, fully textured and with effects, while the Saturn clocked in at around 200,000 flat-shaded, textured polygons per second, with no effects. The difference between the two performance indicators can be explained partly by the fact that the Saturn has no floating-point capabilities and a processor that runs 10 times slower than the Dreamcast.

CONCLUSION

As can be seen from this chapter, the assumption that processor power is no longer a constraint on the games we can create is a false one. The fact that the constraints have been lessened by the new technologies available does not mean that there are no longer any constraints at all.

On the other hand, we also need to have a good understanding of how far we can push the limits of the available processing power, and also the impact that our coding style can have on how these limits are going to affect the games' real-time speeds.

There are limits, and they must be respected. Some platforms have more limits than others, which does not mean that some games cannot be written for them—we just have to be more clever about how the implementation is done and maybe reduce some of the more-complex aspects so that the new version fits into the envelope that the new limitations produce.

DYNAMIC MEMORY AND LIMITED ENVIRONMENTS

INTRODUCTION

So far in Part V, we have looked mainly at the guts of the system—the processor. It is time to turn our attention to the other important part of the gaming system, the memory. A standard PC now comes with somewhere between 128Mb and 512Mb of memory, not counting the usual 8Mb to 32Mb of dedicated memory on the video card, the processor cache, and other possible spots of memory within the system.

It is clear that unless the game designer really wants to make their game appeal to the widest possible audience (which includes gamers that have not changed their system for at least two years), memory is not really going to limit development. For those developers who really want to address this kind of spread, then a sensible limit to look at is around 64Mb of memory. It is unlikely that very many game players with lower-end machines have the buying power to purchase a standard-priced game.

However, when we turn to the console and handheld markets, the situation is very different. Since these machines (with the possible exception of the Microsoft Xbox) are truly dedicated games systems, they have memory in nonstandard places, as we shall see. In fact, the purpose of the system is different—a PC is designed to do many tasks at once—run the operating system, have an e-mail client open, do some word processing, switch to a calculator, and so forth and so on.

A game console does only one thing only—play the game. For this reason, the console's memory layout is slightly different than a PC's, and it requires slightly different handling. At the same time, of course, many of the techniques that are used to program consoles and handhelds can be carried

over to the PC world, simply because some of the 'restrictions' actually lead to better game-programming style.

ROM VERSUS RAM

ROM and RAM mnemonics are industry-standard abbreviations for two types of memory: Read Only Memory (ROM) and Random Access Memory (RAM). In the first-ever home computers, the ROM was used to store the operating system, and the RAM was used for program code and data. As a concrete example, the Acorn Electron had 32Kb system memory (RAM) and also a larger 32Kb ROM (*Acorn Electron Advanced User Guide,* Holmes & Dickens. Adder Publishing, 1984, pp. 194, 240).

The Acorn Electron ROM contained an OS 1.00 and a BASIC interpreter, as well as an assembler for assembly language programs. The RAM was where any user programs (and their data) and screen memory resided (more complex display modes requiring more memory). This is a model that has not changed much over the years, except that in some cases, system architects have done away with the concept of a system ROM altogether. The point is, we do not need to be aware of the system ROM, since it does not contain anything that needs knowing about.

This is especially true in the PC world, where the operating system makes the underlying machine transparent, since it is the operating system (OS) that manages all the programs and the way in which they interact with the system and each other. This is also what makes developing for the PC market difficult; there are three radically different operating systems to choose from: Windows, Macintosh, or Linux.

This digression serves to set the scene, because at the end of the day, the choice of handheld platform comes down to three machines, all by Nintendo, and two of them with essentially the same architecture: Game Boy (GB) and Game Boy Color (GBC). Developing for the console market is a feature-based choice, and we shall see how the different features compare later on in this chapter.

Generally speaking, in the handheld world, the ROM refers to the game cartridge, and you can put as much on the cartridge as it will physically store. However, you will only be able to load a limited amount of information into the machine's RAM at start-up. This means that the actual game code is limited by the RAM available to the system, no matter the size of the cartridge ROM. If it is too large, the game will simply not work.

In the console world, things have changed since the original Nintendo and Sega machines sparked a rivalry that still continues almost a decade later. Originally, the SNES (Super Nintendo Entertainment System) and Mega Drive (from Sega) adhered to the same principle as handhelds—with a cartridge ROM, system RAM, and a system management or operating system chip hidden inside the machine.

These days, technology has stepped up a little, and the actual game storage is now on CD-ROMs, DVDs, and other optical discs, which offer anything from 700Mb to 1.5Gb of storage. Clearly, the system RAM is going to be far below this, so the limitation of loaded code size is going to crop up. However, this has been worked around in the past by pulling code off the distribution media for execution as required (though the exact mechanism by which this can be achieved has not been confirmed).

Given that the amount of RAM available for a variety of uses is going to be limited, before we rush off to design the next number-one smash hit for the chosen platform, we need to know exactly what those limitations are; later on, we shall see how we can employ some techniques to try and get around the limitations that will inevitably be imposed upon us.

HANDHELD GAME MACHINES

The Game Boy
With 8Kb of working RAM (the program area), at first glance it would appear that the GB has less available resources than the humble Acorn Electron, to which copious references have been made throughout this book as a kind of bare-minimum benchmark with a theoretical 32Kb of memory available to programmers. However, once we factor out all the reserved memory, since the machine itself needs to reserve some space for a variety of purposes (such as storing screen element position information), we are typically left with around 18,944 bytes, or 18.5Kb.

This value is closer to the GB's, but still about 10Kb more than the handheld. This is to be expected, since the Electron is a multipurpose machine, and the GB is a handheld games machine. But in the case of the GB, we also have 8Kb of video memory for storing the sprites that will be used in the game. Besides which, we effectively gain back all the memory that would be required to write a sprite-handling game engine, since that is an inherent feature of the GB operating system.

So, if we take all these factors into consideration, the 8Kb RAM plus 8Kb video memory afforded the game designer seems quite generous, especially

since everything related to managing the joy-stick interface, screen, and sound is taken care of in the design of the basic system.

The Game Boy Color

Besides the obvious (color) difference between the GB and GBC, the GBC is also blessed with 16Kb of working RAM, four times as much as its predecessor. This is a big boost for the designer and allows for a much more sophisticated game. The expanded video RAM (doubled to 16Kb) is a mixed blessing, since it will inevitably be used up due to the increased storage requirements of the color data, which is based on a palette system.

In addition, the GBC comes with a *caveat* for the game designer. Three types of game can be written, according to the official Nintendo developer's guide. The first is the basic monochrome game, which is designed for use in the original Game Boy, and Pocket Game Boy (a smaller, slimmer version). None of the extra GBC features (including extra memory) can be used.

The second type is known as a dual-mode or compatible game, which follows one of three implementation possibilities. It can be a simple colorized version, which is still a regular GB game, with the possibility to add 10 colors to the original, by manipulating the palette information. This has no effect on a regular GB, since the palettes remain the same; the difference is that they contain color information on the GBC and monochrome information on the regular GB.

The second alternative, the dual-engine model, is where the *caveat* creeps in. A game written in this way has a simple start-up routine that detects which kind of GB it is running on it and starts up one of two versions of the game (color or monochrome), which are stored on the cartridge. The problem is that any memory advantages in programming for GBC are lost because two versions of the game need to be stored on the cartridge.

The third option is a variation on the dual-engine model and is known as the adaptive model. Here, the color specific information is added to or adapted from the monochrome versions at run-time, but the core game engine remains the same. This is not such a difficult feat as it might at first seem, since the GB and GBC differences in terms of sprite handling and representation are very slight. There will still, however, be a certain necessary overhead for the adaptation decision processes. Furthermore, since the game must run on both the GB and GBC (and equally well at that), the amount of GBC features (such as the additional memory) that can be used is limited.

Finally, we can write a game that can be used solely on the GBC (known as a "GBC-dedicated" game) that can take advantage of all of the GBC features, including all that memory, and will not be restricted by attempting to remain compatible with the original GB; so the memory can be used purely for game code, level data, or whatever else the designer can think of, and not spent on the effort in trying to fit into two different platforms.

The Game Boy Advance

The most recent Nintendo addition is the GBA, with plenty of memory in all the right places. To start with, there is 256Kb of working RAM, which is a very large increase (and also shows the way in which the market has changed over the intervening years—the price of memory has come down so much that 256Kb is cheap enough to be put into a handheld machine).

In addition, there is also 32Kb of CPU-based RAM and 96Kb of video RAM on top of that. This is just as well; the GBA supports a larger screen and up to 511 colors (sprite palette-based) in character mode (the original GB sprite mode), and 32,768 in bitmap mode. All in all, there is plenty of memory to play with for a handheld. Of course, it pales in significance compared to a dedicated games console.

GAMES CONSOLES

There is a good reason why games consoles have more memory—the screen resolution is such that they need a lot of memory just to map one frame. Also, they will be used for a variety of different game styles, from sprite-based through to line art-based games, driving simulations, fighting games, and, more recently, DVD movies.

Historical Background

Since we included a look at the memory available to the Nintendo Game Boy in the previous section, perhaps we should also do the same here for consoles. The market, however, is very different. At the start, there were two main competitors, Nintendo and Sega, who were later joined by Sony, with Microsoft now also making a play for market share. The inclusion of Sony and Microsoft in a list of console manufacturers is a recent phenomenon, so this historical background will only include references to the main competitors, Sega and Nintendo.

The Sega Genesis (called the Mega Drive in Europe) has 64Kb of graphics memory, which translates roughly into 2048 tiles, assuming that is all you wanted to use the memory for. Since the machine has two processors,

the memory and related programming is a little more complex than a handheld, but essentially there is 64Kb of memory devoted to the main processor and 8Kb assigned to the slave, which can accept and run programs sent to it by the main processor.

The Genesis was released at the same time as the Super Nintendo Entertainment System (SNES), which followed the same memory mapping principles of the Game Boy; memory is allocated as either working RAM or video RAM. The SNES had 128Kb of working RAM, 64Kb more than the Genesis, but only 16Kb of video memory, a quarter of that of the Genesis. This explains why some games (with line-art graphics), such as *Steel Talons* (a helicopter simulation), were never ported to the SNES—due to limitations in the sprite system and the video memory, it simply would not have been possible using traditional techniques.

Current Technology

The Genesis and SNES were released around 1993. Not even a decade later, console technology has exploded and jumped forward. Nintendo's latest offering, the GameCube, boasts a massive 40Mb of system memory, split between main memory (24Mb) and very fast A-memory (16Mb). The Sega Dreamcast console, released just a few years before the GameCube, had only 16Mb of main memory. The arrangement of the video memory of these systems is explored in the next section.

The two newcomers, the Microsoft Xbox and the Sony Playstation 2, have 64Mb and 38Mb of memory, respectively. With all these figures being bandied about, we could be forgiven for thinking that maybe there is enough memory for almost any project. However, there will always be a need for more storage space, even if it ends up as buffers for graphics. One of the reasons the Game Boy and Nintendo Entertainment System (and to a certain extent the Genesis) could have so little memory was that most of the work required for displaying the game sprites was performed by the machine, and so very little 'graphics' code was required.

As an aside, the Xbox is a slightly revolutionary device in that it also contains an 8Gb hard drive, which provides a nice chunk of pseudo-RAM. (We shall deal with this toward the end of this chapter.)

SPECIALIZED SUBSYSTEMS

In an effort to ensure that the game designer gets as much memory for the game as possible, most gaming systems, including PCs, are built in such a way that much of the 'donkey work' is delegated to the system's hardware and processed in a much faster, more optimized way. This trend began

with the sprite-handling capabilities of the Nintendo Game Boy and has been carried through to the latest systems.

This helps reduce the code overhead of the game, and therefore leaves more memory available for mapping, levels, and other pieces of game data, both static and dynamic; although strictly speaking, the static information should be left on the distribution media.

The Sega Dreamcast, for example, has 8Mb of texture memory and 2Mb of sound memory to help reduce the load, and the Nintendo GameCube has memory scattered all over the system, such as a 2Mb frame buffer, 1Mb texture cache, 16Kb sound processor instruction memory, and 12Kb sound processor data memory. This is without all the internal cache, which is traditionally used for very fast, temporary storage.

Since machines such as the Xbox and Playstation 2 also play DVD movies, we would also expect similar subsystems in those machines. Of course, all the graphics systems come with a standard array of built-in image manipulation functions, including fog, texture mapping, lighting, filtering, and hardware texture decompression. With all this space and power, it may seem that we do not need to take care when designing our games because there are no real limits. Limits—perhaps not; but there are always better ways to use memory than relaxing your coding style.

MAKING THE MOST OF THE SPACE

We shall now restrict our discussion to those systems that are still in circulation in the handheld arena, namely the Game Boy, Game Boy Color, and Game Boy Advance, and the Nintendo GameCube and Microsoft Xbox in the console arena. The reason that we have selected these specific machines is that each one has a limitation or feature that has to be either overcome or can be exploited.

This is not to say that the techniques discussed here are specifically tied to these platforms, only that the platforms are used as concrete examples. Future platforms might contain the same limitations or features that can also make use of these techniques.

The Game Boy Series
When Nintendo designed the Game Boy, they made a distinction between the cartridge and the rest of the system in that the cartridge was meant to serve only as a distribution medium. The game code has to be downloaded into the working RAM, of which there is 8Kb on the original GB and 32Kb on the GBC, and the video RAM is populated with all the graphical information needed for the game.

The video RAM is split up into background tiles, with a portion of the video RAM set aside to reflect the background screen contents, each slot of memory pointing to character data. Character data is represented by sprites 8 × 8 pixels in dimension, with each pixel having one of four shades of gray assigned to it.

There is also a section of video memory reserved for game objects (up to a maximum of 32 on-screen at once), with each object having their screen location, z-order, and palette information. All the display routines and general screen management are part of the underlying Game Boy system, and all the game programmer has to do is relocate a background tile or game object by either changing its position in memory (for background tiles) or updating its location information (for game sprites).

In terms of dynamic memory limitations, there are two. The first is that there is limited space for defining the game graphics. The second limitation is that the actual game code, including all the memory required for the definition of the game universe, has to be stored in the 16Kb of available working RAM.

Of course, both can be populated during the play session, and it is here that the workaround for these limitations becomes possible. However, care must be taken to know the limitations of the workaround and not get too carried away; it is quite easy to overuse the following techniques.

Sprite & Tile Generation

We have already covered tile generation in previous chapters, but it really comes into its own when programming for the handheld market. The limitation on the number of 8 × 8 pixel sprites (used both for the background and game objects) can be overcome by actually generating them as they are needed. A simple example would be to have changing maze tiles, depending on the level, for both the floor and walls. Figure 25.1 shows a variety of different level tiles, all based on geometric calculations, which we shall explore presently.

While this is not the place to go into advanced discussions of Game Boy programming, it is worth noting that if one is programming for the Game Boy Color or Game Boy Advance, then this technique can be taken one step further. The addition of color or animation will allow the game designer to have even more tiles at their disposal, whether generated or adapted from a base tile, as we have discussed in preceding chapters.

For now, we shall look at some simple example code that could be used in game development for the original Game Boy. Sample Code 25.1 shows how to create a simple tile.

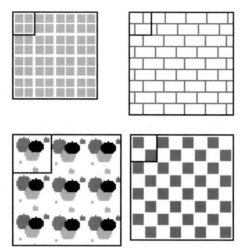

FIGURE 25.1 Geometric tiles.

CODE SAMPLE 25.1 Game Boy tile creation.

```
unsigned char * szTile[] =
{
  0xFF, 0xFF, // Line 1
  0xFF, 0xFF, // .
  0xFF, 0xFF, // .
  0xFF, 0xFF, // .
  0xFF, 0xFF, // .
  0xFF, 0xFF, // .
  0xFF, 0xFF, // .
  0xFF, 0xFF  // Line 8
};
```

Each line is grouped into two bytes, each of which having a value from 0x00 to 0xFF, or 0 to 255. Since a tile is built from sets of bytes in this way and created programmatically, we can also generate the tiles programmatically and change them in tile memory as we go along. Not only does this give us a good interface for extending tile sets to encompass ever-more-complex patterns, but it is also the basis of the line-art interface for the Game Boy, which was introduced in Chapter 23. It brings even further benefits in being able to use texture bases, in which tiles can be modified beyond their original hard-coded format.

THE MICROSOFT XBOX

To the best of our knowledge, the Microsoft Xbox is the first game console to have a built-in hard drive, and it is not a small one, either. At 8Gb, the Xbox has enough storage space for an entire DVD movie, as long as it is suitably encoded. In fact, one of the key uses for the hard drive could be for decompressing game data (video, audio, etc.) from the distribution media (DVD or CD-ROM) for use during the play session.

CONCLUSION

So, we have been forgiven for our assumptions about processing power, and we can now be forgiven for assuming that dynamic memory is infinite, both in supply and speed. Managing memory is one of the most complex aspects of a computer operating system, as anyone who has tried to make do with a small amount of memory will attest to. It is, however, possible to wrestle quite a lot of performance out of a small amount of memory if the programmer is prepared to make the investment in terms of time and research.

STATIC STORAGE LIMITATIONS

INTRODUCTION

Static storage refers to the media upon which the game has been distributed. It limits the amount of game data that can be stored and retrieved for gaming purposes, as well as any video, sound, image, or executable data. Much of this book has be devoted to ways of encoding, compressing, and generating gaming data, and some of the techniques that we have discussed can be used to overcome the static storage limitations of the target platform.

First, though, an anecdote: There exists a competition, called The Assembly, in which programmers pitch their coding skills against each other in categories such as Best Music and Best PC Demo, some which limit the size of executables that can be used. Although this is an artificial limit imposed by the competition organizers, it is quite amazing to see what the programmers can squeeze into a 32Kb, or 1Mb executable.

Of course, the demo machine's limit in terms of RAM allows the programmers to expand an awful lot of compressed data into volatile storage. This, along with some clever mathematics, enables the entries to include three-dimensional fly-throughs of model buildings, excellent rolling sound tracks, and some weird and wonderful visual effects.

The point to this anecdote is that just because the platform dictates a storage limit of 64Kb for code and data, that does not necessarily preclude the possibility of writing a complex game. In fact, using techniques such as those expressed here, static storage limitations will become overshadowed by other limitations of the system, such as the LCD screen.

First, though, we need to know exactly what the limitations are and which of these techniques can be used to overcome these limitations.

CD-ROM & DVD MEDIA

Most modern machines that are nonportable, and even the portable ones (e.g., the Sony Playstation with optional color LCD screen) come complete with a CD-ROM or DVD drive. Modern consoles are based around a CD-ROM/DVD drive; most PCs will have one (although currently, CD-ROM drives are still more prevalent than DVD drives). It will not be long, however, before this trend adapts to evolving technology.

CD-ROM LIMITATIONS

A compact disc, containing uncompressed data, can store 74 minutes of PCM audio at a sampling rate of 44.1kHz with 16-bit resolution in stereo. Although, if we calculate on the basis of these figures, we arrive at around 747Mb of data storage (see Chapter 12). Most CD-ROMs are rated at up to 650Mb. The difference between the raw capacity (which can be used for audio data) and the actual data capacity is due to various checksum and other mechanisms that ensure the integrity of the data.

Video data is more intensive than audio. Consider, for example, 640 × 480 pixels. If each pixel is represented by a number that gives the exact mix of red, green, and blue required to display it, we would need a staggering 32 bits per pixel: a total of 1.17Mb per frame. At 20 frames per second, we could not even fit one minute of video on a single CD-ROM. This, of course, is why encoding and compression schemes (such as MPEG Layer 2) were first invented.

This is not the place to enter into a lengthy discussion of the various compression formats available for pure video; however, it is worth mentioning that the accepted industry format is known as "MPEG," and was designed by the Motion Picture Expert Group. MPEG compresses the video stream so that the resulting data takes less space. But it was not until the invention of the DVD that the actual hardware capacity caught up enough to be able to store a whole movie on a single disc.

To illustrate the MPEG-2 compression capabilities, the ISO MPEG groups' official figures state that it can handle resolutions of 720 × 480 pixels at 30fps (frames per second). Using our figures from above, at 32 bits per pixel, the raw data would need 1.38Mb per frame, 41.4Mb per second. Since MPEG is only rated up to 15 thousand bits per second, the maximum design throughput is 1875 bytes per second, or 62.5 bytes per frame (on average). Clearly, there is some complex compression being performed, but a 160-minute film will still require 4.6Gb, according to calculations made

by Sony Electronics, Inc. (Web site: www.sony.com), which is larger than a standard CD-ROM.

The DVD offers a much larger capacity, and as a distribution medium for movies, has been heralded as the replacement for video tapes. Whether this will happen any time soon is debatable. What is certain is that it will soon become the de facto standard for PC game distribution. Since the Playstation 2 and other consoles also have the ability to read DVDs, they will also probably push their way into that arena too, if they haven't already. With this in mind, we should have a look at just how much this medium improves the situation for static storage.

DVD LIMITATIONS

The next step up from the CD-ROM is the DVD (Digital Versatile Disc). These are essentially multilayered CD-ROMs with a denser surface coating that enables more data to be stored per layer than on a regular CD-ROM. Big though they are, if we need to store audio or video data, some encoding is still going to be necessary, hence the adoption of the aforementioned MPEG-2 standard for DVD movie distribution.

For information purposes, the DVD standard is split into two separate formats: single-sided and double-sided. Single-sided DVDs have a capacity of 4.7Gb or 8.5Gb, while double-sided DVDs can contain 9.4Gb or 17.0Gb. The lower-capacity discs use a single layer (one on each side for double-sided DVDs), while the higher-capacity discs use two layers per side.

The adoption of multiple layers alone would not have extended the capacity of a CD-ROM enough for storing the substantial amounts of audio or video data required for movies. Therefore, DVD technology also uses a shorter-wavelength laser. This means that the pits and tracks that store the information can be closer together and smaller, thus increasing the information density per layer.

Other than these differences, DVDs are similar to CD-ROMs in their operation and capacity—DVDs are just capable of storing more. The encoding, compression, and general operation remains the same.

THE LARGE-CONSOLE MARKET

A 'large' console has very little to do with the size of the box. Rather, it refers to the capabilities of the machine and the features that have been packed into it. Perhaps the largest of the consoles on the market at the

time of this writing are the Sony Playstation 2 (which is a game machine, DVD movie player, and even has the ability to be connected to the Internet) and the Microsoft Xbox, which has been eagerly awaited and looks set to take the market by storm.

Sega has abandoned the hardware market, and as such has no consoles left on the open market. The Dreamcast machine, Sega's last console, used CD-ROMs as the medium of distribution for software titles, like most of the other manufacturers. But it should be pointed out that, in light of our discussion above about CD-ROM/DVD media, simply looking at a Sega Playstation CD-ROM reveals that although the technology might be similar, there are differences that lead the discs to be either higher capacity or more robust (such as the Playstation 'black' discs).

Reading the technical specifications for the Nintendo GameCube (Web site: www.nintendo.com), we can see that some console manufacturers have moved away from the accepted disc format completely. The Game-Cube accepts a 3-inch disc with a capacity of 1.5Gb, apparently based on Matsushita's optical disc technology.

Despite this slight movement away from traditional media, the Xbox and PS2, arguably the two contenders for the title of "most popular console" (although the PS2 had a huge head start), both use a standard DVD.

Although we looked at the Xbox 8Gb hard drive as a dynamic storage device in Chapter 25, it is perhaps worth mentioning that it can also fall under the category of static storage. Imagine, for example, having highly compressed information on a standard DVD and being able to decompress it onto the hard drive prior to the game's beginning.

This would perhaps alleviate some of the wait time that we traditionally associate with games on the Playstation 2 and also provide a further area of storage that the game would treat as static media. In any case, it would allow much more data to be stored on the DVD than a similar PS2 title. This is left for the industry to explore.

DATA TRANSFER RATES

When we looked at the proprietary distribution media used by Nintendo and Sega, we neglected to find a specific reason why they chose to not use traditional CD-ROM/DVD discs. Part of the answer could lie in copy protection, but performance is also possibly one of the main reasons. The following table shows the transfer rates for the six main consoles.

TABLE 26.1 Main Console Transfer Rates

GameCube	3125 Kb/sec.
Dreamcast	1800 Kb/sec.
PS2	4800 Kb/sec.
Xbox	4800 Kb/sec.
Standard CD-ROM 1x	150 Kb/sec.
Standard DVD 1x	1200 Kb/sec.

This comparison shows no advantage in Nintendo's proprietary media in terms of transfer rate, except that the discs might be cheaper to manufacture. They are, however, lower capacity and slower than the theoretical maximum offered by the DVD discs accepted by the PS2 and Xbox.

COMPARATIVE STUDIES: CONSOLE VERSUS HANDHELD

Apart from the Playstation 1 (which falls into a category of its own, being somewhere between a handheld and a console), the storage and distribution media provided in handheld devices is a cartridge that contains circuitry and, above all, a series of ROM chips that store the game itself.

The Game Boy cartridges (Game Paks) were capable of storing up to 2Mb (or 16Mbit) of information, with the Game Boy Color extending that to 4Mb (or 32Mbit). While this may seem like a pittance when compared to the CD-ROM and DVD media, remember that they also require much less power because they have no moving parts.

In addition, the data transfer rate will be much higher (although, as of this writing, how much information actually travels to the Game Boy CPU in any given millisecond is unclear). Other consoles admit to a certain amount of downloading, and unofficial information indicates that there was only 8Kb of RAM available to the programmer for the original Game Boy title, and 32Kb was available on the Game Boy Color.

The question that arises from these pieces of information is: If there is no downloading from the game cartridge during the game-play session, why would Nintendo offer up to 2Mb of data storage on one cartridge? Obviously there is some way of accessing the memory on the cartridge, either before or during the play session.

To perform an accurate comparison between cartridge technologies, we need to measure the handheld cartridge sizes against the Sega Genesis (Mega Drive). Before we do this, however, please remember that there is no longer much interest in developing for the Mega Drive; but there is substantial interest in developing the Game Boy, which has a huge market that will continue to expand for the foreseeable future (even after the introduction of the Game Boy Advance, which can also read GB and GBC cartridges).

According to the curious, like Rick McTeague (E-mail: sysrick@star-base.spd.louisville.edu), who have actually dismantled Sega Genesis cartridges and the Genesis itself, the cartridge is a box with a circuit board and a single 40-pin or 42-pin chip, which is manufactured by Sharp. These 16-bit chips store either 256,000 or 512,000 words (4Mb or 8Mb). However, some games (*Pit-Fighter* by Tengen, for example) have been advertised as "8Mbit," which is only 1Mb, so clearly the 4Mb/8Mb limits are purely theoretical.

So, all in all, the cartridge technology is comparable to the handheld and older consoles, and more applicable; if we introduce moving parts, we end up with a handheld with high power consumption and a bulky exterior, something that even the revamped Sony Playstation is limited by.

One last piece of data: A Game Boy Color screen is 160 × 144 pixels in size with up to 56 colors, and it has up to 4Mb of data storage (assuming of course that the entire Pak can be accessed). The typical resolution for a console game is around 640 × 480 pixels with 24-bit color. Clearly, the limitation of static storage is more closely linked with the design of the system (graphics and sound) than anything else.

DEALING WITH THE CONSTRAINTS

So, having looked at all the constraints in detail, what kind of effect are they going to have on the game design? First of all, game designers should not fall into the trap of believing that 8.5Gb is enough storage. It may be enough to store a single movie, but games are slightly more than that; they are like having hundreds of possible movies, each of which can be interwoven with the others as the viewer watches events unfold.

This slightly colorful description of a game highlights the fact that game players are a discerning group of people who only expect the best—the best graphics, the best sound, and the best gameplay. If we begin to sacrifice any of these in favor of the others, then we will find that the market disappears from under us. So, a balance must be struck between the different elements that make up the game.

However, we are loathe to actually remove video just because there is no space. For example, if we are developing a driving game (e.g., *F1* or *Rally*) and want commentary to tell us what to look out for around the next bend in the road while the race is occurring, then we will probably need to record some sound samples to facilitate building the commentary on the fly.

We saw two ways of doing this in Chapter 15 (either using words and phrases or individual sounds), and it is worth noting that the storage requirements of the two possibilities are not exactly the same. Just how different they are depends largely on the amount of words required and the use made of different voices (male or female), not to mention accents. As we have seen, some effects can be synthesized algorithmically, but the differences between male and female voices are too great to be able to pull off this feat.

The base technique has been discussed in almost every single chapter of *IGU*, although without actually stating it. Now is the time to create a generalization of the technique that we will call "storage by object resolution."

STORAGE BY OBJECT RESOLUTION

Assuming that as phrases are built up from words (which are built from syllables) and graphical models are built from shapes (which are built from lines, comprising pixels), so too can most game objects be built from smaller pieces. As a result, surely some objects have component pieces in common with other objects. By this we mean that each word can be created from sounds that, if rearranged, can be used to make other words.

Indeed, words can be combined to create phrases (which we discovered in Chapter 18), and if they are rearranged, other phrases can also be created. The question is, what level of resolution is applicable for the game object in question? It may prove to require more storage to generate the words from scratch than just to store the words outright. Of course, if we want to create new words, we will need to store some letters as well as their combination possibilities and probabilities; and to use existing words, we will need to know how the letters go together to form the words—so some combinational rules will also need to be stored.

In fact, the best level of resolution (as relates to the commentary example, above) might be to store textual words plus some rules for stringing them together, to make phrases based on the activities of the player in the game universe. To actually play these words, it would be more realistic to store each spoken word individually, which might also be less data-intensive than storing syllables.

Note that we do not need to store the textual information more than once, since each voice will speak the same words. Furthermore, we need not even use the full textual representation (although it might be useful for the hearing impaired), and instead use an integer code for each word. Even across languages we will not expand the basic data-storage needs by much, although more samples will be needed. Dual-language support will require twice as much audio and a varying amount of plain-text data.

Back to the example of the driving game: Suppose we want to port it to a handheld platform. We can dispense with the audio data, since it is unlikely that the platform will be able to realistically reproduce the sound anyway. So, we shall keep the logic of the textual information and replace it with arrows on the screen. So far, not much change to the code is required.

However, storing track data is a different matter. Suppose we want 30 tracks, the data we need to store for each one will need to be efficiently encoded. There is, however, a relationship between the commentary data and the twists and turns of the track. If we can tie the two together, we can save even more space.

Finally, there is a problem with this representation—what happens if the player leaves the track? If we store the track data in the way described above, then the game will not know what to display as either commentary or track; so clearly, we have a choice to make. Either we limit the extent to which the player can leave the track (which is less realistic), or we store fewer tracks than in the console version. These are the kinds of decisions that the designer will have to be aware of. Programming wizardry can only extend the platform so far.

CONCLUSION

There is a fine balance between the static storage available to the programmer and the tasks that it is required to perform. Moreover, different platforms have different distribution media—from cartridges through to DVDs—and each comes with its own specific set of requirements and limitations.

The techniques that have been put forward throughout this book try to do as much as possible with as little as necessary, but it is a three-way battle between the space required for data, the code, and the media (such as video and audio blocks). In the end, it is no use trying to implement some

sophisticated code to decompress full-motion video if the resulting code requires more storage than can be afforded. But the game designers and programmers will usually only know the end result through trial and error, which requires an investment in another precious commodity: time.

Predicting the impact of decisions that are designed to reduce the impact of other aspects of the game's implementation is also often impossible, and mistakes will be made, sometimes to the detriment of the game itself. It is not, however, a battle that is destined to be lost, and this chapter hopefully gives sound advice for making those decisions.

NETWORK &
ONLINE GAMING

INTRODUCTION

Throughout Part V, we have seen examples of limitations in target game environments, limitations in aspects that the PC world takes for granted, such as suitable memory, processing speeds, hard disk space, or a combination of these factors.

Often, these shortcomings are balanced in some way by an embarrassing amount of power in another area, such as graphics processing, or, in the case of network gaming, the ability to play against people in either the same room or on the other side of the world.

In terms of the infinite game universe, the possibility of network gaming adds a whole new dimension to the concept. It also allows an essentially simple idea to get a new lease on life, even if the interface is a basic, text-based console. This has been proven by the popularity of multiuser dungeons (or MUDs), which have spawned their own breed alongside of traditional games.

In this chapter, we shall examine the specific implementation problems associated with games that are designed to be played over a local (LAN) or wide area network (WAN), with specific reference to multiplayer Internet games. Although the information is particularly useful when designing games for networked environments, some of the techniques will also be useful in many other situations.

TYPES OF NETWORKED ENVIRONMENTS

Networks are used for playing games so that a number of individuals can play either against each other or as a team against the computer or other teams. This experience can be implemented in many ways, which fall into two broad categories.

In the first category, the network aspect of the game provides some of the backdrop, but is not key to the game itself. That is, the game itself does not rely on networking, but the addition of networking makes it more interesting. First-person shoot-em-up games fall into this category, but only if based on death matches; any game that requires teamwork falls into the second category.

The second category is reserved for games that would fail without the networking aspect. Many online role-playing games, for example, would not be possible without multiple users in a networked environment. More-over, there are some fairly complex single-user games that would not be possible without a networking aspect.

SHARED-FOLDER NETWORKING

When deciding how to implement the networking aspect of a game, whether it is single- or multiplayer, one of the first concerns is the representation of the link between the players. The simplest way in which this can be achieved is by using the underlying networking features of the target operating system. This can be achieved in the PC and mainframe world by using shared folders or directories.

In essence, no network programming is required at all, since sharing is handled by the target platform. It is possible, for example, in a Windows or Macintosh environment to share directories on a central machine or server among multiple users. The game needs to be pointed at a set path in order to store and access user-specific information, using a standard name (such as a Uniform Resource Locator, or URL) that points to a specific root directory.

At best, this is extremely platform-specific; at worst, it is a nightmare for the system administrator to set up. The reason for this is that each player will need specific access rights, which are set up by the system administrator to enable them to access to the games folder without introducing their own (cheat) files into the directory, so that the gaming client can use the directory freely.

Where this technique comes into its own, however, is in certain types of Internet games where specific applications are executed in order to carry out interaction with the core game system. This is made possible because

most CGI scripts run as a specific user, and the Web server itself handles the security aspects, only allowing access to the folders via the provided interface, and not directly. (We shall be dealing with shared-folder networking in both single- and multiplayer Internet gaming presently.)

PROTOCOL-SPECIFIC NETWORKING

If the game is not designed to work in conjunction with a Web server, but as a pure client/server application, then the developer will need to make use of a given networking protocol. The most popular is TCP/IP, the basis for the Internet.

It is also possible, using TCP/IP, to run games on a peer-to-peer basis—that is, without a server controlling the interaction. Games that run in this way often designate a specific player as a pseudoserver (e.g., *The General*) to which the other players connect. This pseudoserver becomes the owner of the play session.

Since the applications themselves play a large role in the proceedings, they can be made intelligent in a way that browser-based gaming can not. Again, we shall be dealing with a basic implementation of network gaming in due course.

SPECIAL CASE: LIMITED BY SOFTWARE

Web server-based games played through a Web browser (such as Internet Explorer or Netscape Navigator) come with their own special set of platform limitations and advantages. The key advantage is that the client side is not restricted by platform. That is, so long as a browser exists for the target platform, be it a Windows-based PC, Unix, or even a mobile device (which has its own basket of limitations, as we shall see in Chapter 28), the chances are that the player can participate.

On the other hand, games that are played through a Web browser come with the key limitation that they can not contain much game-playing logic. The reason for this is twofold. First, although browsers can often support scripting, such as JavaScript or a similar language, they are limited in scope and are often platform-dependent. Second, sending scripts over the Internet that contain a lot of gaming logic reveal much about how the game has been written, and this opens potential doors for cheating.

Therefore, it is wise to remain with a system that simply uses HTML (the widely-supported document exchange standard for the World Wide Web) as an interface to the CGI scripts that make up the inner workings of the

game, and perform all the game-logic specific actions at the server. Of course, this also serves to limit the scope of the game in some cases. Briefly, though, it makes full animation (such as that seen in most shooting games) impossible, unless cleverly animated pictures are used.

Finally, the Web-based environment suffers from one final limitation—connection speed. It is of no use to create a wonderful interface with HTML and inline images, all generated at the speed of light at the server end, if the clients are surfing the Web at low speeds. Thus, it is common to have low-, medium-, and high-speed variations of the user interface.

CLIENT-SIDE LIMITATIONS

There will usually be a certain amount of limited storage available that can be accessed via the Web interface in the guise of 'cookies.' The cookie is a Netscape Corp. invention used to store persistent client-side information, which is accessible by the server upon a specific HTTP request to the client. Games programmers can put cookies to good use for storing information pertinent to the game in play.

There are a number of reasons to do this, one of the principal being that it reduces the amount of data transfer required. For example, we could use cookies to store information that is activated by JavaScript embedded in HTML pages; and furthermore, we could use scripts to generate the cookie data that can then be passed back to the server.

If all this talk of HTML, JavaScript, and cookies fills the reader with a sense of foreboding, then that is a good thing. Without appearing cynical about the future of online gaming, there are a few small problems that developers of online games face. The first is that cookies might or might not be available to the game software. Furthermore, JavaScript might not be the chosen scripting language of the browser—or the user might have decided that security concerns preclude its use.

It might be better to write a clever Java-based game, which will run in a browser window (assuming that the user has Java activated and that they allow Java applets to run), and use server-side storage of game data. Such game data could be run-length encoded to save bandwidth or, in advanced cases, double coded.

Double coding is too intensive for games where static storage is an issue; but in cases where the volume of transmitted information must be kept to a minimum, it really comes into its own. There is a subtle difference between the two problems. First, if there is a static storage limitation that

would benefit from doubly coding the data, then the platform does probably not provide enough processing power to make it a reality.

The other side of the coin is that there are cases where the machine is very powerful, but is let down by data transfer speeds and available bandwidth. This is not noticeable when playing with a 52-speed CD-ROM drive, but it becomes very noticeable over a 56k modem. The *maximum* data transfer rate is 56,000 bits per second, or 7,000 bytes per second. Since most equipment speeds are quoted in kilobytes per second (Kb/sec.), we should convert the 7,000 bytes per second to a transfer rate of 6.8Kb/sec. Modern CD-ROM drives and hard drives attain throughput of up to 4.8Mb/sec. (CD-ROM) and up to a staggering 65Mb/sec. (Western Digital 120Gb hard drive).

Since we are restricted by the volume of data we can usefully exchange, and the speed at which it can be transferred, we need to reduce the volume of data as much as possible, which is where double encoding comes in.

The principle behind double encoding is simple. First we choose the data that needs to be encoded and select a series of codes that can represent the data so that it can be easily encoded (compressed) under a different scheme that will save space when the data is transmitted. Usually, the first compression technique to be applied (as we have already seen) is to reduce the redundancy of the data.

If we want to transmit changing information, such as video, then we can apply another technique that takes advantage of redundancy of information; we only transmit the data that is changing. However, in this case, we need to somehow mask out the static (nonchanging) data. To do this, we reserve one value to represent 'no change.' In this way, if we have 1 pixel in 10 that changes, we can represent this as follows:

0 0 0 0 0 0 0 0 0 3 becomes 9 0 3

This follows the RLE-style representation already encountered. The same trick can be used for coordinate information and almost all types of rapidly changing data. However, most of the time, it is not going to be data transmission speed that provides limitations, but security and cheating.

The final limitation, then, is that the client software exposes a lot of information about the game by transmitting it elsewhere. When a client-only game plays (i.e., a single player restricted to one computer), it can keep a lot of information hidden. As soon as we start sending information elsewhere, that information can be trapped, replicated, and put to malicious use. RLE gives us a very limited level of security, since it is an encoding scheme.

This, however, is not going to hold back the majority of subversive players, and further encoding needs to be undertaken, using whatever scheme provides the best security. The trade-off is going to be that the information will need to be encoded and decoded, thereby reducing the performance of the system; also, the size of the once-compressed data might rise back to the uncompressed level, since encoded data tends to have a lower redundancy.

SERVER-SIDE LIMITATIONS

One big advantage that the server has over the client is that there will be more hard drive space available, not to mention more processing power. On the client side, the machine has to cope with running an emulator (e.g., a virtual machine, like the Java VM) or Web browser, or even both. The server just has to do what it is already doing—serving information.

This also means that the server is limited by what it can and cannot do. Unless the developer really trusts the game players, access to the server is going to be very limited. In fact, in most cases, the server will only provide an information conduit.

THE MULTIUSER ASPECT

The key behind using a client/server model is to allow multiple players to connect and play either against each other or as a team. The server is in charge and manages both the interaction between the different processes as well as the state of the game universe.

On the other hand, there is another possibility, which has been used to great effect in the past by the developer of *The General* (IBM PC and compatibles), which is to allow one of the clients to also be the server. Taking this approach, then the logic for the server-side processing needs to be built into each and every client.

CLIENT-SIDE ENVIRONMENTS

There are several choices when deciding what kind of environment to use for the client end of a server-based system. For example, the client can be a dedicated single-platform piece of software that runs on the client machine and manages the player's interaction with the server. In order to minimize the amount of work that the server needs to do, we need ensure that the highest possible performance can be extracted from the client platform— hence, we use a special piece of client software.

In other words, we are using the client to provide as much information as possible to the server process so that it doesn't have to do as much work, and more players can play at the same time. On the other hand, we can write a piece of software that is platform-independent (such as a Java Applet), which is downloaded by the client.

This has the advantage of keeping the downloaded software up to date; but the disadvantage is that since the game is going to be interpreted by the client's operating system, it can be less powerful. It does not *have* to be less powerful, but it *can* be if we want to widen our potential audience across all possible platforms.

So, the two possibilities are: run on the operating system, or run in a sand-boxed environment, such as the Java VM. If the software runs as a 'real' application on the operating system, we can also build server-side extensions into it so that a third-party server is not necessary.

Conclusion

There are many solutions to the problems of online gaming, and it is easy to lose track of the technologies available to build online games. The simplest examples, those that involve multiple players in a text-only environment, are the best supported, but many other commercial games often offer online options.

Such games take into account the type of data transmitted, along with the possibilities for encryption and compression. These things become very specific to the games themselves. We have looked at a few ways in which the online environment can be exploited, but the main attraction will always be the possibility to play against multiple human opponents.

THE MOBILE MARKET

INTRODUCTION

The final kind of restrictive platform we shall be looking at is a recent arrival to the world of games, and as such has not yet been fully exploited. Some readers might take exception to a statement like this, but the facts remain: Nobody buys a Palmspring Visor or Psion Organizer so that they can play games on it. By the same token, no one who buys a Game Boy expects to be able to send e-mail, edit documents, or dial the office.

These are two separate platforms for two separate purposes. This, atmosphere, however, is changing—not that teenagers are suddenly going to want their Game Boy Advances to be able to perform as a word processor, but they might want it to send text messages like a mobile phone.

In anticipation of the Internet's explosion into the retail games market, many vendors are now putting modems into their consoles: the Xbox and GameCube are two examples. For a long time, the mobile phone manufacturer Nokia has also put some simple games on their phones. The markets are converging.

As screens get bigger and more sophisticated, more developers will turn their hands toward developing for the truly mobile market: the cell phone (or GSM). After all, what modern device is always by your side, can connect to the outside world, and can relay text messages between the two? Your cell phone.

PLATFORM NOTES

Broadly speaking, the mobile market is split into two categories, neither of which are blessed with large amounts of processing power (typically

between 16Mhz and 33MHz) or memory (usually between 128Kb and 8Mb). Historically, the market has been divided between two operating systems, PalmOS and Epoc (Psion), both of which were originally operating systems for small, handheld machines.

Epoc machines typically had a keyboard, while PalmOS machines, typified by the Palm III and Palm V, had a touchscreen instead of a keyboard, complete with a stylus and handwriting recognition. Arguably, Psion was the first to market a successful handheld machine, sold as a 'pocket organizer.' With the advent of Palm, these pocket organizers took on the moniker PDA (Personal Digital Assistant).

Since these devices moved on from being a useful fashion accessory to a legitimate pocket computer in their own right, the market has expanded. Microsoft recently decided to get into the picture with a version of their Windows operating system called Windows CE, and there are numerous Palm 'clones,' such as the ill-fated Olivetti Davinci and Handspring Visor.

However, a new twist has been added to the story of mobile computing with the movement of the Epoc operating system and its close relative, Symbian OS, to mobile phones. Nokia, for example, is backing Symbian for their 9200 model phone, and it seems that the movement from pure organizer to PDA-plus-phone will continue.

Such machines might be wildly different in their external shape and typical usage, but the key to the survival of these devices is going to be the amount of software available for them; and to this end, they *generally* use one of the three main operating systems: PalmOS, Symbian (Epoc), or Windows CE. Or, they might employ a very close (and sometimes compatible) specialist system.

Where the machines are very similar is in the small screen size (which might be static or differ from one machine to another), which for PalmOS is held at 160×160 pixels. They also share sophisticated memory management subsystems and lack hard drives, all of which are also common to portable gaming systems, such as the Nintendo Game Boy.

However, the mobiles are true computers—designed to be able to perform multiple duties, and not just for playing games. This is an important difference, since it means that there are some useful features for game programming that are included in the operating system itself, such as native support for database-style information management, as well as extensive communications facilities.

These features have two advantages for game developers. First, they make the general development a little easier (if one can find a way to put

them to good use), such as for temporary storage, score keeping, or map generation. A second advantage is that features can be added to the game that take advantage of the various extensions, which compensates them for possible shortcomings in the system.

INTRODUCTION TO THE MOBILE OS

Whether it is a handheld or a truly mobile device, such as a telephone, the operating system has to be efficient and have a small memory footprint. Battery resources are going to be at a premium, and the screen will eat up a lot of power, so there is not much left for the processor. Hence, we should not expect to find a processor more powerful than a 32-bit Motorola running at 33MHz.

With this in mind, most developers have chosen a very modular, object-oriented (OO) design philosophy. The diverse reasons for this revolve around being able to protect each process, only activate those parts of the OS that are required at a given moment in time, and, above all, as the SymbianOS online C++ developers guide states: "The most powerful aspect of OO arises from relationships between classes." (Martin Tasker, Head of Technical Communications, "Managing C++ APIs," June 1999: Section 2.1, available online at http://www.symbian.com/developer/techlib/papers/cppapi/cppapi.htm.)

The OO notion of classes is important to any programming context because it allows the designer to build up a model of the system, block by block, with similar object types (classes) being related to each other to the point that they can share definitions and be seen as an extension of the each other. Furthermore, OO design fits in with the highly graphical user interface that is required to make the devices easy enough to use so as to have broad appeal.

Interestingly, the model used for event processing is subtly different on mobiles than that on the Game Boy. An OS such as Windows, for example, processes information during a special kind of loop known as the "message loop." The loop is entered when a message is available for processing, and a set of case statements determine the processing that is to be performed.

CODE SAMPLE 28.1 Message loop processing – Windows style.

```
// So long as we are alive, we'll process messages
while ( GetMessage ( &msg ) )
{
  switch (msg.type)
  {
    case LEFT_BUTTON :
       // Process left-button action
    break;
       .
       .
       .
    // Other message types
       .
       .
       .
    default:
       // Let the OS handle it
  }
};

// GetMessage returned a value that means we have to
stop...
```

Actually, Code Sample 28.1 is a highly simplified version of a Windows message-processing loop; usually there is a loop that checks for a message and sends it to another function for processing. This allows for 'idle time' processing, which we shall come back to later. This model can be extended using an application framework (series of classes) that process the actual messages, leaving the programmer with the simpler task of programming the behavior.

These extensions are made possible because each interface object usually has a unique identifier, and so messages can be mapped to class behavior in an easy and fairly portable manner. (Interested readers should see the Microsoft MFC or .NET specifications for more information.)

Application frameworks of this kind are perfect for rapid application development where execution speed and application size do not matter, but performance issues and 'bulk' coding mean that they are inappropriate for games programming. In fact the inherent difference between the Win-

dows-style message-processing loop in Code Sample 28.1 and the Game Boy-style processing in Code Sample 28.2 highlights one of the major challenges presented by the mobile market.

CODE SAMPLE 28.2 Message loop processing – Game Boy style.

```
// Do forever...
while (1)
{
  .
  .
  // Do some game processing, if any tasks outstanding
  .
  .
  // Test the user interface
  if (user_pressed_button() == LEFT)
  {
    // Process left-button action
  }
  .
  .
  .
  // Other UI code
  .
  .
  .
};
// If we got here, restart
```

What should be obvious is that Code Sample 28.2 shows that the Game Boy allows the *game* to be in control, whereas in Code Sample 28.1, it is the *user* that is in control. Strictly speaking, of course, in both cases, the operating system is really in control, a lesson quickly learned by most Windows programmers at an early stage in their careers.

The point is that any action game does some processing that is independent of the users' actions, which is almost excluded by the Windows-style OO paradigm adopted by most handheld OS developers. Luckily, they have left the loophole of idle time processing, which we mentioned briefly

above. What we are effectively saying is that "should the OS not be doing anything else, please process this code."

We have to ask nicely, because another difference between the traditional gaming platform and these 'real' computers is the fact that our game might not be the only application running. We hope it is, because it might very well be doing things that require a lot of processing power; but it might not be. The same goes for memory and any other system resources we might need. We have to share them all, which goes slightly against the grain of games programming.

MOBILE VERSUS HANDHELD

We have discussed handheld and mobile machines almost in the same breath without really explaining that, at least as far as this book is concerned, there is a difference. Handheld systems such as the PocketPC (Windows CE device), Psion (Epoc), and Palm (PalmOS) are very different from truly mobile devices like the Nokia 9200, which is based on SymbianOS.

A cell telephone is truly mobile—it can fit very snugly into your pocket, goes everywhere with you; and if you can play games on it, becomes indispensable. Nokia phones are a big European hit partly due to the fact that they were the first cell telephones to have games, logos, and user-definable ring tones. With devices like the 9200, they are adding a color screen and a proper operating system, which makes them perfect for games—not to overlook the fact that they *are* telephones; and as such, they can communicate with the rest of the world (which most handheld devices cannot yet do) with multiple possibilities, such as direct machine-to-machine connections, Internet access, or even SMS (Simple Message System) messaging (or 'texting'). By the same token, however, handheld systems have many desirable aspects, such as a larger screen, more memory, and less chance of being interrupted by an important call.

ATTENTION SPAN & EXCESS COST

Besides the danger of actually being interrupted by a phone call, the inherent portability itself is a problem that the truly mobile market suffers from. If you can play on it anywhere, and it is always there, then the temptation is to play on it all the time. This is not really practical, because the small

screen means that after a while, it becomes both difficult to see and concentrate on.

This slight problem means that the game style has to change slightly. The ideal game would be playable in short bursts (with goals that are achievable fairly quickly), be a multiplayer game over the Internet, and mesh well with the smaller screen size of a mobile phone.

Puzzle games fall into this category, something that Nokia understood and implemented in such games as *Snakes* (eat things and grow longer), *Pairs* (match two symbols), and others. These types of games are simple to learn; yet they are hard to master and make the best of the limited environment by staying simple.

With telephones that have advanced to the point that we can now watch films on them (Nokia again), the above statement might seem a little out of place. Besides the problem that playing games requires much more close-up concentration, there is a slight cost issue. According to industry figures (BBC World Service), 2001 was the first year in which global handset sales declined.

It seems that we will soon come to a point where people will simply not replace their handsets for the newest models mainly because they like them and have become attached to them, and they know how they work. Perhaps software, rather than hardware updates, will be the future trend. Above all, there is the issue of cost—phones capable of playing movies are expensive, probably too expensive for general consumption.

DESIGNING FOR THE MOBILE MARKET

So, the goal of game development for the mobile market is toward simple, low-impact games such as *Tetris* or *Space Invaders*—games with easy-to-learn rules and graphics that do not require a large number of pixels or complex sprites. Perhaps multiplayer extensions of regular games, or games based upon simple concepts (like mazes) would fit into this category most easily.

If the current trend continues toward mobile device manufacturers using high-powered operating systems like Epoc/SymbianOS and PalmOS, then a few of these concerns will go out of the window. The PocketPC platform, running Windows CE, also has its own game developer API, called "GAPI" (or Games API), which was developed primarily to make up for the lack of a decent DirectX implementation for the mobile/handheld market. Strangely, as John Kennedy (Web site: www.microsoft.com) points

out, there once was a low-end DirectX that shipped with the Dreamcast that might have done the job.

GAPI provides drawing and button support, and also allows for full-screen applications in a simplified way, so that the game can pretend it is the only application running on the CE machine. Of course, it doesn't begin to match the capabilities offered by consoles, as Mr. Kennedy notes:

> *If you're going to get serious about writing some entertainment software, you'll need to spend a some time working on a sprite routine (or porting that 3D voxel routine you found on the Internet), and playing with techniques, such as double-buffering and real-time WAV file mixing.* ("Time for GAPI," November 14, 2001, available at http://www.msdn.microsoft.com)

We have dealt with some of this already in this chapter. One of the aspects we have not covered relates to a technique that can be used anywhere, called double-buffering. This is where we store not just one, but two copies of the screen ahead of time, and swap between the screen and two buffers to improve performance.

However, this is not going to help every possible platform; they are just too different. There is a world of difference between a phone and a PocketPC, even if they are both running the same operating system. So, if there is one final piece of advice for mobile platform development: Always remember to check aspects like the dimensions and capabilities of the screen.

CONCLUSION

As we noted above, every platform is different; and between two mobile platforms running the same basic operating systems, there will also be differences. Research will be the key to finding a solution, and often, a complete reengineering will be the only workable approach.

We also often tie the concepts of mobile and online gaming together for obvious reasons; and this chapter, along with the Chapter 27, should be considered precursors to independent research into how the various problems can be approached, taking into consideration the game style, target audience, and platform capabilities.

WHAT'S ON
THE CD-ROM

As an accompaniment to the book, the companion CD-ROM contains all the applications used to generate the images that appear throughout *Infinite Game Universe: Level Design, Terrain, and Sound* in executable form for the Microsoft Windows platform (95/98/NT/2000/Me/XP), which were compiled using the Borland Turbo C++ compiler. These are in the "/binary" directory, and they are organized by chapter.

The Linux version of the CD-ROM does not include these binaries, but they can probably be persuaded to run under the Wine (http://www.winehq.com) environment. This is due to the large amount of Win32 graphical API functions used.

The source code snippets that provide the basis for some of these applications also appear on the CD-ROM in the "/source" directory, and again are organized by chapter. Of course, some of the samples are tied specifically to the Microsoft Windows platform, for which the author apologizes, but the actual code used is pure ANSI C and C++, with no unsupported extensions used, except those macros required to compile Windows software.

Finally, there is a "/figures" directory that contains Figure 1.1 through Figure 25.1, in full color where applicable, and these can be viewed on any platform supporting the TIFF and BMP file formats.

SYSTEM REQUIREMENTS

For the Windows binaries, a machine with a Pentium MMX processor and 64Mb of memory are the minimum requirements, so long as the machine is running Windows 95/NT. For machines running Windows 98/Me/2000/XP a Pentium III processor is recommended, with at least 64Mb of memory. To

compile the source code, any C++ compiler capable of producing Win32 executables will suffice; however, the project (or make) files will have to be recreated by hand.

Linux users will find that their operating system will compile and run the source code. For further information on Linux integration with Wine, please visit the Wine Web site at http://www.winehq.com.

B

SOFTWARE & RESOURCES

INTRODUCTION

Games programming is a detailed field, and we can use all the help we can get. There are tools that can be used on several levels, from concept work through to developing full-scale commercial games software. These applications address specific problem domains, and some are more general-purpose. In writing this book, many pieces of software have surfaced, both Web sites and tools that have proven helpful, and this Appendix contains a selection of them with descriptions and references.

Before we launch into the list, note that the Web site www.lecky-thompson.net contains pointers to information and updates on the information covered in *IGU* as and when they become necessary.

COMPILERS & INTERPRETERS

The usual workhorse for any games programmer will probably be a C/C++ compiler, (or similar software) along with a linker and build tool targeted toward the specific development platform. From time to time, however, it can be necessary or useful to step off the beaten track and use something a little different.

A good C++ compiler is available from MinGW.org (for Windows users) and is almost the same as the GCC compiler shipped with most Linux distributions. The excellent SourceForge Web site at www.SF.net has many compilers and tools also.

RAPIDQ

This is an implementation of BASIC targeted specifically at GUI development, although the compiler also supports command-line application creation. RapidQ is very useful for creating small applications that perform a specific task. It has support for all manners of functions, from sockets through HTTP, regular file handling, and, of course, full GUI support.

It is also cross-platform, and the actual compiler exists for Unix-based operating systems as well as Windows, which means that while the binaries are not portable, the source code is; and people working on different platforms can have access to the same software. Apple Macintosh machines are not supported, however.

RapidQ is freeware and can be downloaded from www.basicguru. com/rapidq.

LCC

For those of you who have not heard of lcc, it is a retargetable C compiler and is used as the compiler of choice for many projects, such as the Game Boy Development Kit (GBDK). The idea behind a retargetable compiler is to use one tool for many separate platforms. Although it cannot compensate for differences in the paradigms of these platforms, the byte code that it generates is directly usable by those platforms.

For a more detailed look at lcc and how it can be used, visit www.cs. princeton.edu/software/lcc.

TOOLS

Many of the tools used to produce a game will be custom written by the game developers for that software house or project. There are some tools, however, that just make life a little bit easier—time is not wasted in re-inventing the wheel.

GOLDWAVE

GoldWave is fairly indispensable for manipulating sound waves. It is not free, but it comes packed with a whole range of features that make it excellent value for the money. In case the reader is thinking that this is a shameless piece of marketing, please note that there are other sound wave editors available, and most sound cards also come with some solid tools.

However, GoldWave outstrips most other packages for ease of use, value for the money, and all-around performance. A trial version (fully-featured) can be downloaded from www.goldwave.com.

THE DEMETER TERRAIN ENGINE

From the official Web site at www.terrainengine.com:

> *Demeter is a cross-platform C++ library that renders 3D terrains using OpenGL. Demeter is designed for fast performance and good visual quality, and makes use of advanced techniques such as dynamic tessellation (adaptive mesh) to render vast landscapes in real-time, without the need for high-end hardware. It is written as a stand-alone component that can be easily integrated into any kind of application.*

This says it all, except that it is free and open-source; integration with other projects will be a very painless process. Be aware, however, that it is wholly reliant on OpenGL, and therefore, it might not be compatible with all platforms.

EMULATORS

Whenever console development is concerned, it is always useful to be able to emulate the target device rather than having to constantly download to it. In the end, the final product will have to be tweaked so that it runs on an actual production unit. But in early stages, an emulator is usually good enough.

Also, for those readers who want to hone their programming skills without going to the expense of buying a lot of expensive, redundant hardware, emulation provides access to a whole range of platforms that would otherwise remain out of reach.

The most popular site by far is www.emulationzone.org, which provides a good starting point for any search for emulators. They also have many technical articles and source code, as well as pointers to other sites containing emulation information.

INDEX